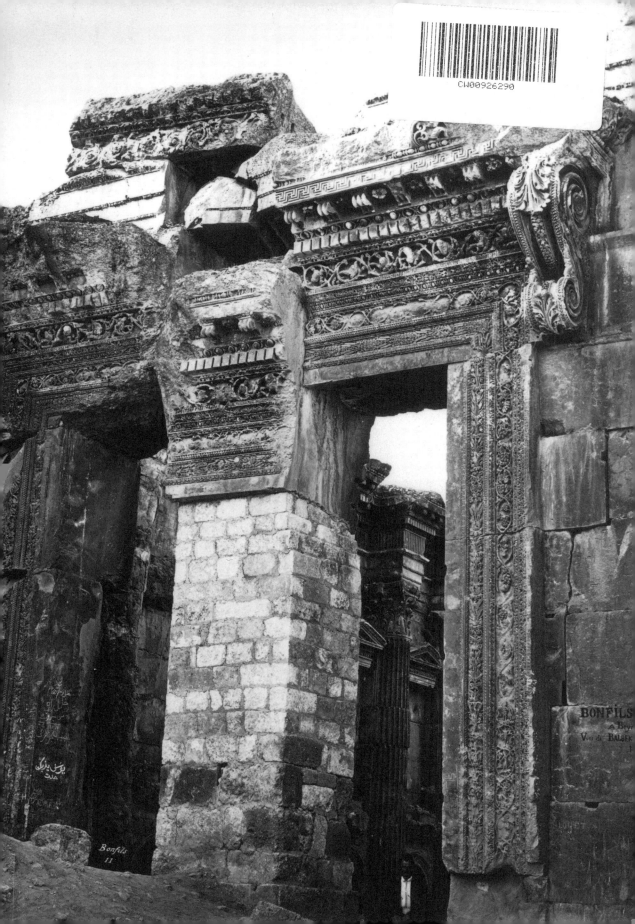

BONFILS
à Bey
Vue de BALBEK

Bonfils
11

urbing
ins

Dist

Rema

Published by the Getty Research Institute

urbing
ns

**Disturbing Remains: Memory, History, and Crisis
in the Twentieth Century**
Edited by Michael S. Roth and Charles G. Salas

Issues & Debates

The Getty Research Institute Publications Program

Issues & Debates
Julia Bloomfield, Thomas F. Reese, Michael S. Roth, and Salvatore Settis, *Editors*

Disturbing Remains: Memory, History, and Crisis in the Twentieth Century
Edited by Michael S. Roth and Charles G. Salas
Michelle Bonnice, *Manuscript Editor*

This volume, the seventh in the series Issues & Debates, evolved from "Memory, History, Narrative: A Comparative Inquiry into the Representation of Crisis," a symposium sponsored by the Getty Research Institute and held 3–5 July 1997 at the Warburg-Haus, Hamburg, Germany

Frontispiece: Félix Bonfils, *Syrie: Porte du temple de Jupiter à Balbek* (Gateway to the Temple of [Bacchus], Baalbek, [Lebanon]) (detail), early 1870s, albumen print. Los Angeles, J. Paul Getty Museum, 84.XO.1167.38

Library of Congress Cataloging-in-Publication Data
Disturbing remains : memory, history, and crisis in the twentieth century / edited by Michael S. Roth and Charles G. Salas.
 p. cm.—(Issues & debates)
 Includes bibliographical references and index.
 ISBN 0-89236-538-2 (pbk.)
 1. Totalitarianism—History—20th century. 2. Genocide—History—20th century.
3. Crimes against humanity—History—20th century. I. Roth, Michael S., 1957–
II. Salas, Charles G. III. Series.

D445.D57 2001
909—dc21

00-059274

Contents

Part III. Memory and History

Acknowledgments

This book stemmed from a symposium sponsored by the Getty Research Institute that was held at the Warburg-Haus, Hamburg, Germany, in July 1997. Entitled "Memory, History, Narrative: A Comparative Inquiry into the Representation of Crisis," the symposium brought together scholars from around the world and a range of disciplines to focus on specific instances of crisis and examine different cultural responses to societal trauma. All the contributors to this volume were participants in this event, which generated many fresh insights into the connections between memory and history.

Without the symposium this book would not have come into being, so we would like to thank all those who made the one, and thus the other, possible. Salvatore Settis, then Director of the Getty Research Institute, made the decision that both symposium and volume were worth doing. We are grateful. We also thank Martin Warnke, who welcomed us to the Warburg-Haus, and our colleague at the Getty Research Institute, Sabine Schlosser, who helped the participants in the symposium make the most of the experience. The proof of the symposium's success, we believe, is in the book. We are grateful to the contributors for their insights and for their continued engagement over the course of the book's production. Here we are most indebted to Michelle Bonnice of Getty Trust Publications. Copyediting is too weak a term to describe her contribution; in some respects she has acted as a third editor, and the volume is much stronger for her criticisms, her thoughtfulness, and her attention to detail.

—Michael S. Roth and Charles G. Salas

Introduction
Michael S. Roth and Charles G. Salas

What is to remain of the past? That which is the least disturbing? Or the most? Remains of the past are all about us, and all about us they fall away into oblivion—unless we intervene. Some relics we preserve. Some memories we hold onto. Some traces we use to imaginatively reconstruct what has passed away. The essays of this volume examine the power and the problematic nature of such interventions by focusing on crises. A desperate villager fills cement bags with his ancestors' remains to save them from flood. A political leader in his final speech chokes upon the name of the predecessor he betrayed. A woman's plea to her neighbors for compassion speaks through the historian for the trauma of millions. Critical moments are transformed in memory and history. Our choices of *what is to remain* often means disturbing remains that are there already.

Since the 1980s there has been a steady increase of interest in social or collective memory. Scholars in many disciplines have focused on how groups retain a sense of the past, and on how a sense of the past can inform a group's politics, religion, art, and social life in general. The importance of memory is taken for granted, but the functioning of memory (the registration, recall, and representation of experience) in any particular circumstance is regarded as problematic. This volume contributes to the exploration of memory by focusing on the recall and representation of extreme events. Through case studies, *Disturbing Remains* extends the range of contemporary scholarly debates about public memory while deepening our understanding of how specific crises affect remembrance and its representation.

Woven into the fabric of modern research is the perception that crises are revelatory, that it is through the extreme that the normal is revealed. Despite the social historian's critique of *histoire événementale*, many who are concerned with the study of the past still focus on those moments in which the normal patterns of historical continuity are strained or broken. In the life of an individual, such moments may be called "traumatic." A trauma is a painful occurrence so intense that it exceeds one's capacities to experience it in the usual ways. A trauma breaks through the categories we use to take in the world, and thus it seems to be registered in our memories in ways that are unlike those used to register conventional experience. How, then, is the traumatic recalled? How is it represented? These questions, important at the level of individual memory, can also be posed at the level of collective memory.

How can traumas that affect an entire community—events so dire that they exceed the categories it uses to take in the world—be adequately represented?

The concept of trauma has been used since the late nineteenth century to denote occurrences that block recollection and yet demand expression. The blocking results in a radical dysfunction of memory, the cure for which is said to be a deeper recollection and a reordering of the past. The modern concept of trauma emphasizes the demand for representation and the refusal to be represented. This demand and refusal stem from the overwhelming nature of the event. On the one hand, its intensity cannot be ignored; on the other hand, any representation pales before the intensity of the trauma. Until the 1980s, it was rare to find the word "trauma" used outside of medicine. In recent years, scores of publications in the humanities and social sciences have used the idea of trauma, and a specialized field of trauma studies has come into being.

One of the key forces that spurred and shaped this nonmedical interest in trauma was the development of Holocaust studies and the emphasis by scholars on the less tangible effects of persecution on survivors and their descendants. The magnitude of the Shoah and the difficulty of integrating this event into a general history of European culture and society have seemed to some scholars similar to the individual's resistance to integrating a traumatic experience into his or her life history. Other key forces that have given rise to the widespread interest in the traumatic are feminism and identity politics. The modern conception of the self has memory at its core: you are what you remember (and forget). Building on this perception, feminist scholars have brought to light how the identities of women have been crucially marked by traumatic events: memories that can be neither fully recollected nor successfully forgotten. Other groups have embraced this paradigm, stressing how their identities have retained the traces of past injuries in subtle but important ways. You are what you've been marked by.

Another key force contributing to the contemporary interest in trauma is the recent move in the humanities from epistemology to ethics—that is, from a critique of knowledge to a concern with doing (and being) good. During the decline of grand theory in the early 1990s, deconstruction and its derivative forms were repeatedly charged with nihilism and political impotence. In answer, thinkers interested in "theory" attempted to move from a skeptical critique of representation to an engagement with the real. Here, the concept of trauma—which referred to an intensity whose reality was palpable, yet unrepresentable—has proved useful. For some, trauma is a basic feature of consciousness. Awakening to the real is itself said to be traumatic and thus to undermine the unity and stability of the individual subject.[1] For others, trauma underscores the inability of any representation to fully convey experience.[2] The recognition of this inability has led some historians and critics to argue that the structural importance of trauma should reinforce our basic human and ethical obligation to hear one another out. An openness to testimony is seen as an ethical response to the fragility of representation and the woundedness of consciousness.[3]

The concept of trauma has gained academic currency in the intellectual atmosphere of postmodernism and antifoundationalism, by which we mean the suspicions about truth and the celebration of ambiguity that have marked the last few decades of cultural life. Even in the ordinarily conservative field of history, postmodern critiques of realism and objectivity have become commonplace. There has also been a reaction to these intellectual tendencies. "How do you deal with the radical evil of Nazism?" the postmodernist is asked. "Are you saying that all representations of the Shoah are equally valid?" The ethical turn in postmodernism has been an attempt to respond to such questions without relying on some new epistemological foundation. It is in this context that discussions of memory in opposition to history have become so prevalent. Appeals to memory are not subject to the same criteria of adjudication as appeals to historical evidence. They claim an unmediated authenticity not subject to academic critique. In the wake of the ferocious critique of the legitimacy of history, memorial gestures have become ever more important.

The horror of trauma is such that it is often seen as a black hole of sense and meaning that consumes even the principles of its interpretation: no meaningful relationships between what came before and after a traumatic event can be created; every attempt to apply concepts of development fails. Yet, as Jörn Rüsen points out, this view contradicts the logic of history. Historical events demand a place as such in that pattern "within which we understand ourselves, express our hopes for and fears about the future, and develop our strategies for communicating with one another." While there have been attempts to find a place for traumatic events within historical consciousness, it is an open question whether this effort can ever be more than an aspiration. Paradoxically, the fact that a traumatic occurrence may be a black hole of experience may actually increase our efforts to remember and understand the effects of what happened in that occurrence.

The essays in *Disturbing Remains* respond to the problem of how we make our histories and ourselves in relation to a past that contains extreme events. Do we construct our present and future by domesticating that extremity? Or do we find some mode of narrating, imagining, re-presenting those events that, at least to some extent, does their extremity justice? Saul Friedländer points in this direction when he integrates into his own narrative the voice of a victim. The impossibility of representing atrocities *even to ourselves* is what strikes Philip Gourevitch; the more dead bodies he sees, the more unreal the sights seem. But if such sights cannot be adequately registered, how can they possibly be adequately represented? And if sights such as *these* cannot be represented adequately, can anything at all? Is anything at all immune to forgetting? Can anything at all be really remembered? The authors in this volume refuse to take the slippery path from trauma to paralyzing skepticism, but they keep their footing by not losing sight of these questions.

Part I. Narrative and History

At times of crisis the importance *and* the difficulty of figuring out what to believe become all the more obvious. Which is the *right* narrative? Which is likely to lead to the best outcome? Are Sikhs planning to kill Hindus? Are Hutus planning to kill Tutsis? Are Germans planning to kill Jews? Or are these just rumors? The choice of narrative can be a fatal one. Even as we choose among the narratives of others to understand what is happening, we generate our own narratives to help us cope. Should our narratives go out into the world, others may rely upon them. In communication, as Reinhart Koselleck has noted, "the private sphere disappears into the saying, and you are not anymore the master of the saying."[4] In other words, when an individual's memories are represented for another, they move from private to public memory and then perhaps into the domain of history. In this domain, questions of accuracy, truth, and judgment (empirical, religious, moral, aesthetic) are dealt with quite differently than in the domain of individual recollection.

Often we use narratives to explain what we have not ourselves observed directly. Our narratives can obscure even as they reveal, recounting fantasies and rumors about the unobserved. They can become so powerful that they leave little room for subjectivity and common sense. They can transform a neighbor, a colleague, even a family member into the enemy, and the results can be terrible. When the crisis has passed, its memory too is structured through narratives. These, in turn, can be used to sustain the narrative of the historian, sometimes the final arbiter of a crisis's remains. The essays in part I address the capacity of narratives to precipitate, facilitate, and retrospectively frame traumatic events.

David William Cohen focuses on the mysterious and still unsolved death of Robert Ouko, Kenya's minister of foreign affairs and international cooperation, in February 1990. Various versions of historicism share the notion that historians should be detectives who by interpreting evidence can reenter the state of mind of the historical actor so as to understand the action "from the inside." In effect, the multiple investigations of Ouko's death proceeded along these lines, attempting to determine his state of mind in the absence of definitive physical evidence. But Cohen takes a different approach, examining the discourse surrounding Ouko's death for "how people come to 'know' and how some 'knowledge' gained authority." In the conflicting descriptions of Ouko's state of mind and the contradictory explanations for his pain that the witnesses before the Judicial Commission of Inquiry layered into the public record, Cohen sees contending strategies for exercising power indicative of the negotiation involved in the construction of history and memory in the modern or postmodern era. What he finds is that the negotiation among different accounts of Ouko's demise opened normally hidden processes of the state to public view. But the question "Who killed Ouko?" may never receive a definitive answer, and the questions "What was Ouko's state of mind?" and "How much pain was he in?" are fundamentally undecided. That undecid-

ability—which tells us much about the normally hidden processes of constructing history—is the subject of Cohen's essay.

Where Cohen studies the expression of memory in the public record, Veena Das looks at the interaction of hate speech, stereotypes, memories, and rumors in the production of hate between two social groups, each seeking dominance of public spaces and discourse. An exploration of how in times of crisis shared collective beliefs can overwhelm the solidarities of everyday life, her essay traces how the Sikh was constructed in the Hindu imaginary as devoid of all human subjectivity and unworthy of being treated as *"an Other with a face."* Operation Blue Star and the assassination of Indira Gandhi accelerated the loss of trust between Hindus and Sikhs. Social memory of past crises provided narrative structures (rumors) that claimed to make sense of the assassination for Hindus but exaggerated the threat Sikhs posed to Hindus and the Indian state, thus exacerbating the danger to Sikhs. Das examines the wild accusations, tracking their power to create paranoia and violence. Their claims on the real were based upon understanding the assassination in light of a particular vision of the past, upon seeing it as part of an unfinished narrative with profound ramifications for the future.

Narrative is present from beginning to end, providing the framework through which experiences can be *had*—as well as come to terms with. Given that narrative structures both the experience and the recollection of an event, it seems impossible for the historian or anthropologist to have access to a crisis in which narrative plays no part. Moreover, narratives differ depending on how one is situated in relation to the event. For example, bystanders, perpetrators, and victims may have their perceptions and memories structured in very different ways. Both Cohen and Das take seriously the difficulty (if not the impossibility) of resolving the interpretive conflict that results from such differences. That is, both take seriously the ways in which the representation of traumatic events challenges our faith in the capacity for successful narrative representation more generally.

Despite their wariness about getting to the "objective truth" of an event, Cohen and Das proceed with confidence to lay out the contradictions and distortions in the narratives of the particular crises with which they are concerned. For this is the responsibility of the intellectual in the face of crisis and its remembrance: to sort representations so as to provide a framework for reinterpreting the inaccessible, and to indicate how acknowledgment of skepticism affects the ability to represent (or work through) traumatic events. It is not enough to bemoan the incapacities of representation or to declare that the truth cannot be known because it is always already embedded in a narrative. In writing about a crisis and its remembrance we *are* committing ourselves to a version of the past, and we are asking our readers to commit to our version as well. Wanting our own narratives to convey the complexities of experience and remembrance does not disconnect these narratives from the world.

Like Cohen, Das focuses on the difficulty of which narratives to believe.

But where Cohen represents this narrative competition as a welcome challenge to state power, Das foregrounds the competition's chaotic results. Where competition brought Kenyans together, it tore Indians apart. Philip Gourevitch is less patient with narrative competition than either Cohen or Das. Gourevitch's essay deals with the aftermath of murderous horror, engaging in an acknowledgment of the difficulties of perception and remembrance of trauma even as the essay itself performs a kind of memorialization. How does one report what one has seen, when the sight beggars the imagination? Gourevitch relates his visit to Nyarabuye, a church in eastern Rwanda where the Tutsis who were slaughtered there by Hutus in the genocide of 1994 have been left unburied. Even standing over the dead, Gourevitch finds perception inadequate for taking in the reality under his feet. Similarly, he finds that two human rights monitors who had witnessed extraordinary horror at the closing of the Kibeho displaced persons camp in 1995 are stunned by their own difficulty in taking in the experience at the moment, of *really seeing* what was right there in all its intensity. Gourevitch wonders "whether people are wired to resist assimilating too much horror." Intensity cannot be fully perceived, and our memories are fraught with this initial incompleteness. There never is a completely satisfying perception or experience to report.

Gourevitch's description of efforts to look closely, to take in extreme events so as to bear witness to them later on, seems to dovetail with the emphasis on framing narratives found in the essays of Cohen and Das. Yet Gourevitch is not interested in keeping open the process of arbitration about what happened in Rwanda. On the contrary, he calls attention to the perpetrators and victims so as to allow some form of accountability. That no absolute justice can be had in the crime of genocide does not invalidate efforts at some juridical action. Likewise, the inability to fully verify a narrative *qua* narrative does not mean that its key components are incapable of being proved. The Hutu Power narrative served genocide in very specific ways, and this can be convincingly demonstrated. Gourevitch has become a witness to the legacies of genocide, and this has imposed important obligations on him as a reporter, as a writer. Does this mean that he gets to *the* truth about this attempt at genocide? Of course not. Gourevitch knows, as Das put it in her essay, that narratives of events in zones of emergency appear as "unfinished." Our retrospective reports do not provide final closure, but neither should they simply leave things as they were. Such narratives must disturb the remains of the past and themselves be disturbed by subsequent retellings. Gourevitch's remembrance of his visit to a site of killing and of his conversations with witnesses to horror again points to the competition of narrative retelling. His essay is aimed against the Hutu perpetrators' efforts to "obliterate the memory that condemns them." At the same time, there is in Gourevitch the sad recognition that there is no true justice in the wake of genocide and that there is no narrative, no picture—no matter how horrific—that is immune to the forces of forgetting.

Part II. Objects and Memory

The essays in part II look at the function of objects, images, and ritual practices in retaining or losing a sense of the past. Leah Dickerman and Carlo Ginzburg raise crucial issues about the impact of aesthetic forms on representations and recollections of an individual or event. Dickerman concentrates on artists active in the Soviet Union in the wake of Lenin's death, and Ginzburg on Pablo Picasso's *Guernica*. Dickerman's essay is concerned with how modernist depictions tried to escape easy ritualization and comfortable appropriation. Ginzburg's perspective on modernism's critical edge is more suspicious: he wonders whether there is a politics of avoidance rather than engagement in what is usually regarded as Picasso's antifascist masterpiece. Modernism asks for the critical engagement of the viewer; it invites the viewer's interpretive participation in making meaning out of a group of signs. These first two essays in part II examine how this interpretive participation affects the status of the representation *as* a sign of the past.

Taking her cue from Walter Benjamin's distinction between the aestheticization of politics (for him, a very dangerous and reactionary tendency) and the politicization of aesthetics (a very powerful and progressive tendency), Dickerman examines two models for the commemorative portrait deployed in the Soviet Union to cope with the trauma of Lenin's demise. The modernist project of Alexandr Rodchenko and the Lef group rejected the sentimental aestheticizing characteristic of state-sponsored memorial practices. Using multiple photographs and a profusion of texts and archival documents, these artists called attention to problems of representation and memory—even as they were engaged in a memorialization project of their own. They rejected the effort to create iconic images of the Great Leader and instead used the indexical properties of photography and documents to put the legacy of Lenin to work: memory for political use in the present. But the revolutionary Soviet state, paradoxically enough, had more use for good old-fashioned icons, for mass-produced and state-approved images that did not call attention to their own representational status and instead fostered fossilizing ritual and sentimental aestheticizing. The modernist moment was closed down (as were so many other things) in favor of an aesthetics and a memorial practice geared to enhancing the state's power and the authority of the new leader.

Carlo Ginzburg's essay, in turn, focuses on one of the great icons of modernist art: Picasso's *Guernica*. *Guernica* has come to stand as a mark of outraged protest against the Fascists' deliberate bombing of civilians during the Spanish civil war. The canonical readings of this painting usually match modernist aesthetics with the progressive politics characteristic of antifascism. Ginzburg questions this accord, however, noting that as a work of antifascist art *Guernica* has the odd distinction of not depicting any Fascists. His essay explores Picasso's "private mythology" and traces Picasso's engagement with Georges Bataille and the Parisian avant-garde. What he finds makes any neat assimilation of *Guernica* with democratic antifascist forces problematic. Is

the ambiguity of *Guernica*'s iconography a sign of the ambiguity of Picasso's own politics in 1937? Or is it, like the reflexivity of Dickerman's Lef group, a refusal to create an icon for a political movement?

In Ginzburg's analysis, *Guernica* is a mnemonic artifact. A past event, the bombing of a Spanish village, is commemorated by a painter who relies on radio and newspaper reports of the event and draws on a pictorial tradition that he also alters in the process of making his picture. Picasso becomes a vicarious witness, and his witnessing is now part of our cultural memory. It is the historian's task to render that memory more reliable or at least less vulnerable to anachronistic rewritings.

Unable to interview Picasso and those around him in the 1930s, Ginzburg relies on delicate inference and the reconstruction of historical context to create a "likely" or at least possible scenario. The authors of the final two essays in part II, Carlo Severi and Jun Jing, have access to their subjects. The reactions to trauma that concern Severi and Jing are not those of individuals in the past but those of collectivities in the present. They too have mnemonic artifacts to study, but, unlike the historian, they can situate them in the context of discussions with members of the communities that produced and continue to employ these artifacts. Both focus on the traces of trauma in altered or reinvigorated ritualistic practices and images, and both are concerned with how the researcher interacts with people who are engaged in those practices.

Severi's essay begins with the issue of memory's dependence on narrative that was central to part I of *Disturbing Remains*. How, he asks, is that dependence related to the ways in which *images* work as traces of the past? If images, like symptoms in Freudian theory, are mnemonic traces of some past event, how does the traumatic intensity of the event affect its functioning as an image? In answer, Severi focuses on the use of balsa statuettes carved in the likeness of whites and on the manifestations of the White Spirit in the shamanistic traditions of the Kuna Indians of Panama.

Severi recognizes the ambiguous, polymorphous nature of the shamanistic imaging of whites. However, he rejects assimilating these constructions to some postmodern understanding of ambiguity. Instead, he examines them within salient shamanistic traditions. The conjunction of contrary features in the representations of whites, in both shamanistic chants and statuettes, is tied to the Kuna's framing of their greatest enemy as supernatural beings within traditional Kuna cosmology. In a society for which a being is defined by the territory to which it belongs, the White Spirit is a representation that is "negative in a complex way." The traditional world of the Kuna has been radically disturbed—but not destroyed—by centuries of coexistence with whites. By giving whites a place *within* the traditional world picture, the Kuna not only renew their own traditions but also mark the white man as a source of suffering in the community's social memory.

Jun Jing's essay is also concerned with the ways in which rituals come to embody memories of traumatic experiences: in this case the suffering of

the villagers of Dachuan due to famine and the Yanguo Gorge dam project, which permanently flooded the village in March 1961. Since Mao Zedong's death, traditional religious practices have made a strong comeback in China. Some observers have seen this in relation to the state's increased tolerance for activities that do not immediately threaten the Communist Party's monopoly on power. Others have discussed the revival in terms of the search for meaning and transcendence, which continues alongside newly sanctioned capitalist economic activities. In his essay, Jing frames the revival of specific religious practices in Dachuan as a way of remembering and (to some degree) repairing the traumas suffered by a close-knit community.

More than thirty years after the great famine, those difficult times still cannot be too openly discussed. The official version of events (which it is unclear that anyone really believes) is that these were times of "natural disasters." The village elders interviewed by Jing had experienced the horrors of starvation joined to what might be called the horrors of cultural amnesia. Weakened by famine and skeptical that the dam would be completed, the villagers either failed to salvage ancestral remains or salvaged them in ways that violated the relations between the living and the dead. The failure to properly protect the dead (and thus the living) is part of the burden of memory that Jing finds in his interviews. For this community, rituals and ritual objects help to diffuse the burden of the traumatic past—famine, death, resettlement, and breakage in the family line. The veneration of ancestors, the worship of fertility goddesses, the continuation of written genealogies are all means of renewing "the symbiotic relationships among past, present, and future generations," of healing a community whose wounds cannot (for personal and political reasons) be freely narrated. Collective memory bears the burden of the trauma and is also the means of recovery from it.

All the essays in part II are concerned with reading images or practices as mnemonic traces of the past, as symptoms that reveal shared memory in transcoded form. Memories do not always appear marked as such; they can be embedded in a variety of (sometimes surprising) objects. In considering individual memory, Marcel Proust put it this way: "The past is hidden somewhere outside the realm, beyond the reach of intellect, in some material object (in the sensation which that material object will give us) of which we have no inkling. And it depends on chance whether or not we come upon this object before we ourselves must die."[5] Shared images and rituals improve our chances of remeeting the past. They transform but still retain a link to the past that we can have access to—as long as we still have the know-how or the beliefs necessary to participate in the practices. But such images and rituals do not only point backward toward the past; they also perform functions (sometimes specific, sometimes ambiguous) in the present. The essays in part II are concerned with the political and social *uses* to which remembrance of traumatic events can be put when it is embodied in nondiscursive forms. As Jing writes about the villagers of Dachuan, "To build a good tomb for the dead is to build a good life for the living."

Part III. Memory and History

The central themes of part III are how we turn private memories into public history and how we make meaning out of traumatic events. How are crises appropriated in the service of identity building and at whose expense? How do representations contribute to our understanding of horrific events, and what are the costs of this understanding? Does understanding mean that we become less open to their power? Does it mean that we domesticate the horror? In recent years these questions have become more urgent, as testimony of personal and public catastrophe has saturated the public domain. When the culture of memory becomes a culture of giving testimony or of officially sanctioned memorial practices, how do our relations to the perpetrators and the victims change?

In the opening essay, István Rév explores how the memory of the events of the Hungarian revolution of 1956 is covered (that is, both represented and obscured) by various attempts to officially acknowledge this painful episode from the past. There is no epistemologically safe spot from which to view these events because every meaningful view of them sees them in relation to their antecedents and their aftermath. History is written by the winners, it is often said, but sometimes even the winners have trouble domesticating the crimes that allowed them to come out on top. When the Soviet Union succeeded in repressing the revolution, its allies in Budapest were faced with the task of finding an appropriate form through which to commemorate "their" victory. But a memorial practice that marked the victory of Soviet-style Communism also functioned as a reminder of the rebellion against that system. How was a commemorative narrative to be created without pointing to the existence of a counternarrative? Gustave Flaubert's comments about the dizzying events of 1848 seem perfectly appropriate to the maelstrom of memory of postwar Central Europe: "The mind of the nation was unbalanced, as it is after great natural upheavals. Certain intelligent men stayed fools for life because of it."[6]

Rév shows us that the desire to manipulate the past in Hungary has not been confined to any one political faction. In the effort to determine identity in the present and a political orientation for the future, the representation of the past is up for grabs. Even when people can more or less agree that certain key events happened on particular days in the fall of 1956, agreement on the *sens* of those events — their meaning and direction — is difficult. Events are framed by narratives that integrate them into a more general process of continuity and change, but there are competing narratives. Rév's own frame for discussing the passage of memory into history produces skepticism about how persons attend to the complexities of the past when the personal and the political are intertwined there. Does this skepticism lead to some orientation toward the future, or to suspicion about any orientation?

Jörn Rüsen takes a very different approach to the problem of integrating a crisis into a coherent historical narrative. For Rüsen, history is one answer to the human experience of crisis and contingency, one that weaves together

forms of continuity to create a shared identity. History goes beyond memory in bringing into the process of identity building intergenerational continuity, critical efforts at coherence, and ethical and political questions of legitimation. An identity is not necessarily a stable construction, but it is a useful defense against the centrifugal forces of accident, violence, and unreason.

Rüsen's subject is the Holocaust and its effects on German national identity. How can collective identity arise out of a past that is so traumatic that it resists every attempt to incorporate it into historical narrative and yet so important that it demands a place in the historiography of the twentieth century? Rüsen explores this question by historicizing German remembrance of the Holocaust. His schema is dialectical. First there was a refusal of acknowledgement in the aftermath of the war, a denial of responsibility and the repression of memory. This was followed by a condemnation of those who were in denial: *you* supported a murderous regime, *you* participated in this horror, and now *you* refuse to face the past. Rüsen calls this response (of the generation that came of age in the post–World War II world) "moralistic" because it places blame on the other. In the current stage, which is still taking shape, he sees a more properly historical response to the Holocaust by Germans. This means that they are marking both their connection to and distance from events of the past. They are finding ways to include the memory of both perpetrators and victims in their historical sense of collective identity. The result is necessarily unstable—an identity built of fragments. But the critical sense of "imperfectability" it fosters may also be a responsible vehicle for drawing lessons from the past in the attempt to build a future that does not depend on the exclusion of the traumatic.

In the essay that concludes *Disturbing Remains,* Saul Friedländer also historicizes what he calls the "expanding memory of the Shoah." Most crises receive less and less attention as time passes. Not the Shoah. Friedländer attributes this (paradoxically) increasing presence of the past primarily to three factors. One, the "generation of the grandchildren" has enough historical and psychological distance from the events of World War II to enable it to *stand in relation* to its catastrophic dimension at a time when the media has propelled these events into the limelight. Whether this relation indicates a collective "working through" or a collective "return of the repressed" in the form of morbid fascination with Nazism is unclear to Friedländer. Two, the call for justice on behalf of the victims and the associated debates over degrees of guilt and comparative victimization continue to fuel the memory of the Shoah. Finally, lacking a really threatening enemy to define itself against, liberal society has turned to Nazism to play that role—making Nazism *the* metaphor for evil.

This expanding and heavily charged memory creates dilemmas for historians. "On the one hand, we find the desire for precise factual information offered within strict limits and organized around a central idea that would give it coherence; on the other hand, we meet an outburst of pain and despair that, in principle, rejects the possibility of order and coherence." Historians

have been trained to seek out what is most "important" and to avoid the individual memory, but the magnitude of the Shoah staggers the imagination, blocks narrative, exceeds the bounds of reason. Should historians now embrace memory's demands for recognition in coming to grips with this era? Friedländer believes they should—or at least, he is less worried by the potential incoherence of these demands than he is by a methodological complacency that fails to engage the moral breakdown and the terror of these times. The testimony of an individual victim, for example, may not have a place in traditional historiography: of what importance is one voice when millions died? What that one voice can do which statistics cannot, says Friedländer, is evoke the depth of the terror and the suffering that is what gives these terrible times their (moral) importance.

The essays in this last part, then, think about (and are themselves illustrations of) the interplay of memory and history among historians. As historians and other scholars have tried to take memory seriously, they are no longer able to conduct their scholarly endeavors in what Thomas Laqueur has called a "business as usual" manner.[7] When critical remains are disturbed, writers must find some way to make meaning out of their own struggle to know and represent the unfinished business of the past and the objects it has left to us.

One of the key words in contemporary trauma discourse is "healing." But what is the relation of healing to justice and to history? Is it the case that healing always demands a certain measure of forgetting, and, if so, what is the position of scholars in relation to this will-to-forget? Contemporary identities are often built on an acknowledgment of a painful past, but there are serious questions about how this acknowledgment can be fitted into a stable political environment—or whether it should be. What, then, is the value of studying the catastrophic past? To relieve in some measure the pain of those catastrophes? To help prevent new ones? It is certainly idealistic to think that digging around in the remains of the traumatic past can help us prevent future disaster. It does, however, give each of us a clearer idea of how we come to terms (or not) with traumatic events and how we represent them. If this clarity cannot protect us against the future, perhaps it will enhance our capacities to live with the past.

Notes

1. See Jacques Lacan, "Tuché and Automaton," in idem, *The Four Fundamental Concepts of Psychoanalysis*, ed. Jacques-Alain Miller, trans. Alan Sheridan (New York: Norton, 1981); originally published as Jacques Lacan, "Tuché et automaton," in idem, *Le séminaire de Jacques Lacan: Livre XI, Les quatre concepts fondamentaux de la psychanalyse, 1964*, ed. Jacques-Alain Miller (Paris: Editions du Seuil, 1973).

2. See the discussions by Hal Foster, *The Return of the Real: The Avant-Garde at the End of the Century* (Cambridge: MIT Press, 1996), 127–68; and Mark Seltzer, *Serial Killers: Death and Life in America's Wound Culture* (New York: Routledge, 1998), 253–92.

3. See the discussions in Shoshana Felman and Dori Laub, *Testimony Crises of Witnessing in Literature, Psychoanalysis, and History* (New York: Routledge, 1992); Cathy Caruth, *Unclaimed Experience: Trauma, Narrative and History* (Baltimore: Johns Hopkins Univ. Press, 1996); and, more critically, Dominick LaCapra, *History and Memory after Auschwitz* (Ithaca: Cornell Univ. Press, 1998), 180–210.

4. Reinhart Koselleck, comment during panel discussion at "Memory, History, Narrative: A Comparative Inquiry into the Representation of Crisis," Warburg-Haus, Hamburg, Germany, 4 July 1997.

5. Marcel Proust, *Remembrance of Things Past,* vol. 1, *Swann's Way,* trans. C. K. Scott Moncrieff and Terence Kilmartin (New York: Vintage, 1981), 47–48; Marcel Proust, *A la recherche du temps perdu,* vol. 1, *Du côté de chez Swann* (Paris: Gallimard, 1954), 58: "Il [le passé] est caché hors de son domaine et de sa portée, en quelque objet matériel (en la sensation que nous donnerait cet objet matériel) que nous ne soupçonnons pas. Cet objet, il dépend du hasard que nous le rencontrions avant de mourir, ou que nous ne le rencontrions pas."

6. Gustave Flaubert, *The Sentimental Education,* trans. Perdita Burlingame (New York: New American Library, 1972), pt. 2, chap. 1, 330; Gustave Flaubert, *L'éducation sentimentale: Histoire d'un jeune homme,* ed. Edouard Maynial (Paris: Librairie Garnier Frères, 1947), 2:185: "La raison publique était troublée comme après les grands bouleversements de la nature. Des gens d'esprit en restèrent idiots pour toute leur vie."

7. Thomas Laqueur, "The Sound of Voices Intoning Names," *London Review of Books,* 5 June 1997, 3.

Part I

Narrative and History

Robert Ouko's Pain:
The Negotiation of a
"State of Mind"
David William Cohen

> I can see that Dr Ouko's attitude and demeanour and some of his actions during the last few days of his life may have given some people the impression that he was in a state of mind which, with the benefit of hindsight, is suggestive of suicide. I find it highly unlikely that a man of Dr Ouko's intelligence and loyalty to his family would not have left some indication in writing or otherwise of his intention to commit suicide and the reasons why.
>
> —Retired New Scotland Yard detective superintendent John Troon[1]

On 16 February 1990, the government of Kenya announced that the mutilated body of Robert Ouko, Kenya's minister of foreign affairs and international cooperation, had been found several kilometers from his Koru farm in Kisumu District.[2] Ouko's death has preoccupied Kenyans for years now, despite multiple investigations into his disappearance on the night of 12 February 1990 and subsequent demise. Followed day by day, week after week, on radio and television, in print and on the street, in homes, clubs, and offices, the Ouko investigations constituted, for various Kenyan publics, windows on a nation in formation.[3] The intractability of the case allowed scrutiny of worlds hardly inscribed or speakable in Kenya's recent past, and the prolonged search for answers invigorated critiques of the Kenyan state, sanctioning demands for multiparty democracy, political and economic reform, and a change in the republic's leadership.[4]

While questions of how, where, for what reasons, and at whose hands Ouko died have driven the official inquiries to date—and to date there are no definitive answers—I am interested here in the means of inquiry rather than the ends,[5] in how people come to "know" and how some "knowledge" gained authority despite the inconclusive forensic evidence. Since 1990 observers such as I have been able to scrutinize an array of investigative and interpretative activity[6]—not only to read the New Scotland Yard investigation and its final report as a source, for example, but also to watch Detective Superintendent John Troon and his team and their witnesses operating in a field of discovery and guile. In examining the layers of discourse within the public record, I have been intrigued by the tensions among and between accounts, texts, interpretative rereadings, and narratives, both oral and written. In retrospect it is clear that representations of Ouko—his crises, his suffering—and

the details of what others knew and did not know were, in all their incomplete dialectics, what became critical to understanding Ouko's death. Ouko's words, gestures, expressions, and movements during his final days were invested with the capacity to present a narrative that would solve the mystery of his death; and Ouko himself became the most accessible and powerful witness to his own demise, to the extent that various individuals were in a position to, in essence, make Ouko reveal his state of mind.[7]

In the end, however, the negotiation of Ouko's state of mind would serve interests far broader than the quest to solve the mystery of his death. As object, and as an object of negotiation, Ouko's state of mind provided a stage upon which various parties sought to animate distinctive interests. Ouko's suffering — or, more precisely, representations of his fraught state of mind — would simultaneously intervene in the public debate about his demise and reveal the inner workings of power in Ouko's family, in Kenya, and internationally. The mediations that made it possible for Ouko to speak from the grave demonstrate the potential authority of the dead body in the constitution and dissolution of societies in the late twentieth century. These mediations also suggest the economies — the constraints and possibilities — attendant upon the expression of pain in the arena of contested memory.

Epistemological Moments

The voluminous investigative record published in Kenya's newspapers — specifically the records of the New Scotland Yard investigation (the so-called Troon report and associated materials)[8] and the accounts of the proceedings of the Judicial Commission of Inquiry (known also as the Gicheru Commission) — focused on Ouko's movements during the seven to fourteen days before he disappeared: what he ate and drank, what he wore, with whom he met, what he is said to have said, what those who heard him speak took what they heard him say to mean, what others felt he felt, and how they saw him dealing with his emotions. Of particular interest to the New Scotland Yard team and the Judicial Commission of Inquiry were the last interactions and conversations Ouko had with family, friends, employees, and government colleagues.

Without any particular problematizing of the idea, witnesses and authorities appeared to agree on — and to have constructed by this agreement — a notion of an almost tangible state of mind. This agreement did not extend to the content or substance of that state of mind, for the close and continuing attention to Ouko's last days stemmed from the collision of assertions that Ouko had committed suicide with claims that Ouko was a "forewitness" to his own murder, one who had pointed to possible suspects. It did extend, however, to the proposition that Ouko's state of mind was an accessible and valid frame for explaining his death. At the Judicial Commission of Inquiry, which sat from 9 October 1990 to 26 November 1991, some 50 of the 172 witnesses presented testimony on Ouko's state of mind as they observed and interacted with him before his disappearance. The stuff of these narratives — the reports of conversations with Ouko, the observations of Ouko in different places and at differ-

ent times — saturated the possibility of Ouko, raising the question of how many of the narratives, explanations, and meanings packed onto his every gesture, posture, action, and word Ouko's mind and body could sustain.

Significantly, the constitution of Ouko's state of mind was as contingent on differences between representations as it was on consensus among them. The manifestations of dissent were in part the product of the investigative process, in which detectives, counsels, and judges drew out variations among witnesses' accounts. If some witnesses saw Ouko as suffering, in crisis and in pain, during his last days, others saw the Ouko of this period as not so different from the Ouko they knew at other times. If one witness identified a specific source for Ouko's crisis, his or her reading of Ouko's state of mind would be confronted by readings that offered competing explanations or sources for the observed pain. The witnesses to Ouko's state of mind variously referred to his difficult relations with his brothers, particularly Barrack Mbajah, and to his experiences as a member of the delegation that accompanied President Daniel arap Moi to Washington, D.C., in late January 1990. They referred to tensions with Nicholas Biwott, then Kenya's minister of energy, and to the notion that Ouko was assembling evidence regarding high-level governmental corruption in Kenya. They spoke of the anxieties imparted by a traffic accident in which Ouko was involved two days before his disappearance, by rumors of a mistress and difficulties with his marriage, and by the management of his Koru farm and other properties.

These unveilings of Ouko's state of mind in his last days as recounted by witnesses constituted epistemological moments — moments replete with evidentiary and explanatory contingencies that were subject to interpretive investigation and that, in most instances, received conflicting readings. From the twenty-five epistemological moments I have identified in the public record, I have chosen three that suggest not only the range of such moments but also the challenges of rendering Ouko's behavior into a state of mind.

Ayub (Job)

In testifying before the Judicial Commission of Inquiry, a number of Ouko's friends and family members expressed concern — or reported Ouko's concern — that a traffic accident on Friday, 9 February 1990, in which his vehicle was forced off the road by an oncoming truck, had been a deliberate attempt to kill him. This accident was the starting point for the wide-ranging testimony of eighty-year-old Namaan Ondu Ominde, a born-again Christian and an elder of the Africa Inland Church, who identified Ouko as "the son of my brother and … also my friend." Ouko and his wife visited Ondu the evening of the day of the accident.

> ONDU: I was there [on his farm near Koru] on that day [8 February 1990] and on February 9. It was a Friday. Between 5 and 5:30 P.M., I was studying the Bible, Jeremiah Chapter 12, in the Dholuo translation. It is God who made me read that chapter.

ONDU: ...I read Jeremiah Chapter 12, verse 1 to 6. (He begins reading from the Bible in Dholuo) "Righteous art Thou, O Lord, that I would plead my case with Thee; Indeed I would discuss matters of justice with Thee: Why was the way of the wicked prospered. Why are all those who deal in treachery at ease? Thou hast planted them, they have also taken root; they grow, they have even produced fruit. Thou art near to their lips, but far from their mind. But Thou knowest me, O Lord; Thou seest me; and Thou dost examine my heart's attitude toward Thee. Drag them off like sheep to the slaughter. And set them apart for a day of carnage! How long is the land to mourn, and the vegetation of the countryside to wither? For the wickedness of those who dwell in it. Animals and birds have been snatched away, because men have said, 'He will not see our latter ending'.

"If you have run with footmen and they have tired you out, then how can you compete with horses? If you fall down in a land of peace, how will you do in the thicket of the Jordan?

"For even your brothers and the household of your father. Even they have dealt treacherously with you, even they have cried aloud after you. Do not believe them, although they may say nice things to you."[9]

Responding to questions from Bernard Chunga, a leading counsel for the commission, Ondu explained that he was alone that Friday afternoon, reading to himself. He also provided this gloss on Jeremiah: "Jeremiah was like a prophet and the people were made to suffer so that they could not preach the word of God. That is why he was complaining, saying the sinners were being rewarded by getting rich and prospering while the other people suffered." Asked whether he had a particular reason for reading Jeremiah, Ondu replied, "I had something concerning me in mind. My daughter died in Nairobi...she was a teacher. I was wondering why it had to happen."

He went on to recall that "As I was reading the Bible, some visitors arrived. It was Dr Ouko and Mama Ken [Christabel Ouko, Robert Ouko's wife]. They found me at the verandah and I welcomed them into the house where I prayed for them." When questioned about why he prayed at that time, Ondu elaborated, "I was thanking God for keeping them safe and bringing them to visit me. I did not tell them what I had been reading about in the Bible." After learning from Ouko about the traffic accident, Ondu said he "prayed for them again and told Mama Ken to take Dr Ouko back to their home.... [W]e prayed God to give him strength and heal any injuries he may have. They left me at about 6 P.M. and I stayed there."[10]

Ondu then explained that during the night he came to feel more troubled about Ouko's situation because his daughter-in-law had found Ouko surrounded by visitors when she went to see Christabel Ouko that evening: "I was wondering why people were going to see Dr Ouko. Might he have been injured? As a result, I decided to go and see him the next morning." Arriving at 7:15 A.M. on Saturday, he was greeted by Christabel Ouko and Ouko joined them in "his sleeping clothes." Ondu recounted that he "knelt and prayed for them at the verandah ... [as follows:] Thank you God for helping them. Continue to help

them. Bless the Minister and heal him of any injuries." Ouko returned to bed, according to Ondu. Eventually Christabel Ouko called Ondu into the dining room for tea, and when Ouko joined them "He [Ouko] sat next to me. He was feeling hot and requested to go and sit outside. He could not eat his toast and I ended up eating it." Chunga: "Was he happy?" Ondu: "Not all that happy."

At this point, Bishop Gabriel Ogonyo Ngede of Kisumu and his wife arrived to pay their respects. The bishop's perception of Ouko's demeanor, judging from his testimony before the commission on 18 March 1991, differed from Ondu's:

> NGEDE: I drove in [through the gates of the farm] and parked the vehicle on the right hand side next to a grass-thatched structure. Then my wife and I entered the house and found Mama [Christabel Ouko] and Mzee Ondu . . . I met Mrs Ouko and she welcomed me very warmly into the house.
>
> I found them taking tea in the sitting room (Mrs Ouko and Mzee Naaman Ondu). When I was taking tea, the Minister came we shared jokes, started talking and hugging each other. I had been anxious to see him.

Duncan Mwanyumba, a leading counsel for the commission, asked Ngede, "Having known the Minister for those five years, how can you describe his mood that day?" Ngede: "He was very happy. Very joyfull." According to Ngede, Ouko told him about the accident, "'*No wachononi joo jaka nera, gari ne dwaro nega to nyasaye okonya*' (Man from my mothers['] land this vehicle wanted to kill me but God helped me). . . . He only told me that and I encouraged him to be strong and forget about the accident." Justice Evans Gicheru, the commission's chairman, then queried, "Did he [Ouko] appear to be unduly concerned about the accident?" Ngede: "Yes, he was very concerned about the accident." According to Ngede, shortly thereafter he asked the Oukos to come and pray at his church but Ouko told him that "he was going to pray with Mzee Ondu. So I offered a prayer. I conducted the prayer in the sitting room where we had moved. . . . All of us moved there. We prayed while standing and I prayed God to continue protecting the Minister. I was praying particularly for the Minister. I think the prayers lasted for 15 minutes."[11]

After Ngede left, Ondu and Ouko agreed to pray together at the African Inland Church in Koru the following day. On Sunday morning, the Oukos arrived at Ondu's home, then "About 10 A.M. I left with Dr Ouko and his wife in her small car. She was driving. When we reached the church, I requested that the Minister preaches that day, as his father used to do, and he told me that I should start." In response to a question from Chunga, Ondu related that he did the first reading: Jeremiah 12. It was, according to Ondu, a chapter

> brought to me by the spirit of God. And then I preached. I gave Dr Ouko an opportunity to greet the congregation. He gave me the Bible to read Ayub (Job) Chapter 3, verses 1 to 11. I read it out on his behalf.

ONDU: (Reads out the chapter in Dholuo and it is interpreted by Mr Charles Pacho).

Afterward, Job opened his mouth and cursed the day of his birth.
And Job said,
"Let the day perish on which I was born,
and the night which said, 'A boy is conceived.'
May that day be darkness;
Let not God above care for it,
Nor light shine on it.
Let darkness and black gloom claim it;
Let a cloud settle on it;
Let the blackness of the day terrify it.
As for that night, let darkness seize it;
Let it not rejoice among the days of the year;
Let it not come into the number of the months.
Behold, let that night be barren;
Let no joyful shout enter it.
Let those curse it who curse the day,
Who are prepared to rouse Leviathan.
Let the stars of its twilight be darkened;
Let it wait for light but have none,
Neither let it see the breaking dawn;
Because it did not shut the opening of my mother's womb,
Or hide trouble from my eyes,
Why did I not die at birth,
Come forth from the womb and expire?"

After I read the chapter, he talked. He said that is how he greeted the congregation, in accordance with the chapter. We finished, prayed and gave thanks.

In response to a question from Gicheru, Ondu added that Ouko "said that Job was crying for his life. He did not tell me why he selected that chapter.... He said [to the congregation] that any Christian can experience problems. Job had problems but he was contented all along and so all Christians must be contented." The questions continued in this vein, focusing on Job:

CHUNGA: Ayub seems to have been expressing himself very strongly.
ONDU: Yes because most of his things were spoilt and his riches destroyed.
CHUNGA: Why was he talking like that? Ayub, not the Minister?
[JUSTICE RICHARD] KWACH: Because he had so many things; camels, 10 children—seven sons and three daughters—and all those died. The wind blew up the roof off their house, and they all died.
CHUNGA: What was the extent of the damage suffered?
ONDU: His camels and herdsboys were all killed, his seven sons and three daughters who were celebrating all died. The wind blew the house and it fell on them and they all died. Ayub said: "I came to this world naked and I am going back naked. All these things were brought by God and he has taken them away."

CHUNGA: Was Ayub praying or what was he doing?

ONDU: He was praying as he respected God and was tempted by satan through the loss of his property and children.

CHUNGA: Was he talking in despair?

ONDU: Yes. Later he had wounds all over the body and he was very ill.

GICHERU: Do you know what relevance that had to the Minister?

ONDU: I thought he was encouraging the congregation but when I thought about it later, I found it very very difficult to understand why the Minister should read that to the congregation. When I went back, I read this chapter and I found it very difficult to see how or why the Minister read it. That is why I am here to bring you that chapter so that you can go, read it, interpret it and find the meaning.

GICHERU: Did you speak to the Minister about why he chose that passage?

ONDU: No. I've been reading it but I've not known why the Minister chose it. But he told the congregation that any Christian should be aware that on any occasion he might have problems, like Ayub.

CHUNGA: Ayub had wounds, what happened to him in the end?

ONDU: God healed him and returned to him all his wealth and children.

Ondu's account of Ouko's selection from Job and discussion of the verses in church on the Sunday between Ouko's traffic accident and disappearance provided an extraordinary space for the reading and interpretation of Ouko's state of mind from the edge of the grave. The verses from Job (and, indirectly, Jeremiah) could be read as a critique by Ouko of the state of the Kenyan state in early 1990 and of the deeds of the country's elite. Indeed, they could be seen as parallel to the documents on governmental corruption in Kenya that some thought Ouko was assembling in his bedroom at the Koru farm the evening of his disappearance. But Ondu's testimony also foregrounded his own ongoing uncertainty as to the meaning of Ouko's request for the verses from Job: "I am here to bring you that chapter so that you can go, read it, interpret it and find the meaning." Did the text reveal Ouko's own despondency? If so, why was he in despair? Was his despair prompted by public or private difficulties? Or did Ouko choose the text to indicate hope and redemption? In that case, was he anticipating a downturn in his fortunes?

In testifying before the Judicial Commission of Inquiry, both Ondu and Ngede provided details about Ouko's actions and state of mind in his last days. Yet, although they were at the Oukos' home on 9 February at the same time, and each commiserated with Ouko about the traffic accident and offered thanks for the minister's survival, the two churchmen produced different accounts not only of Ouko's demeanor but also of the movements of individuals into and out of rooms and even of where prayers were offered.[12] It was Ondu's testimony that gained ascendancy, however.[13] The words of the worried eighty-year-old man who had risen early to walk for an hour and a quarter to reach the Oukos' farm at 7:15 A.M. were far more compelling than those of the man who arrived midmorning in a pickup. Similarly, Ondu in church reading Job on Ouko's behalf carried more weight than Ngede in the

Oukos' sitting room discovering that the Oukos were going to Ondu's church. Ngede observed Ouko as a survivor of a traffic accident and offered his own views on Ouko's well-being, whereas Ondu ate the toast of a man who had no appetite and used his voice to both convey and reflect on Ouko's thoughts. Thus, at a time when churches were emerging in Kenya as critical (although not necessarily safe) sites of opposition to the government, Ondu's testimony spread across Kenya, augmenting other church-based critiques of the Kenyan state with his dramatic and politically subversive story of Ouko and Job.

"Telo-tek" [Leadership Is Not Easy]

The last acknowledged visit to Ouko at his farm before his disappearance was by Dorothy Agneto Randiak, Ouko's sister, who arrived with three of Ouko's old colleagues or friends around 7 P.M. on 12 February. "They found Dr Ouko seated alone next to the outer study door. There was darkness [because of an unexpected electricity outage] and the Minister was holding a book and a torch [flashlight]. They joined the Minister where he was seated and were served with drinks."[14] Those accompanying Randiak "expressed their sympathies to the Minister for the [traffic] accident." While the four were visiting with Ouko, he received several telephone calls. Eventually the lights came on and Selina Ndalo Were, the Oukos' housemaid, invited the group to the table in the dining room, where they had dinner.[15]

Then, according to Randiak's testimony before the commission, they moved into the sitting room, and Ouko received

a call from a person whom Dr Ouko addressed as "George". Dr Ouko went to speak to the caller from the bedroom extension. Mrs Randiak said she went to summon the Minister from the bedroom so that he could turn on the television set for them to watch the 9:30 P.M. news and the Minister went back to the bedroom after turning on the set. She did not know whether he went back to the telephone.

Mrs Randiak said the news on Nelson Mandela's release from prison was being shown and she called Dr Ouko from the corridor to come and see the freedom fighter leaving the Rob[b]en Island a free man.[16]

She said that because Dr Ouko was a fan of Mr Mandela, she expected the news to excite him.

The Minister went to the TV room but did not sit down. He just stood and watched. "But he was not very excited as I had expected. As he was walking back to the sitting room, he said: 'I hope this is not just a cosmetic release'["].[17]

She said that she did not find out what the Minister was doing in the bedroom because that could have meant probing him.

RANDIAK: But later on, when I decided to return to Kisumu, I went into the bedroom, this time to inform [him] that I was leaving. He sat on the left side of the bed facing the bedroom door. He had several files—more than three—and two briefcases on the floor.... He had some files on the bed and there was this particular orange file, different from the rest (and) marked confidential. It was bound with an orange ribbon across.[18]

According to Randiak, Ouko left the bedroom to say good-bye to his guests. The three men in the visiting party left the house, leaving the siblings alone for a few minutes. During this time, Ouko raised two issues with his sister: their brother's behavior toward the family — "Dr Ouko said Mr Mbajah had not been sending money to the home servant" and asked his sister to discuss the matter with Mbajah and promised to speak to Mbajah when next in Nairobi; and the behavior of a government official — "He told me what he had said to me on the sixth about his disappointment with his Cabinet colleague.... He said he would give me details when he comes to Nairobi. I never saw him again, my lords."[19]

Oki Ooko Ombaka, a counsel for the Ominde Society (Ouko's clan organization), asked Randiak to elaborate the details of this conversation:

OMBAKA: You told the Commission that the Minister [Ouko] brought up the issue of Mbajah when you were about to leave (the Minister's home on 12th night) Koru, that is when he said in Dholuo "telo-tek", interpret to their lordships what that means.

RANDIAK: Literally, it means that leadership is not easy. He said so in the general complaint about his younger brother. As an elder, he was not seeing the real qualities of leadership in family matters in Mbajah.

KWACH: Would that mean that there was a struggle for power in family leadership between Mbajah and Dr Ouko?

RANDIAK: I do not think so because there was no question of leadership in the family.

OMBAKA: In the context of what you told this Commission of the Minister's state of mind and that he was apprehensive and anxious and feared for his life, could that comment "telo-tek" have any other meaning?

CHUNGA: I am sorry, with respect, my lords, but that is highly speculative in the circumstances.

GICHERU: That is actually speculating...

OMBAKA: I can put that question directly. Dorothy, do you think that, because the Minister feared for his life, he was wondering about Barrack [Mbajah]'s ability to lead the Seda family.

RANDIAK: I do not want to speculate, that could be so but he did not tell me. But it could have that meaning.[20]

With these words, Randiak refigured Ouko's concerns about Mbajah and Ouko's somber reaction to Mandela's release as consequential to Ouko's reported anxieties regarding his "Cabinet colleague" Nicholas Biwott. These two areas — Ouko's relations with Mbajah and with Biwott — were heavily traveled fields of investigation. Because Randiak was able to situate in Ouko's voice that the fraternal conflict was not of murderous or suicidal import — "there was no question of leadership in the family" — her account of her brother's last conversation with her would help focus speculation on Ouko's relationship with Biwott. The force of Randiak's testimony rested, in part, on

the fact that she was evidently the last family member or colleague to speak with Ouko, and it was strengthened by the fact that she could give a fixed temporal location — the televised report of Mandela's release — to her last interactions with her brother. It rested as well on her manifest ability to represent Ouko's concerns in his own voice and words.

"Magi e gik ma biro nega" [These Are the Things That Will Kill Me]

While Ouko's words to his sister, recounted eighteen months later, would hold forever in suspense what he would have told her in Nairobi, Randiak was nevertheless well informed about his quarrels with Biwott. On 6 August 1991, Randiak recalled her conversation with Ouko two days after he had returned from Washington, D.C., and several days before he disappeared:

> RANDIAK: I did also commend him (Ouko) for the able manner in which he handled a press conference he held in the U.S. I also drew his attention to letters of commendation appearing in our daily newspapers. To this, he looked down for a few moments and, with a sigh, he returned: "*Magi e gik ma biro nega* (These are the things that will kill me)". We remained silent for a little moment then he started on a different topic.
> GICHERU: How was his mood?
> RANDIAK: He was sombre, he looked concerned. He then introduced a different topic — (that) of corruption.[21]

In the examinations and cross-examinations before the Judicial Commission of Inquiry, such indications that Ouko was a deeply troubled man were countered by other evidence. Under cross-examination on 9 and 12 August 1991, Randiak was pressed to explain inconsistencies between Ouko's remarks to her about his public life — as she had reported them variously before the commission and in previous inquiries — and reports, documents, and events that seemed to situate him there differently. She was pressed, moreover, not only to describe and explicate what Ouko said to her on 6, 9, and 12 February 1990 but also to recall and explain conversations that they had between 1987 and 1990.

Randiak's credibility was left to stand or fall on her ability to navigate among competing revelations and constructions of Ouko's intimate reflections and anxieties and among a range of different readings of Ouko from public and official sources. Having stated that Ouko had told her that Biwott had driven Dominico Airaghi and his Italian consulting firm out of the project to complete the molasses plant in Kisumu (essentially disqualifying Airaghi's firm from any other Kenyan development project financed by Italian capital), she had to explain before the Judicial Commission of Inquiry a letter that seemed to indicate that Airaghi's firm was working comfortably in Kenya with Asea Brown Boveri, the international firm that, according to Randiak's testimony, Ouko had named as part of the "incredible" team that was corruptly driving Airaghi's firm out of Kenya. Having recounted Ouko's reports of conflict with Biwott in Washington, D.C., because Ouko was given special security arrange-

ments but Biwott was not, she then was pushed to explain official paperwork for this trip that showed Ouko and Biwott sitting together on a flight, sharing the same car, and staying in rooms on the same floor of the Willard Inter-Continental Hotel. Having stated that the conflict between Ouko and Biwott stretched back many years and involved allegations that Biwott had supported Ouko's opponents in parliamentary elections, she was asked to explain why Biwott asked Ouko to stand in for him as guest of honor at ceremonial occasions in 1989 and why Ouko accepted these invitations. Having narrated Ouko's anguish regarding his fear of Biwott, she was confronted with a note in Ouko's diary, in his handwriting and dated 2 February 1990, that "Hon. Biwott told me Ken [Robert and Christabel Ouko's eldest son] is to be recruited to [Biwott's] Ministry Energy even as a student."[22]

Randiak, marked by her own assertions as the most informed witness to Ouko's state of mind, commanded Ouko's capacity to "speak" as a forewitness to his own death. In her case, the challenge of managing disjunctures and contradictions in the representation of Ouko's speech, gestures, emotions, and actions while testifying before the Judicial Commission of Inquiry was made more complex by the commission's references to earlier statements, both oral and printed. The counsel and commissioners involved had access to notes taken by investigating police officers, statements prepared by members of the New Scotland Yard team, reports of what she said to others (including other witnesses in the investigations), and her earlier testimony to the commission. The transcripts of the commission's proceedings thus show how Randiak's authority over her accounts of Ouko's speech and demeanor was sustained and where the openings were for challenging her authority, undermining her credibility, deconstructing her agenda, and removing any possibility of establishing Robert Ouko as a forewitness to his own demise.

Ishan Kapila, counsel for Nicholas Biwott, gained legal standing before the commission when testimony that included references to and allegations against Biwott was introduced. It was Kapila, along with two colleagues, who directed the attack on Randiak's credibility and on the trajectory of testimony and disclosure that situated Biwott, and the alleged conflict between Ouko and Biwott, at the center of the commission's inquiries. Having failed at the outset to exclude testimony regarding Biwott from the public process of the Judicial Commission of Inquiry, Kapila developed several lines of cross-examination before the commission: [23]

- Noting that Troon and his team had questioned Randiak some ten times, Kapila argued that discrepancies among her several written statements and her testimony before the commission showed her to be an unreliable witness, one who had lied about what her brother told her. Far from being a useful witness to the commission, Kapila postured, Randiak should be prosecuted for perjury.[24]
- By introducing into evidence various documents, Kapila attempted not only to discredit Randiak's expertise concerning the international consulting

and contracting arrangements surrounding the molasses plant but also to suggest that Ouko and Biwott were *not* in fact rivals in regard to these arrangements.

- By referring to entries in Ouko's diary and to details regarding the trip to Washington, D.C., Kapila attempted to show that there was nothing particularly dysfunctional about the behavior and the relations of the two ministers while on this trip.
- By citing sections of Randiak's statements prior to her testimony before the commission, Kapila attempted to demonstrate that Randiak herself knew that Ouko's relations with his brother were far worse and far more threatening to Ouko's safety and well-being than Randiak was acknowledging to the commission.
- By comparing statements Randiak made at different times over the course of the investigation, Kapila attempted to prove that her "memory" had been augmented just in time to move attention from Mbajah to Biwott.
- By bringing into play the testimony of certain Kenyan police officials and district officers, Kapila attempted to show that initially there was a great deal of certainty that Ouko had committed suicide and that the early reports of Ouko's behavior and state of mind gave foundation to the theory that the despondent minister had taken his own life.

In Kapila's cross-examination of Dorothy Randiak, considerable attention was paid to the discrepancies between what she was saying to the commission and what had appeared previously in her New Scotland Yard statements. It was left up to Randiak to explain many of the "technologies" of testimony and inscription, namely,

- that what she said to Troon during a specific interview might not have been what he wrote into his notebook
- that the intentions and needs of the interviewer and witness during an interrogation may produce disjunctures in lines of inquiry and response
- that a witness's account of an event may be enlarged through questioning and further reflection without surrendering its integrity (that is, the first account is not necessarily the most complete and truthful account)
- that the increasing detail of her statements over time might be due as much to her changing feelings about her personal security as to the elasticity of memory
- that reported speech within signed statements and contracts does not confer authority on the words of those whose positions are being reported

In addition, Randiak had to explain

- that there can be a difference between what cabinet ministers expect of one another in a formal or public professional setting and what happens in their behind-the-scene relations

- that she knew her brother so well that she could read his fears and state of mind accurately, whether or not he was speaking openly about his state of mind

Kapila's tactics had unanticipated results, however. In restating Randiak's earlier statements and testimony within his cross-examination, Kapila often presented her allegations more clearly or tersely than she did and then unexpectedly found her agreeing with his construction of what she said. In a sense, through restatement and repetition, Kapila enlarged the surface area of Randiak's claims as to what Ouko told her in their last conversations. One might suggest, after looking across the several days of Randiak's testimony, that rather than employing the terms set by the commission or conforming to its intentions, Randiak relentlessly forced the commission into accepting the terms and intentions she set forth her testimony. Before the Judicial Commission of Inquiry, Randiak effectively constituted for years to come the terms of debate about Ouko's demise.[25]

The standing of Randiak's representations of Ouko's crisis rested on her capacity to mediate all these issues (and more), not by simply asserting the authority of her account but by negotiating in a more complex way the extraordinary contingencies of testimony and investigation within and around the Ouko case—by managing all the epistemologies, one might say. That she could focus and sustain attention on the affairs of Biwott, in the voice of Ouko, brought Kenyan publics to a particular understanding of Ouko's demise and permitted greater comprehension of the routines of state contracting in the international domain. At the same time, her responses under cross-examination protected Ouko's personal life and his family relations from still closer and more intimate scrutiny.

The Negotiation of a State of Mind

One may project onto or into the records within and surrounding the five investigations of Ouko's disappearance and death an almost palpable tension between the assurance that one is close to understanding what happened and the need for still more foundation (evidence, testimony) as to what actually happened.[26] Whether one is considering the judicial process or the wider terrains in which the judicial process is situated and surveilled, this tension is the product of an eagerness to fill in, or constitute, *a* narrative and a sense of obligation to construct *the* narrative—to maintain the critical distinction between a "subjective" rendering of Ouko's reading of his (and Kenya's) situation in the world and an "objective" rendering of Ouko's demise. Between these two programs lie the workings of an official inquiry searching, arguably, for a finite narrative as well as the workings of witnesses seeking value and interest through the surplus or excess of narratives of Ouko's state of mind.

Bringing the idea of arbitrage—the simultaneous purchase and sale of a commodity in order to profit from price discrepancies—to bear on the analysis of literary texts,[27] M. Ackbar Abbas has argued that the power of interpretation

lies not in the "next and better reading" but in the comprehension of the difference and disjuncture between readings, in discovering "the interpretive, explanatory, and representational powers that are located *between* first and second 'readings,' or that develop among multiple and sometimes disconnected readings of the past."[28] Abbas's approach helps one see how the participants in the Judicial Commission of Inquiry exploited their "reading" opportunities not only toward the "next and better reading" but also as a means of comprehending the sources of interest and power that were behind and between different accounts. For example, the close readings, with so much attention paid to difference, of Randiak's statements and testimony provided an opportunity to elaborate the attributions, interpretations, and allegations that sought standing before the commission. This approach produced representations of a scale and depth eclipsing any one of Ouko's assertions as conveyed into the commission's record by any one of the participants. The possibility and reality of incommensurate, incompatible, and incomplete readings and narratives actually animated fuller accountings of Ouko's crisis.

As I have already argued, the very notion that Ouko was experiencing pain made his state of mind a stage upon which various individuals and groups could act out their interests by managing the array of "moments" that constituted his final days. Paradoxically, it was Ouko's demise — his place at the center of the inquiries but his absence from them — that not only permitted him to speak from the grave but also made him speak about things that he could or might not have spoken of in life and in a way that he may or may not have done while alive. The three epistemological moments discussed in this essay — Ouko's preaching on a passage from Job, words on the burdens of leadership, reaction to his sister's compliments about his success while abroad — bear traces of this paradox. The incidents are first narrated by a witness, then examined for signs of Ouko's state of mind, and finally constructed as signs of a public man in pain. Hence the "play" of the use of state of mind in this essay: the quest for Ouko's state of mind, as constituted by his family, friends, and colleagues, was in certain respects about the mapping of the Kenyan state and its crisis onto the "mind" of Ouko.

What is notable here is that without Ouko's pain, there would be no state in crisis, no production of knowledge marking practices of the state that were simultaneously routine and only barely speakable. There is, as Carolyn Hamilton has noted, little direct investigation of pain and its meaning in recent African historiography: "one observes virtually no interest whatsoever in the literature [in the field of history]."[29] In Africa, one might ask, is pain so palpable, so omnipresent, so haunting that pain in itself becomes unremarked, virtually unspeakable? Is it because suffering can be read so easily without, on the bodies and landscapes of the continent, that the emotion within remains unexplored? In Africa, is suffering another state whose practices are simultaneously routine and only barely speakable?

Pain always entails multiple and intersecting dialectics. There is the relational bind of comprehending the meanings of pain within oneself; and there

is the relational bind of explaining one's pain to another, whether in a thera-
peutic situation, a conversation, or another mode. Questions of power are
situated in these relational binds, and not merely in the workings of power
that create and appropriate pain through the modes of discipline or history.[30]
Power is situated, to build onto a point made by Elaine Scarry, in the dialec-
tics of "conviction." As Scarry has noted, "pain enters into our midst as at
once something that cannot be denied and something that cannot be con-
firmed (thus it comes to be cited in philosophical discourse as an example of
conviction, or alternatively as an example of scepticism). To have pain is to
have *certainty;* to hear about pain is to have *doubt.*"[31]

In framing her study of the body in pain, Scarry focuses attention on the
political implications of the "inexpressibility" of pain. "The failure to express
pain — whether the failure to objectify its attributes or instead the failure,
once those attributes are objectified, to refer them to their original site in the
human body — will always work to allow its appropriation and conflation
with debased forms of power; conversely, the successful expression of pain will
always work to expose and make impossible that appropriation and confla-
tion."[32] Her discussion attends primarily to the shared but incommensurate
discourses of subjects and experts, on the problematics of meaning and under-
standing across the threshold of subjectivity. Scarry reveals the culturally and
politically situated subject attempting to be heard amid different programs
of acknowledging and analyzing pain, yet she hardly attends to the work of
mediation, to the work of re-enactment and interpretation discernible in the
testimony about Ouko's last days provided by Ondu, Randiak, and many
others.

Indeed, the public record of Ouko's death provides a reading opportunity
well outside of the dialogics of subject-expert representations. It locates the
force of *mediation* and *negotiation* in the representation of suffering and pain
once the body in pain — that is, the subject and the only expert — is dead. The
will to read Ouko's pain produced a saturation of readings and explanations
across the several years of investigation and public debate regarding Ouko's
demise.[33] Each attempt to disclose a section of Ouko's last days, or mark the
meanings of his words and actions, was a venture onto an already or poten-
tially crowded stage, a venture that would draw attention to the mediations of
each narrative and negotiations along competing trajectories as Kenyans came
together to bear witness to Ouko's pain and to create a narrative of Ouko's
demise. In exploring the anthropology of pain, Veena Das has built upon
Ludwig Wittgenstein's discussions of the communicability and the inalienabil-
ity of pain. Wittgenstein's formulations of these aspects of pain, Das argues,
show that each of us has the potential to read and comprehend pain outside
his or her own body, in the body of another. This leads her to conclude not
only that "there is no individual ownership in pain" but also that there
is a "moral significance . . . [in] 'forming one body.'"[34] In negotiating Robert
Ouko's state of mind, in feeling his pain as their own as they attempted to
create a narrative of Ouko's demise, Kenyans were, I believe, able to form one

body — the body of a nation conflicted and in crisis. Through the contentions of an unsettled narrative, Kenyans gave moral force both to Ouko's death and to their own pain at the state of the state of Kenya.

Notes

1. Retired Detective Superintendent John Troon, New Scotland Yard, in his testimony given 18 November 1991, before the Judicial Commission of Inquiry, as published in the *Daily Nation* (Nairobi), 19 November 1991, 12. Along with each day's coverage of the proceedings of the Judicial Commission of Inquiry, which sat from 9 October 1990 to 26 November 1991, the *Daily Nation* printed, in a box headed "Who is who in the proceedings," the names of the judges of the commission, the various counsel, and the secretaries, as well as the subject of the inquiry. In passages quoted from these reports of the commission's proceedings and other sources, I have enclosed in square brackets text that I have added for clarification.

2. See, for example, the report published in the *Weekly Review,* 23 February 1990, 3. Ouko had been shot through the head, one ankle was broken, his upper arms showed some bruising, and his torso was partially burned. Found at the scene were an empty jerrican that had contained diesel fuel, Ouko's revolver with an empty cartridge in it, Ouko's Somali sword walking stick, a plastic bag containing clothing belonging to Ouko (socks, jeans, a shirt, and a leather jacket with four bullets and 450 Kenyan shillings in the pockets), a box of matches, and a flashlight. According to Troon, the bullet that went through Ouko's head was not fired from Ouko's revolver.

3. Ouko was the fourth leading political figure to die violently and mysteriously since Kenya gained independence in 1963, and in the days after his death there were large-scale demonstrations in Nairobi and Kisumu and at the time of his funeral, which was held on 23 February. An impartial investigation of Ouko's death was one of the demands voiced by the protesters. President Daniel arap Moi called in the New Scotland Yard team, which included detectives and a British pathologist who assisted with the investigation. Led by Detective Superintendent John Troon, the team arrived in Kenya on 21 February 1990 and conducted a four-month investigation; they submitted an interim report dated 7 June 1990 and a final report dated 28 August 1990. Troon would return to Kenya to testify before the commission from 31 October to 22 November 1991. On 26 November 1991 — the day that President Moi terminated the Judicial Commission of Inquiry, which he had appointed on 2 October 1990 — former cabinet minister Nicholas Biwott (who had been fired from the cabinet on 19 November 1991, shortly after being transferred from the post of energy minister to that of industry minister), former internal security chief Hezekiah Oyugi, Nakuru district commissioner Jonah Anguka, Nyanza provincial commissioner Julius Kobia, and George Oraro, a lawyer representing the Ouko family at the inquiry, were arrested for Ouko's murder; they were released for lack of evidence within a few weeks. Jonah Anguka was formally charged with Ouko's murder on 10 December 1991 and was acquitted on 29 July 1994. No other arrests have been made. The Troon report (generated by the New Scotland Yard team) was released — along with the so-called Ongoro report (generated by the Kenyan police; see note 25 for more information) — on 24 March 1999, at which time

police commissioner Philemon Abong'o stated, "The police department does not currently have evidence on which somebody can be successfully prosecuted for the Ouko murder."

The investigations into Ouko's disappearance and death have left a vast record, opening views not otherwise available of matters ranging from the protocols of presidential and ministerial travel to the organization of the Oukos' farm, from the procedures of security for Kenya's officials and elite to the intimate details of Ouko's relationships with his family, friends, and colleagues, from the terrains of international development assistance and the "routines" of transnational corruption to the workings of investigations by the Kenyan police, the Kenyan Special Branch, and New Scotland Yard and within a Judicial Commission of Inquiry and the ultimately unsuccessful criminal prosecution of one suspect. In 1997, more than seven years after Ouko's demise, the Kenyan Parliament debated a motion to establish a Parliamentary Select Committee to investigate the murder; a week earlier, in putting forward the motion, James Orengo, deputy leader of the opposition, suggested that Ouko "might have been killed by people in the Special Branch" and asserted that "the late minister's skull is being kept in the United Kingdom." Orengo's motion was defeated by the governing majority. It was the second defeat of such a motion in twelve months, but the press noted the defection of several members of the Kenya African National Union to the opposition's position. See *Daily Nation,* 1 May 1997, 16; 8 May 1997, 1, 16.

4. The Ouko inquiries brought no explicit attention to the lively question of whether Kenya should abandon the one-party state, but multiparty advocates won their first important battle in the days immediately after President Moi shut down the Judicial Commission of Inquiry on 26 November 1991. The campaign for fresh inquiries into Ouko's death has since been a key plank among issues advanced by Kenya's opposition parties. Although there was an economy of interest in the ready answer or the definitive solution to the mystery, there was and is also a powerful economy of interest in the elaboration of further lines of inquiry, observation, and conversation centering on the case but reaching into diverse arenas.

5. See Simon Schaffer, "Self Evidence," in James Chandler, Arnold I. Davidson, and Harry Harootunian, eds., *Questions of Evidence: Proof, Practice, and Persuasion across the Disciplines* (Chicago: Univ. of Chicago Press, 1994), 56–91, and, especially, the exchange of views between Lawrence Rothfield ("Massaging the Evidence," 92–97) and Schaffer ("Gestures in Question," 98–104) immediately following in the same volume.

6. Between 1990 and 1993, five extended narrative accounts of Ouko's disappearance and death were published, for the most part outside of Kenya. One of them was produced as the signed and witnessed affidavit of Robert Ouko's brother Barrack Mbajah, written from the United States, where Mbajah had fled in advance of his having been called to testify before the Judicial Commission of Inquiry. His affidavit was published in the *Nairobi Law Monthly* 38 (November 1991): 21–23. These early accounts have been augmented by Jonah Anguka's *Absolute Power: The Ouko Murder Mystery* (London: Pen Press, 1998), a three-hundred-page book by the only person yet tried for Ouko's murder; a chapter in former U.S. ambassador to Kenya Smith Hempstone's *Rogue Ambassador: An African Memoir* (Sewanee, Tenn: Univ. of the

South Press, 1997); and a chapter in Andrew Morton's *Moi: The Making of an African Statesman* (London: Michael O'Mara, 1998). With E. S. Atieno Odhiambo, I am presently completing a book-length study of the investigations into and narratives of Ouko's disappearance and death.

7. I am grateful to E. S. Atieno Odhiambo, Gretchen Elsner-Sommer, Carolyn Hamilton, Hans Medick, and Martin Schaffner, as well as to members of seminars at the Universität Basel, the University of Michigan, and Emory University, who have pressed me to clarify this point of departure. They have done so generously without necessarily subscribing to my program.

8. The New Scotland Yard team took 235 statements from witnesses. While the 140-page Troon report was not published in and of itself until 25 March 1999, in November 1991 it was read into the Judicial Commission of Inquiry's proceedings by Troon himself and by aides, and from this the report was published serially in the *Standard* (Nairobi), 3–11 December 1991. From the first days of investigation up through Troon's appearance before the Judicial Commission of Inquiry — seventeen months — the New Scotland Yard's investigation was the subject to "informed reports," "premature publication," rumors, accusations of leaks, and other forms of access and dissemination (and also "divination"). The manner in which the New Scotland Yard's findings made their way among Kenyans brought diverse renderings of the Ouko investigations into public view in Kenya as well as abroad.

9. Ondu testified before the Judicial Commission of Inquiry on 19 March 1991, and the fragments of testimony presented here are from the English translation printed in the *Daily Nation,* 20 March 1991, 2, 13–15.

10. *Daily Nation,* 20 March 1991, 14.

11. *Daily Nation,* 19 March 1991, 13.

12. *Daily Nation,* 20 March 1991, 14.

13. Troon focused considerable attention on Ondu's report of Ouko's selection of Job as the text to be read in church. He also drew attention to the reading of Job as part of his reconstruction of Ouko's movements over the weekend, specifically in reference to how and why Ouko evidently sought to move his wife, Christabel, from Koru to Nairobi — according to Troon's suppositions — so that Ouko could be alone to work on papers dealing with corruption in Kenya; see *Standard* (Nairobi), 6 December 1991, 12.

14. *Daily Nation,* 7 August 1991, 16. The three men who accompanied Dorothy Randiak to Koru on 12 February 1990 gave statements to the New Scotland Yard team and the Judicial Commission of Inquiry. Their accounts align fairly well with Randiak's account, to the extent they were in a position to observe.

15. Ouko's wife, Christabel, had left for Nairobi earlier in the day, leaving Ouko and the housemaid as the only persons staying at the house on the evening of 12 February; Ouko was scheduled to travel to the Gambia on government business on 14 February.

16. Mandela was released not from Robben Island Prison but from the facility where he was held while the terms of his release were negotiated.

17. There is an opening here for drawing a comparison with a reading of Samuel Pepys's torment in 1668; see Francis Barker, *The Tremulous Private Body: Essays on Subjections* (London: Methuen, 1984), particularly the first part ("A Challenged

Spectacle," 1–69). I am grateful to Mark Auslander for bringing Barker's essays to my attention.

18. *Daily Nation,* 7 August 1991, 16. The record of the Judicial Commission of Inquiry proceedings as published in the *Daily Nation* moves from first to third person and back again in no clearly systematic fashion. The parenthetical material and parentheses employed in the quoted text here appear in the *Daily Nation* reports.

19. *Daily Nation,* 7 August 1991, 16.

20. *Daily Nation,* 10 August 1991, 12.

21. *Daily Nation,* 7 August 1991, 13. It was in the same conversation on 6 February 1990, according to Randiak, that Ouko told her for the first time about a woman caller who claimed to be his mistress. The woman "would call and speak to Mrs Ouko. Mrs Randiak said Dr Ouko did not have any idea as to whom the woman caller was.... She said the Minister appeared disturbed because the callers were interfering with the Ouko family's privacy.... Dr Ouko learned of the callers from his wife after his trip to the United States.... Dr Ouko suspected that the callers got their information from Mr Mbajah."

22. *Daily Nation,* 7 August 1991, 16; 13 August 1991, 1, 14; 14 August 1991, 14.

23. See *Daily Nation,* 14 August 1991, 14, 16. Randiak's responses and explanations are but briefly abstracted here; a fuller account of the to-and-fro of Kapila's cross-examination of Randiak will be developed in a longer treatment.

24. In an extraordinary motion, Kapila managed to convince the commissioners to "mark" sections of Randiak's statements and testimony in advance of Troon's testimony before the commission, to open the opportunity to compare what Randiak claimed she said to Troon to what Troon would "confirm" before the commission. The several counsel participating in the inquiry intervened in debating this motion and produced a most interesting discussion on what would, theoretically and philosophically, constitute a "contradiction"; see *Daily Nation,* 14 August 1991, 14, 16.

25. Kapila's brief against Randiak's testimony resurfaced on 28 November 1998, when the Kenyan government released an eighty-five-page report, titled "Government Statement on Ouko Death Puzzle," on Ouko's death, and on 24 March 1999, when the government released the so-called Ongoro report, which was prepared under the direction of a former Kenyan police official, Crispus W. Ongoro. Both reports claim to have reviewed all the available evidence and appear to be restatements of Kapila's brief; both cleared Biwott of any involvement in Ouko's disappearance and death. The Ongoro report appears to have been presented to support the report of 28 November 1998, which itself seemed to have been timed to substantiate Daniel arap Moi's view of Ouko's demise as published in Morton's more-or-less authorized biography of Kenya's president (see note 6).

Both reports poured cold water on the New Scotland Yard team's findings, which were consonant with Randiak's testimony. Like Kapila's cross-examination of Randiak in August 1991, both reports restated the allegations against Biwott in order to refute them, thereby providing the Kenyan public and members of parliament with additional records through which to consider the role of Biwott and others in Ouko's disappearance and death and in the subsequent cover-up. Both reports were met with considerable suspicion and triggered calls for more investigation into the matter.

26. Note that the number of investigations to date is disputed. In fall 1999, the Kenyan press reported denials by the British government that the British foreign intelligence service MI6 had developed, with help from the British foreign office, an independent report on Ouko's disappearance and death; see Paul Redfern, "Fresh Claims on Ouko Murder," *Daily Nation,* 30 September 1999, http://www.nationaudio.com/News/DailyNation/300999/News/News51.html; and Michael Purvis James, "His Master's Voice," *New African,* October 1999, http://www.africasia.com/icpubs.

27. M. Ackbar Abbas, *Hong Kong: Culture and the Politics of Disappearance* (Minneapolis: Univ. of Minnesota Press, 1997), 137–38.

28. For a brief discussion of Abbas's position, see David William Cohen, *The Combing of History* (Chicago: Univ. of Chicago Press, 1994), 122.

29. Carolyn Hamilton, conversations with author, Madison, Wis., November 1996.

30. I am especially grateful to Windsor Leroke and Carolyn Hamilton for guidance and encouragement in pushing this discussion of Robert Ouko's pain. Also see Luc Boltanski, *La souffrance à distance: Morale humanitaire, médias et politique* (Paris: Métailié, 1990); Michael Pollak, *Une identité blessée: Etudes de sociologie et d'histoire* (Paris: Métailié, 1993); Veena Das, *Critical Events: An Anthropological Perspective on Contemporary India* (Oxford: Oxford Univ. Press, 1995); Liisa Mallki, *Purity and Exile: Violence, Memory, and National Cosmology among Hutu Refugees in Tanzania* (Chicago: Univ. of Chicago Press, 1995); and Arthur Kleinman, Veena Das, and Margaret Lock, eds., *Social Suffering* (Berkeley: Univ. of California Press, 1997).

31. Elaine Scarry, *The Body in Pain: The Making and Unmaking of the World* (New York: Oxford Univ. Press, 1985), 13.

32. Scarry, *The Body in Pain* (note 31), 14.

33. David B. Morris has put this another way in his "About Suffering: Voice, Genre, and Moral Community," in Arthur Kleinman, Veena Das, and Margaret Lock, eds., *Social Suffering* (Berkeley: Univ. of California Press, 1997), 30:

As in the Book of Job or in the voluminous writing that responded to the unprecedented disaster of World War I, readers may confront halting and troubled voices, voices that are angry and confused, hurt, exhausted, foolish, or blasphemous. The content of the utterance, while crucial to its writer or speaker, matters less in suggesting what literature can tell us about suffering than the sheer act of speech itself: affliction has at last broken through into language. We are finally in the presence of words that cross over from the other side of torment.

34. Veena Das, "The Anthropology of Pain," in idem, *Critical Events: An Anthropological Perspective on Contemporary India* (Delhi: Oxford Univ. Press, 1995), 194–96. The concept of "forming one body" was formulated in Drew Leder, *The Absent Body* (Chicago: Univ. of Chicago Press, 1990), according to Das.

Crisis and Representation:
Rumor and the Circulation of Hate
Veena Das

In the 1980s, the Sikh militant movement in the Punjab and the counter-insurgency operations of the Indian government generated considerable animosity between many Hindus and Sikhs leading to violent confrontations that obliterated the solidarities of everyday life. The grievous public events that anchor my argument here—the Indian army's Operation Blue Star;[1] the assassination of Prime Minister Indira Gandhi by two of her Sikh bodyguards; and Hindu violence against Sikhs in the resettlement colonies in Delhi and across India in the days after Indira Gandhi's death—were, by any definition, extreme. They were not events in a genocide, as the term is understood in its current *avatāra* (incarnation) in international instruments and covenants. But, like genocidal events, they were enabled by the social production of hate between communities.

This essay on the social production of hate between Sikhs and Hindus focuses on images to be found in emergent Sikh militant discourse in the early 1980s and on the understanding of events diffused in rumors during the crises of 1984. I argue that the circulation of particular images created the conditions under which many Hindus and Sikhs turned against each other in fear and mutual hatred, constructing perceptions of Self and Other from which the subjectivity of experience had been evacuated. In other words, the crises of 1984 were located within discursive formations that allowed certain enunciative modalities to open up in the public space. The perlocutionary force of language was used to wrest open the unhealed wounds of the past and to give the present a particular direction.

I do not mean, however, to suggest a causal connection between the earlier events and the later ones, between the emergent Sikh militant discourse and what happened to Sikhs in 1984. The violence Hindu mobs unleashed against Sikhs after Indira Gandhi's death cannot be represented as a backlash against Sikh militancy, and the Sikh militant movement was not responsible in any way for that violence. The linearity fundamental to most narrative forms produces the effect of causality, yet it must be recognized that the order imposed in telling a story never corresponds to the order of events in pure durational time. At any point that a teller chooses to begin a story, he or she ignores or activates parts of prior stories that have been lying inert or circulating within limited zones. This means that the way in which memories of the crises of 1984 are recounted by Sikhs and Hindus is strongly influenced but not completely

determined by their immediate social and temporal location. It is this play of experience and memory that I hope to capture here.

The Discourse of Militancy

The emergence of a militant movement among Sikhs in India and abroad was an important phenomenon of the 1980s.[2] Between 1981 and the end of 1984, Sikh leaders led a series of mass civil disobedience campaigns against the Indian government for fulfillment of demands related to the rights of the Sikh community. Some activists sought only greater autonomy for Punjab within the federal structure of the state of India, but others were interested primarily in the creation of a sovereign Sikh state, to be named Khalistan. In articulating the separatist agenda, Jarnail Singh Bhindranwale and other fundamentalist Sikh leaders deployed stereotypes of Hindus and Sikhs in the movement's literature, on posters, and in speeches. They also encouraged the use of violent means to achieve the movement's ends. Their discourse was evolved to create a politically active group and to forge effective unity among Sikhs. Out of a heterogeneous community, the militants sought to make a "we" group that would function as a compelling political agent in the context of the modern state structures of India.

Benedict Anderson has noted that a large collectivity such as a nation may be invested with the status of a "natural" entity through the use of kinship terms to metaphorically specify the relationship between the individual and the collectivity.[3] In most cases, this involves using metaphors defining "false kinship" to disavow selected previous intimacies as well as metaphors of "true kinship" to confirm other relationships. The interplay of true and false kinship raises questions about just how natural an entity constituted through kinship categories can be, of course. Nonetheless, whether used for purposes of inclusion or exclusion, metaphors of kinship and intimacy provide frameworks for belief that generate intense feelings of love and hate, fidelity and betrayal.

Metaphors of male relatedness were used extensively in the oral discourse of Sikh militants to create a sense of community. One set of metaphors was used to define the "true kinship" of Sikh father-son relations, which were to be acknowledged and celebrated; another set defined the "false kinship" of the long-standing metaphorical father-son relations between Hindus and Sikhs, Hinduism and Sikhism, which were now interpreted as implying Sikh illegitimacy. For instance, Bhindranwale, while addressing a congregation in the early 1980s, stated,

> Khalsa *ji* (you, who are the pure ones), the Sikhs are the son of the true king Guru Gobind Singh *ji*. Now you know that a son must resemble his father. If the son does not resemble his father, then you know the term used for him [that is, bastard]. If he does not behave like his father, then people begin to view him with suspicion. They [the Hindus] say the Sikhs are the descendants of Hindus. Are they pointing a finger at our pure ancestry — how can a Sikh bear to be called anyone else's son?[4]

The concern with establishing "pure ancestry" and the doubts about illegitimacy and true paternity are obviously *male* doubts. Such anxieties point to the extent to which Sikh militant discourse conceived of the Sikh homeland as a masculine nation. In its imagination, being worthy of having a nation, being able to lay claim to a homeland, was plotted along the axis of being deserving sons of a valiant father — an assertion that was articulated through the motif of being capable of making sacrifices, of bearing pain and hardship as would a martyr. I need only mention here that in the Hindu imaginary, the homeland was a *motherland,* and although the nation was conceived as masculine, it was made up of the sons of a mother. Nationalist discourse during the struggle against British colonialism represented the nation as a mother who had been shackled by the ties of foreign rule and had to be rescued by her valiant sons. Concern with masculinity thus marked both Sikh and Hindu militant discourses, but the different genealogies (sons of a father versus sons of a mother) shaped the notions of Self and Other in diverse ways.

Complicating the situation was the fact that in his nonviolent movement, Mahatma Gandhi transformed notions of masculinity and femininity by advocating strategies of passive resistance such as fasting and offering the body to receive wounds, rather than the active and aggressive strategies of violent resistance.[5] Sikh militant anxiety about "passive" and "womanly" nonviolence as the defining principle of the Indian nationalist struggle became palpable in the movement's oral discourse, in which nonviolence was presented as a threat to "manly" ways of confronting evil, further characterized as the natural inheritance of the Sikh. As Bhindranwale propounded in one speech, it was an insult for Sikhs to be included in a nation that claimed the "feminine" figure of Mahatma Gandhi for its father (*bapu* — the affectionate title given to Gandhi by the populace). Not only were Mahatma Gandhi's techniques of fighting quintessentially female but he had added insult to injury by choosing a women's tool, the *charkha* (spinning wheel), as the symbol of the nonviolent movement. "Can those," asked the Sikh militant leader, "who are the sons of the valiant *guru,* whose symbol is the sword, ever accept a woman like Mahatma as their *father?* Those are the techniques of the weak, not of a race that has never bowed its head before any injustice — a race whose history is written in the blood of martyrs."[6] A nonviolent movement led by Gandhi, it was said in Sikh militant discourse, was appropriate only for the feminized Hindus.

Thus the Sikh militant construction of the past in terms of a genealogy of father-son relations was also a construction of Self and Other. Through the particular narrative web of Sikh history as a history of martyrdom, Sikh militants sought to create the Sikh character as well as its negative counterpart, the Hindu character. In the organization of images in emergent Sikh militant discourse, the Self of the Sikh was portrayed as that of the martyr whose sacrifices had long fed the Sikh community with its energy. Concurrently, the Hindu was represented as weak and effeminate or cunning and sly — that is, as an Other who had long depended on the protection offered by Sikhs but was

not averse to betraying its erstwhile protectors. Masculinity became the defining feature of the Sikh community, and the history of the Sikh community as inscribed on the body of the martyr was established as a reflection of the "masculine" Sikh character. Femininity became the defining feature of the Hindu community, and the history of the Indian nation, which Sikh militants regarded as simply the history of Hindus in need of Sikh protection against Muslim and European invaders, was portrayed as a reflection of the "feminine" Hindu character.

A "Hindu" history was dangerous, militant Sikh authors said, not just because Sikhs are denied their rightful place in that history but also because it was a conspiracy to make the martial Sikhs into a weak race:

> [T]he Sikhs have been softened and conditioned during the last fifty years to bear and put up with insults to their religion and all forms of other oppression patiently and without demur, under the sinister preachings and spell of the narcotic cult of non-violence, much against the clear directives of their Gurus, their Prophets, not to turn the other cheek before a tyrant, not to take lying down any insult to their religion, their self-respect and their human dignity.[7]

The danger was not Sikh defeat in heroic confrontation with a masculine Other but complete dissolution of the masculine Self of the Sikh through contact with the feminine Other of the Hindu. To be able to claim true descent from the proud Gurus (the ten canonical founders of the Sikh religion),[8] it was argued, all corruption that had seeped into the Sikh character because of the closeness to the Hindus was to be exorcised. "With such an enemy," went one warning, "even your story will be wiped out from the face of the earth."[9]

In view of this articulation of community as a community of men (and, further, as a community of sons descended from the father in whose ancestry all signs of the mother have been obliterated), it is not surprising that in the oral discourse of militancy, Sikhs were explicitly urged to shed their femininity and display their masculinity. The sword was cited as the most visible sign of Sikh masculinity, a sign that was both external and a product of Sikh history.[10] The simple exhortation "shastradhari howo" [Become the bearer of weapons] appeared often, and in most of his speeches, Bhindranwale asked Sikh households to collect weapons, especially Kalashnikovs, so that they could protect the honor of the community when the time came.

The other visible sign of Sikh masculinity cited in militant discourse was the beard. Bhindranwale exhorted Sikhs to let their beards grow: "If you do not want beards then you should urge the women to become men and you should become women. Or else, ask nature that it should stop this growth on your faces. Then there will be no need to exhort you to wear long beards. Then there will be no need for me to preach [prachar karna], no need to break my head on this [matha khapai karna]."[11] Another leader, a functionary of the Akali Dal (a powerful Sikh political party), stated that the flowing beard of

the Sikh constituted a direct challenge to the authority of the state. [12] In articulating the threat to the Sikh community, militant Sikhs often stated that "they" have their eyes on "your" sword, on "your" beard (*ona di nazar twadi kirpan te hai—ona di nazar twadi dadi te hai*). The theme of the feminine Other destroying the Sikh community by robbing it of its masculinity and instead bestowing on it a feminine character returns again.

The production of communal hate in this case was not based on a long history of hostility between Hindus and Sikhs. It was rather the case that hate was deployed to shatter a shared history and a social ecology of connectedness. A master narrative of Sikh history couched in terms of a series of systematic dualisms separating the Sikh Self from the Hindu Other was built by systematic "forgetting" of the close relations between Hindus and Sikhs in everyday life, especially the bonds of language, common mythology, shared worship, and the community created through exchange.[13] In addition, all the darker aspects of the Sikh past were purged by being projected onto the Hindus. The participation of Sikhs in the communal riots against Muslims — attested not only by history texts but also by personal experience — was not acknowledged any more. Instead, incidents of communal tension were discussed primarily in terms of Hindu-Muslim conflicts, as if Sikhs did not figure in these at all. This absenting of Sikhs occurs, for example, in the following passage from a white paper entitled *They Massacre Sikhs:*

> It was in the late twenties of this century that a cultural ancestor of the present anti-Sikh Hindu urban crust wrote and published a small book, purporting to be a research-paper in history, under the title of *Rangīlā Rasūl* "Mohammad, the pleasure-loving Prophet." ... The entire Muslim world of India writhed in anguish at this gross insult to and attack on the Muslim community but they were laughed at and chided by the citified Hindu Press of Lahore.... [T]he process of events that led to bloody communal riots in various parts of India till the creation of India and Pakistan and the partition of the country itself, with tragic losses in men, money and property is directly and rightly traceable to a section of the majority community exemplified in the matter of *Rangīlā Rasūl.*[14]

One manner of willful forgetting, then, involved purging the Sikh community of any evil done during past communal conflicts, which was instead projected onto "the citified Hindu majority." Another type of forgetting was to construe all acts of violence involving Sikhs — both those contained within the Sikh community in institutional practices such as feud and those directed outward in communal conflict — as the violence of martyrdom. Finally, there was the forgetting that construed the Indian state as an external — in fact, Hindu — institution that had been imposed on the Sikh community, rather than as an institution created through practices prevalent in the Punjab and India. This allowed the Sikh community to absolve itself of blame in relation to the corrupt practices of the institution of the Indian state, which were instead attributed to the Hindu character.

This figuring of the Indian state as an external institution also fed into the metaphor of the Sikh as the betrayed (male) lover of the (female) Indian state, an idea that occurred repeatedly in emergent Sikh militant discourse. Although it was the sacrifices of the Sikhs that brought India freedom, the militants declared, Sikhs were denied their rightful place in the new configuration of nations. As Bhindranwale stated in one speech, while the Muslims got Pakistan and the Hindus became the de facto rulers of India, the *nishan sahib* (the flag that was to be the sign of the Sikh nation) was not allowed to fly over India. In another speech, he stated that an agreement had been reached that in the Indian flag the saffron stripe — the symbol of Sikh martyrdom — would fly above the other two colors — white for Hindus and green for Muslims — because it was always a Sikh who led the procession of *satyagrahis* (Gandhi's term for the nonviolent protesters; lit. "adherents of truth"), as Hindus were too cowardly to do so.[15] This is not, of course, how the scheme of colors in the national flag is interpreted in official narratives — but the story has the power of anchoring a floating truth with the stamp of authenticity. To bolster the idea of the Sikh as the betrayed lover of the Indian nation, the theme of the innate untrustworthiness of Hindus was elaborated through reference to the literal and metaphorical femininity of the ruler of the Indian state. Indira Gandhi was the widow — thus considered inauspicious — and was born into the household of Pandits — the Brahman caste that was always subservient to the ruling class of warriors. In Sikh militant discourse, only Hindus could be so degraded as to accept being ruled by a woman or by a Brahman leader.

Interestingly, the theme of betrayal by the Indian state was as much a part of the repertoire of militant Hindu discourse as it was of militant Sikh discourse — although among Hindus the opposition was usually Muslim, not Sikh. Likewise, both Sikh and Hindu militant rhetoric was shot through with contempt for the supposed "weak" and "emasculated" Hindu, and both movements used that stereotype to mobilize followers.[16] In speeches made by the Hindu female ascetic politician Sadhavi Rithambra, for example, a repudiation of the supposed passivity and emasculation of Hindus provided the subject matter for passionate utterances against Muslims.[17]

In any event, by constituting an Other against whom the Self could be defined, the Indian state provided the essential context for the emergent militant discourse of Sikhs and Hindus. But one could go further and say that it was the overarching presence of the Indian state that provided the context in which images of Hindus and Sikhs circulating in militant discourse were torn away from their anchorage in everyday life. The militants had much to gain by propelling themselves and their images of Self and Other into public spaces, where each community strove to establish dominance. The repertoire of negative and hateful images of Self and Other thus seeped into the understanding of many individuals, where it provided the unconscious grammar by which the charged events of 1984 were produced, diagrammed, and interpreted.

The Phenomenology of Rumor

The diffused understandings of Sikh and Hindu character circulating in the public sphere in the early 1980s intersected with the phenomenology of rumor after the assassination of Indira Gandhi to produce societal crisis. This crisis was characterized by mounting hysteria, which signaled the breakdown of social communication; the animation of a societal memory of Operation Blue Star, a significant event widely perceived as unfinished; and panic rumors[18] that were unattributed and yet anchored to images of Self and Other circulated in the discourses of militancy. The withdrawal of trust in the normal functioning of words and individuals led to actions over which all control seemed to have been lost. It was in these moments that images previously generated by a Bhindranwale or a Rithambra found a place in the collective repertoire of social groups and replaced the subjectivity of everyday life with a subjectivity more correctly described as appropriate to a form of death.

My emphasis on rumor's displacement of the subjectivity of everyday life casts the functioning of rumor in a somewhat different, more negative light than is usual. A detour to sketch the contours of this difference may be useful, especially in indicating the social contexts in which rumor may perform a critical function and those in which it may create the conditions for the circulation of hate. It should show as well that a theory of rumor that treats rumor as independent of the forms of life within which it is embedded is not possible.

In 1959, George Rudé published his classic study on the role of rumor in mobilizing crowds during the French revolution.[19] Since Rudé, the power of rumor to mobilize crowds has been seen in a positive light by many scholars, who regard crowds as agents of collective action concerned with redress of moral wrongs.[20] E. P. Thompson, for example, stated, "The food riot in the eighteenth century was a highly complex form of direct popular action, disciplined and with clear objectives."[21]

More recently, Ranajit Guha has secured a place for rumor as "a necessary instrument of rebel transmission" in popular peasant uprisings in colonial India. In Guha's exemplary formulation, rumor acts as a trigger and mobilizer. Guha identifies the anonymity of the source of rumor, rumor's capacity to build collective solidarity, and the almost uncontrollable impulse to pass a rumor on as important elements in building a theory of rumor. He repeatedly draws attention to rumor as a "both *universal* and *necessary* carrier of insurgency in any pre-industrial, pre-literate society" and as an expression of a "code of political thinking" that was "in conformity with the semi-feudal conditions of his [the peasant's] existence." From the official point of view, peasant insurgencies fueled by rumor were instances of peasant irrationality. For the peasant insurgents, rumor was the means of spreading a message of revolt and an effort after meaning improvised within existing cultural and ideological patterns.[22]

Homi K. Bhabha has isolated two aspects of rumor in Guha's presentation as particularly important for building a general theory of rumor: the enunciative and the performative. He argues,

> The indeterminacy of rumour constitutes its importance as a social discourse. Its intersubjective, communal adhesiveness lies in its enunciative aspect. Its performative power of circulation results in its contagious spreading.... The iterative action of rumour, its *circulation* and *contagion,* links with panic—as one of the affects of insurgency.... The indeterminate circulation of meaning as rumour or conspiracy, with its perverse, psychic affects of panic, constitutes the intersubjective realm of revolt and resistance.

In other words, the political effects of rumor—and its primary affect, panic—is to influence groups through the spread of indeterminate fear, and to thus unify or divide different groups of people. He concludes, "What articulates ... sites of cultural difference and social antagonism, in the absence of the validity of interpretation, is a discourse of panic that suggests that psychic affect and social fantasy are potent forms of political identification and agency for guerilla warfare."[23]

Other theorists, especially those studying mass psychology, have likewise emphasized the emotional, capricious, temperamental nature of groups of people. For example, in 1895 Gustave Le Bon declared that crowds are everywhere distinguished by feminine characteristics.[24] Some of this denigration of crowds (and women) may be easily understood in terms of Guha's formulation of elite prejudice against subaltern forms of communication. Nonetheless, it is difficult to ignore the spectacular politics of crowds, which were developed during the Nazi regime and have been seen since in communal riots in India and elsewhere. In these cases, too, crowds act according to ideological premises based on their own understanding of events,[25] but the repertoire of images used cannot be schematized within the kinds of subaltern politics on which scholars from Rudé to Guha and Bhabha have focused. In his analysis of Nazi crowds, Serge Moscovici suggested that crowds came to be spoken of as women simply to mask the exchange of homosexual images as an exchange between an "active" male leader and a "feminine" crowd.[26] I have elsewhere suggested that the imagery of a community that has been emasculated and seeks to recover its masculinity through crowd action plays on the register of gender in various ways.[27] For example, themes of revenge dominate when such a community is mobilized around the image of a raped woman or a dead child.

What is common in the deployment of rumor in these various situations is the perlocutionary force of words[28]—their capacity to do something by saying something. The conclusion to be drawn is that the rumor's essential grammatical feature (in Ludwig Wittgenstein's sense) is that it is conceived to *spread.* Images of contagion and infection have long been used to represent rumor in elite discourse, but this is not simply a matter of noncomprehension on the part of elites of subaltern forms of communication. Such images also point to rumor's transformation of language from a medium of communication to something communicable, infectious, to something that causes things to happen almost as if they had happened in nature. It is a short step to the

phenomenological feature of mounting hysteria, the naturalization of stereotypes, the masking of the social origins of violence, and the production of hate between social groups.

The Event: The Assassination of Indira Gandhi

Indira Gandhi was shot by two or more of her bodyguards on 31 October 1984 at about 9:00 A.M. Although the religious identity of the assassins was not announced until the following morning, people somehow immediately "knew" that she had been killed by her *Sikh* bodyguards and began speculating as to the genealogy of the assassination and the consequences it might have for the safety of Sikhs in Delhi. Many connected Indira Gandhi's assassination to Operation Blue Star, in which the militant leader Bhindranwale had died. Launched by the Indian army in June 1984 allegedly to remove Sikh militants from the Golden Temple, Operation Blue Star resulted in the forced entry of Indian army troops into the Golden Temple, an action that was widely seen as a desecration of Sikhism's most sacred site. Many Sikhs found the action deeply hurtful, and it was rumored that some Sikhs had taken oaths in *gurdwaras* (Sikh temples, lit. "doorways to the Guru") binding them to avenge the insult by assassinating Indira Gandhi before the end of October 1984. It was also said that Indira Gandhi had been warned by the security police that she should not have Sikhs as bodyguards but had refused to have them transferred.

In general, opinion was divided as to whether the two assassins were to be regarded as martyrs who had risked their lives in penetrating the formidable security system of the Indian state[29] or as cowards who had shot a defenseless woman who had trusted them even against the advice of her security personnel. In any case, the identity of the assassins was assumed purely on the basis of rumor and speculation. This uncanny knowledge can, I believe, be traced to what was widely perceived to be the unfinished character of Operation Blue Star. Many felt that the death of Bhindranwale and the invasion of the Golden Temple were so unsettling that they were bound to have a sequel in the form of another calamitous national event.

Moreover, the events of Operation Blue Star were themselves unsettled and the subject of conflicting narratives. On the one hand, the government insisted that the Golden Temple had become a sanctuary for Sikh militants and terrorists and that illegal weapons had been stockpiled in the shrine in large quantities, thus endangering public order and the sovereignty of the Indian state. On the other hand, the Sikh militant literature portrayed the army operation as a flagrant violation of the rights of Sikhs to their sacred sites, arguing that Operation Blue Star was a deliberate insult to the Sikh religion and the Sikh community and therefore must not go unavenged.[30] On the one hand, many civil rights groups maintained that innocent Sikh pilgrims had been shot, among whom were women and children. On the other hand, the army stated that its personnel had gone into the temple with their hands more or less tied behind their backs, because the terrorists[31] had used innocent pilgrims as human shields. The army also claimed that its losses were far in excess of

what might be expected in such a confrontation because the soldiers had to protect the civilians. Every aspect of Operation Blue Star was the subject of allegations and counterallegations. Much of the event lived in different versions in the social memory of different social groups, contributing to the unfinished character of Operation Blue Star.

The uncertainty introduced by the assassination of Indira Gandhi *in the present* seemed to many to be exacerbated by its link with this past. It was as if the particular turn of events was part of a plot that had been unfolding since Operation Blue Star. The uncanny knowledge of the religious identity of the guards was part of that experience of the seriality of the plot. Yet, despite the uncertainty in which events were shrouded for the first few hours, between the time when rumors of Indira Gandhi having been shot began to spread and their confirmation in the official media, there was no sense of panic. It was only later in the evening the plot began to take another twist.

The Vulnerability of the Hindus

The early speculations and judgments about the uncertain facts of the assassination soon devolved into stories expressive of uncertainty about the context in which the event was to be placed. The crucial elements in the rumors in circulation by the evening of 31 October were as follows:

1. Sikhs had started massive violence against Hindus in Punjab, and trains full of dead Hindus were arriving from there.
2. Sikh militants were planning to poison the water supply of Delhi.
3. There had been widespread defection of Sikhs from the ranks of the Indian army and the police.
4. Sikhs were celebrating everywhere: some were dancing in the streets, while others were distributing sweets to Hindus, mockingly condoling them for Indira Gandhi's death.[32]
5. The assassination of Indira Gandhi was to be followed by utter chaos and anarchy incited by Sikhs, and the creation of Khalistan would be announced during this time of disorder. Negotiations had already been held with powerful countries, and while it would not rush to recognize Khalistan, the United States had persuaded some small countries to do so.

Each of these elements made claims to the real — and thus became persuasive enough to exercise the perlocutionary force mentioned earlier — by a specific mechanism. Appeal to the experience of the partition riots was used as *proof* that the events of the first element were happening. Elderly people would tell younger people, "You are too young to remember this ... but I saw with my own eyes ...," as if having seen such things in 1947 confirmed the veracity of what was *heard* in 1984. The second element accompanies almost every communal riot. It combines fears induced by two aspects of urban life: the lack of control over vital necessities such as water; and the lack of familiarity with those living around one that leads to a sense of lack of control over

others, to a sense of vulnerability to unknown enemies. The third element built on the identity of the assassins as well as on recent rumors of events that also seemed to expose the fragility of the institutions of the Indian state when pitted against traditional Sikh institutions. For example, after Operation Blue Star it was said that a Sikh junior commissioned officer had killed the Jodhpur regiment's commandant, who had gone unarmed to this man because he believed that loyalty to the regiment would outweigh all other allegiances.[33]

It was, I believe, the mechanisms supporting the fourth element that gave credibility to so many others. If Sikhs were celebrating, then they must know the immediate future in ways not evident to Hindus and other groups. The image of Sikhs dancing in the streets *in England* shown on the BBC World Service was taken as evidence of celebrations witnessed *in India*. Moreover, when people told anecdotes of celebrations by Sikhs in India of which they had only heard, their words were regarded as true because of the BBC's footage, rumors of which had spread even among those without access to television. Ironically, the BBC's reputation for impartial reporting was cited as evidence of widespread celebration by Sikhs in India.

The fifth element was supported by the other four elements, each of which, if true, could have pushed Indian society toward chaos. In addition, elements four and five were cited to support each other: Sikhs were celebrating all over the country instead of being frightened of reprisals *because* local *gurdwaras* had announced to their congregations — on the strength of secret international negotiations — the plan to create Khalistan in the chaos following the assassination; *because* the plan to create Khalistan had been announced in local *gurdwaras* and *because* the United States had arranged to support Khalistan, it must be true that Sikhs were celebrating in the streets. The fifth element was supported as well by the previously existing rumor that Bhindranwale had amassed missiles at the Golden Temple and had been prevented only by the timely launch of Operation Blue Star from announcing the creation of Khalistan from the temple; in other words, because Sikh militants had "nearly succeeded" in creating Khalistan once before, the Indian state was weak and likely to descend into chaos, which meant that the creation of Khalistan must be imminent.

Within twelve hours of the event, then, Indira Gandhi's assassination was being imagined by many as the first act in a massive conspiracy that was still to unfold. The representation of the crisis drew considerable energy from claims about the vulnerability of the Indian state and the support that Sikh militants were expected to receive at home and abroad. For example, Bhindranwale had reported in a speech that he had been asked by some journalists whether Sikhs would fight on the side of India if India were attacked by the Khalistani Liberation Force that was supposedly situated in the United States, Canada, and England and supported by the U.S. Army. Bhindranwale had replied that not a single Sikh would lift a weapon against such a holy force.

We can see that rumor operated here in the twilight of judgment. Carlo Ginzburg has suggested to me that it would be useful to distinguish between

those events that did happen (such as trains full of corpses moving across the border between Pakistan and India during the riots in 1947) and those events that were only alleged to have happened (such as terrorists poisoning the water supply).[34] The difficulty with drawing a sharp distinction between that which happened (the brute facts) and that which was only alleged to have happened (the imaginary) is that such distinctions can be seen with clarity only *after* the crisis has passed.

The regions of the imaginary to which the claims of the real were anchored were varied indeed—they ranged from images seen or reported to have been seen on television to stories heard about other times. Contrary to the notion that certain classes of people—the educated, for example—are protected from the mesmerizing effect of rumors, I found that many professionals—such as bureaucrats, teachers, and physicians—inhabited for a while that twilight zone in which it was difficult to know whether it was safer to trust rumors or the official versions of events. Other professionals—such as members of a Jesuit seminary, the students who later provided the foundation for organizing relief work—were able to resist the force of rumors that they were under threat.

The diffused rumors created, within the space of twenty-four hours, the sense that there was a conspiracy against Hindu society, one that the authorities responsible for the protection of citizens and the maintenance of public order would be quite unable to handle. Instead of creating the Sikhs as a group vulnerable to mass violence, and hence in need of the protection of law, the rumors fed on existing images from the written and oral discourses of militant Sikh leaders: the weak, vulnerable Hindu; the corrupt and emasculated Indian state; the militant Sikh armed with swords and Kalashnikovs and ready, when the moment of reckoning came, to fight for Khalistan. These images all came to be believed with a vengeance. The assassination of Indira Gandhi was read as proving the power of the Sikhs and the vulnerability of the Hindus, and the images were evoked with ever-increasing intensity as Hindu men and women circulated rumors with mounting panic.

The Vulnerability of the Sikhs

While rumors about the unpreparedness of emasculated Hindus to meet the challenge of the imminent Sikh attack were being freely discussed and circulated on street corners and in *paan* shops,[35] many Sikhs were increasingly fearful of being attacked by Hindus. On 31 October, newspapers reported that hoodlums had gathered at various railway stations and that in many places Sikhs had been dragged from the trains and beaten or killed. The absence of police in crucial public spaces and the denial by public officials that any Sikhs had been attacked convinced many Sikhs that the antisocial Hindu elements had the support of the Indian police force. For many Sikhs, these events were seen in continuity with Operation Blue Star, since they too had to do with teaching Sikhs a lesson about their (lack of) place in the Indian Union.

Being able to interpret rumors correctly soon became a matter of life and death for many Sikhs, rather than a matter for disinterested inquiry or mild

titillation. Let me illustrate with an example. On the morning of 1 November, while driving through the deserted streets in the Civil Lines, my husband and I met a distraught Sikh who waved wildly at us to stop. He was an employee of the National Defence Institute who had worked through the night in his laboratory. He knew nothing of the events following Indira Gandhi's assassination, but he sensed that something eerie was happening. There were no buses running, and the usual street sounds were missing. Could we help him by dropping him at the nearest bus stop, so he could get home? We told him that there were reports of attacks on Sikhs and it might be best to avoid the streets. We suggested that we could take him to a friend who lived nearby and he could telephone his family. We also suggested that he could stay there until things quieted a bit. As we were talking I had opened the door of the car for him and he had seated himself in the back after muttering words of thanks. Moments later, a group of four or five men materialized. They did not look threatening, but they spoke in conspiratorial tones. Further ahead, they said, was a mob. If it saw a Sikh in our car, it would not only drag him out and beat him or kill him but also attack us. I became visibly angry. The men shook their heads sadly and said they were doing their best — what more could they do except warn us of what lay ahead? They said that it would be better for the man to hide under the seat and for us to drive the car fast so that he was not visible from a distance. They would neither talk directly to the man nor look at him; it was as if they were discussing a troublesome object rather than a person. At this point the Sikh man visibly panicked. I assured him that our friend's house was a minute's drive and if he wanted he could simply stay there, where he would be safe. "No," the man said, "why should you risk your lives for me?" He opened the door even as the car had begun to move and stumbled on the road. "He will not come with us," my husband said. "He probably fears that we will trick him and deliver him to his killers." I shouted to the man that he should not try to negotiate the roads — he should just go back to the National Defence Institute and hide there for a few days. I lost sight of him then, but many months later I saw him in the vicinity of Metcalfe House. He had survived.

In the days after the assassination many Sikhs were persuaded to take shelter in the houses of Hindu or Muslim friends, but it was with shreds of rumor and information that they were making choices — the extent of the violence was not at all clear at the time. Although the three days of violence in Delhi that left more than three thousand Sikhs dead and many more brutalized and homeless began on the evening of 31 October, the full horror of these days began to be known only on 3 November and was not officially acknowledged until much later.[36]

A New Turn
As the extent and brutality of attacks against Sikhs came to be known through reports in newspapers and the work of several voluntary agencies, the rumors took a new turn. It began to be whispered that news had come in from several

places that Sikhs who had been given shelter by Hindus had killed their hosts, stolen their goods, or raped the women of the household before running away in the middle of the night. Names of several residential colonies were evoked when people said they knew someone who had seen it or heard it or had known the family. This element of the new complex of rumors was connected with the assassination of Indira Gandhi by reference to her bodyguards: if they, whom she trusted enough to ignore the advice of her security personnel, could betray her trust and kill her simply because they had been sworn to exact vengeance for Operation Blue Star, then what further evidence was needed, some Hindus said, to convince us that Sikhs did not have any loyalty beyond their religion? The Sikh character was that of a snake, a creature that bites the hand that feeds it milk.[37]

The second strand of the new complex of rumors interpreted the actions of Sikhs terrified of mob violence as preparations for revenge. In the earlier complex of rumors that I identified, the theme of the collapse of the state and the simultaneous passage of power into the hands of the Sikh militants was prominent. By the second day after the assassination, it was clear that this was not about to happen. President Zail Singh (himself a Sikh) had returned from abroad on hearing of the assassination, and Rajiv Gandhi had been sworn in as India's new prime minister on the evening of 31 October. Similarly, the idea of Sikhs as set to create Khalistan was contradicted by reports of sporadic attacks on Sikhs—which kept all sorts of people off the streets for fear that the mobs persistently described in newspapers as "antisocial elements" would harm not only Sikhs but others as well.

Yet rumor continued to construct Sikhs as aggressive, angry, and waiting to strike. When a large number of Sikhs took shelter in *gurdwaras*, rumors spread that Sikhs had stockpiled vast amounts of weapons at these sites and would be launching attacks against Hindus from them. Several middle-class localities organized neighborhood watches so they would not be caught unawares when attacked by the Sikhs at night. When a group of frightened Sikh taxi drivers — who normally slept in makeshift shelters at the taxi stand and who had, in order to avoid identification, shaved their beards and cut their hair on the evening of 31 October when they heard about the attacks on Sikhs in Delhi — hid in the shadows of the towering walls of a women's college, they were spotted and the rumor immediately went around that they had assembled there to attack the college and rape the women. On receiving calls from the college, the police took the frightened men to a nearby relief camp. Hindu constructions of the Sikhs as aggressors, which were circulated until the very end of the crisis, turned the victims into aggressors and simultaneously created a sense of panic among those who (if one were granted a god's-eye view) were under no special threat.[38]

One other strand in the new complex of rumors that needs mentioning is the motif of a fanaticism approximating madness in the Sikhs. For instance, during one of my first visits to Sultanpuri, a resettlement colony where I was engaged with my team in relief and rehabilitation work,[39] we were taken to a

street where not much physical damage seemed to have occurred. But a group of Sikh men and women were vociferous in claiming the status of victim. One woman said, "We were all attacked. Our men were killed in large numbers, but we say that they were not murdered—they were martyred."[40] A young Hindu Punjabi among the students helping me said, "Sikhs have such an urge to claim martyrdom," adding, after changing his voice to mimic a supposed Sikh, "We want to be martyrs—you can put any place and date on our act [*Asi tan ji shahid hona hai—jagah te tarikh tusi pa lao*]." He then described stories he had heard about Sikhs refusing to be moved to the safety of refugee camps and trying to challenge heavily armed mobs with the few weapons they had and dying in the end. I too had heard these stories, but my interpretation was not that the Sikhs were seeking martyrdom but that it was difficult at the time for them to know whether they were being taken to a refugee camp or being lured into a situation where death and degradation awaited them. The social memory of the partition riots, in which people were thus betrayed and killed, may have given substance to such fears.

Other constructions of the "madness" of the Sikhs were less benign. Trying to organize medical help for the victims, I spoke to a group of physicians approximately fifteen days after the riots. My major contact in this group was a socially conscientious physician (a member of the Arya Samaj, a reform sect of modern Hinduism) who had read accounts of the work my colleagues and I were doing. He said that he wanted to organize his colleagues to help but found them to be so prejudiced against Sikhs that it was impossible to get their cooperation. "Please don't think that they [the physicians] are bad people," he said. "One of them worked day and night in a government hospital on a voluntary basis when a tornado hit the city in 1978 and hospitals were finding themselves very short of staff. But somehow even he cannot be persuaded to work for the Sikhs." I decided that by talking directly to this group and telling them of the suffering of the victims in Sultanpuri, I might be able to get their help.

I met with sullen resistance—which, at the time, I construed as refusal to listen but, in retrospect, may have been a reaction to my accusatory tone when speaking about the Hindu community. Then one woman doctor said that in her opinion the Sikhs had brought all this on themselves because they were like mad people. To substantiate this, she said that she had heard that in the tire market near Bada Hindu Rao where many shops were owned by Sikhs, a mob had put burning tires around the necks of owners, locked them inside their shops, and let them burn to death. Normal people, she said, would have shouted and asked for mercy or forgiveness, but one Sikh was seen at the window shaking his fists at the mob, which had laughed hysterically at this sight. She seemed to have no sense that normal people would not burn another human to death, much less mock the victim. Then another person said laughingly that the weight of their long hair piled on their heads perhaps makes Sikhs mad.

The creation and use of these stories did not seem to have anything to do

with the experience of the physicians. They themselves had not gone around burning people or looting shops — yet there was a voyeuristic pleasure in these rumors of the madness and extraordinary behavior of Sikhs. As the discussion gathered momentum, others began to offer other kinds of supporting evidence. One claimed that in the Sikh tradition, it was believed that one who died for the cause of the Gurus did not feel any pain even under torture. This is why, he said, they behaved like fanatics in taking questions of life and death so lightly and why there had always been so much violence in the Punjab. Another example was then offered. Sikhs in the Punjab, one member of the group said, had proudly proclaimed that when a number of the Sikh boys trapped in the Golden Temple during Operation Blue Star were rounded up by an Indian army officer and asked to shout, "Bharat mata ki Jai" [Victory to Mother India], they had shouted in unison, "Jo bole so nihal — bolo sri sat sri akāl" [He who proclaims [the faith] is fulfilled — say truth, auspiciousness, and eternity], the ritual proclamation of Sikh faith, so the Indian army officer had killed the boys.[41] The physician then said, How could one explain such (Sikh) madness, which did not value the life of the young? He seemed completely uncritical of the officer's unjustifiable action, of the officer's lack of respect for (Sikh) lives. He also seemed entirely unaware of the irony that he had evoked Sikh lack of respect for life as evidence of Sikh madness, and hence as an exoneration of Hindu violence against Sikhs, during a discussion prompted by the killing of Sikhs by Hindus.

Let me conclude this discussion with an example that gives a slightly different perspective on the motif. A Hindu priest told me that a meeting was held on 31 October in a recently built temple on the outskirts of Delhi known for its lavish interiors and its patronage by politicians and powerful members of the underworld. There was a major discussion of whether Sikhs were part of the Hindu community and the assassination should therefore be treated as the aberration or crime of two individuals or whether the whole Sikh community was to be implicated. It was agreed that over the last several years Sikh militants and terrorists had killed and terrorized Hindus in the Punjab and looted their homes and businesses.[42] Therefore, the priest continued, Sikhs were now like a god who begins to behave like a demon.[43] Such gods, he said, do not learn through reasoned conversation — they have to be kicked to rid them of the evil. The phrase he used in Hindi was "laton ke devata baton se nahin mante" [gods who need kicks cannot be pacified with words]. With this twist on the common saying that "laton ke bhut baton se nahin mante" [demons who need kicks cannot be pacified with words], he substituted the symbolism of gods (though *devata* is used for lesser gods) for that of demons. The language of possession and exorcism here becomes a political language through which the Sikh is figured as a god transformed by possession into demon and the violence linking the aggressors (Hindus) and the victims (Sikhs) is figured on the model of the beneficent exorcist and his mad patient.[44]

I could give many more examples of the overlaying of elements in the new complex of rumors to create the Sikh as aggressive, vengeful, incapable of

loyalty, and mad—and, correspondingly, the Hindu as vulnerable, frightened, and acting out of self-defense against a powerful and insane enemy. But I think that it is time to present the events of Operation Blue Star as they appeared in an ideal typical form to the Hindu and the Sikh communities, and then to see how these perceptions fed into a Hindu imagination of Hindu society under siege after the assassination of Indira Gandhi.

Hindu Perceptions of Operation Blue Star

Mytheme A. Bhindranwale was about to announce the formation of Khalistan from the precincts of the Golden Temple when the Indian army stormed the temple and foiled the plot.

Mytheme B. Sikh terrorists used pilgrims as human shields, which led to more civilian and army casualties than would have been the case if normal rules of warfare had operated.

Mytheme C. Sikh militants compelled young children to act as human shields, so that the children could be claimed as martyrs for the cause.

Sikh Perceptions of Operation Blue Star

Mytheme a. Operation Blue Star was meant to teach Sikhs a lesson.

Mytheme b. Indian army officials shot innocent pilgrims.

Mytheme c. Indian army officers lined up and shot Sikh children in the Golden Temple when the children refused to shout Hindu nationalist slogans as the officers instructed.

Mytheme d. Bhindranwale did not die during Operation Blue Star—he is like a sleeping bull who will rise to lead the Sikhs against the Indian state.

Before I discuss these opposing perceptions of Operation Blue Star, let me note that not all Hindus believed one construction and all Sikhs the other. The many instances of solidarity built by individuals and groups across communities during the crises of 1984—some of which are mentioned here—are evidence of the fact that such totalizations can be resisted.[45]

Nonetheless, these two sets of perceptions fed the imagined sequel of Indira Gandhi's assassination. In the Hindu imaginary, the assassination was part of a bigger plot. This was validated by Hindu and Sikh perceptions of Operation Blue Star: the assassination was the logical sequel to Operation Blue Star for Hindus in that both were supposedly about the creation of Khalistan (mytheme A); it was the logical sequel for Sikhs in that it could be read as a sign that Bhindranwale was alive and waiting to lead the Sikhs against the Indian state (mytheme d). The Hindu imaginary was also haunted by the perception that Sikhs would easily defeat Hindus because Sikhs had martial traditions whereas Hindus were weak and effeminate—ideas promulgated in Sikh as well as Hindu militant literature. The rumors of how Sikh militants and pilgrims had courted death during Operation Blue Star became the basis in the subsequent crisis for the construction of the Sikh character as inherently heroic (mytheme c) or inherently fanatical (mytheme B, mytheme C). Although clips of Sikh militants

surrendering to the Indian army were aired on television after Operation Blue Star, the prevailing vision of Sikhs in the first two days of the riots following Indira Gandhi's assassination was of a people who would defy death by suicidally attacking Hindus.

In the Sikh imaginary, the situation had a parallel but not strictly symmetrical development. This was because of a deep ambivalence regarding Indira Gandhi's assassins. No militant group was willing to condemn the assassins outright, but if any Sikh religious organization actually made, as some claimed, a public statement condemning the assassination, it was later withdrawn. Even among Sikhs who were not sympathetic to the militant cause, Operation Blue Star was seen as an insult to the whole religious community. Hence they saw the aftermath of the assassination as a further step in the politics of teaching Sikhs a lesson (mytheme a, mytheme b, mytheme c). Moreover, many Sikhs were rightly offended that instead of being treated as a crime committed by individuals, the assassination was portrayed as an event that put the whole Sikh community on trial, which meant that Sikhs were targeted as a people.

It would be a grave error to assume a homogeneity of opinion and a consequent totalization of affect among Sikhs. Reaction ranged from public celebration of the act as a deed in the tradition of Sikh martyrdom to distancing oneself from the assassins to outright condemnation of the action. This variation was not recognized in the stabilization of the attributes of "Sikh character" by Hindus, however — although the individuality of the different kinds of people who make a community was clearly articulated in practice. Such totalization seems to be characteristic in times of collective violence, as it is in the processes of ethnic and religious mobilization in the service of violence.[46]

But what I would like to emphasize here is how the categories of aggressor and victim were reversed for many Hindus. The primary elements that went into the creation of the Sikh character in the Hindu imaginary were as follows:

1. A Sikh is loyal only to his religion — he can betray even those closest to him or who have placed the greatest trust in him.
2. A Sikh is like a snake — he will bite even the hand that feeds him.
3. Sikhs are naturally aggressive and attracted to violence, and they are not capable of observing normal social constraints.
4. There is a fanaticism bordering on madness in the Sikh character.

In other words, the Sikh in the Hindu imaginary was characterized by treacherousness, aggressiveness, and fanaticism. The rumors that circulated among Hindus after Indira Gandhi's assassination expressed and confirmed the supposed character traits of the Sikh:

Treacherousness
Indira Gandhi's Sikh security guards had betrayed her despite the trust she had placed in them (element 1).

Sikhs were defecting from the ranks of the Indian army and police (element 1).

Sikhs who had been given shelter in Hindu homes had stolen goods from those houses, killed the hosts, and raped the women (element 2).

Sikhs were caught trying to poison the water supply (element 3).

Sikhs were celebrating Indira Gandi's violent death (element 4).

Aggressiveness

Sikhs had gathered in large numbers in *gurdwaras* to attack Hindus and to spread chaos before announcing the formation of Khalistan (element 1).

Sikhs were murdering large numbers of Hindus in the Punjab (element 1).

Sikhs had gathered near a Hindu women's college because they wanted to use the opportunity created by the riots to rape the students (element 3).

Fanaticism

Sikhs believe that one who dies in the cause of his religion does not suffer pain even he while being tortured (element 1).

Sikhs court martyrdom at every opportunity (element 4).

When being burnt alive, Sikhs gesticulate in anger rather than plead for mercy (element 4).

Sikhs are proud of children who court death in the cause of Sikh religion (element 4).

Sikhs are like gods possessed by demons (element 4).

I present this schema to help explicate the participation of many Hindus in the collective violence against Sikhs after Indira Gandhi's assassination even though they themselves may not have killed or injured any Sikhs or looted any Sikh property. Rumor — and especially its ability to animate the past, its lack of signature, its appeals to the uncanny, its contagious aspect — gave language the perlocutionary force that brought a new form into existence — not a form of *life* but a form of *death*.

In other words, different elements of rumor combined to create a sense of Hindus as an "endangered collectivity." In the Hindu imaginary, the whole social order was imagined as about to collapse under a massive and violent Sikh conspiracy. The Hindu imaginary also emptied the Sikh of all human subjectivity, endowing every Sikh with traits of madness and demonic possession, which then allowed Hindus to assume that the Sikh was not worthy of being treated as *an Other with a face.* The peculiar nature of rumor led to the temporary transformation of the world into a phantasmagoria populated "by shadows of others ... by *fabricated,* or *improvised* men."[47]

Conclusion

The images generated in the emergent militant discourses bore a relation to existing stereotypes circulating in everyday life. The putative fanaticism of Sikhs and the supposed effeminacy of Hindus, for example, were not new notions. It is a matter for inquiry, then, as to how and under what conditions

existing stereotypes came to acquire a lethal quality in the aftermath of Indira Gandhi's assassination.

What I have described in this essay is one way in which the world as it is known in everyday life was obliterated and replaced with a world that bore a resemblance to the structure of paranoia, a world full of excessive distrustfulness and delusions of persecution by others. Clearly, the social production of hate can give birth to discourses and practices of genocide, yet I would suggest that such transformations become possible only under special conditions, when *my fear of the Other* is transformed into the notion that *the Other is fearsome*. As I have tried to show, such transformations are bound to the conception of important past events as "unfinished," indeterminate, and capable of molding the present in new and sometimes unexpected ways. The present can suddenly become the site where the elements of the past that had not been integrated into a stable understanding of the past press upon the world with the same insistence and obstinacy with which the real creates holes in the symbolic. It is in this manner that rumor's adequacy within a reality that has become suddenly unrecognizable makes rumor the privileged mode of communication and constructs panic as the corresponding affect in the altered world. Doubts and uncertainties exist in everyday life, but the worst is not expected to happen every time. By contrast, zones of emergency are marked by diffused images of the unfinished past that void the Other of all subjectivity and people the world with a phantasmagoria of shadows.

The perlocutionary force of rumor shows how fragile the social world that we inhabit can be. If I take a considerably more pessimistic view than others have of the role of rumor in mobilizing people, it is not to deny the possibility that rumor can create or further critical awareness. It is to register that rumor has a dark side. Because existing images of hate between social groups may take volatile forms when the social order is threatened by a critical event, rumor can so transform the world that the worst becomes not only possible but also probable. Yet I would like to close by reaffirming that the heterogeneity of everyday life frequently provides protection against the totalization of the Other as enemy and other paranoid delusions. Thus, while it is important to study the processes by which everyday life is overwhelmed during times of emergency, it is also important to examine the processes by which (at least minimal) trust is maintained or reestablished between communities torn apart by hate.

Notes

I am grateful to Charles Briggs for his acute comments on an earlier draft of this essay. A version of this essay has been published as "Official Narratives, Rumour, and the Social Production of Hate," *Social Identities* 4 (1998): 109–30.

1. Operation Blue Star refers to the army offensive allegedly to flush out the militants from Harmandar Sahib (also known as the Darbar Sahib or, most commonly, the Golden Temple), Sikhism's holiest shrine, which is located in the city of Amritsar, Punjab. The offensive began on 5 July 1984 and lasted several days. The militant Sikh

leader Jarnail Singh Bhindranwale as well as hundreds of other Sikhs and many soldiers of the Indian army died during this event. There is a voluminous literature on this event; see Rajiv A. Kapur, *Sikh Separatism: The Politics of Faith* (London: Allen & Unwin, 1986). The Golden Temple adjoins the Akal Takht, the headquarters of Sikhism.

2. For an excellent account of this complex process, see Kapur, *Sikh Separatism* (note 1), xi–xvi.

3. Benedict Anderson, *Imagined Communities: Reflections on the Origin and Spread of Nationalism* (London: Verso, 1983), esp. 131.

4. My translation; speech by Jarnail Singh Bhindranwale, audiocassette. Recordings of Bhindranwale's speeches were widely circulated in the Punjab and elsewhere in the 1980s, but the audiocassettes do not give the dates on which particular speeches were delivered.

5. I cannot take up here the complicated question of the gender of the Indian nation. Almost every conceivable image — ranging from the nation as a consuming mother, courtesan, beloved, or goddess to the nation as a sodomizing father — has made an appearance in the social imagery of different groups. On this issue, see Sudhir Chandra, *The Oppressive Present: Literature and Social Consciousness in Colonial India* (Delhi: Oxford Univ. Press, 1992); Partha Chatterjee, *Nationalist Thought and the Colonial World: A Derivative Discourse* (Minneapolis: Univ. of Minnesota Press, 1993); Lawrence Cohen, "Holi in Banaras and the *Mahaland* of Modernity," *GLQ* 2 (1995): 399–424; Sudipta Kaviraj, *The Unhappy Consciousness: Bankimchandra Chattopadhyay and the Formation of Nationalist Discourse in India* (Delhi: Oxford Univ. Press, 1995); and Veena Das, "Language and Body: Transactions in the Construction of Pain," *Daedalus* 125, no. 1 (*Social Suffering*, ed. Arthur Kleinman, Veena Das, and Margaret Lock) (1996): 67–91.

6. My translation; speech by Jarnail Singh Bhindranwale, audiocassette.

7. Kapur Singh, *They Massacre Sikhs: A White Paper by the Sikh Religious Parliament (Shiromani Gurdwara Prabandhak Committee)* (Amritsar: Shiromani Gurdwara Prabandhak Committee, 1978), 18.

8. *Guru* literally means "teacher"; *Sikh* is a derivative of the Sanskrit *shishya* meaning "student." A combination of elements of the Hindu bhakti movement and Islamic Sufism, Sikhism was founded in the Punjab by Guru Nanak in the late fifteenth century. Sikhs are disciples of their ten Gurus, beginning with Nanak (1469–1539) and ending with Gobind Singh (1666–1708). Into the twentieth century, many Sikhs did not consider themselves as a distinct group or community outside the Hindu framework.

The Akali Dal, a religious and political body whose leaders have been committed to a unique Sikh identity since the organization's inception in the 1920s, has long dominated Sikh politics. As a political party, it has its base primarily in the Punjab among Sikhs. It is, however, not the case that all Sikhs are allied with the Akali Dal: the Congress Party has been Akali Dal's main rival in the Punjab and has had a long history of Sikh leadership and Sikh support. The interface between religious organizations and political parties in the Punjab is a complicated question, and it should be borne in mind that political allegiances of both Sikhs and Hindus cut across political party and religious affiliations.

9. My translation; speech by Jarnail Singh Bhindranwale, audiocassette.

10. This point is important to bear in mind since the sword is claimed as an important symbol of masculinity and valor in the Hindu Rajput tradition also, but the flowing beard singles out the Sikh male. On the past as sedimented in the body, see Paul Connerton, *How Societies Remember* (Cambridge: Cambridge Univ. Press, 1989), 72.

11. My translation; speech by Jarnail Singh Bhindranwale, audiocassette.

12. Speech by a functionary of the Akali Dal, audiocassette.

13. The relation between memory and forgetting in constituting a community has been noted in many contexts in recent years. In a very interesting article on Polish-Jewish relations during World War II, Jan T. Gross has shown the importance of memory in the resistance to totalitarianism and the importance of simultaneous forgetting for the construction of a community as purged of its past evil; see Jan T. Gross, "Polish-Jewish Relations during the War: An Interpretation," *Archives européennes de sociologie* 27 (1986): 199–214. Gross comments powerfully on the Polish conviction that "a halfway victory over totalitarianism's attempts to destroy social solidarity would still be won if the community's history were rescued from the regime's ambition to determine not only the country's future but also its past" (p. 90). Yet the same Polish people developed elaborate myths to conceal from themselves the nature of Polish-Jewish relations and how existing anti-Semitism in Polish society led to both covert and overt support being given to the Nazi ideology of scapegoating the Jew.

14. Singh, *They Massacre Sikhs* (note 7), 16–17.

15. My translation; speech by Jarnail Singh Bhindranwale, audiocassette.

16. On the construction and use of these stereotypes, see Gyanendra Pandey, ed., *Hindus and Others: The Question of Identity in India Today* (New Delhi: Viking, 1993); Ashis Nandy, *The Illegitimacy of Nationalism: Rabindranath Tagore and the Politics of Self* (Delhi: Oxford Univ. Press, 1994); Gyanendra Pandey, "The Prose of Otherness," in *Subaltern Studies*, vol. 8, *Essays in Honour of Ranajit Guha,* ed. David Arnold and David Hardiman (Delhi: Oxford Univ. Press, 1994), 188–221; Veena Das, *Critical Events: An Anthropological Perspective on Contemporary India* (Delhi: Oxford Univ. Press, 1995); Das, "Language and Body" (note 5); and Sudhir Kakar, "The Construction of a New Hindu Identity," in Kaushik Basu and Sanjay Subrahmanyam, eds., *Unravelling the Nation: Sectarian Conflict and India's Secular Identity* (New Delhi: Penguin, 1996).

17. See Pandey, *Hindus and Others* (note 16); Pandey, "The Prose of Otherness" (note 16); and Kakar, "The Construction of a New Hindu Identity" (note 16).

18. Although panic seems to be an accompanying affect of rumors in times of trouble, I am hesitant to assume that all rumors are accompanied by panic. I do not have the space to deal with rumor in everyday life in this essay, but a general theory of rumor needs to come to terms with the different discursive formations within which rumors function.

19. George Rudé, *The Crowd in the French Revolution* (Oxford: Clarendon Press, 1959); and George Rudé, *The Crowd in History: A Study of Popular Disturbances in France and England, 1730–1848* (New York: Wiley, 1964). See also Georges Lefebvre, *The Great Fear of 1789: Rural Panic in Revolutionary France,* trans. Joan White (New York: Pantheon, 1973), in which he observes, "Indeed, what was the Great Fear if not one gigantic rumour?" (p. 74).

20. See Veena Das, "Introduction: Communities, Riots, Survivors: The South Asian Experience," in Veena Das, ed., *Mirrors of Violence: Communities, Riots, and Survivors in South Asia* (Delhi: Oxford Univ. Press, 1990), 1–36.

21. E. P. Thompson, "The Moral Economy of the English Crowd in the Eighteenth Century," *Past and Present*, no. 50 (1971): 78.

22. Ranajit Guha, *Elementary Aspects of Peasant Insurgency in Colonial India* (Delhi: Oxford Univ. Press, 1983), 256, 226, 251, 264, 265.

23. Homi K. Bhabha, "By Bread Alone: Signs of Violence in the Mid-Nineteenth Century," in idem, *The Location of Culture* (London: Routledge, 1994), 201, 203.

24. See Gustave Le Bon, *The Crowd: A Study of the Popular Mind* (London: T. F. Unwin, 1952); originally published as *Psychologie des foules* (Paris: F. Alcan, 1895).

25. See Das, "Introduction" (note 20).

26. Serge Moscovici, *The Age of the Crowd: A Historical Treatise on Mass Psychology*, trans. J. C. Whitehouse (Cambridge: Cambridge Univ. Press, 1985).

27. Veena Das, "The Spatialization of Violence: Case Study of a 'Communal Riot,'" in Kaushik Basu and Sanjay Subrahmanyam, eds., *Unravelling the Nation: Sectarian Conflict and India's Secular Identity* (New Delhi: Penguin, 1996), 157–203.

28. In J. L. Austin's classic formulation, illocutionary force is distinguished from perlocutionary force in that in the former one does something *in* saying something while in the latter one does something *by* saying something. See J. L. Austin, *How to Do Things with Words*, eds. J. O. Urmson and Marina Sbisà, 2d ed. (Cambridge, Mass.: Harvard Univ. Press, 1975), 99–132 passim: "We can similarly distinguish the locutionary act 'he said that...' from the illocutionary act 'he argued that...' and the perlocutionary act 'he convinced me that...'" (p. 102); "we distinguished the locutionary act... which has a *meaning*; the illocutionary act which has a certain *force* in saying something; the perlocutionary act which is *the achieving of* certain *effects* by saying something" (p. 121). In general, the presence of the first person indicative characterizes utterances that have illocutionary force, while the attributes of perlocutionary force are much more difficult to designate. Nonetheless, we can say that a rumor's perlocutionary force would be lost if the utterance were tethered to the speaking agent or, for that matter, if the speaker were to frame a rumor by saying that "I am spreading the rumor that..."

29. The idea of the two guards as martyrs crystallized much later in the militant literature of the Sikhs, when the assassins were depicted as incarnations of two heroic figures, Sukha Singh and Mehtab Singh, who had avenged the dishonor done to Harmandar Sahib in Amritsar in 1752 at the hands of a Muslim minor chieftain, Massaranga, by killing the latter; see Das, *Critical Events* (note 16). To my knowledge this comparison was not evoked in 1984; instead their action, which involved risking their own lives, was compared to the suicide squads of militant groups in the Middle East.

30. For a further description of the rendering of this event in militant literature, see Das, *Critical Events* (note 16).

31. In the usage of the Indian army, the followers of Bhindranwale were "terrorists," but in their own self-understanding, they were "martyrs"; in popular usage, in the media or conversations, there was frequent slippage between different kinds of terms.

As Reinhart Koselleck has pointed out, most social scientific concepts are marked by a political plenitude; see Reinhart Koselleck, *Futures Past: On the Semantics of Historical Time,* trans. Keith Tribe (Cambridge, Mass.: M.I.T. Press, 1985). In this case, what is clear is that ordinary people in the Punjab and elsewhere had to bear the burden of much violence due to both the insurgency operations of the Sikh militants and the counterinsurgency operations of the police and the army. Thus it would be a mistake to assume that the distribution of terms was neatly divided between a populace fighting for freedom or justice, on the one hand, and a repressive state apparatus, on the other.

32. One man related to me that a Sikh colleague in his office had brought a box of sweets and given it to his Hindu colleagues, saying that he was consoling them because their mother was dead.

33. Yet note that another rumor, which also swept across the Punjab after Operation Blue Star, said that a Sikh army officer had made Sikh pilgrims crawl on their stomachs before him "to teach them a lesson." This contrasting rumor seems to indicate that the institutions of the Indian state were strong enough to make Sikhs ignore their Sikh heritage in the line of duty. That these contrasting rumors could be evoked simultaneously should warn us against placing too much emphasis on the stability of representations of state and community in popular consciousness.

34. Carlo Ginzburg, comments during panel discussion at "Memory, History, Narrative: A Comparative Inquiry into the Representation of Crisis," Warburg-Haus, Hamburg, Germany, 3 July 1997.

35. *Paan* shops—small roadside shops where betel leaves and betel nuts are sold—are typical gathering places for exchange of news, gossip, and information. These are strongly gendered spaces: women would not be found standing and gossiping around these shops.

36. For a vivid summary of the violence, see Amrit Srinivasan, "The Survivor in the Study of Violence," in Veena Das, ed., *Mirrors of Violence: Communities, Riots, and Survivors in South Asia* (Delhi: Oxford Univ. Press, 1990), 308–9:

> Not only was this the first historic instance of Hindu-Sikh confrontation, but the form of violence, also, was distinctive. At no time were the communities confronting each other as two warring factions. Rather the attacks were all one-sided and aimed primarily at the massacre of Sikh males falling between the age-group 20–50 years. The peculiar uniformity in the sequence of violence in wide-flung parts of Delhi, as also the uniformity and efficiency of the mobs' method of travelling, hunting and killing—felling the victim with the help of iron rods of the kind used for construction purposes, cracking the skull, pouring kerosene on the body and then setting it alight, sometimes with the help of some incendiary power—were additional factors leading to the strong suspicions of the riots being politically organized. The particular brutality of the violence and arson was matched by its spectacular quality; burnt shops and shells of homes, looted goods and dead bodies were easily available for public viewing.

See also Smitu Kothari and Harsh Sethi, eds., *Voices from a Scarred City: The Delhi Carnage in Perspective* (Delhi: Lokayan, [1985]); People's Union for Democratic Rights

and People's Union for Civil Liberties, *Who Are the Guilty? Report of a Joint Inquiry into the Causes and Impact of the Riots in Delhi from 31 October to 10 November 1984,* 2d ed. (New Delhi: People's Union for Democratic Rights; Delhi: People's Union for Civil Liberties, 1985); Uma Chakravarti and Nandita Haksar, *The Delhi Riots: Three Days in the Life of a Nation* (New Delhi: Lancer International, 1987); and Veena Das, "Our Work to Cry: Your Work to Listen," in Veena Das, ed., *Mirrors of Violence: Communities, Riots, and Survivors in South Asia* (Delhi: Oxford Univ. Press, 1990), 345–98.

37. This analogy was to recur. For instance, one man helping in the running of a relief camp went to buy milk for the children from a *gwala* (milk vendor). The *gwala* asked, Why do you need so much milk? Do you have a wedding in the family? The man replied that he was getting milk for the children of Sikhs in the Ludlow Castle camp. The *gwala* told him, You want to feed the snake's child with milk — but when he grows up, he will grow up to be a snake, not a man. *Astin ke samp — mauka pate hi das lenge* [snakes nourished in your shirt sleeves — they will bite you as soon as they get a chance]. This is a common saying that refers to dependants who betray their benefactors' trust and do harm to them.

Note that in militant Sikh discourse, the snake had been used to trope the Hindu as an untrustworthy enemy. One poster declared, "A Hindu never kills a snake. He asks the Muslim to kill the snake. If the snake dies, the Hindu is happy; if the Muslim dies, the Hindu is happy." It concluded, "In confrontation with such a community, even your name will be wiped out from the annals of history."

38. I am tempted to say that the "objective" conditions did not warrant this fear of a Sikh plot against the whole of society. But the problem here is precisely to see a crisis by placing oneself within it and to explain how categories of people who are themselves vulnerable come to be vested with such evil powers during the crisis.

39. See Das, "Our Work to Cry" (note 36); and Das, "The Spatialization of Violence" (note 27).

40. I have shown in my earlier work that in the streets where the violence occurred, people simply did not use the category of martyrdom nor did any other ready-made categories come easily to them; see Das, "Our Work to Cry" (note 36).

41. This story was much in circulation after Operation Blue Star and was cited in a letter by a senior police official in Punjab in his resignation letter to Zail Singh, then the president of India; see Das, *Critical Events* (note 16).

42. There was always a "forgetting" at such points in a discussion that, statistically, more Sikhs than Hindus had died in terrorist attacks.

43. Hindu mythology is replete with such examples, and the expressions "devata chaddha hai" [a god has possessed one] and "bhut chaddhaa hai" [a ghost has possessed one] can both be used in seeking to exorcise a troubling spirit.

44. See Bruce Kapferer, *A Celebration of Demons: Exorcism and the Aesthetics of Healing in Sri Lanka,* 2d ed. (Washington, D.C.: Smithsonian Institution Press, 1991), for some analogies with the situation in Sri Lanka, in which the themes of possession and exorcism made an appearance in political cartoons in relation to Tamil militants.

45. See Valli Kanapathipillai, "July 1983: The Survivor's Experience," in Veena

Das, ed., *Mirrors of Violence: Communities, Riots, and Survivors in South Asia* (Delhi: Oxford Univ. Press, 1990), 321–45.

46. See Das, "Introduction" (note 20); Das, *Critical Events* (note 16); and Kanapathipillai, "July 1983" (note 45).

47. Jacques Lacan, "'I've Just Been to the Butcher's,'" in idem, *The Seminar of Jacques Lacan*, bk. 3, *The Psychoses, 1955–1956*, ed. Jacques-Alain Miller, trans. Russell Grigg (New York: W. W. Norton, 1993), 53; originally published as Jacques Lacan, "« Je viens de chez le charcutier »," in idem, *Le séminaire de Jacques Lacan: Livre III, Les psychoses, 1955–1956*, ed. Jacques-Alain Miller (Paris: Editions du Seuil, 1981), 65: "par des ombres d'autre ... par des bonshommes *foutus,* ou *bâclés à la six-quatre-deux.*"

Among the Dead

Philip Gourevitch

> Leontius, the son of Aglaion, was coming up from the Peiraeus, close to the
> outer side of the north wall, when he saw some dead bodies lying near the exe-
> cutioner, and he felt a desire to look at them, and at the same time felt disgust
> at the thought, and tried to turn aside. For some time he fought with himself
> and put his hand over his eyes, but in the end the desire got the better of him,
> and opening his eyes wide with his fingers he ran forward to the bodies, saying,
> "There you are, curse you, have your fill of the lovely spectacle."
>
> —Plato, *The Republic* 4.439–40 (trans. A. D. Lindsay)

In the province of Kibungo, in eastern Rwanda, in the swamp- and pasture-
land near the Tanzanian border, there is a rocky hill called Nyarubuye with
a church where many Tutsis were slaughtered by Hutu compatriots in mid-
April 1994. A year after the killing, I went to Nyarubuye with two Canadian
military officers. We flew in a United Nations helicopter, traveling low over
the hills in the morning mists, with the banana trees like green starbursts dense
over the slopes. The uncut grass blew back as we dropped into the center of the
parish schoolyard. A lone soldier materialized with his Kalashnikov, and
shook our hands with stiff, shy formality. The Canadians presented the paper-
work for our visit, and I stepped up into the open doorway of a classroom.

At least fifty mostly decomposed cadavers covered the floor, wadded in
clothing, their belongings strewn about and smashed. Macheted skulls had
rolled here and there.

The dead looked like pictures of the dead. They did not smell. They did not
buzz with flies. They had been killed thirteen months earlier, and they had not
been moved. Skin stuck here and there over the bones, many of which lay scat-
tered away from the bodies, dismembered by the killers, or by scavengers —
birds, dogs, bugs. The more complete figures looked a lot like people, which
they were once. A woman in a cloth wrap printed with flowers lay near the
door. Her fleshless hipbones were high and her legs slightly spread, and a
child's skeleton extended between them. Her torso was hollowed out. Her ribs
and spinal column poked through the rotting cloth. Her mouth was open and
her head was tipped back: a strange image — half agony, half repose.

I had never been among the dead before. What to do? Look? Yes. I wanted
to see them, I suppose; I had come to see them — the dead had been left unburied
at Nyarubuye for memorial purposes — and there they were, so intimately

exposed. I didn't need to see them. I already knew, and believed, what had happened in Rwanda. Yet looking at the buildings and the bodies, and hearing the silence of the place, with the grand Italianate basilica standing there deserted, and beds of exquisite, decadent, death-fertilized flowers blooming over the corpses, it was still strangely unimaginable. I mean one still had to imagine it.

Those dead Rwandans will be with me forever, I expect. That was why I had felt compelled to come to Nyarubuye: to be stuck with them—not with their experience, but with the experience of looking at them. They had been killed there, and they were dead there. What else could you really see at first? The Bible bloated with rain lying on top of one corpse and, littered about, the little woven wreaths of thatch that Rwandan women wear as crowns to balance the enormous loads they carry on their heads, and the water gourds, and the Converse tennis sneaker stuck somehow in a pelvis.

The soldier with the Kalashnikov—Sergeant Francis of the Rwandese Patriotic Army, a Tutsi whose parents had fled to Uganda with him when he was a boy, after similar but less extensive massacres in the early 1960s, and who had fought his way home in 1994, and found it like this—said that the dead in this room were mostly women who had been raped before being murdered. Sergeant Francis had high, rolling hips, and he walked and stood with his butt stuck out behind him, an oddly purposeful posture, tipped forward, driven. He was, at once, candid and briskly official. His English had the punctilious clip of military drill, and after he told me what I was looking at, I looked instead at my feet. The rusty head of a hatchet lay beside them in the dirt.

A few weeks earlier, in Bukavu, Zaire, in the giant market of a refugee camp that was home to many Rwandan Hutu militiamen, I had watched a man butchering a cow with a machete. He was quite expert at his work, taking big precise strokes that made a sharp hacking noise. The rallying cry to the killers during the genocide was "Do your work!" And I saw that it *was* work, this butchery; hard work. It took many hacks—two, three, four, five hard hacks—to chop through the cow's leg. How many hacks to dismember a person?

Considering the enormity of the task, it is tempting to play with theories of collective madness, mob mania, a fever of hatred erupted into a mass crime of passion, and to imagine the blind orgy of the mob, with each member killing one or two people. But at Nyarubuye, and at thousands of other sites in this tiny country, on the same days of a few months in 1994, hundreds of thousands of Hutus worked as killers in regular shifts. There was always the next victim, and the next. What sustained them, beyond the frenzy of the first attack, through the plain physical exhaustion and mess of it?

It is widely understood that the achievement of social order and peace requires political discipline. But mass violence, too, must be organized; it does not just occur aimlessly. Even mobs and riots have a design, and great and sustained destruction requires great ambition. It must be conceived as the means toward achieving a new order, and although the idea behind that new order may be criminal, and objectively very stupid, it must also be compel-

lingly simple and at the same time absolute. The ideology of genocide is all of those things, and in Rwanda it went by the bald name of Hutu Power. For those who set about systematically exterminating an entire people—even a fairly small and unresisting subpopulation of perhaps a million and a quarter men, women, and children, like the Tutsis in Rwanda—bloodlust surely helps. But the engineers and perpetrators of a slaughter like the one just inside the door where I stood need not enjoy killing, and they may even find it unpleasant. What is required above all is that they want their victims dead. They have to want it so badly that they consider it a necessity.

So I still had much to imagine as I entered the classroom and stepped carefully between the remains. These dead and their killers had been neighbors, schoolmates, colleagues, sometimes friends, even in-laws. The dead had seen their killers training as militias in the weeks before the end, and it was well known that they were training to kill Tutsis. It was announced on the radio, it was in the newspapers, people spoke of it openly. The week before the massacre at Nyarubuye, the killing began in Rwanda's capital, Kigali. Hutus who opposed the Hutu Power ideology were publicly denounced as "accomplices" of the Tutsis and were among the first to be killed as the extermination got under way. In Nyarubuye, when Tutsis asked the Hutu Power mayor how they might be spared, he suggested that they seek sanctuary at the church. They did, and a few days later the mayor came to kill them. He came at the head of a pack of soldiers, policemen, militiamen, and villagers; he gave out arms and orders to complete the job well. No more was required of the mayor, but he also was said to have killed a few Tutsis himself.

The killers killed all day at Nyarubuye. At nightfall, they cut the Achilles tendons of survivors and went off to feast behind the church, roasting cattle looted from their victims in big fires, and drinking beer. In the morning, still drunk after whatever sleep they could find beneath the cries of their prey, the killers went back and killed again. Day after day, minute by minute, Tutsi by Tutsi: all across Rwanda, they worked like that. "It was a process," Sergeant Francis said. I can see that it happened, I can be told how, and after nearly three years of looking around Rwanda and listening to Rwandans, I can tell you how. But the horror of it—the idiocy, the waste, the sheer wrongness—remains uncircumscribable.

I presume that you are reading this because you, like Leontius, the young Athenian in Plato, desire a closer look and that you, too, are properly disturbed by your curiosity. Perhaps, in examining this extremity with me, you hope for some understanding, some insight, some flicker of self-knowledge—a moral, or a lesson, or a clue about how to behave in this world; some such information. I don't discount the possibility, but when it comes to genocide, you already know right from wrong. The best reason I have come up with for looking closely into Rwanda's stories is that ignoring them makes me even more uncomfortable about existence and my place in it. The horror—as horror—interests me only insofar as a precise memory of the offense is necessary to understand its legacy.

The dead at Nyarubuye were, I'm afraid, beautiful. There was no getting around it. The skeleton is a beautiful thing. The randomness of the fallen forms, the strange tranquillity of their rude exposure, the skull here, the arm bent in some uninterpretable gesture there — these things were beautiful, and their beauty only added to the affront of the place. I couldn't settle on any meaningful response: revulsion, alarm, sorrow, grief, shame, incomprehension, sure, but nothing truly meaningful. I just looked, and I took photographs, because I wondered whether I could really see what I was seeing while I saw it, and I wanted also an excuse to look a bit more closely.

We went on through the first room and out the far side. There was another room and another and another and another. They were all full of bodies, and more bodies were scattered in the grass, and there were stray skulls in the grass, which was thick and wonderfully green. Standing outside there, I heard a crunch. The old Canadian colonel stumbled in front of me, and I saw, though he did not notice, that his foot had rolled on a skull and broken it. For the first time at Nyarubuye my feelings focused, and what I felt was a small but keen anger at this man. Then I heard another crunch and felt a vibration under-foot. I had stepped on one, too.

I had been reluctant to go to Nyarubuye. A week or so earlier, I had made what I thought — and still think — to be a good argument against such places. I was at a bistro in Kigali, sharing a pot of fondue bourguignonne and a pitcher of wine with Annick van Lookeren Campagne and Alexandre Castanias. Annick, who is Dutch, and Alexandre, a Greek, worked as monitors for the office of the United Nations High Commissioner for Human Rights in Rwanda. In mid-April 1995, a month before our dinner, they had been at the Kibeho displaced persons camp in southern Rwanda when the army came to close the camp. There were more than eighty thousand displaced people at Kibeho, Hutus who had fled their homes the previous summer, after the genocide was brought to a halt by the predominantly Tutsi rebel movement whose members formed the core of Rwanda's new government. The displaced people at Kibeho had feared punishment or retribution for the massacres, and among their number was a sizable contingent from the Hutu militias who had formed the shock troops of the genocide. The army's camp-closing operation was poorly organized, and it went badly. Alarmed by the soldiers, and worked into a panic by the resident Hutu Power operatives, the crowd stampeded, and soldiers opened fire for hours on end. After the shooting stopped for a while, it started again, and once more it lasted for hours. The terror continued like that for several days before order was restored. Perhaps two thousand were dead — nobody knows exactly. Most were crushed to death in the surging throng, many were killed by the army, and the former militiamen also did their share of killing, with machetes and spears and a few rifles.

Annick and Alexandre were at Kibeho throughout the catastrophe, and our dinner was the last time they would have together before Annick returned

to the Netherlands. After we finished eating, we stayed in the restaurant for a long time. We ordered a second pitcher of wine and sent out for cigarettes, and Alexandre kept standing us rounds of cognac.

The talk about Kibeho started when Alexandre asked me if I had been to the church at Nyarubuye, to see the memorial there of the unburied dead from the genocide. I said that I was resistant to the very idea of leaving bodies like that, as they were found after their massacre, forever in their state of violation — on display as monuments to the crime against them, and to the armies that had stopped the killing, as much as to the lives they had lost. Such places, it seemed to me, contradicted the spirit of the popular Rwandan T-shirt: "Genocide — Bury the dead, not the truth." I thought that was a good slogan, and I doubted the necessity of seeing the victims in order to confront the crime fully. The aesthetic assault of the macabre creates excitement and emotion, but does the spectacle really serve our understanding of the wrong? Judging from my own response to cruel images, I wondered whether people are wired to resist assimilating too much horror. Even as we look at atrocity, we find ways to regard it as unreal. And the more we look, the more we become inured to — not informed by — what we are seeing.

I said these things, and Alexandre said, "I totally disagree. I experienced Kibeho as a movie. It *was* unreal. Only afterward, looking at my photographs — then it became real."

When the first wave of shooting began, Alexandre had been with Zambatt — the Zambian contingent of the United Nations peacekeepers at Kibeho. He said, "I remember there were thousands of people crushing into the parking area. Thousands and thousands of people. I was up on the roof, watching. And I saw this one woman, a fat woman. In thousands and thousands and thousands of people, this one fat woman was the only thing I saw. I didn't see anyone else. They were just thousands. And this fat woman, pressing along with the crowd — while I watched she was like a person drowning." Alexandre brought his hands together, making them collapse inward and sink, and he appeared to shrink within his own frame. "One second she was standing, one second she was falling in the people, and I watched this happening. She disappeared. That was when I wanted only to take photographs. That fat woman, one fat woman, when you say the word Kibeho, she is all I really remember. That will be my one real image of Kibeho forever, that fat woman drowning in thousands and thousands of people. I remember she wore a yellow chemise."

I never saw Alexandre's photographs, but I told him that his description of that moment, and of his own passage from a sense of unreality during the events to the reality of his pictures, was more disturbing, more vivid, and more informative than anything I believed the photographs themselves could tell. In some ways it was quieter; the moment of shock was less concentrated, but it also involved one more, and took one along with it.

"I don't know," he said. "I couldn't tell you anything if I wasn't looking."

"You see and you don't see," Annick said. "Mostly you just do things. The pictures come later. When they were crushing on the gate at Zambatt,

we were crushing back on it so it didn't fall, and people started throwing babies over. You just catch them. You do things you'd never want to see a picture of."

"Like walking over the bodies," Alexandre said. "I feel very bad about that. It was very unreal and very insane, this decision to walk on dead people. I don't know. I don't know what was right or wrong, or if I feel guilty, but I feel bad. It was necessary. It was the only way to get through."

"We had to pull the live ones out," Annick said. She and Alexandre had collected hundreds of lost and orphaned children from the body piles, and from every crevice where a small person could hide: from the wheel wells of trucks, from under the hoods.

"I don't know why but I didn't care about the people killed by a bullet. I didn't give a fuck about them," Alexandre said. "They were dead, and the people wounded by bullets, they meant nothing to me. It was the people who were crushed."

"Bullets and machetes are supposed to kill," Annick said. "The people who got crushed were just killed by other people, like them, vulnerable, trying to live."

"I got a doctor," Alexandre went on, "and I said, 'They just look like they're sleeping, I don't know how to tell if they're dead.' He went through and checked twenty or thirty people, and he said, 'They're dead. They're all dead.' But when I had to walk on them, I felt like I might wake them."

"They were like all the luggage," Annick said. I was able to picture that: Kibeho was a ghost town, piled deep with the abandoned belongings of displaced persons, and smelling of death. "When we walked on the luggage," Annick said, "there were probably people underneath. You can't feel guilty, because it's useless, and you walked on them to save lives."

"Walking on them was about being alive," Alexandre said. "After a while it was just about getting on with life. The dead are dead. There's nothing you can do. Even with the living, what could we do? We gave them water. It was our only medicine. It was like a miracle. You'd see the face of a boy, fallen and death-like in the crowd, and you drop a few drops of water on him and he is like—aahhh!" Alexandre's face expanded and he rose a bit in his seat, like a sped-up film of a flower blossoming. "Then you turn around," he said. "And the next minute everyone we gave water to was dead."

"Yah," Annick said.

"Bodies," Alexandre said.

"That guy with the spear in his throat," Annick said. "I just left him. And at one time I was laughing and laughing. I couldn't stop laughing. I was with the wounded, blood everywhere, and a shoulder hanging off from a grenade, or a mouth split open with a machete, and I was just laughing. Me!" she said. "I used to faint for injections, and here I was sewing machete wounds. All I could think was, Do I wrap the bandage this way"—she whirled a hand in a horizontal orbit—"or this way?"—vertically.

"Sunday when we drove away, there were people all over the road, bodies,

and wounded," Alexandre said. "In a normal time, for people in much less bad shape, you would stop and do anything. We didn't stop. We just left them. I feel very bad about that. I don't know if it's guilt, but it's a very bad feeling."

"Yah," Annick said. "That was bad, eh? We just drove. It was too many people."

"Too many people," Alexandre said. Tears had welled from his eyes, and his nose was running, streaking his lip. He said, "I don't know how my mind works. I just don't know. When people are dead, you expect to see more people dead. I remember in 1973 in Athens, we had cars making a blockade, and the tanks came and crushed the cars. I was eleven or twelve, and I saw the people. They were dead, and I expected more and more to see dead people. It becomes normal. We have so many films to see death with bullets, but this is real death, the crushing. At Kibeho, in the second attack, they were just shooting like hell. Shooting like you can't imagine. The army was just shooting and shooting, they didn't even look where. I was standing out there, it was raining, and all I could think was, I want to get out of the rain. I didn't even think of the shooting, and it was shooting like hell. To get out of the rain—that was all I wanted."

"You shouldn't feel badly," Annick said. "We saved a lot of lives. Sometimes it was useless, there was nothing we could do."

"You know," Alexandre said, "the army—they were taking the wounded and throwing them in the pit latrines. They were alive. You know that?"

"Yah," Annick said. "That was bad."

"I don't want to be judged," Alexandre said. "This is the first time I talk of it. I don't know why now. I don't want you to judge me."

He got up to go to the toilet, and Annick said, "I'm worried about Alexandre."

"How about you?" I asked.

"They tell me go to a psychiatrist," she said. "The Human Rights mission. They say I have post-traumatic stress. What will they give me—Prozac? It's stupid. I don't want drugs. I'm not the one with the problem in Kibeho."

Treading among and on the dead at Nyarubuye, I thought about my evening with Annick and Alexandre. It seemed strange that Kibeho was what we had talked about, not the genocide. "And you don't know how to think about it," Alexandre had said when he returned to the table, "who is right and who is wrong, who is good and bad, because the people in that camp were many of them guilty of genocide."

But how do we think about a genocide? "I'll tell you how," an American military adviser in Kigali said to me one day. "It's the passenger pigeon. Have you ever seen a passenger pigeon? No, and you never will. That's it. Extinction. You will never see a passenger pigeon." Sergeant Francis, the army officer who showed me around Nyarubuye, understood. "The people who did this," he said, "thought that whatever happened, nobody would know. It didn't matter, because they would kill everybody, and there would be nothing to see."

I kept looking, then, out of defiance. At least 95 percent of the species of animals and plants that have graced the planet since life began are said to be extinct. So much for providence in the fall of a sparrow. Perhaps even extinction has lost its shock. I saw several hundred dead at Nyarubuye, and the world seemed full of dead. You couldn't walk for all the bodies in the grass. Then you hear the numbers: eight hundred thousand, one million. The mind balks.

For Alexandre, all of Kibeho had come down to one fat woman in a yellow chemise drowned by the thousands and thousands of others. "After the first death, there is no other," wrote Dylan Thomas, in his World War II poem, "A Refusal to Mourn the Death, by Fire, of a Child in London." Or, as Joseph Stalin, who presided over the murders of at least ten million people, calculated it: "A single death is a tragedy, a million deaths is a statistic." The more the dead pile up, the more the killers become the focus, the dead only of interest as evidence. Yet turn the tables and it is clear that there is greater cause for celebration when two lives are saved instead of one. Both Annick and Alexandre said they had stopped counting the dead after a while, although counting was in their job description and tending to the wounded was not.

Still, we imagine that it's a greater crime to kill ten than one, or ten thousand than one thousand. Is it? "Thou shalt not murder," says the commandment. No number is specified. The number of dead may increase, and with it our horror, but the crime does not grow proportionally. When a man kills four people, he isn't charged with one count of killing four but with four counts of killing one and one and one and one. He doesn't get one bigger sentence but four compounded sentences, and if there is a death penalty, you can take *his* life just once.

Nobody knows how many people were killed at Nyarubuye. Some say a thousand, and some say many more: fifteen hundred, two thousand, three thousand. Big differences. But body counts are not the point in a genocide, a crime for which, at the time of my first visit to Rwanda in May 1995, nobody on earth had ever been brought to trial, much less convicted. What distinguishes genocide from murder, and even from acts of political murder that claim as many victims, is the intent. The crime is wanting to make a people extinct. The idea is the crime. No wonder it's so difficult to picture. To do so you must accept the principle of the exterminator, and see not people but *a people*.

At Nyarubuye, tiny skulls of children were scattered here and there, and from a nearby schoolyard the voices of their former classmates at recess carried into the church. Inside the nave, empty and grand, where a dark powder of dried blood marked one's footprints, a single representative corpse was left on the floor before the altar. He appeared to be crawling toward the confession booth. His feet had been chopped off, and his hands had been chopped off. The bones emerged from his cuffs like twigs, and he still had a square tuft of hair peeling from his skull, and a perfectly formed, weather-shrunken and weather-greened ear.

"Look at his feet and his hands," said Sergeant Francis. "How he must have suffered."

But what of his suffering? People at Kibeho suffered, and Kibeho was not a genocidal crime, just a police action gone criminally bad. At Nyarubuye, even the little terra-cotta votive statues in the sacristy had been methodically decapitated. "They were associated with Tutsis," Sergeant Francis explained. So what does suffering have to do with anything, when the idea is the crime?

———

There were no other visitors at Nyarubuye on the day I flew in with the Canadians. Sergeant Francis said that was normal. "Some Rwandans do come here, some ministers and members of parliament. But many don't want to see."

Why would they? Rwanda's dead are omnipresent as absences, and most Rwandans have less need for access to the memory of genocide than to some relief from it. Such relief takes very different forms for Tutsis — all of whom are either survivors or returnees from exile, and whose loss is irreparable — and for Hutus, who continue to outnumber Tutsis by about five to one, and the mass of whom either participated directly in the extermination campaign or are bound by family or community ties to the perpetrators. Even among Hutus of good conscience, there is widespread resentment of the burden of blame that the memory of the dead carries.

Shortly after my visit to Nyarubuye, I attended an official mass reburial ceremony for genocide victims in the northwestern province of Gisenyi. On a hilltop amid the lush tea plantations, in a setting of astonishing tranquillity, the newly grown grass had been pulled back to disclose a mass grave. The broken bodies within it had been exhumed and laid out on a long rack in the drizzle, and the local peasantry had been gathered by the village authorities to see, and to smell the death smell. President Pasteur Bizimungu was there with a half-dozen cabinet ministers and many other officials. Soldiers distributed translucent plastic gloves among the villagers and put them to work placing pieces of the corpses in coffins and wrapping the rest in green plastic sheets. There were speeches and benedictions. A soldier explained to me that the president, a Hutu, had used his speech to ask the villagers to consider where they had been when these people were killed in their community, and to exhort them to make atonement. Then the remains were placed in new mass graves and covered up again with earth.

A few weeks after this reburial ceremony, I was at the Lumasi refugee camp for Rwandan Hutus in Tanzania, about twenty miles across the border from Nyarubuye. Among the camp leaders I spoke with was Donat Ruhigira, who had been a secondary-school French teacher in Rukira — very near to Nyarubuye — and who was now the leader of the Rukirans in exile. Ruhigira claimed, absurdly, that there had been no genocide in Rwanda and that to the extent that there had been massacres, the victims had been Hutus more often than Tutsis. He also said that the memorial at Nyarubuye had been augmented with the bodies of Hutus, who were now being represented to the world as slain Tutsis.

"Sometimes," Ruhigira told me, "important personalities visit Rwanda, and they go to Nyarubuye and they are shown around and told this is a massacre of Tutsis. But there were also the corpses of Hutus massacred by Tutsis that were brought in to increase the numbers. So everyone comes and sees the Tutsi and Hutu bodies together and the government says it's a genocide."

There is no evidence whatever to support such negationist claims. The number of bodies around the church has, in fact, diminished — not increased — over time, in part because of killers seeking to destroy the evidence of their crimes, and in part because, as Sergeant Francis said, "The families would wish them buried. They are not happy to see them here, and walked on."

Ruhigira, who had not been in Rwanda since a week after the slaughter at Nyarubuye, was either making up his stories or repeating lies that others had told him. The fact that such lies have a very wide following among Rwandans underscores the fact that "commemorative" projects like the Nyarubuye memorial are about the present at least as much as the past.

The conventional view of official memorials to extreme, and often contested, chapters of historical memory is that they serve as an antidote to oblivion. But in Rwanda, genocide commemoration must combat something far more insidious than mere forgetting: the deliberate distortions of false remembrance. The desperate efforts of perpetrators to obliterate the memory that condemns them have included a campaign to exterminate survivor-witnesses. In a typically bizarre case, in April 1997, a Hutu was arrested at a memorial similar to Nyarubuye, in the southern town of Gikongoro, for stealing the skull of a boy he was alleged to have killed.

The argument is often made that justice — whether through the sluggish United Nations tribunal for Rwanda or in the more aggressive but roughshod domestic prosecutions — would be the finest memorial possible for the genocide. But after a genocide, true justice is impossible, and the question for Rwanda's survivors is not so much how to remember but how to live with the unforgettable.

———

A few months after my visit to Nyarubuye, I was having a drink at a friend's house in Kigali when a Lebanese named Mohammed came in, impatient for news from Bosnia where, at that moment, the Muslims in the "safe haven" of Srebrenica were being massacred. So we watched reports of this latest outrage on CNN. Thomas Kamilindi, a Rwandan journalist, was sitting beside me on the couch, leafing through an issue of *Time* magazine he had taken from the coffee table. After a moment he let out a little grunt of disgust, and only then did I notice that the magazine was a special issue marking the fiftieth anniversary of the liberation of Auschwitz.

Thomas had survived the massacres in Kigali, but he had never before seen the famous photographs from Europe. A Swiss journalist who was with us observed Thomas's shock and began telling him about a recent collection of particularly raw photographs from the Rwandan genocide — images so boldly

horrifying, this man said, that nobody hereafter could ever doubt the crime, much less forget it. Thomas sat with *Time*'s pictures of the tangled heaps of naked dead and the walking cadavers of survivors spread across his knees. He listened politely to the journalist's assurances, but he did not seem convinced.

Part II

Objects and Memory

Lenin in the Age of
Mechanical Reproduction

Leah Dickerman

In 1925, *Lef*—the journal around which much of the Soviet avant-garde coalesced—published an editorial under the title "Ne torguite Leninym!" [Don't Traffic in Lenin!]. It must have hit a politically sensitive nerve, for the editorial was removed by the censor after the issue was printed, leaving only the trace of its title in the table of contents. As the Maiakovskii scholar Lars Kleberg later recovered the editorial from the uncensored duty copies turned over to the Lenin Library, we now know that the text began by reprinting an advertisement in facsimile:

BUSTS OF

V. I. LENIN

plaster, patinated copper, bronze,

marble, granite

LIFE- AND DOUBLE LIFE-SIZED

from the original approved for reproduction

and distribution by the Commission for the Immortalization

OF THE MEMORY OF V. I. LENIN

MADE BY THE SCULPTOR

S. D. MERKU[R]OV

═══ OFFERED BY ═══

THE STATE PUBLISHING HOUSE

for state institutions, party and professional

★ ★ ★ organizations, cooperatives, etc. ★ ★ ★

EVERY COPY IS AUTHORIZED.

[...]

REPRODUCTION AND COPYING WILL BE PROSECUTED

ACCORDING TO THE LAW.[1]

Lef's editors followed the advertisement, which so insistently trumpeted the authenticity of these mass-produced works of art, with the terse statement, "We are against this."[2]

Their objections went deeper than issues of taste or decorum. The profusion of images of Lenin that accompanied the emergence of an officially fostered cult brought into sharp relief the complex status of the commemorative

portrait in the age of mechanical reproduction, within what was to be the new collective society, and in the wake of that society's first historical trauma—the death of its founding leader. Two historical phenomena worked simultaneously to destabilize the genre of the commemorative portrait: the precipitous growth of a mechanically reproduced mass visual culture, which, as Walter Benjamin has so famously argued, challenged traditional concepts of authenticity within the artwork;[3] and the loss of Lenin, which provoked what might be called a "memory crisis"—a moment of reevaluation and reconceptualization of mnemonic models, of the way the past is represented in the present.[4]

Here I will examine two positions staked out in the years immediately following Lenin's death. Both were motivated by the desire to shore up memory against loss, but they define the possibilities of modern memorialization in very different terms. One model—exemplified here by the work of Sergei Merkurov and Isaak Brodskii—was supported by the Commission for the Immortalization of the Memory of V. I. Lenin (Komissiia po uvekovecheniiu pamiati V. I. Lenina) and would eventually serve as the conceptual basis for the official aesthetics of socialist realism. The other model was proposed by artists and writers associated with the Left Front of the Arts (Lef; Levyi front iskusstv)—an avant-garde position that I will illustrate primarily through the work of Aleksandr Rodchenko.

The Immortal Lenin

The cult of Lenin emerged in his absence as a political force. In the power vacuum created first by Lenin's disability after a stroke on 10 March 1923 and then by his death on 21 January 1924, the Bolshevik leadership worked to fix a conception of an eternal Lenin that could serve as the cornerstone for an entire ideological edifice. In her important study on the veneration of the revolutionary leader, Nina Tumarkin recounts that Lenin's Communist Party confederates, eager to maintain their hegemony after his stroke, hid his disability from public view by publishing reports of glowing health and withholding recent photographs.[5] At the same time, in speeches and the press, political aspirants began to speak their opinions through Lenin's texts, each competing to present himself as Lenin's most faithful apostle.

The importance of Lenin as a source of political authority only increased with his death. Tumarkin chronicles the contemporary phenomenon of pledging in the name of Lenin: from Joseph Stalin on down, Party members invoked the deceased leader as sanction and motivating force for political behavior. Proclamations of Lenin's eternal life, as a token of faith and loyalty to the Party, also became a central aspect of the public rhetoric of mourning. The slogan "He has not died and will never die"—which seems to echo the French Renaissance formula "Le roi est mort, vive le roi!" [The king is dead, long live the king!]—appeared in the newspaper *Petrogradskaia pravda* on 25 January.[6] Radio stations and telegraph operators transmitted a slightly less literal slogan at 4:06 P.M. on the day of the funeral: "Lenin has died—but Leninism lives!"[7]

The problem of constructing an eternal Lenin was understood as an issue of visual representation as well as rhetorical persistence. The rather bizarre decision to embalm and display the body of Lenin provides the most overt and striking example. The Funeral Commission (Komissiia po organizatsii pokhoron V. I. Lenina) — soon to be renamed the Commission for the Immortalization of the Memory of V. I. Lenin — defined its task as the preservation of the leader's corpse "*in such a state that it can be viewed,* and [such] that the external appearance of the body and the face should preserve the physical features of Vladimir Il'ich in just the same way that he looked in the first days after his death,"[8] thus emphasizing the importance of both the body's public visibility and its appearance of incorruptibility. Along with managing the production of the official corpse, the construction of the mausoleum, the regulation of works bearing the image of Lenin, and the collection of physical descriptions of Lenin to serve as the basis for portrait images fell under the commission's purview.[9] The Immortalization Commission thus functioned as the central official actor in the attempt to deal with the crisis in representation provoked by Lenin's death. It constituted, one might say, a mnemonic bureaucracy.

The commission's report on embalming Lenin's body presented a peculiar narrative. First, before any preservation attempts, the corpse was photographed using ordinary as well as stereoscopic cameras; the mechanically reproduced image was enlisted, it seems, in an attempt to stabilize this most unstable referent. Then Leonid Krasin, the commission member charged with the body's care, tried refrigeration.[10] This effort to defy contingency failed and, in a flight of virtuoso bureaucratese, the report notes the onset of decay without naming it as such: "Time has done its work, and pigmentation and changes in the color of the skin appeared on the body of V. I. Lenin, which indicates the beginning of a process that could influence the further preservation of it."[11] Experts were called in to re-embalm the body — to perform the (almost) impossible task of stabilizing it against the effects of time and reversing the damage already wrought. In June 1924, the commission announced imminent success with a chemical mixture containing formalin, glycerin, alcohol, and a mysterious group of "other substances."[12]

In August 1924, Lenin's body was exhibited to the foreign press. The American journalist Walter Duranty seemed to confirm the commission's success, reporting in the *New York Times* that "the face appears normal in every way, there being no indication of pigmentation of the flesh, emaciation of the body or shrinkage of features. The embalmers have even contrived to impart a smile to the face."[13] (Notice how Duranty's description of the body, with its masking of the marks of contingency and the addition of a smile, evokes nothing so much as the retouched photograph.) Through a strange elision — the effacement of decay — the Immortalization Commission succeeded in producing a supertemporal original, its authenticity bolstered by a narrative of scientific triumph.

What are we to make of this strange offering of a permanent corpse for view?

The ingenuity of the conceit (if ingenuity is the correct word, though it conjures nicely the resourcefulness of the manufacture of a permanent corpse, its existence on edge of technological possibility) lies in the complete identity of the body-as-politic and the body proper. The problematic itself is old: if power is identified with the life of a body, the death of the body is the death of power, unless the real is transformed into the symbolic. Of course, as with earlier images and rituals of kingship, it is not the Lenin who ate, slept, made love, got ill—the organic body subject to the effects of time—that had to be preserved beyond death, but the Lenin who wielded authority—the political body. What is shocking here is the literalness of the equation, the utter collapse of one into the other. Through a kind of technological magic, organic life is hypostatized and converted into sign. In this, the body of Lenin exceeds other artistic constructions of the figure of the leader as the body-of-power.[14] Metaphor is put under extreme pressure.

Portraiture traditionally makes claims to providing a likeness, a copy faithful in some way to its subject. The preserved body of Lenin aims higher, offering the original itself. In this extravagant effort to stabilize an undeniably singular presence against time, the preservation of the corpse can be seen as the ultimate attempt at constructing an auratic portrait after what Benjamin has defined as the aura's historical demise. Its tautological excess speaks of doubt, of authenticity under duress from what one might suppose is a complex of historical factors—the threat to the traditional artwork posed by mechanical reproduction as well as the oligarchic succession of the originary leader. It suggests a pursuit of presence activated by pain of absence. Yet of course the technological production of aura is bound to fail. Here the longing for a secure sense of presence provoked a misidentification that became paradigmatic for all cult images of Lenin: the mistaking of the cadaver (or its stand-in) for the unique aura of an individual.

Lenin's death produced not only a permanent corpse but also, radiating from it, a vast quantity of ephemera with his image, including posters, brochures, badges, illustrated biographies, funeral albums, paintings, and sculptural busts. Sergei Merkurov, whose work was featured in the advertisement reprinted in Lef's editorial, boasted that in 1925 one foundry attached to the State Publishing House (Gosizdat; Gosudarstvennoe izdatel'stvo) had produced thirty thousand busts of Lenin and fifty thousand medallions with Lenin's portrait.[15] In the journal he kept while in Moscow in December 1926 and January 1927, Walter Benjamin ironically noted the rampant-commodity status of such images after finding, in a once-fashionable shopping district, a store that specialized in Lenin, stocking him "in every size, pose and material."[16] Given that much of this paraphernalia was generated by a subunit of the Immortalization Commission,[17] the mass replication and distribution of the image of Lenin was clearly an official strategy.

And why? As Benjamin suggested, mechanical reproduction lessens one sense of monumentality: it reduced the size and scale of the image so that it was no longer experienced by the viewer as an overwhelming power.[18] Yet

through pervasive dissemination of mass-produced images to individuals and throughout the spaces of daily public life, an kind of alternate monumentality was created for Lenin, one peculiarly modern in its horizontal array. The layering of reminder upon reminder of the historic body of the deceased leader approached such density as to make forgetting impossible. The degree of saturation suggests, on the one hand, the obsessive repetition born of traumatic experience—a buffering of the collective psyche against the pain of loss. On the other hand, such quantitative excess seems to signal the omnipresence of power, its infiniteness and its spectacularization.

Much of the official Lenin memorabilia was displayed in niches or decorated spaces in public and institutional sites. In an example of religious atavism, these so-called Lenin corners (*leninskie ugolki*) borrowed both their form and their name from the icon display or "red corner" (*krasnyi ugolok*) often found in peasants' homes. The portrait of Lenin thus competed for and conquered the territory of the religious icon. According to Benjamin, the Lenin corners in the classrooms of a children's home looked like "a kind of temple wall.... interspersed with Soviet stars and heads of Lenin," and the portrait of the dead leader at the entrance of the Kremlin collections hung "as if converted heathens had planted a cross where sacrifices previously used to be made to the gods."[19] In both its mass-produced ubiquity and its appropriation of religious structures, the cult object promised universal access to the authoritative and authorizing presence of Lenin. As a type of religious image, the icon is defined in Eastern Orthodox Christianity by its status as *proxy*—in praying to an icon of the Virgin, one prays directly to the Virgin. It is a work that offers a privileged and direct relationship to the original, a copy that claims some kind of essential connection with the divine referent and participates in the referent's sacred nature. In Derridean terms, the icon is a metaphysical or logocentric concept, depending as it does on a notion of secure origin.[20] It was, then, the Immortalization Commission's desire to produce an iconic image of Lenin within a culture of mechanical reproduction and mass dissemination that prompted anxiety about whether existing portrait images established such an essential connection or "true" resemblance to the departed leader.

In his essay "O pamiatnikakh Vladimiru Il'ichu" [About Monuments to Lenin], Leonid Krasin complained that "in actuality there is not one bust or bas-relief of which one might say: yes, such was V. I. Lenin."[21] Here Krasin appears to be wrestling with the difficult Platonic distinction, commented on by Gilles Deleuze, between the claims of objects that are "true" or authentic copies of Ideal forms bound by an "internal and spiritual" connection, and those that are so infinitely degraded as to offer only semblance—a distinction between, as Deleuze puts it, *icons* and *simulacra*.[22] It is the visual manifestation of the Idea, so difficult to recognize, that grounds the claim of "true" copies. But, as Rosalind Krauss points out, the very existence of the "false" copy throws the whole system into question.[23] The simulacrum embodies and internalizes the concept of *dissimilitude;* untied from the original, such an image threatens the very possibility of either an intrinsic relation to the model

or a privileged reproduction. It is this threat to the icon that Krasin seems to be attempting to ward off in his desire to exclude all "false" copies.

What the Immortalization Commission understood as the "danger of the assimilation of the distorted external features of V. I. Lenin by the broad masses" spurred it to action in an (ultimately futile) attempt to prevent slippage, the opening of a gap between representations of the leader and what was understood to be the original.[24] On 24 April 1925, the Executive Troika of the Immortalization Commission passed a resolution on the regulation of representations of Lenin. This resolution constituted the most significant effort to control image making since the Russian Revolution. All reproduction, sale, and public exhibition of representations of Lenin "*except photographic,* but not excluding photomontage" without the explicit permission of the Immortalization Commission or one of its subcommittees was prohibited, and offenders were to be prosecuted. Photographs were the significant exception, their indexical claim to authenticity unchallenged. The commission also resolved that approved originals were to be placed in the collection of the Lenin Institute.[25] The state was to act as a guarantor of the authenticity of all publicly distributed images of Lenin.

Many of the approved depictions of Lenin were produced in the years immediately following his death, a concentration that Ivan Matsa attributed to both the initiatives of the Immortalization Commission and "the artists' own desire."[26] At least one list of a group of approved depictions of Lenin remains. Of the works included on this list, Isaak Brodskii created the most by any one painter — three — while the very Merkurov held up to contempt in *Lef* created the most by any one sculptor — five.[27] Like many of the other artists represented on the list, Merkurov and Brodskii belonged to the Association of Artists of Revolutionary Russia (AKhRR; Assotsiatsiia khudozhnikov revoliutsionnoi Rossii) — a group that advocated the model of didactic realism that would serve as the foundation for the official aesthetics of socialist realism.[28]

Among the four works by Merkurov collected and preserved by the Lenin Institute was a death mask — an indexical impression of the dead leader's face. In an absurd competition for closest proximity to the authentic (living) original, Merkurov claimed that his death mask was the first of several to be made and thus took precedence over all others.[29] This death mask served Merkurov well as the basis for many other images. Indeed, an unending chain of reproductions, epitomized in the busts hawked in the advertisement reproduced by the editors of *Lef,* became something of a hallmark of Merkurov's work. The 1938 edition of the *Bol'shaia sovetskaia entsiklopediia* [Great Soviet Encyclopedia] noted, "After the death of V. I. Lenin, M[erkurov] took a sculptural mask of his face, incessantly worked on the image of Lenin, executing a whole series of his portraits and participating in competitions for projects for monuments to Lenin for various cities of the USSR."[30] Here, again, the body of Lenin — fixed, stabilized, and made eternal — becomes the ultimate referent. This effort to tie the reproduced image to an unassailable original, to establish an authority of presence, pervaded the socialist realist enterprise. Fittingly,

however, a whiff of the corpse itself, a certain sunkenness and compression in the features, adhered to Merkurov's works, even as he strove to portray the living Lenin (fig. 1). In pursuit of the aura of the individual, Merkurov succeeded in capturing only the cadaver, the trace of the original's passing.

Isaak Brodskii also produced a multitude of Lenin portrait images in the wake of the leader's death.[31] In Brodskii's *Lenin in Front of the Kremlin* (fig. 2) the Bolshevik leader is shown full-length and almost in profile on the near bank of the Moscow River. Across the river is the Kremlin, the traditional site of Russian state power, rendered picturesquely in light-colored pastels, while an antlike procession of people with red banners marches along the far bank. With a somber, meditative expression, Lenin watches over his nation and its people. At the center of Brodskii's *Lenin in Front of the Smol'nyi* (fig. 3), Lenin stands among fallen leaves, face forward, one hand in the pocket of his greatcoat, the other in his trouser pocket, a worker's cap perched on his head, while behind him can be seen the yellow buildings of the Smol'nyi Institut, the convent girls' school in Petrograd from which Lenin launched the Bolshevik coup on 25 October 1917. The autumn setting affirms the historical connection, inserting Lenin into the narrative of the Russian Revolution and vouching for his centrality.

For all its virtuoso brushwork, Brodskii's heroic portraiture depended in a very direct way on photographic sources.[32] *Lenin in Front of the Kremlin* copies the figure of Lenin from a widely distributed documentary image of the leader standing in the courtyard of the Kremlin a few weeks after being wounded by the would-be assassin Fania Kaplan (fig. 4).[33] Brodskii transferred the Bolshevik leader out of the banal pebbly expanse and encompassing buildings of the courtyard, maintaining only a trace of the original setting in the rocky terrain at Lenin's feet. He also removed the shadows that indicated the presence of others and reduced Lenin's own shadow, mitigating its competing presence. For *Lenin in Front of the Smol'nyi,* Brodskii lifted the image of Lenin from a photograph taken in 1919 in which Lenin stands with his wife, Nadezhda Krupskaia, in a crowd of figures, each with his or her own strength of presence, watching the First of May parade at Red Square in Moscow (fig. 5).[34]

Yet despite the blatancy of his appropriation from photographic sources, Brodskii sought to disavow the mechanical origins of his work, constructing instead a narrative of original authority deriving from proximity to the bodily presence of Lenin. In autobiographical statements, the artist insisted on his personal contact with Lenin and on his opportunities to sketch the model himself. His memoirs even offer documentary proof of his physical proximity to the revolutionary leader: a photograph, dated 1921, of Lenin working at the third congress of the Comintern while the artist sketches him (fig. 6).[35] This photograph evokes the model of Saint Luke painting the Virgin, in that we see the artist creating a holy image in the presence of the divine figure, which both guarantees the authenticity of the artist's account and privileges him as an interpreter or a biographer. A crisp line around the figure of Brodskii suggests that the photograph was doctored, however. And the artist's

deceit is exposed most tellingly in his portrait of Lenin working in his study at the Smol'nyi Institut, a widely reproduced image of enduring iconic status that Brodskii painted in 1930 (fig. 7). The figure of Lenin is taken directly from the suspect photograph, showing Lenin from the camera's point of view, not that of the sketching artist.

Brodskii's repudiation of the photographic source reveals a need to maintain the fiction of a singular image, of individual essence distilled by the artist and expressed in the stroke of the hand. Nonetheless, Brodskii's works are haunted by their photographic origins. The trace may be detected in the smooth surface of the painting that analogizes itself to the photographic; in the lack of integration of the central figure into the background, which announces the figure's treatment as a portable object; and in the reproducibility made apparent when several of Brodskii's portraits of Lenin are compared. The conflict embedded within this strategy of mutual dependence on and masking of the photograph points to anxiety about the photograph itself — an extreme ambivalence in the face of the precipitous growth of mass photographic culture. On the one hand, Brodskii's use of — and even more his insistent fidelity to — a photographic source speaks of desire for the photographic, a coveting of its evidential force. He seems to use these familiar camera images to lend a factual aspect to his painted work, to establish a claim to presenting Lenin as he really was. The photographic origin, marked as it is, functions as proof of presence. Like Merkurov's death mask, another indexical impression, the photographic trace binds the image to the original and thus to the source authority: the body of Lenin.

On the other hand, the masking of the photographic image effected by its insertion into a painted context reveals the extent to which the unmanipulated photograph threatened disturbance. It points to a fear not only of the photograph's unfiltered detail but also of the loss of significance and monumentality attendant upon its isolation from narrative. The painted frame in Brodskii's pictures works to tie the photographic figure to meaning. In the paintings of Lenin before the Kremlin and in front of the Smol'nyi, for example, the figure of Lenin is central and radically foregrounded, his head rising heroically above the horizon line, and his dominance is underscored not only by his distance from the other elements in the picture but also by the contrast between the minutely painted detail of his figure and the impressionistic strokes that render the background. The visual hierarchy established by the painted frame thus establishes an interpretative superstructure for the once-photographic object — linking the body of Lenin to the will of the collective masses, to rule in their name, to a narrative of revolution. It guides our approach to this object, quite literally encompassing it, pinning it from all sides, and proposing its interpretation. In other words, the transfer of the camera image into the painting functions to control the photograph's anarchic excess of visual information. It is a move that limits the number of possible meanings by repressing some and enhancing others.

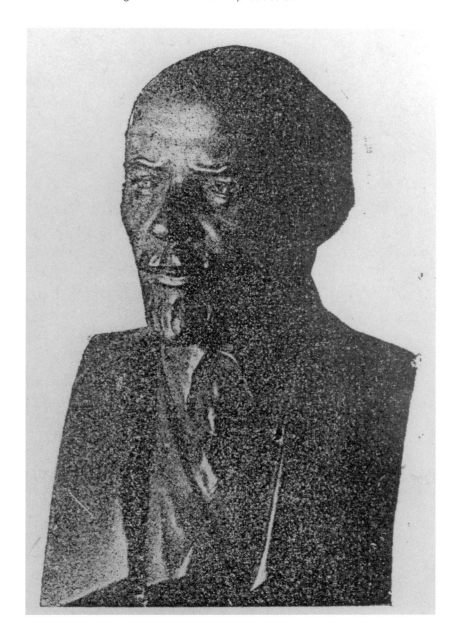

Fig. 1. Sergei Merkurov
Lenin, ca. 1924, plaster
Whereabouts unknown

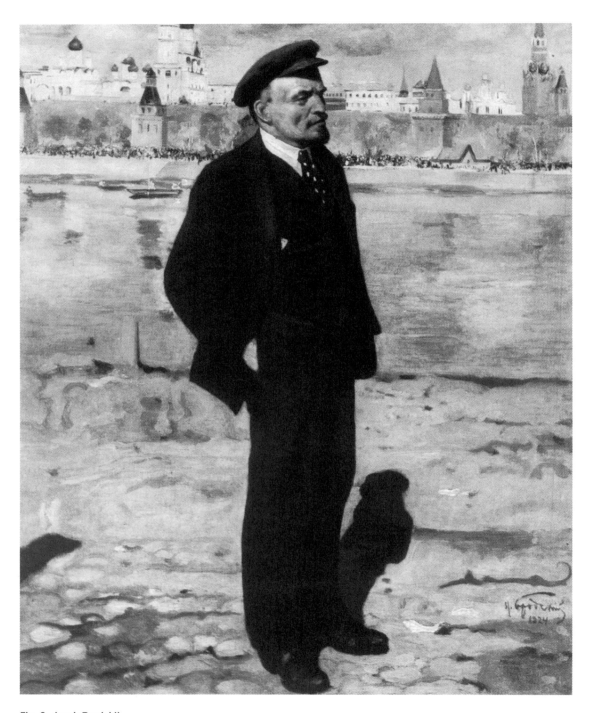

Fig. 2. Isaak Brodskii
Lenin in Front of the Kremlin, 1924, oil on canvas,
74 × 52 cm (29⅛ × 20½ in.)
Moscow, Tsentral'nyi muzei V. I. Lenina

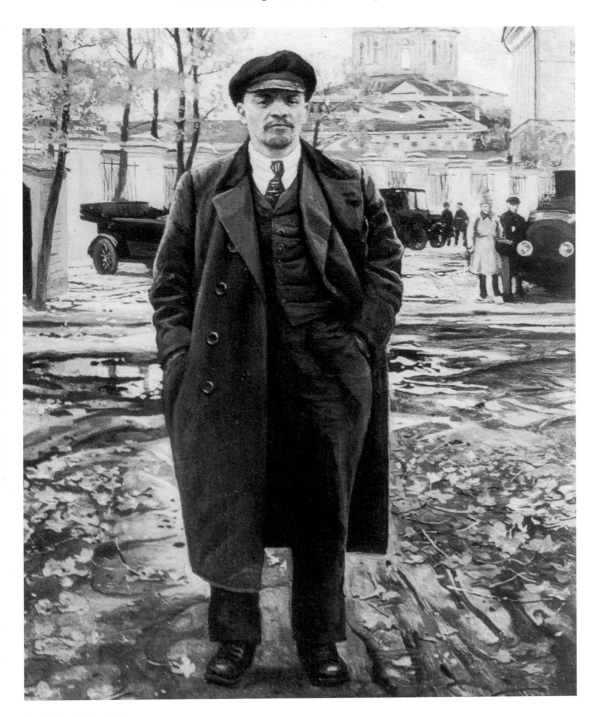

Fig. 3. Isaak Brodskii
Lenin in Front of the Smol'nyi, before 1926, oil on canvas,
40 × 30.8 cm (15¾ × 12⅛ in.)
Saint Petersburg, Kvartira-muzei I. I. Brodskogo

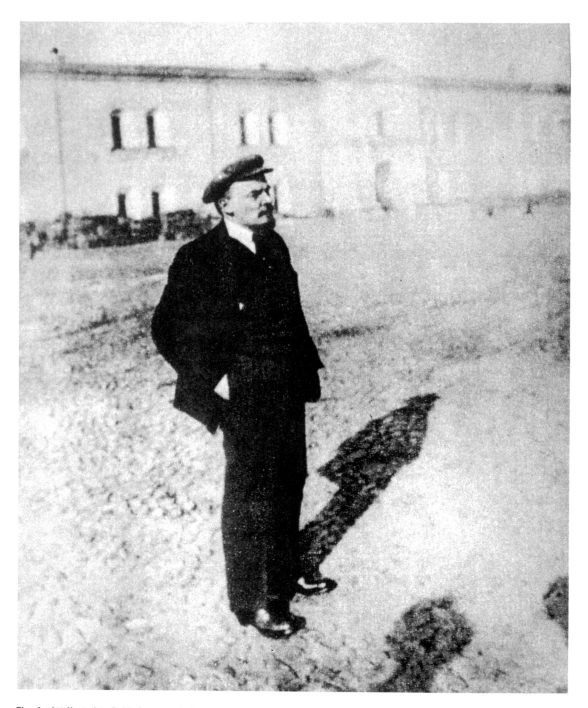

Fig. 4. Attributed to P. N. Otsup or A. F. Vinkler
Lenin in the Kremlin courtyard, 1918

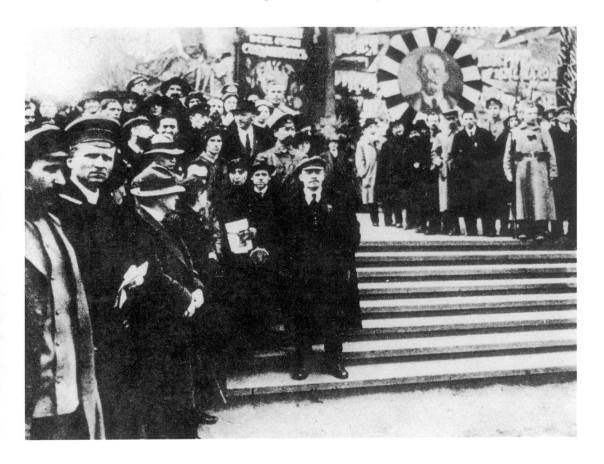

Fig. 5. L. Ia. Leonidov
Lenin at the First of May parade at Red Square, 1919

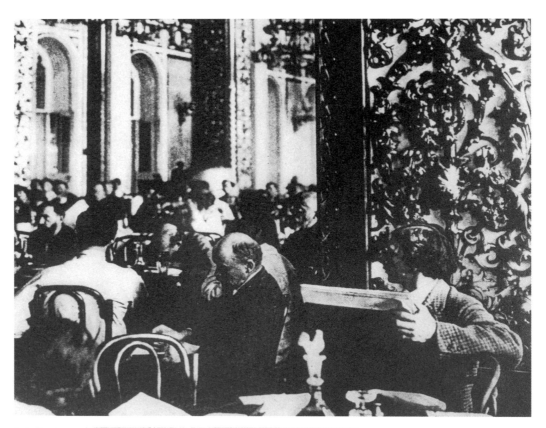

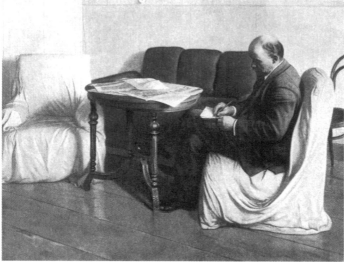

**Fig. 6. Lenin at the Third Congress of the Comintern,
with Isaak Brodskii at the right, 1921**

Fig. 7. Isaak Brodskii
Lenin at the Smol'nyi, 1930, oil on canvas, 198 × 324 cm
(78 × 127½ in.)
Moscow, Tsentral'nyi muzei V. I. Lenina

The Living Lenin

Merkurov's sculptural multiples were a particular target for Lef's scorn, as we have seen in the ironic reprinting in *Lef* of the advertisement for his portrait busts. That text made a claim for a privileged or authentic reproduction, for an "authorized" copy. *Lef*'s editors rejected such a concept of authenticity in words that allowed for no misapprehension: "We are against this."

On the next page of the issue, the editors wrote more expansively:

> We agree with the railroad workers from the Kazan Railroad who asked an artist to equip the Lenin hall in their club without busts and portraits of Lenin, saying: "We don't want icons."
>
> We insist:
>
> Don't mechanically stamp out Lenin.
>
> Don't print his portraits on posters, on tablecloths, on plates, on collector's boxes, on cigarette cases.
>
> Don't bronze Lenin.
>
> Don't take from him his lively gait and human aspect, which he was able to retain while directing history.
>
> Lenin is still our contemporary.
>
> He is among the living.
>
> We need him alive, and not dead.
>
> Therefore —
>
> Learn from Lenin, but don't canonize him.
>
> Don't create a cult in the name of a person who fought against every kind of cult during his whole life.
>
> Don't traffic in the articles of that cult.
>
> Don't traffic in Lenin.[36]

The *Lef* editorial slips between (and thus ties inextricably together) a critique of the resurrection of ritual structures for the memorialization of Lenin and an attack on the construction of a market for things that use the portrait of Lenin to bolster their exchange value. It denounces two manifestations of fetish structures: the commodity, in which use value and the human needs and relations implied are no longer apparent; and religious veneration, in which people bestow upon some physical entity an imaginary power. In describing a mode of petrifaction in which the object replaces the living person, the editors of *Lef* invert the official rhetoric about Lenin's immortalization: they liken the processes of deification and commodification to death rather than eternal life.

A similar set of concerns appears in the poem "Vladimir Il'ich Lenin," which Vladimir Maiakovskii was writing at the time of the *Lef* editorial.[37]

> I fear
>
>> these eulogies
>>
>>> line upon line

like a boy
 fears falsehood and delusion.
They'll rig up an aura
 'round any head:
the very idea—
 I abhor it,
that such a halo
 poetry-bred
should hide
 Lenin's real,
 huge
 human forehead.
I'm anxious lest rituals,
 mausoleums,
 and processions,
the honeyed incense
 of homage and publicity
should
 obscure
 Lenin's essential
simplicity.
I shudder
 as I would
 for the apple of my eye
lest Lenin
 be falsified
 by tinsel beauty.[38]

Maiakovskii's narrator subsumes contemporary manifestations of the cult veneration of Lenin—rituals, mausoleums, and processions—under the concept of aura and links aura to traditional art forms: it is a "halo / poetry bred." This resurrection of historically anachronistic forms threatens Lenin's revolutionary significance: it falsifies and deludes, obscuring truth as the fetish does. The invocation of "tinsel beauty" suggests Lenin's transformation into a commodity—his reproduction as a counterfeit, a devalued copy claiming false authenticity. Here, aura functions as death shroud.

The poem does not itself entirely avoid a venerational tone, however. At times, Maiakovskii uses Lenin symbolically, as an abstract, ahistorical collective force whose beginnings go "Far, far back / two hundred years or so."[39] At other points, the narrator recites the leader's legendary biography and even makes use of religious metaphor. The line that "Even now, Lenin is more alive than the living!"[40] echoes the "He lives" formula characteristic of the memorial albums, tribute wreaths, and eulogizing slogans condemned by *Lef*. Nonetheless, for all the ambiguity of the poem, Maiakovskii's linking of aura, poetry, and cult veneration constituted an important conceptual grouping—

one that resonates with Benjamin's 1936 essay on art in the age of mechanical reproduction. Benjamin's analysis of the decay of aura in modern culture offers a critical distinction in modes of reproduction between the devalued copy of an original and equivalent multiples that render the concept of an original meaningless. These are the very terms around which *Lef*'s critique of the Lenin cult portrait seems to turn.

For Benjamin, aura is associated with bodily presence in front of a unique original, and it manifests in the phenomenon of distance, of unapproachability; it is a positional circumstance, based on the work's integration within a specific site of meaning. By substituting a plurality of copies for a singular original, mechanical reproduction performs an act of displacement, prying the work of art "from its shell" of ritual structure and tradition.[41] For Benjamin, the social origins of the decay of the aura are related to the antihierarchical impulses of the contemporary masses, to their desire to overcome the distance imposed by a traditional artwork and "to bring things 'closer' spatially and humanly."[42] But this desire on the part of the masses, as Benjamin implied, is politically double-edged and can cut two ways: either in the direction of the commodified copy of the unique work of art or in the direction of new reproductive technologies that transform the traditional art object. The former involves a chain of progressive devaluation from an original whose form was developed within and derived from ritual. When such a copy is put to instrumental uses, Benjamin argued, the result is the reactionary harnessing (via technology) of traditional social and ideological structures to politics.

Yet Benjamin suggested another political possibility for mechanical reproduction, one that depends upon the copy that has no original. He seemed particularly attracted to film for what he saw as its ability to compel the viewer to assume an active, critical role—to submit cult values to a kind of "testing" that they cannot withstand.[43] Film undoes the link between art object and ritual, making no effort to resurrect authority based on unique presence. Rather, it proposes a radical equivalence between images. For Benjamin, the new law that governs the assembly of such images is part of a theory of art "completely useless for the purposes of Fascism."[44]

Certainly the portrait images of Lenin that Benjamin saw in such profusion during his two months in Moscow can be aligned within this formulation on the side of the commodified cult object. As we have seen, artists favored by the Immortalization Commission sought to claim authority through lineage from a unique original; though mechanically reproduced, their works point backward, searching with great anxiety for a singular presence that could no longer exist. The displayed corpse of Lenin itself can be read as a heroic attempt to resurrect presence within the corpse—to resist quite literally the decay of the integral subject. Critiquing such an ossified cult representation, Lef attempted to define an alternative practice, which they signaled by calls for "the living Lenin." In the visual realm, Aleksandr Rodchenko and other artists associated with Lef attempted to define a new type of commemorative portraiture, one that would offer a radical multiplicity instead of a true copy.

Not surprisingly, given the paradoxical imperative to both venerate the memory of a singular figure and challenge the construction of essential identity, the result seems ultimately ambivalent. Cult value was not so much eradicated as transformed.

In his first theoretical article about photography, "Protiv summirovannogo portreta za momentalnyi" [Against the Synthetic Portrait, for the Snapshot], Rodchenko posed the question,

> Tell me frankly, what ought to remain of Lenin:
> an art bronze,
> oil portraits,
> etchings,
> watercolors,
> his secretary's diary, his friends' memoirs —
>
> or
>
> a file of photographs taken of him at work and rest,
> archives of his books, writing pads, notebooks, shorthand reports,
> films, phonograph records?[45]

The artist himself answers, "I think there is no choice."[46] With this largely rhetorical question, the artist articulates a divide between alternate modes of memorialization — without, it should be noted, questioning the significance of remembering Lenin. He rejects the established hierarchy of artistic media, which would privilege the traditional art object as the most appropriate form for the memorialization of a revolutionary leader, choosing instead another class of memory objects. In the first group, each item is shaped by an interpretative persona (an intercessor like Saint Luke, an artist, a friend, or a colleague). The second group minimizes the interpretative interference of another subjectivity and privileges instead a kind of tactile bond, the trace of direct contact: Lenin's pen on paper, the sound waves of his voice, the reflected light from his body on film. Between the two groups, there is a passage from the mediated to the relatively unmediated, from secondary source to primary document, and from the icon to the index. With this traversal, mechanical inscription is privileged over human memory. The valuing of the trace of physical contact — even when technologically mediated, as in the second group — is a variant of the traditional indexical impulse, of course. And, as Annette Michelson has pointed out, like the icon, the photograph has an acheiropoietic function — it is created by contact with and causal emanation from the (sacred) personage whose image it bears.[47] Rodchenko's two groups echo, then, the traditional hierarchy of relics of the second and the first degree. Yet Rodchenko's construction of the memory object as indexical impress might be seen as another form of the collapsing of distance that Benjamin diagnosed as an expression of the desire "to bring things 'closer' spatially and humanly."

Implicit in Rodchenko's distinction between memory objects is a temporal

difference. In the first group that the artist lists are what could be called objects of retrospection, while the second group comprises objects that are relatively immediate, or synchronic, in nature. The issue of time gets to the very heart of the matter for Rodchenko. In his words "the first big collision between art and photography, a battle between eternity and the moment," took place over the image of Lenin.[48] Painting, Rodchenko argued, attempts a distillation of individual essence over time and from a distance, presenting what is deemed characteristic. Photography, in contrast, captures "a precise moment documentarily."[49]

Rodchenko contended as well that the very possibility of stable and essential knowledge assumed by painting and its allied genres was no longer historically available. Whereas in the past encyclopedias provided whole generations with eternal truths, in the rapidly unfolding present "people do not live by encyclopedias, but by newspapers, magazines, card catalogues, prospectuses and directories."[50] This change in the structure of knowledge implied the death of the integral subject. Dismissing the pursuit of "the real V. I. Lenin," Rodchenko wrote that "It should be stated firmly that with the appearance of photographs, there can be no question of a single immutable portrait. A man is not just one sum total; he is many, and sometimes they are quite opposed."[51] Therefore, one should take a "whole lot of snapshots . . . at different times and in different conditions."[52] The portrait subject Rodchenko pursued was irrevocably fractured.

For Rodchenko, the mass of photographs (and other documents) representing Lenin in all of his contradictory manifestations does important political as well as aesthetic work, by challenging the false wholeness of any synthetic representation. "There is a file of photographs and this file of snapshots allows no one to idealize or falsify Lenin," he stated, pointing to the critical potential of the archive.[53] In their multiplicity and discontinuity, photographs work against the display of any one representation as an exemplar of the universal and undermine, like the simulacrum, the concept of a true copy or icon. Moreover, while the photograph brings viewer and memorialized subject closer by its registration of physical proximity, it maintains a certain historical distance. Rather than a mythic resurrection of Lenin's bodily presence before the viewer in a kind of iconic substitution (a "true" copy), the photograph presents the trace of a past presence — it speaks of Lenin's *absence*. In pointing to what was but no longer is, photography "maintains the memory of the dead *as being dead*," as Christian Metz observes.[54]

How is such a model expressed in Rodchenko's own work? In one drawing for the workers' club that Rodchenko designed for the Exposition Internationale des Arts Décoratifs et Industriels Modernes held in Paris in 1925 (fig. 8), the artist offered a transformed version of the Lenin corner. On the left half of a bicolored wall, a white rectangle, a blank, holds a space for Lenin's image; on the right, beneath the word "ЛЕНИН" (Lenin) are five arrows bearing dates that break the leader's life into a set of discontinuous moments (1871, the date on the enlarged arrow at the lower left, is the year after Lenin's birth, the date when he was first photographed). Each arrow

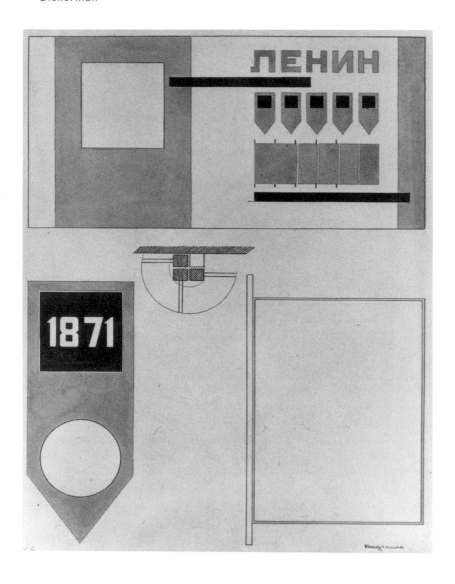

Fig. 8. Aleksandr Rodchenko
Design for the Lenin corner of the USSR Workers' Club, Soviet Pavilion, Exposition
Internationale des Arts Décoratifs et Industriels Modernes, Paris, 1925, black and red
india ink on paper, 36.5 × 25.5 cm (14⅜ × 10 in.)
Moscow, Rodchenko/Stepanova Archive

points downward to a panel hinged to swing outward in an arc (see fig. 8, lower right). Photomechanical copies of documents from the period indicated by the date on the arrow were to be placed on the corresponding panel below. The wall display thus constructs a new mode of biography — one in which disjunctive moments are collected under a name and reconciled only through the reader's interpretative activity. Lenin is presented *not* as an integral body but as a word with multiple signification. A placard visible in a photograph of Rodchenko and Varvara Stepanova's studio underlines the structural significance of this conception of biography: it shows arrows pointing outward from the word "ЛЕНИН" (Lenin) to multiple photographic representations (fig. 9). In representing Lenin, Rodchenko insisted on the exploded subjectivity of the modern individual.

This brings us back to Rodchenko's question. If what is to remain of Lenin is "a file of photographs taken of him at work and rest, / archives of his books, writing pads, notebooks, shorthand reports, films, phonograph records" — a collection of disparate, contradictory fragments of his past presence — then how can these images and texts, left in all their multiplicity, be deployed? And how can they be contained?

It seems from his plans, as well as from photographs of the workers' club as it was built in Paris, that Rodchenko conceived of the workers' club as a new kind of public space structuring a new mode of reception — an exploded archive of sorts. In an article in *Sovremennaia arkhitektura* [Contemporary Architecture], Stepanova described the Lenin corner in the workers' club (in its intended rather than executed form) to a Russian audience: "A model set of equipment was devised for a corner devoted to Lenin: a movable wall case for storing and displaying materials, documents, and photographs with room for headlines and theses; a movable display case for posters and slogans; a movable display case for exhibiting the latest photographic material."[55] Stepanova emphasized the archival abundance, even excess, that was to accompany the image of the deceased leader. At the same time, her description underscored the manipulability of the display, and the contingency of the structures and the relationships they establish. The workers' club as built in Paris did not achieve such archival density — not everything could be completed in time, according to Stepanova — but the conception of the club as montage-machine, as a complex set of documentary delivery devices, remained legible.

Novyi lef carried two photographs of the installation of the workers' club in Paris, with the caption, "The equipment of the workers' club. Executed according to the design of A. M. Rodchenko. Model given to the French Communist Party" (fig. 10).[56] On the bicolored wall at one end of the room, a photograph of Lenin was hung on the right half and a glass display box labeled "стенгаз" (*stengaz*, a shortened form of *stennaia gazeta* [wall newspaper]) on the left half (see fig. 10, bottom). In her article, Stepanova described this display case as "an installation for the wall newspaper, with movable bars for automatic layout."[57] A display stand supporting three

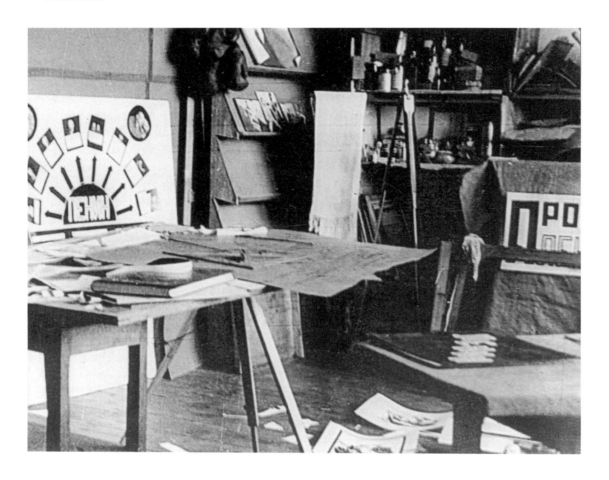

Fig. 9. Aleksandr Rodchenko
Rodchenko and Varvara Stepanova's studio at Miasnitskaia
Street, Moscow, 1924
Moscow, Rodchenko/Stepanova Archive

Fig. 10. Aleksandr Rodchenko
Two views of the USSR Workers' Club exhibited at the
Exposition Internationale des Arts Décoratifs et Industriels
Modernes, Paris, 1925
Moscow, Rodchenko/Stepanova Archive

rotating hexagonal cylinders covered with photographs was placed along the
wall to the left. A bookshelf on the same wall offered reading material, and at
the other end of the room was a collapsible structure that could be configured
as a rostrum, a bench, or a movie screen (see fig. 10, top). Clearly, the image of
Lenin was to be accompanied by a profusion of texts, written and oral, visual
and verbal. Rodchenko conceived of the workers' club as a space for media
saturation.[58]

The club's structures of display erode the venerative distance of the auratic
work of art. In the proposed design for the Lenin wall, in which each arrow
pointed downward to a panel displaying documents from the date indicated
(see fig. 8), the reader-viewer was to work *through* the panels, turning them
like pages in a book while standing between the documents as displayed —
a demand for physical handling that abolished the traditional distancing of
the viewer from the object. Similarly, in the workers' club as it was actually
installed, much of the equipment required manipulation. The worker was to
turn the hexagonal wheels of the display stand, adjust the layout of the wall
newspaper, and transform the rostrum into a bench or movie screen and back
again as needed. The workers' club beckoned interaction, eroding the aspect
of unapproachability. The relatively diminutive scale of the texts and images
displayed on Rodchenko's apparatuses complemented such egalitarian incli-
nations, working "to bring things 'closer' spatially and humanly." As Benja-
min suggested, the reduction in size that mechanical reproduction often entails
gave the mass viewer the confidence to stand before the work of art, to expe-
rience it not as an overwhelming power but as an equal.[59]

Rodchenko's workers' club offered itself as a kind of technology of arti-
ficial collective memory constructed in the name of a proletarian audience.
In its collection and display of documents and photographs, it represented
an effort to shift the terms of reception, from the structure associated with
the traditional work of art — a single viewer in a subordinate position at a
distance from the unique object — to a collective and class-based structure.
Its very density can be understood as celebrating mass access to political infor-
mation and to history itself. The workers' club thus speaks of a kind of
media optimism about the emancipatory potential of the archive in the new
political order — a confidence untouched by the profound media ambiva-
lence we found in the proto-socialist realist portraits of Lenin by Brodskii and
Merkurov.

But such optimism seems at the same time poised on the edge of a precipice.
Media density has its dangers, of course, and quickly leads to overload. The
utopian dream of informational access and collective reception could slide into
inundation, toward subjugation through spectacle, as Rodchenko's workers'
club and the dense installation of other contemporary works such as El
Lissitzky's Pressa display of 1928 might suggest.[60]

Perhaps (though perhaps not) this potential for alienation is mitigated in
the workers' club by the way that Rodchenko tied memory — and the memory
of Lenin in particular — to praxis. By definition, representations of Lenin —

whether Party-sanctioned bronzes or Lef's file of snapshots—had an active public and political function: they constituted both the focus of veneration and a reference to a suprastructural authority. Yet their actual use, *Lef* suggested, was generally profoundly passive—a quality taken one step further in the shrinelike Lenin corners. With the workers' club, Rodchenko imagined the way a variety of representations of Lenin might be put to use. It was to be a new type of public space, a reworking of the Parisian café for the collective (minus, of course, the alcohol), a combination archive and recreation area. Within the club, electricity (the geometrical hanging lamp construction), reading (the slanted table and bookshelves), and chess (the chess table with its swiveling game board) all appeared under the aegis of the word "ЛЕНИН" (Lenin) and the leader's photograph. Neither electricity nor reading nor chess was politically neutral in early Soviet culture: literacy and electrification had been among Lenin's first major policy initiatives,[61] while chess had emerged slightly later as a political concern, in 1924, when a Soviet victory over France in the game's first-ever state-sponsored tournament catalyzed a drive to convert chess from a bourgeois pastime to a mass activity.[62] Despite the late date, chess was associated rhetorically with Lenin—his own play was frequently invoked—and, like reading and electricity, it was promoted as a means of producing a worker capable of actively participating in the new society.[63] In its entirety, the workers' club can be seen as a kind of extended portrait of Lenin, relating his political legacy to activities of work and play that would transform the worker into a conscious subject. In contrast to the site of contemplative veneration offered by the Lenin corner with a painted or sculptured portrait set in a niche, Rodchenko imagined the Lenin memorial as the site of practice.

———————

Rodchenko's overarching project of assembling fragmentary portrait images for the edification of the worker was too fragile to survive into the Stalinist and post-Stalinist era. Once an image is granted mobility within a system, it is easily removable, made singular, and recuperated as a venerational icon. Lef's public protest against trafficking in Lenin quickly retreated into the realm of private expression, and then silence. But the resistance of its members to such trafficking did not go away, as we know from Rodchenko's appalled reaction to the posthumous treatment of Maiakovskii, his friend and Lef colleague. After Maiakovskii's death by suicide in 1930, Stalin encouraged a cult of this poet who so despised cults. The Merkurov who had been mocked by the organization to which Maiakovskii had belonged made a death mask of the poet, undoubtedly meant to serve as the "original" for the manufacture of busts and monuments of all sizes.[64] In contrast, and perhaps as a kind of pendant to his earlier series of portraits, Rodchenko immediately took five photographs of his dead friend looking unmistakably dead: the body is fully dressed underneath the sheets, and the back of the shirt is pulled up in a way that suggests it was slid into position by others (fig. 11).[65] Rodchenko's

Fig. 11. Aleksandr Rodchenko
Vladimir Maiakovskii, 1930

photographs of the closed, averted face of the poet's corpse left no room for cult value, just as his reminiscences about the mourning period record his resistance to covering Maiakovskii in ritual trappings:

It wasn't without battles, I struggled with flowers.... They wanted to pile him with flowers, they brought and brought.... Suddenly everyone wanted to bring flowers—all organizations, editorial offices, publishing houses. I wanted to preserve a certain severity, a dislike of *meshchanstvo* [a loaded Russian word that hovers between "philistinism" and "kitsch"]; I was constantly taking flowers away.[66]

Rodchenko was waging a losing battle, as we know. In the battle between eternity and the moment, eternity won.

Notes

1. My translation; unless a published translation is cited, all translations are mine. For a facsimile of the editorial and a discussion of its publication history, see Lars Kleberg, "Notes on the Poem 'Vladimir Il'ich Lenin,'" in Bengt Jangfeldt and Nils Åke Nilsson, eds., *Vladimir Majakovskij: Memoirs and Essays* (Stockholm: Almqvist & Wiksell International, 1975), 168–69. Originally published as "Ne torguite Leninym!" *Lef,* no. 7 (1924): 1–2:

Biusty V. I. Lenina
gipsovye, patinirovannye, bronzovye, mramornye, granitnye
v natural'nuiu i dvoinuiu velichinu
s originala, razreshennogo k vosproizvedenuiu
i rasprostranenuiu Komissiei po uvekovecheniiu
raboty skul'ptora
S. D. Merkulova [*sic*]
predlagaet
Gosudarstvennoe Izdatel'stvo
dlia gosuchrezhdenii, partiinykh i professional'nykh
organizatsii, kooperativov i proch.
Kazhdyi ekzempliar avtopizovan.
Osmotr i priem zakazov
[...]
Vosproizvedenie i kopirovanie budet presledovat'sia po zakonu.

Note that this issue did not appear until January 1925, although it was labeled as the third issue of 1924; see Halina Stephan, Lef *and the Left Front of the Arts* (Munich: Sagner, 1981), 36.

2. Kleberg, "Notes on the Poem" (note 1), 168: "My protiv etogo."

3. See especially Walter Benjamin, "The Work of Art in the Age of Mechanical Reproduction," in idem, *Illuminations: Essays and Reflections,* ed. Hannah Arendt, trans. Harry Zohn (New York: Schocken, 1969), 217–51. The first published version of this essay varies significantly from the version in *Illuminations;* see Walter Benjamin,

"L'oeuvre d'art à l'époque de sa reproduction mécanisée," trans. Pierre Klossowski, *Zeitschrift für Sozialforschung* 5 (1936): 40–66.

4. The term *memory crisis* is Richard Terdiman's; see his *Present Past: Modernity and the Memory Crisis* (Ithaca: Cornell Univ. Press, 1993).

5. Nina Tumarkin, *Lenin Lives! The Lenin Cult in Soviet Russia* (Cambridge: Harvard Univ. Press, 1983), 114.

6. *Petrogradskaia pravda,* 25 January 1924, 2; quoted (in English translation) in Tumarkin, *Lenin Lives!* (note 5), 165.

7. Andrei Nikolaevich Kotyrev, *Mavzolei V. I. Lenina, proektirovanie i stroitel'stvo* (Moscow: Sovetskii khudozhnik, 1971), 23; quoted (in English translation) in Tumarkin, *Lenin Lives!* (note 5), 162.

8. Boris Il'ich Zbarskii, *Mavzolei Lenina* (Moscow: Gosudarstvennoe izdatel'stvo politicheskoi literatury, 1944), 31; quoted (in English translation) in Tumarkin, *Lenin Lives!* (note 5), 184 (emphasis mine).

9. *Otchet komissii TsIK SSSR po uvekovecheniiu pamiati V. I. Ul'ianova (-Lenina),* Glavlit no. 32629 (Moscow: Glavlit, 1925), 35.

10. *Otchet komissii* (note 9), 36.

11. *Otchet komissii* (note 9), 43: "Vremia delalo svoe delo i na tele V. I. Lenina poiavilas' pigmentatsiia i izmenenie tsveta pokrovov, chto ukazyvalo na nachavshiisia protsess, mogushchii povliiat' na dal'neishee ego sokranenie."

12. *Otchet komissii* (note 9), 43–44.

13. *New York Times,* 4 August 1924, 2; quoted in Tumarkin, *Lenin Lives!* (note 5), 195.

14. Going further even than, for example, Hyacinthe Rigaud's portrait of Louis XIV; see Louis Marin, "The Body-of-Power and Incarnation at Port Royal and in Pascal; or, Of the Figurability of the Political Absolute," trans. Martha M. Houle, in Michel Feher with Ramona Naddaff and Nadia Tazi, eds., *Fragments for a History of the Human Body: Part Three* (New York: Zone, 1989), 421–47; and Louis Marin, *Portrait of the King,* trans. Martha M. Houle (Minneapolis: Univ. of Minnesota Press, 1988).

15. Sergei Merkurov, "Lenin v skul'pture," *Sovetskoe iskusstvo,* no. 3 (1925): 61–62.

16. Walter Benjamin, *Moscow Diary,* ed. Gary Smith, trans. Richard Sieburth (Cambridge: Harvard Univ. Press, 1986), 50. Originally published as *Moskauer Tagebuch,* ed. Gary Smith (Frankfurt am Main: Suhrkamp, 1980), 75: "Man findet auf Kusnetzki-Most ein Geschäft, in dem er [Lenin] Spezialartikel ist und in allen Größen, Haltungen und Materialen zu haben ist."

17. *Otchet komissii* (note 9), 23.

18. Horst Bredekamp states that one of the central arguments in Benjamin's essay is that a primary function of mechanical reproduction was to reduce the size and scale of the object depicted. See Horst Bredekamp, "Der simulierte Benjamin: Mittelalterliche Bemerkungen zu seiner Aktualität," in Andreas Berndt et al., *Frankfurter Schule und Kunstgeschichte* (Berlin: Dietrich Reimer, 1992), 117–37; cited in Benjamin H. D. Buchloh, "Warburg's Paragon? The End of Collage and Photomontage in Postwar Europe," in Ingrid Schaffner and Matthias Winzen, eds., *Deep Storage: Collecting, Storing, and Archiving in Art,* exh. cat. (Munich: Prestel, 1998), 58 n. 11.

19. Benjamin, *Moscow Diary* (note 16), 30, 65; Benjamin, *Moskauer Tagebuch* (note 16), 44: "Eine Art Tempelmauer.... Sie [die Flecken] sind durchsetzt mit Sowjetsternen und Leninköpfen"; 97: "Jetzt aber hängt am Eingang dieser Sammlungen ein Lenin-Bild, wie an einem Orte, wo früher den Göttern geopfert wurde, von bekehrten Heiden ein Kreuz erstellt wurde."

20. See, for example, Jacques Derrida, "The End of the Book and the Beginning of Writing," in idem, *Of Grammatology,* trans. Gayatri Chakravorty Spivak (Baltimore: Johns Hopkins Univ. Press, 1976), 6–26; originally published in Jacques Derrida, *De la grammatologie* (Paris: Editions de Minuit, 1967).

21. Leonid Borisovich Krasin, "O pamiatnikakh Vladimiru Il'ichu," in *O pamiatnike Leninu: Sbornik statei* (Leningrad: Gosizdat, 1924), 10: "Net v sushchnosti ni odnogo biusta barel'efa, po otnosheniiu k kotoromu mozhno bylo by skazat': da, takim umenno byl Vladimir Il'ich."

22. Gilles Deleuze, "Plato and the Simulacrum," trans. Rosalind Krauss, *October,* no. 27 (1983): 45–56, esp. 47, 52–53; originally published in Gilles Deleuze, *Logique du sens* (Paris: Editions de Minuit, 1969).

23. Rosalind Krauss, "A Note on Photography and the Simulacral," *October,* no. 31 (1984): 62.

24. *Otchet komissii* (note 9), 39: "opasnost' usvoeniia shirokimi sloiami naseleniia iskazhennogo vneshnego obraza V. I. Ul'ianova-Lenina."

25. *Otchet komissii* (note 9), 40: "krome fotograficheskikh, no ne iskliuchaia fotomontazha" (emphasis mine).

26. Ivan Matsa, "Lenin v izoiskusstve," in idem, ed., *Sovetskoe iskusstvo za 15 let: Materialy i dokumentatsiia* (Moscow: Ogiz-Izogiz, 1933), 393–96: "po sobstvennoi initsiative khudozhnikov." This important anthology of documents seems to be an attempt on the part of the editor to preserve documents of the artistic debates of the 1920s after all artistic groups were abolished in 1932.

27. Ivan Matsa published a list put together by the curator of the Marx, Engels, and Lenin Institute (which superseded the Lenin Institute in the waning of Lenin's cult in 1931); see Matsa, "Lenin v izoiskusstve" (note 26), 393–96. Note that relatively few images of Lenin were executed in his lifetime.

28. Members of AKhRR were painters and sculptors trained in academic techniques. Some of the older members were *peredvizhniki* (wanderers), the late-nineteenth- to early-twentieth-century Russian realists, but most were their students. Having often opposed the Bolsheviks, these artists had for the most part kept a low profile in the years preceding the organization of AKhRR in 1922. When they re-emerged, they advocated a revived mode of easel painting and monumental sculpture—a contemporary realism based on the nineteenth-century tradition—an aesthetic that had been attacked by the Leftist avant-garde groups dominant in Soviet cultural policy in the years immediately following the Russian Revolution. By the mid-1920s, AKhRR was the largest and most influential artists' organization in Soviet Russia, and it received formidable critical and financial support from certain high-ranking Bolshevik officials; its didactic realism adapted from nineteenth-century tradition was becoming the dominant model. For more information about AKhRR, see Brandon Taylor, "On AKhRR," in Matthew Cullerne Bown and Brandon Taylor, eds., *Art of the Soviets: Painting, Sculpture, and*

Architecture in a One-Party State, 1917–1992 (Manchester: Manchester Univ. Press, 1993), 51–72; Brandon Taylor, *Art and Literature under the Bolsheviks,* vol. 2, *Authority and Revolution, 1924–1932* (London: Pluto, 1992), 21–31, 53–68, 123–43, 169–86; and Viktor Nikolaevich Perel'man, *Bor'ba za realizm v izobrazitel'nom iskusstve 20-kh (dvadtsatykh) godov: Materialy, dokumenty, vospominaniia* (Moscow: Sovetskii khudozhnik, 1962).

29. Merkurov claimed that he made a mask only hours after Lenin's death, while Ivan Shadr and then Ginzburg and Aleksei Kharlamov made masks on the following day; see Merkurov, "Lenin v skul'pture" (note 15), 60.

30. *Bol'shaia sovetskaia entsiklopediia* (Moscow: Ogiz-Izogiz, 1938), s.v. "Merkurov": "Posle smerti V. I. Lenina M. snimaet skul'pturnuiu masku ego litsa, neprestanno rabotaet nad obrazom Lenina, vypolnaia tselyi riad ego portretov i uchastvuia v konkursakh proektov pamiatnika Leninu dlia razlichnykh gorodov SSSR."

31. According to a checklist of the artist's work, Brodskii's first portrait of Lenin was executed in 1919, a unique example among moody landscape titles. No other revolutionary subject appears in his oeuvre until 1923, the year in which Brodskii joined AKhRR. Between 1924 and 1927, Brodskii painted eighteen portraits of Lenin, including variant works; in the year 1924 alone, Brodskii executed at least five variations (one might say multiples) of a single painting, *Lenin in Front of the Kremlin,* which appear to have been distributed to various regional Lenin museums. The checklist of Brodskii's work appears in Iosif Anatolevich Brodskii, *Isaak Izrailevich Brodskii: Stat'i, pis'ma, dokumenty* (Moscow: Sovetskii khudozhnik, 1956), 172–91.

32. Brandon Taylor has considered Brodskii's use of photographic images in his "Photo-Power: Painting and Iconicity in the First Five Year Plan," in Dawn Ades, Tim Benton, David Elliott, and Iain Boyd White, eds., *Art and Power: Europe under the Dictators, 1930–45,* exh. cat. (London: Thames & Hudson, 1995), 249–52. Taylor emphasizes the photographic look of such paintings, and understands what he sees as photography's function as "the documentary combined with the agitational" (p. 250) as eliding with the premises of a proto-socialist realism. See also Leah Dickerman, "'Eternity or the Moment': Rodchenko's Portraits of Mayakovsky," in Anne D. Perryman and Patricia J. Thompson, eds., *The Mayakovsky Centennial, 1893–1993: A Commemoration of the Life, Work, and Times of Vladimir Mayakovsky* (Bronx, N.Y.: Lehman College, City University of New York, 1994); and Leah Dickerman, "Camera Obscura: Socialist Realism in the Shadow of Photography," *October,* no. 93 (2000): 136–51. Igor Golomstock notes that portraits of Hitler were largely executed from photographs, which suggests an analogy between socialist realist and Nazi art; see Igor Golomstock, *Totalitarian Art in the Soviet Union, the Third Reich, Fascist Italy, and the People's Republic of China,* trans. Robert Chandler (London: Collins Harvill, 1990), 230.

33. *Lenin: Sobranie fotografii i kinokadrov,* vol. 1, *Fotografii, 1874–1923* (Moscow: Iskusstvo, 1970), 79 (no. 55/54). This image was published as a postcard by the Leningrad Workers' Society for the Union of the City with the Countryside (Leningradskoe rabochee obshchestvo smychki goroda s derevnei) in 1923 and, in 1924, the All-Russian Committee for Aid to War Invalids (Vserossiiskii komitet pomoshchi invalidam voiny).

34. *Lenin: Sobranie fotografii* (note 33), 180 (no. 144/145).

35. Isaak Izrailevich Brodskii, *Moi tvorcheskii put'*, ed. Iosif Antolevich Brodskii (Moscow: Khudozhnik, 1965), 114.

36. Kleberg, "Notes on the Poem" (note 1), 169:

> My soglasny s zheleznodorozhnikami Kazanskoi zhel. dor., predlozhivimi
> khudozhniku oborudovat' u nikh v klube Leninskii zal bez biustov i portretov
> Lenina, govoria; "My ne khotim ikon."
> My nastaivaem:
> Ne stampite Lenina.
> Ne pechataite ego portretov na plakatakh, na kleenkakh, na tarelkakh, na
> kruzhkakh, na portsigarakh.
> Ne bronziruite Lenina.
> Ne otnimaite u nego ego zhivoi postupi i chelovechskogo oblika, kotorii on
> sumel sokhranit', rukovodia istoriei.
> Lenin vse eshche nash sovremennik.
> On sredi zhivykh.
> On nuzhen nam, kak zhivoi, a ne kak mertvyi.
> Poetomu,
> Uchites' u Lenina, no ne kanoniziruite ego.
> Ne sozdavaite kul'te imenem cheloveka, vsiu zhizn' borovshchegosia protiv
> vsiacheskikh kul'tov.
> Ne torguite predmetami etogo kul'ta.
> Ne torguite Leninym!

37. The first part of the poem appeared in *Lef*, no. 7 (1925): 4–5.

38. Vladimir Mayakovsky, "Vladimir Ilyich Lenin," in idem, *Selected Works in Three Volumes*, vol. 2, *Longer Poems*, trans. Dorian Rottenberg (Moscow: Raduga, 1986), 142. Originally published as "Vladimir Il'ich Lenin," *Lef*, no. 7 (1925): 4–5:

> Ia boius'
> etikh strochek tyshchi,
> Kak mal'chishkoi
> boish'sia fal'shi.
> Rassiiaiut golovoiu
>
> venchik—
> Ia trevozhus'
> ne zakrylo chtob
> Nastoiashchii
> mudryi
> chelovechii
> Leninskii
> ogromnyi lob.
> Ia boius'
> chtob shestviia
> i mavzolei,
> Poklonenii

 ustanovlennyi statut

Ne zalili b

 pritornym

 eleem

Leninskuiu

 prostotu.

Za nego drozhu,

 kak za zenitsu glaza,

Chtob konfetnoi

 ne byl

 krasotoi obolgan.

39. Mayakovsky, "Vladimir Ilyich Lenin" (note 38), 148; Mayakovsky, "Vladimir Il'ich Lenin" (note 38), 11: "Daleko davnym / godov / za dvesti."

40. Mayakovsky, "Vladimir Ilyich Lenin" (note 38), 141 (modified from original: "There's no one / more alive / than Lenin in the world"); Mayakovsky, "Vladimir Il'ich Lenin" (note 38), 3: "Lenin / i teper' / zhivee vsekh zhivykh."

41. Benjamin, "The Work of Art" (note 3), 223.

42. Benjamin, "The Work of Art" (note 3), 223.

43. Benjamin, "The Work of Art" (note 3), 228.

44. Benjamin, "The Work of Art" (note 3), 224, 218.

45. Aleksandr Rodchenko, "Against the Synthetic Portrait, for the Snapshot," in Christopher Phillips, ed., *Photography in the Modern Era: European Documents and Critical Writings, 1913–1940*, exh. cat. (New York: Metropolitan Museum of Art/ Aperture, 1989), 241. Originally published as "Protiv summirovannogo portreta za momentalnyi," *Novyi lef,* no. 4 (1928): 16:

Skazhite chestno, chto nuzhno, chotby ostalos' o Lenine:

khudozhestvennaia bronza,

maslianye portrety,

oforty,

akvareli,

dnevnik ego sekretaria, vospominaniia druzei

ili

papka fotografii, sniatykh vo vremia raboty i otdykha,

arkhiv ego knig, bloknoty, zapisnye khizhki, stenogrammy,

kinos"emki, grammofonnaia zapis'.

46. Rodchenko, "Against the Synthetic Portrait" (note 45), 241; Rodchenko, "Protiv summirovannogo portreta" (note 45), 16: "Ia dumaiu, vybora net."

47. See Annette Michelson, "The Kinetic Icon in the Work of Mourning: Prolegomena to the Analysis of a Textual System," *October,* no. 52 (1990): 26.

48. Rodchenko, "Against the Synthetic Portrait" (note 45), 240; Rodchenko, "Protiv summirovannogo portreta" (note 45), 15: "Vot primer pervogo krupnogo stolknoveniia iskusstva s fotografiei, boi vechnosti s momentom."

49. Rodchenko, "Against the Synthetic Portrait" (note 45), 239; Rodchenko, "Protiv summirovannogo portreta" (note 45), 14: "dokumental'no tochnyi moment."

50. Rodchenko, "Against the Synthetic Portrait" (note 45), 239; Rodchenko, "Protiv summirovannogo portreta" (note 45), 14: "Teper' ne entsiklopediei zhivut, a gazetoi, zhurnalom, katalogom statei, prospektom, spravochnikom."

51. Rodchenko, "Against the Synthetic Portrait" (note 45), 241; Rodchenko, "Protiv summirovannogo portreta" (note 45), 15: "Nuzhno tverdo skazat', chto s vozniknoveniem fotodokumentov ne mozhet byt' rechi o kakom-libo edinom neprelozhnom portrete. Bol'she togo, chelovek ne iavliaetsia odnoi summoi, on mnogie summy, inogda sovershenno protivopolozhnye."

52. Rodchenko, "Against the Synthetic Portrait" (note 45), 242; Rodchenko, "Protiv summirovannogo portreta" (note 45), 16: "massoi momental'nykh snimkov, sdelannykh v raznoe vremia i v raznykh usloviiakh."

53. Rodchenko, "Against the Synthetic Portrait" (note 45), 240; Rodchenko, "Protiv summirovannogo portreta" (note 45), 15: "Net i ne budet potomu, chto imeetsia papka fotografii, i eta papka momental'nykh snimkov ne daet nikomu idealizirovat' Lenina."

54. Christian Metz, "Photography and Fetish," *October*, no. 34 (1985): 84.

55. Varvara Stepanova, "Rabochii klub: Konstruktivist A. M. Rodchenko," *Sovremennaia arkhitektura* 1 (1926): 36: "Razrabotano primernoe oborudovanie ugolka Lenina, stennaia, podvizhnaia vitrina dlia khraneniia i demonstrirovaniia materialov, dokumentov i foto s mestom dlia zagolovkov i tezisov, podvizhnaia fotovitrina vystavochnogo kharaktera dlia eksponirovaniia tekushchego fotomateriala."

56. *Novyi lef,* no. 4 (1927): verso after 32. Several additional designs by Rodchenko for the workers' club are illustrated in Magdalena Dabrowski, Leah Dickerman, and Peter Galassi, *Aleksandr Rodchenko,* exh. cat. (New York: Museum of Modern Art, 1998), figs. 160–67.

57. Stepanova, "Rabochii klub" (note 55), 36: "Ustanovka dlia stennoi gazety s dvizhushchimisia polosami dlia avtomaticheskoi verstki."

58. A report of the meeting on 11 February 1925 of the organizing committee for the Soviet section of the Paris exhibition also approved what seem to be Rodchenko's ideas for an electrified map of Lenin's life, a portal with slogans from Lenin, and photographs of contemporary club activities. The committee also resolved that it was desirable to find a more comfortable form of furniture. See Russian State Archive for Literature and Art (RGALI; Rossiiskii gosudarstvennyi arkhiv literatury i iskusstva), fund 841, opus 15, unit 15, p. 1.

59. See Bredekamp, "Der simulierte Benjamin" (note 18), 117–37; and Buchloh, "Warburg's Paragon?" (note 18), 58.

60. See, for example, Sophie Lissitzky-Küppers, *El Lissitzky: Life, Letters, Texts,* trans. Helene Aldwinckle and Mary Whittall (London: Thames & Hudson, 1968), pls. 206–13; originally published as *El Lissitzky — Maler, Architekt, Typograf, Fotograf* (Dresden: Verlag der Kunst, 1967).

61. On literacy and electrification, see Peter Kenez, *The Birth of the Propaganda State: Soviet Methods of Mass Mobilization, 1917–1929* (Cambridge: Cambridge Univ. Press, 1985); and Jonathan Coopersmith, *The Electrification of Russia, 1880–1926* (Ithaca: Cornell Univ. Press, 1992).

62. D. J. Richards, *Soviet Chess* (Oxford: Clarendon, 1965).

63. See Richards, *Soviet Chess* (note 62), 17. Mark von Hagen notes the role of both workers' clubs and chess in the project of transforming Red Army soldiers into model Soviet citizens; see Mark von Hagen, *Soldiers in the Proletarian Dictatorship: The Red Army and the Soviet Socialist State* (Ithaca: Cornell Univ. Press, 1990).

64. Illustrated in Centre de Création Industrielle, *Utopies et réalités en URSS, 1917–1934, agit-prop, design, architecture,* exh. cat. (Paris: Centre Georges Pompidou, 1980), 21.

65. See Christie's, London, *Photographs,* 6 May 1993, lot 152. Some of Rodchenko's portraits of the living Maiakovskii are illustrated in Dabrowski, Dickerman, and Galassi, *Aleksandr Rodchenko* (note 56), figs. 133, 134, 137, 138, 140–45.

66. Aleksandr Rodchenko, "Iz rukopisi 'Rabota s Maiakovskim,'" in *A. M. Rodchenko: Stat'i, vospominaniia, avtobiograficheskie zapiski, pis'ma,* ed. E. Iu. Dutlova and A. N. Lavrent'ev (Moscow: Sovetskii khudozhnik, 1982), 81: "I tut ne bez bor'by, ia borolsia s tsvetami.... Ego khoteli zavalit' tsvetami, vezli i vezli.... Vdrug vse stali vezti tsvety—vse organizatsii, redaktsii, izdatel'stva.... Ia khotel sokhranit' nekotoruiu surovost', neliubov' k meshchanstvu, ia bezpreryvno vynosil tsvety."

The Sword and the Lightbulb:
A Reading of *Guernica*

Carlo Ginzburg

1.

Brassaï, the Hungarian-born photographer, once asked Pablo Picasso why he was obsessed with inscribing a date on every work. Picasso replied,

> Why do you think I date everything I do? Because it is not sufficient to know an artist's works—it is also necessary to know when he did them, why, how, under what circumstances...Some day there will undoubtedly be a science—it may be called the science of man—which will seek to learn more about man in general through the study of the creative man. I often think about such a science, and I want to leave to posterity a documentation that will be as complete as possible. That's why I put a date on everything I do...[1]

This exchange, according to Brassaï's *Conversations avec Picasso*, took place on 6 December 1943, more than six years after Picasso finished *Guernica* (fig. 1), the best-documented painting not only of Picasso's career but arguably in the history of Western art.[2]

Given the exceptional amount of dated evidence concerning its genesis and evolution, *Guernica* presents a case history ideal for addressing the questions, raised by Picasso, of "why, how, under what circumstances" this work of art was made.[3] A scrutiny of the process that generated one of the earliest representations of the mass bombing of civilians—that novelty of modern warfare—may also shed light on Picasso's surprising remark that an inquiry regarding "the creative man" may be relevant for the study of "man in general."[4]

2.

Let us begin with the political circumstances. *Guernica* was first exhibited in 1937, at the Exposition Internationale des Arts et des Techniques Appliqués à la Vie Moderne in Paris.[5] The scene of the International Exhibition was dominated by the German and Soviet pavilions—two huge constructions on the west bank of the Seine facing each other across the axis running from the Palais de Chaillot to the Eiffel Tower.[6] An official brochure issued by the German government presented the two pavilions as "zwei Weltanschauungen" [two worldviews] (fig. 2).[7]

But by 1937 the ideological competition between the two regimes had turned into a political and even military confrontation. For nearly a year the

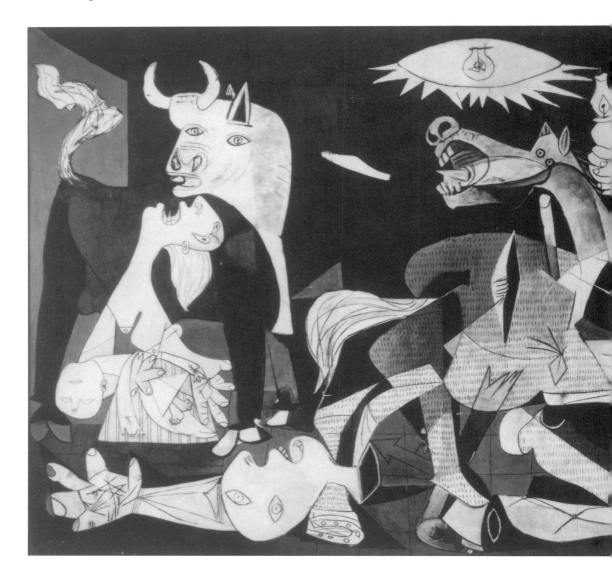

Fig. 1. Pablo Picasso
Guernica, 1937, oil on canvas, 3.49 × 7.77 m (11½ × 25½ ft.)
Madrid, Museo del Prado

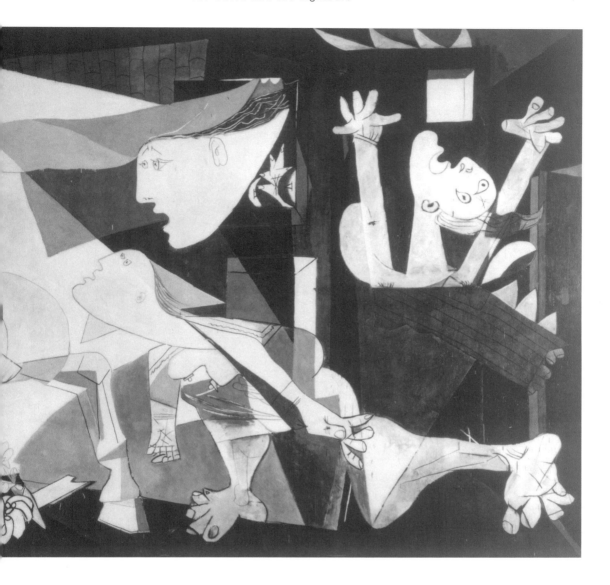

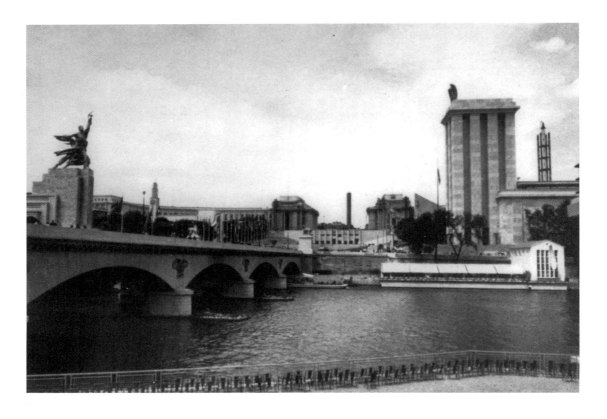

Fig. 2. Heinrich Hoffmann
Two Buildings, Two Views of Life (*Zwei Bauten, zwei
Weltanschauungen*), 1937
Munich, Bayerische Staatsbibliothek, Bildarchiv

Spanish Republican government, with the aid of the Soviet Union as well as the International Brigades and the governments of France and Mexico, had been fighting the insurgent army led by Francisco Franco, who was supported by Nazi Germany and Fascist Italy. Picasso's painting, prominently displayed in the Spanish pavilion, commemorated a bloody event from this civil war: the bombing of the small Basque town of Guernica by a swarm of German (and some Italian) airplanes—the so-called Condor Legion—on 26 April 1937. The town had been razed; approximately two thousand civilians had been killed.

3.

The enormous impact of Picasso's *Guernica* on the twentieth-century imagination is well known. The painting is widely regarded as an anti-Fascist manifesto—a rare example of a great work of art successfully conveying a political message.

But is *Guernica*'s message really so self-evident?

In an essay titled "The Political Confrontation of the Arts at the Paris World Exposition of 1937," the art historian Otto K. Werckmeister opposed modernism—the art of liberal democracies—to the cold classicism favored by totalitarian regimes such as Nazi Germany and the Soviet Union. "[T]he Spanish pavilion with Picasso's mural," according to Werckmeister, fits into this scheme of things as "a deliberate antithesis, an assertion of political freedom expressed by a challenge through modern art to regimes which were engaged in a policy of suppressing modern art in their own countries." I need not emphasize the plurals: "regimes," "countries." Basically Werckmeister regarded *Guernica* as a statement about the role of modern art in the modern world. Through this work, Picasso was to have assailed not Fascism alone but totalitarianism in general—that is, both Nazi Germany and the Soviet Union, which were directly and indirectly fighting each other in Spain. And Picasso's opposition was to have been all in the name of liberal democracy, the only political regime not overtly hostile to modern art: "Picasso's mural is an example of modern art as a free, personal statement without direction by any government agency and without apparent concern for an understanding by the masses." Werckmeister elaborated and nailed down this critical remark, pointing to Picasso's allegedly elitist attitude, in his conclusion: "*Guernica* came to stand as a testimony for the intrinsic commitment of modern art to freedom and democracy. This was the moment when modern art began to be promoted as the ambiguous vehicle of free opinion."[8]

Werckmeister's argument rephrased, albeit from a different perspective, a comment Anthony Blunt made fifty years earlier in an article about the International Exhibition published in the *Spectator* on 6 August 1937. After mentioning the "big mural in the Spanish pavilion which Picasso has dedicated to the Spanish people in memory of Guernica," Blunt wrote,

> The gesture is fine, and even useful, in that it shows the adherence of a distinguished Spanish intellectual to the cause of his government. But the painting is disillusioning.

Fundamentally it is the same as Picasso's bull-fight scenes. It is not an act of public mourning, but the expression of a private brain-storm which gives no evidence that Picasso has realised the political significance of Guernica. The Spanish people will be grateful for the support of Picasso, but not consoled by the painting.[9]

In light of *Guernica*'s subsequent reception, the dismissal of its political relevance by this young, intransigent Marxist art historian seems nearly ludicrous. (Later Blunt changed his mind completely about the mural's political and artistic value.)[10] But one could object that *Guernica*'s success, by turning the painting into an icon, obscured its meaning. Nowadays some of the initial shock induced by *Guernica* has evaporated—as the shift from Blunt's heated remark that *Guernica* was not "an act of public mourning, but the expression of a private brain-storm" to Werckmeister's cool characterization of the mural as a "free, personal statement...without apparent concern for an understanding by the masses" reminds us. To get a sense of its early impact, we need to look at the context in which *Guernica* was exhibited for the first time.

4.

In his article in the *Spectator,* Blunt noticed that on the opening day of the International Exhibition, only the pavilions of the "totalitarian states"—Italy, Germany, and the Soviet Union—were ready.[11] The three pavilions shared a classicizing architectural idiom,[12] although that idiom allowed a range of choices, each having different ideological implications. For the relatively static, four-square German pavilion, which was topped by a large sculpture of an eagle grasping a swastika in its claws, Albert Speer, who dreamed of "becoming a second Schinkel," used a solemn, stately vocabulary close to the reduced neoclassical style of the Ewige Wache temples in Munich, and ultimately inspired by the Doric style of which Hitler was so fond (figs. 3–5).[13] Focused on discipline, hierarchy, and war, the Dorians had long been perceived by a large and cultivated audience as a quintessentially authoritarian society. In a famous essay published in 1934, Gottfried Benn used Doric style as a chilling, deeply ambivalent metaphor for Nazi Germany.[14]

A different, even antithetical note was struck by Boris Iofan's dynamic, progressively stepped Soviet pavilion in the scraped classicizing idiom. It culminated in Vera Mukhina's eighty-foot sculpture, *The Industrial Worker and the Collective Farm Girl* (fig. 6). By echoing the gesture of the two tyrant-killers, Harmodius and Aristogiton (fig. 7), whose statue was venerated in ancient Athens, Mukhina suggested that the Soviet regime based on the alliance between peasants and workers not only brought to perfection the Greek democratic tradition but also overcame its class and gender limitations.[15]

Opposite the German pavilion, across the Seine, the Italian pavilion designed by Marcello Piacentini spoke the classicizing idiom with a Latin accent, combining elements reminiscent of classical Rome, the Renaissance, and the International Style. On a platform to the left of the entrance was

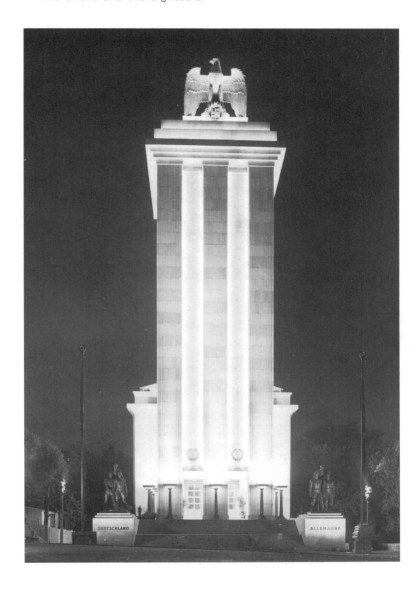

Fig. 3. Heinrich Hoffmann
*The Radiating Tower of the German Pavilion (Der strahlende
Turm des Deutschen Hauses)*, 1937
Munich, Bayerische Staatsbibliothek, Bildarchiv

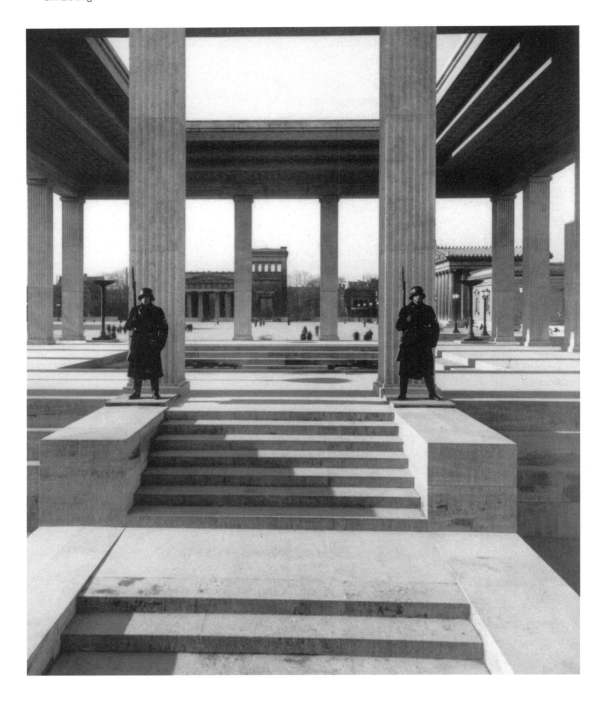

Fig. 4. Heinrich Hoffmann
Ewige Wache, Munich, ca. 1934 [demolished January 1947]
Munich, Bayerische Staatsbibliothek, Bildarchiv

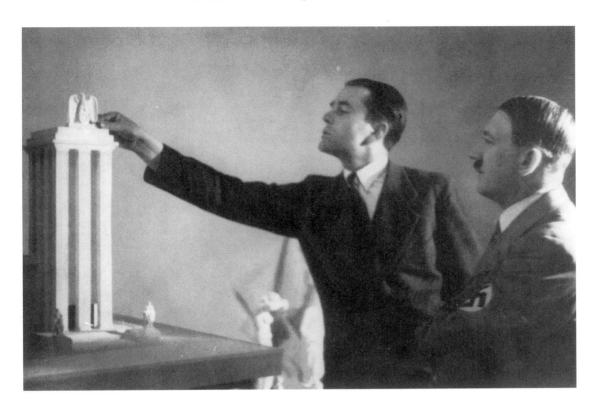

Fig. 5. Heinrich Hoffmann
Albert Speer and Adolf Hitler with a Model of the German
Pavilion, ca. 1937
Munich, Bayerische Staatsbibliothek, Bildarchiv

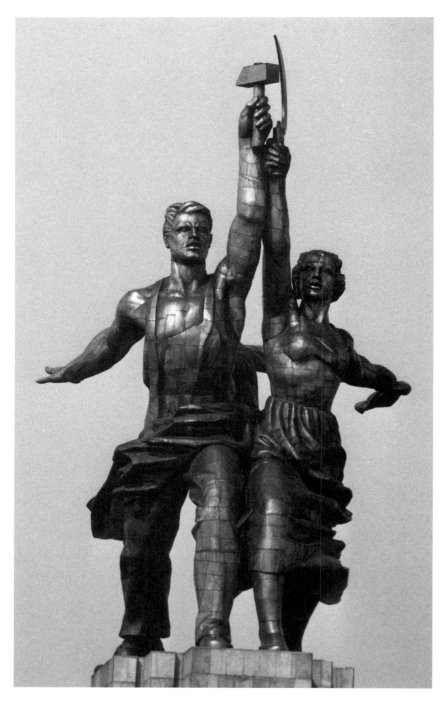

Fig. 6. Vera Mukhina
The Industrial Worker and the Collective Farm Girl (Rabochii i Kolkhoznitsa), 1937, stainless steel, 24.5 m (80⅜ ft.)
Moscow, Vserossiiskii Vystavochnyi Tsentr

Fig. 7. After Antenor
The Tyrant-Killers, marble, 185 cm (73 in.)
Naples, Museo Archeologico Nazionale

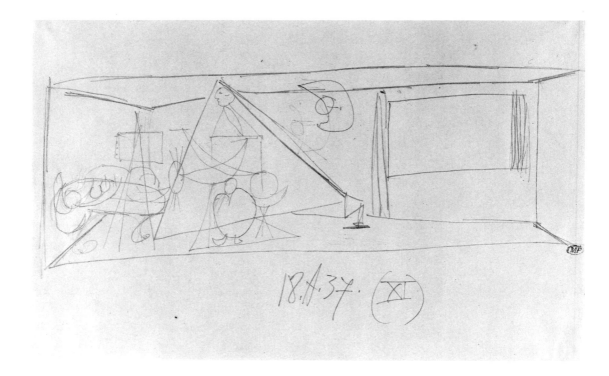

Fig. 8. Pablo Picasso
The Studio: The Painter and His Model, 18 April 1937,
pencil on blue paper, 18 × 28 cm (7⅛ × 11 in.)
Paris, Musée Picasso

Giorgio Gori's twenty-foot sculpture, *The Spirit of Fascism*—a feeble imitation of *Gattamelata,* the bronze equestrian statue made by Donatello in 1447 for Padua's Piazza del Santo, which was, in turn, inspired by the second-century bronze equestrian statue of the Roman emperor Marcus Aurelius.[16]

These three pavilions had been completed by 24 May 1937. The Spanish pavilion—an elegant and unostentatious piece of functionalist architecture—was inaugurated on 12 July.[17] Initially, Picasso's contribution to the pavilion's embellishment had been envisioned as fairly modest. The entry for the Spanish pavilion in the official catalog of the International Exhibition, presumably prepared long in advance, mentioned Picasso among the pavilion's "collaborateurs artistes," along with Joán Miró and Alberto Sánchez Pérez, but only for "sculptures extérieures." In fact, two works by Picasso in unpainted cement were exhibited outside the pavilion. *Head of a Woman with Chignon* (1932; cement cast, Antibes, Musée Picasso) was placed at the left of the main (west) facade, and *Woman with Vase* (1933; cement cast, Antibes, Musée Picasso) was displayed at the south side, near the Polish pavilion; cement casts of two additional heads as well as a small bronze nude were shown inside, on the pavilion's third floor.[18]

But eventually the Spanish authorities wanted a more visible commitment. At the beginning of 1937, Picasso agreed to paint a mural expressly for the pavilion, for which he received (a detail disclosed only after his death) 150,000 francs—a considerable amount of money.[19] According to the recollections of Josep Lluis Sert, the principal architect of the Spanish pavilion,

> one day, we were given the measurements of the wall we had reserved for his [Picasso's] picture and we discussed them. He said the picture would not extend the whole length of the pavilion; the height was low and he wanted the painting to have certain proportions. He promised that the work would be completed, but until the last moment we really doubted if he was going to do it at all. But Picasso always loved to keep his plans mysterious, as he did his pictures.[20]

Sert assumed that "the painting" was *Guernica*. But a series of twelve sketches reveals that Picasso initially chose the painter and his model (fig. 8) as the subject of his mural. The elongated shape of the surviving sketches, whose proportions are very close those of *Guernica*, is certainly compatible with Sert's account.

The painter and the model is a "quite unpolitical theme," one scholar has remarked.[21] One might object that in the past—for instance in Gustave Courbet's large, famous, and cryptic painting *The Studio of the Painter* (1855; Paris, Musée d'Orsay)—the studio had been considered a symbolic space, open to the outside world, including the world of politics.[22] Picasso could have developed his theme in that direction. Or, on the contrary, he might have emphasized the studio's self-reflective, enclosed dimension, possibly as a quiet challenge to the grandiloquent statements made by some of the prominent pavilions at the International Exhibition. We will never know. On 28 April

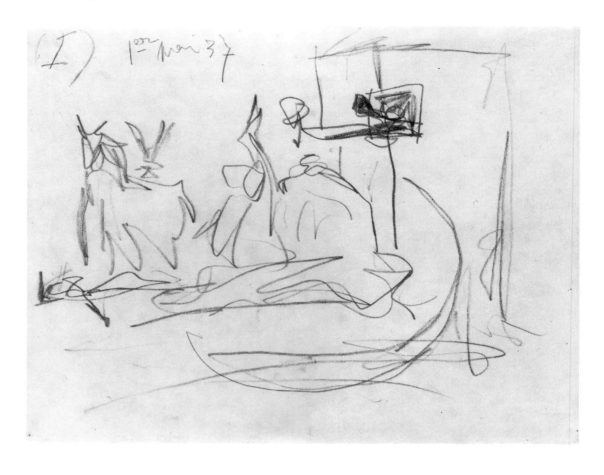

Fig. 9. Pablo Picasso
Study for Guernica, 1 May 1937, pencil on blue paper,
21 × 26.9 cm (8¼ × 10⅝ in.)
Madrid, Museo Nacional Centro de Arte Reina Sofía

the Parisian press announced the news of the bombing of Guernica, which had taken place two days earlier. On 1 May Picasso made the first sketch for *Guernica* (fig. 9).

5.

The relation between the sketches for *The Studio: The Painter and His Model* and for *Guernica* has been repeatedly debated, mostly in terms of content.[23] To me, their formal connection seems more revealing. The gesture of the painter looking at his model (see fig. 8) is clearly replicated by the woman holding a lamp in *Guernica* (fig. 10) whose gesture, in turn, replicates that of the painter at work (fig. 11).[24]

Such comparisons are indirectly supported by comments made by the classical archaeologist Otto J. Brendel in what is arguably the best essay ever written on *Guernica*. Calling the woman holding the lamp "one of the germinating ideas of the entire composition," Brendel connected her to some previous examples of what we might call, echoing a well-known remark by Carl Einstein, Picasso's "private mythology."[25] But compared to the onlooking women cited by Brendel (see, for example, fig. 12), the woman holding a lamp in *Guernica* seems to belong to a less private sphere—an impression conveyed by her classical gesture. This is Brendel again:

> True symbols have a long life and, like dreams, fit many different situations. In this sense I should say that in *Guernica,* the woman with the lamp replaces the onlooker of the former compositions. She fulfills the same functions. Even stylistically, in the context of *Guernica,* she is an exception.... [Her face] was cast in a classical form, alien to the rest of the composition.... The woman herself resembles an ancient masque of tragedy.... She takes the part of the chorus in a Greek tragedy.[26]

She also takes on the role of the painter. In 1963 Michel Leiris, the French writer who was among Picasso's closest friends, would write in his diary, "It seems evident that painting—the act of painting—is for P[icasso] the most important theme of all."[27] Leiris explained that he was referring to Picasso's fascination with the paintings of others, attested by his innumerable pastiches, reworkings, and so forth. But Leiris's words have other implications. For Picasso, the act of painting could be a metaphor for the act of love, or—as in *Guernica*—for the act of knowing.

6.

In an often-quoted interview published two years before he painted *Guernica*, Picasso said,

> In the old days pictures went forward toward completion by stages. Every day brought something new. A picture used to be a sum of additions. In my case a picture is a sum of destructions. I do a picture—then I destroy it. In the end, though, nothing is lost: the red I took away from one place turns up somewhere else.

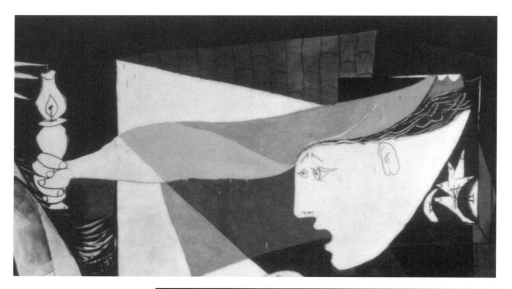

Fig. 10. Pablo Picasso
Guernica (detail)
Madrid, Museo del Prado

Fig. 11. Dora Maar
Picasso Painting in His Studio, 1937
From *Cahiers d'art* 12 (1937): 142

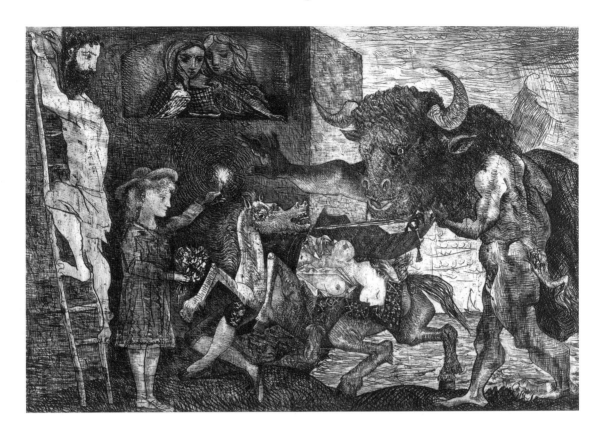

Fig. 12. Pablo Picasso
Minotauromachy, 23 March 1935, etching and engraving
printed in black, plate: 49.6 × 69.6 cm (19½ × 27⅜ in.)
New York, Museum of Modern Art, Abby Aldrich
Rockefeller Fund

> It would be very interesting to preserve photographically, not the stages, but the metamorphoses of a picture. Possibly one might then discover the path followed by the brain in materializing a dream. But there is one very odd thing—to notice that basically a picture doesn't change, that the first "vision" remains almost intact, in spite of appearances.[28]

Picasso's sketches as well as Dora Maar's photographs recording the metamorphoses of *Guernica* confirm that the "first 'vision,'" scribbled down on 1 May, did indeed remain "almost intact" until the end (see figs. 1, 9).

But the "almost" is important. Let me start with a small detail in the first sketch: an object over the bull's back that has been interpreted as a bird.[29] I would prefer to read it as a pair of banderillas, which would be consistent with the idea that Picasso's plan for *Guernica* initially involved a bullfight, although I would not insist on this interpretation. More important is that Picasso in his second sketch for *Guernica,* like the first dated 1 May, started to change, or specify, the object over the bull's back. Whatever it once was, it became the winged horse from ancient Greek mythology, Pegasus (fig. 13).

This winged horse did not survive Picasso's *destructio destructionum*—it is not in the finished painting—but its ephemeral presence set off a chain reaction. On 1 and 2 May, Picasso made two more sketches of the ensemble, both painstakingly executed on wood. The first drawing had several classical elements, including a little winged horse emerging from the belly of a wounded horse, and a man with an antique helmet and a spear who has fallen on the ground (fig. 14). The second drawing left out the winged horse and the helmet; the spear became a picador's pike, and the scene unequivocally became a bullfight (fig. 15).

Clearly Picasso was considering alternative versions distinguished by the presence or absence of classical elements. One wonders whether the atmosphere of the second, bullfight version might have been more frantic, as the contrast between its springing bull and the stately, staring bull of the first, classicizing version seems to suggest. A new sketch of the ensemble, dated 9 May (fig. 16), which included dramatic details such as the advancing woman at the right, seemed to show that Picasso was leaning toward the modern version. But in the final painting, the classicizing details surfaced again, in the broken sword as well as the figure of the prostrate warrior.

The structural permanence of vision mentioned by Picasso is undeniable. But it was matched by a process involving uncertainties, explorations, choices.

7.

To decipher these explorations, we have to understand why Picasso included an allusion to ancient Greek mythology—Pegasus, the winged horse—in a painting commemorating a modern event. Blunt has noticed that the winged horse was a self-quotation. It had appeared in *The Dream and Lie of Franco,* the series of etchings against Franco that Picasso made in 1937. Perhaps more important, the winged horse had appeared twenty years earlier, on the large

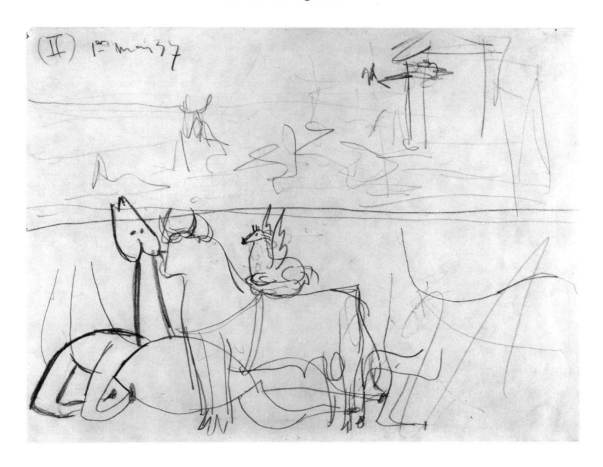

Fig. 13. Pablo Picasso
Study for Guernica, 1 May 1937, pencil on blue paper,
21 × 26.9 cm (8¼ × 10⅝ in.)
Madrid, Museo Nacional Centro de Arte Reina Sofía

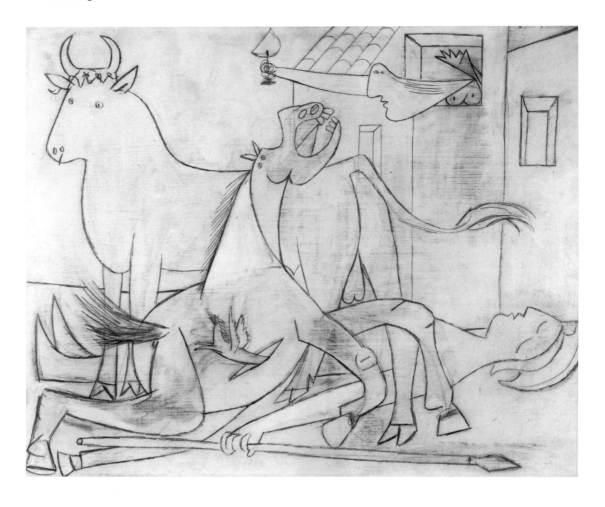

Fig. 14. Pablo Picasso
Study for Guernica, 1 May 1937, pencil on gesso on wood,
53.7 × 64.7 cm (21⅛ × 25½ in.)
Madrid, Museo Nacional Centro de Arte Reina Sofía

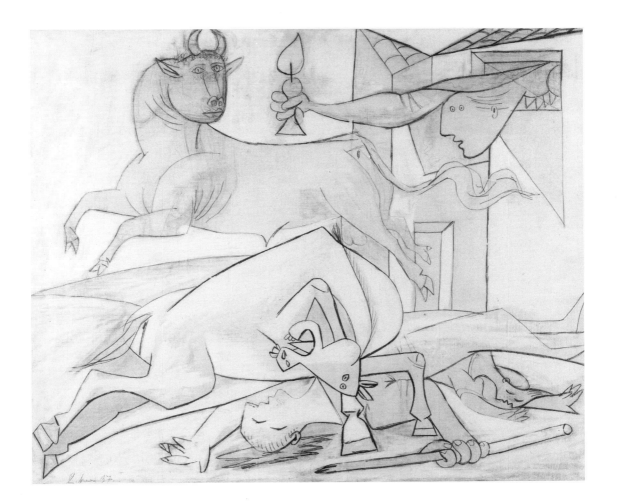

Fig. 15. Pablo Picasso
Study for Guernica, 2 May 1937, pencil and oil on gesso on
wood, 60 × 73 cm (23⅝ × 28¾ in.)
Madrid, Museo Nacional Centro de Arte Reina Sofía

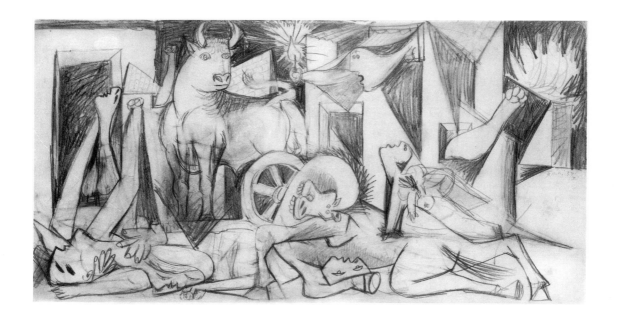

Fig. 16. Pablo Picasso
Study for Guernica, 9 May 1937, pencil on white paper,
24 × 45.3 cm (9½ × 17⅞ in.)
Madrid, Museo Nacional Centro de Arte Reina Sofía

overture curtain for the ballet *Parade* (fig. 17) that Picasso painted while in Rome in 1917. *Parade,* for which Jean Cocteau wrote the scenario and Erik Satie composed the music, was premiered by Serge Diaghilev's Ballets Russes in Paris later that year.[30]

The *Parade* curtain had a lasting impact on Picasso's work, especially on large or particularly ambitious compositions.[31] But the nature of this impact needs some clarification. During a certain period, Cocteau's intellectual and artistic exchanges with Picasso seem to have been very fruitful for both men. One wonders, for instance, whether *le rappel à l'ordre* (the call to order) — the artistic *mot d'ordre* (watchword) that Cocteau would use as a title for the influential collection of essays he published in 1923 — originated from the journey to Rome that Cocteau and Picasso made together in 1917.[32] In Rome Picasso made a portrait of Cocteau, who would stress its stylistic novelty, rightly dismissing the references to Jean Auguste Dominique Ingres that have been made for this and similar drawings.[33] In fact, the portrait displays a nearly cubist elegance wrapped in archaic Greek garb as distilled by Ingres (figs. 18, 19).[34]

The relevance of this drawing was soon remarked by no less a critic than Marcel Proust, in a passage that, if I am not mistaken, has escaped the attention of Picasso scholars. Jacques-Emile Blanche, the artist and art historian who had painted Proust's portrait, published the first volume of his memoirs in 1919. Proust's introduction to this volume contains a sudden, rather convoluted digression. After comparing Blanche to Eugène Fromentin, who like Blanche had been both a painter and a writer, Proust remarked that in his *Les maîtres d'autrefois: Belgique-Hollande,* Fromentin did not even mention the greatest Dutch painter, Jan Vermeer. Then Proust turned back to Blanche — in fact, to Cocteau: "Certainly Jacques Blanche, like Jean Cocteau, would do justice to the great, to the admirable Picasso, who enclosed all Cocteau's features in an image that, for its noble rigidity, makes all my memories of the most charming Carpaccios in Venice seem a little faded."[35] Picasso as Vermeer, the greatest among his peers. This was high praise indeed — as well as proof of Proust's astonishing capacity to keep abreast of new artistic developments.

But his emphasis on the drawing's stylistic rigidity is even more important. One finds the same quality in Picasso's stunning portrait of Igor Stravinsky (fig. 20), also made in Rome in 1917, when they first met;[36] and both portraits anticipate later works by Picasso such as *Three Women at a Fountain* (1921; New York, Museum of Modern Art) and *Mother and Child* (fig. 21). More indirectly, the portraits seem to anticipate the vision of archaic Greece that inspired *Oedipus Rex,* the "opéra-oratorio" created in 1925 by Stravinsky and Cocteau. In 1928 Ernst Bloch attacked *Oedipus Rex,* and its rigidity was his target:

This rigidity is the tribute of the later Stravinsky to Paris reaction, indeed to the capitalist stabilization of the world; from this also stems what is called the

Fig. 17. Pablo Picasso
Overture Curtain for Parade, 1917, tempera on canvas,
10 × 16.4 m (32¾ × 53¾ ft.)
Paris, Musée National d'Art Moderne

Fig. 18. Pablo Picasso
Jean Cocteau, 1917, pencil on paper, 26.3 × 19.4 cm (10⅜ × 7⅝ in.)
Milly-la-Forêt, Edouard Dermit

Fig. 19. Jean Auguste Dominique Ingres
Virgil Reading the Aeneid *to Augustus, Octavia, and Livia, or "Tu Marcellus eris..."*
(fragment), ca. 1819, oil on canvas, 138 × 142 cm (54⅜ × 55⅞ in.)
Brussels, Musées Royaux des Beaux-Arts, Musée d'Art Moderne

Fig. 20. Pablo Picasso
Igor Stravinsky, 1917, pencil on cream wove paper,
27 × 20 cm (10⅝ × 7⅞ in.)
New York, Paul Herring

Fig. 21. Pablo Picasso
Mother and Child, 1921, oil on canvas, 154 × 104 cm
(60⅝ × 41 in.)
Munich, Staatsgalerie moderner Kunst

Fig. 22. Pablo Picasso
Bathers (Study for a Monument), 1928, ink and wash on
paper, 30 × 22 cm (11¾ × 8⅝ in.)
Paris, Musée Picasso

"objectivism" of this music. It is emphatic alienation from all psychology, but also from everything human.... Cocteau's Latin text adding further quite different, indeed almost mysterious elements of fascism.... Picasso, Stravinsky, Cocteau — they have, in approaching antique form, become a triad and the last seduction to "proportion" that the upper stratum of the bourgeoisie, at the eleventh hour, has produced.[37]

Ultimately, Bloch would change his mind about Picasso, and specifically about *Guernica*. But his attack reminds us that in the 1920s and 1930s the use of a classical (or neoclassical) idiom was for the Left, and especially for the noncommunist Left, a highly political issue. In 1932 Carl Einstein launched a full-out assault against classicism on the occasion of the one hundredth anniversary of Goethe's death.[38] The immediate target of Einstein's article was the growing hostility toward the artistic and intellectual avant-garde that was a prominent feature of Stalin's policy toward culture. Einstein rejected the appeal to "humanism" made by Anatoly Lunacharsky, the Soviet commissar for education from 1917 to 1929, claiming that "nowhere is there any mention made of the irrational forces. On the contrary, we have here a cheap, flat historicism and cultural mania."[39]

In attacking Goethe — or his cliché — Einstein struck a similar note:

This optimist [Goethe] never understood that cognition is a form of destruction, a process of death, and it did not occur to him to look at cognition from the standpoint of death, as a means for the destruction of the real, a defense against the chaotic pressure of the world. Cognition, like every form, is a process of death, and means first of all, a diminution of living contacts, the elimination of conventional reality, in order to create a new mythos, which is our strongest reality.[40]

In stressing the need for new myths, Einstein implicitly referred to the work of Picasso, an artist who played in Einstein's mind the role of an anti-Goethe. A year earlier, Einstein had commented on Picasso's works from the year 1928 (see, for example, fig. 22) in the following terms:

What Picasso was here creating was a series of figured images, creatures of a formal mythology.... The visions in their immediacy seem utterly remote from the commonplace and imitative. For these images derive from psychic realms as yet untamed and outreach the calculations of reason. The old symbols — the stake, the skull, the house, and the womb — are here rediscovered....

...Picasso realized that the autonomous image postulates the death of reality. Yet reality is thereby reinforced, to the extent that new masses of imagination are projected into it.[41]

Einstein had been active in anti-Fascist groups long before joining the International Brigades in the Spanish civil war (he committed suicide in 1940, after the defeat of France), and he was one of the first European scholars to

work in depth on African art. Thus, his emphasis on irrationality and the need for new myths, as well as his attack on Goethe's and Lunacharsky's bourgeois classicism, had artistic and political implications. In a sense, Einstein anticipated Thomas Mann's point, made in 1942 in commenting on his own novel *Joseph und seine Brüder* (1933–36), that myth should be taken out of the hands of Fascism,[42] although from a different, even opposing point of view (both the rejection of Goethe and the praise of Picasso would have horrified Mann). But Picasso's solution to the problem of conventional reality, as Einstein himself pointed out, relied upon a "private mythology." The painter and his model, Picasso's initial idea for the mural for the Spanish pavilion, was a theme rich in private associations. His decision to commemorate a public event presumably forced Picasso to include elements taken from a public and widely shared language — that is, classical mythology.[43]

8.

So far I have focused on the classicizing details — the winged horse, the helmet, the broken sword. But it was noted some time ago that the very structure of the mural has classical overtones. In 1946 A. H. Barr Jr. wrote, "The composition is clearly divided in half; and the halves are cut by diagonals which together form an obvious, gable-shaped triangle starting with the hand at the left, the foot at the right, and culminating at the top of the lamp in the center — a triangle which suggests the pedimental composition of a Greek temple" — a remark that inspired Clement Greenberg's definition of *Guernica* as "a battle scene from a pediment that has been flattened under a defective steam-roller."[44]

The emergence of this composition may be traced in the sketches for *Guernica*. After the appearance on 1 and 2 May of the alternative versions of the ensemble — the one with the helmeted soldier, the other with the picador — a hiatus of a week occurred. On 8 May Picasso started to work again on his mural, creating a series of sketches whose elongated proportions were close to those of the final painting.[45] In addition to sketches related to the horse, the bull, and so forth, a new figure emerged: a woman holding a dead child (figs. 23–25). On 9 May a sketch of the ensemble came very close to the final arrangement. A comparison between this sketch (see fig. 16) and the previous, squarish ones (see figs. 13–15), shows that the inclusion of the woman advancing from the extreme right reoriented the whole composition, emphasizing its friezelike features.

Examination of this turning point in the making of *Guernica* permits us to pass into Picasso's studio-laboratory, and encourages us to see more clearly his attitude toward the pictorial tradition. But first a digression is needed.

9.

Nicolas Poussin's *Death of Germanicus* (fig. 26) has been, as Robert Rosenblum noted many years ago, one of the most influential paintings in the Western pictorial tradition.[46] Commissioned by Cardinal Francesco Barberini in 1626,

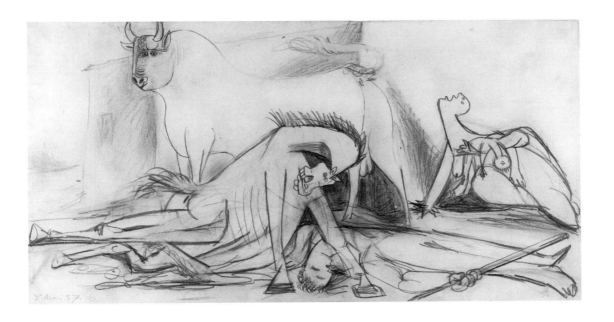

Fig. 23. Pablo Picasso
Study for Guernica, 8 May 1937, pencil on white paper,
24.1 × 45.7 cm (9½ × 17⅞ in.)
Madrid, Museo Nacional Centro de Arte Reina Sofía

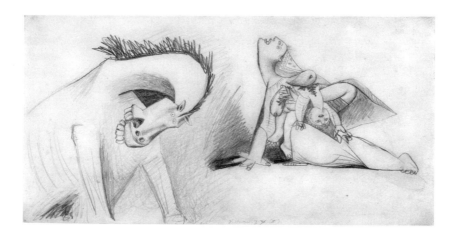

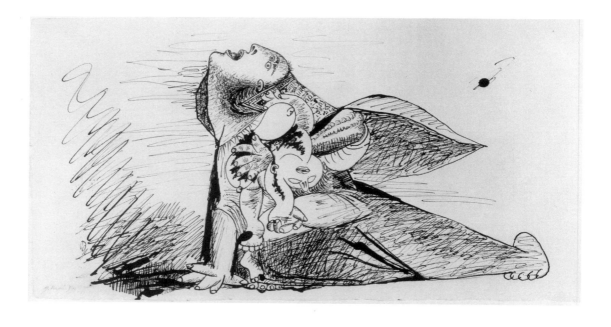

Fig. 24. Pablo Picasso
Study for Guernica, 8 May 1937, pencil on white paper,
24 × 45.5 cm (9½ × 17⅞ in.)
Madrid, Museo Nacional Centro de Arte Reina Sofía

Fig. 25. Pablo Picasso
Study for Guernica, 9 May 1937, pen and ink on white
paper, 24 × 45.3 cm (9½ × 17⅞ in.)
Madrid, Museo Nacional Centro de Arte Reina Sofía

this deathbed scene based on ancient sarcophagi representing the death of Meleager went through innumerable permutations over the course of the eighteenth century. Most of them seem to confirm Francis Haskell's remark that "the achievements of Poussin closed rather than opened avenues for artists — at least until the time of David."[47]

Jean-Baptiste Greuze is the one relevant exception to this rule. Greuze's *The Emperor Septimius Severus Reproaching Caracalla* (fig. 27), a rather slavish imitation of Poussin's *Death of Germanicus* by which he hoped to gain recognition as a history painter, was universally regarded as a failure. In contrast, in the genre scenes for which he was famous, Greuze imaginatively reworked the friezelike arrangement inspired by Poussin's deathbed scene, surrounding his bourgeois characters with a classicizing aura; *The Father's Curse: The Punished Son* (fig. 28) illustrates this perfectly.[48] But it was in the powerful drawing *Death of a Cruel Father Abandoned by His Children* (fig. 29) — exhibited along with *The Emperor Septimius Severus Reproaching Caracalla* at the Salon of 1769 — that Greuze abandoned the stately, solemn language he had taken from Poussin in favor of a frantic mode, which he clearly considered appropriate to a scene devoid of any moral or social dignity.[49] "What a subject! . . . this subject scandalizes me; I am sorry that a Frenchman should have thought of it," a contemporary critic commented.[50] The shock was certainly heightened by the fact that Greuze was then, and for a long time after, widely appreciated as a mild, sentimental painter — an idea that became obsolete only when Willibald Sauerländer demonstrated the profound debt of Greuze's *Pathosfiguren* to Michelangelo and classical sculpture.[51] The reverberations of Michelangelo's *Creation of Adam* (fig. 30) in the *Death of a Cruel Father Abandoned by His Children* are but one instance of the lasting effect of the time Greuze spent in Rome between 1755 and 1757.

If I am not mistaken, it has not been noticed so far that the father's falling body in Greuze's drawing was echoed in Henry Fuseli's most famous work, *The Nightmare* (fig. 31), which dates to 1781.[52] Without Michelangelo, Fuseli would have never existed as an artist, but the specific connection I am pointing to suggests that Fuseli looked not only at both Michelangelo and Greuze but also possibly at Michelangelo *through* the eyes of Greuze.[53] For example, *Julia Appearing to Pompey in a Dream* (fig. 32), a work dated between 1768 and 1770, at the very beginning of Fuseli's time in Rome,[54] brings to mind a passage from Allan Cunningham's biography of Fuseli:

> It was a story which he [Fuseli] loved to repeat, how he lay on his back day after day, and week succeeding week, with upturned and wondering eyes, musing on the splendid ceiling of the Sistine Chapel — on the unattainable grandeur of the Florentine. He sometimes, indeed, added, that such a posture of repose was necessary for a body fatigued like his with the pleasant gratifications of a luxurious city. He imagined, at all events, that he drank in as he lay the spirit of the sublime Michael, and that by studying in the Sistine, he had the full advantage of the mantle of inspiration suspended visibly above him.[55]

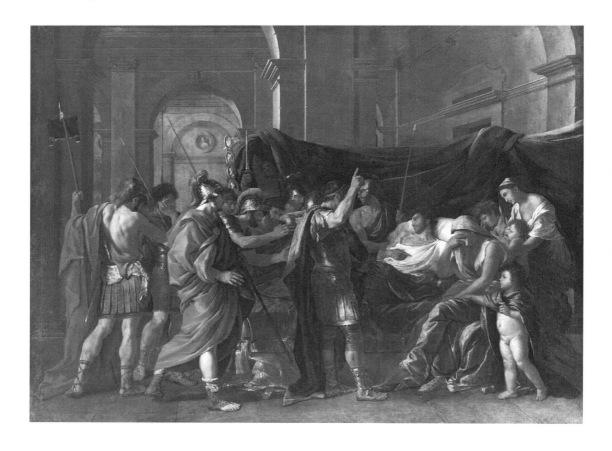

Fig. 26. Nicolas Poussin
Death of Germanicus, 1627, oil on canvas, 148 × 198 cm (58¼ × 78 in.)
Minneapolis, Minneapolis Institute of Arts

Fig. 27. Jean-Baptiste Greuze
The Emperor Septimius Severus Reproaching Caracalla, His Son Who Wanted to Assassinate Him, 1769, oil on canvas, 124 × 160 cm (48⅞ × 63 in.)
Paris, Musée du Louvre

Fig. 28. Jean-Baptiste Greuze
The Father's Curse: The Punished Son, 1778, oil on canvas, 130 × 163 cm (51⅛ × 64⅛ in.)
Paris, Musée du Louvre

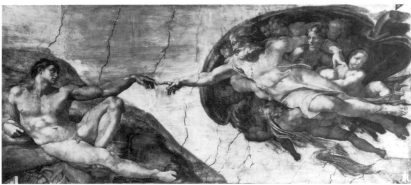

Fig. 29. Jean-Baptiste Greuze
Death of a Cruel Father Abandoned by His Children, 1769,
india and brown ink wash and pencil on paper, 46.8 × 64 cm
(18⅜ × 25¼ in.)
Tournus, Musée Greuze

Fig. 30. Michelangelo
Creation of Adam, ca. 1512, fresco
Rome, Cappella Sistina

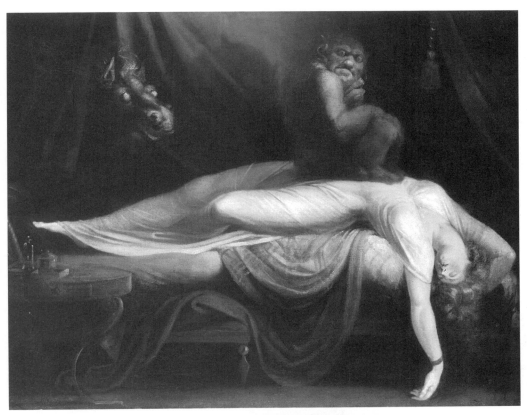

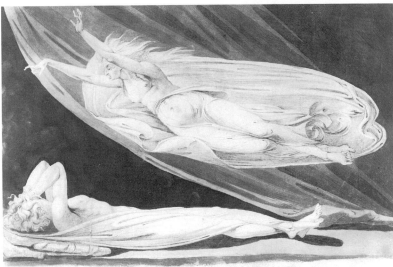

Fig. 31. Henry Fuseli
The Nightmare, 1781, oil on canvas, 101.6 × 127 cm
(40 × 50 in.)
Detroit, Detroit Institute of Arts

Fig. 32. Henry Fuseli
Julia Appearing to Pompey in a Dream, ca. 1768–70, pencil
and watercolor on paper, 26.4 × 38.4 cm (10⅜ × 15⅛ in.)
Manchester, University of Manchester, Whitworth Art
Gallery

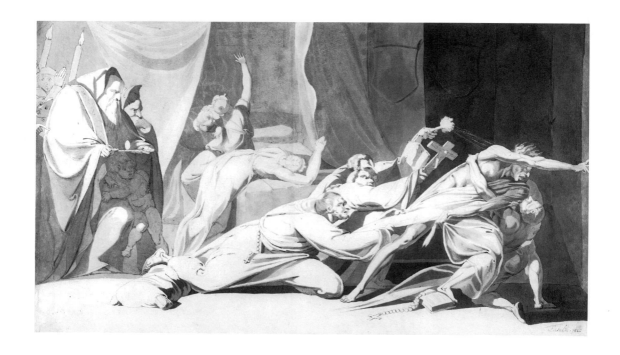

Fig. 33. Henry Fuseli
Scene from the Hospital of Santo Spirito, 1772, pen and
watercolor on paper, 38 × 64 cm (15 × 25¼ in.)
London, British Museum

As we know, Greuze had likewise taken advantage of the "mantle of inspiration" suspended by "the sublime Michael." Other drawings from the Roman years show that Fuseli returned obsessively to the agitated, friezelike composition that Greuze relied on in *Death of a Cruel Father*. Translating Greuze's practice into his own frantic style, Fuseli used the same pattern (although not the same gestures) for a range of subjects focused on extreme emotions — madness, supplication, mourning. A drawing (fig. 33), dated 1772, which Fuseli described as being drawn from a scene he observed in the hospital of Santo Spirito at Rome,[56] illustrates that for Fuseli reality arranged itself according to preexisting *Pathosfiguren* or *Pathosformeln* inspired by Michelangelo — or, more precisely, by a Sturm-und-Drang reading of Michelangelo strongly influenced by both the Italian mannerists and Greuze. Similarly, a copy from a drawing for the (now destroyed) lunette *Phares, Esrom, Aaram* in the Sistine Chapel (fig. 34) was expanded by Fuseli in *The Aetolians Imploring Meleager to Defend the City of Calydon* (fig. 35).[57] In comparing the latter with *Lear Mourning over the Dying Cornelia* (1774; London, British Museum), a drawing Fuseli made in Rome, Frederick Antal observed, "The dynamic way in which, in his [Fuseli's] drawings, long diagonals usually strike right across and dominate the composition, is also uncharacteristic of classicism."[58]

"Classicism" is a word that always needs qualification. In Rome Fuseli saw, and somewhat distantly admired, Poussin's *Death of Germanicus*. He also had a close friendship with Jacques-Louis David, who arrived in Rome in 1775, but their artistic paths never crossed (although I would argue that Fuseli may have helped David to find his own way).[59] The "jerky, agitated classicist style" — I am quoting Antal again — that Fuseli developed in Rome from 1770 on, was as remote as one can imagine from David's interpretation of classical antiquity filtered through Poussin.[60] But some of David's pupils — for example, Anne-Louis Girodet-Trioson and François Jean-Baptiste Topino-Lebrun, who spent some years after the French Revolution as guests of the Accademia di Francia in Rome — drew upon Fuseli to achieve some distance from their imposing master. In 1791–92 Girodet painted *Hippocrates Refusing the Presents of Artaxerxes* (fig. 36) in which he tried to reach a compromise between David's sculptural style and Fuseli's agitated compositions. In this painting, Girodet relied upon his "expression des sentiments de l'âme" [expression of the feelings of the soul], a psychological approach to depicting the human figure that he had developed under the influence of the physiognomic theories of Johann Caspar Lavater, Fuseli's mentor and friend.[61]

Girodet's friend Topino-Lebrun was moving in a similar direction. In Rome, Girodet said of Topino-Lebrun, "il s'y michelangelise" [he is Michelangelizing himself].[62] He could have said "il s'y fuselise" as well. A committed Jacobin, Topino-Lebrun had made the acquaintance of Magdalena Schweizer-Hess, one of Fuseli's friends and models. In turn, she introduced Topino-Lebrun to Lavater as "a painter in the manner of Fuseli of London, a man who is knowledgeable in physiognomy."[63] Topino-Lebrun exhibited at the

Fig. 34. Attributed to Michelangelo or His Workshop
A Man Sleeping, ca. 1510, black chalk on paper, 14 × 14.2 cm
(5½ × 5⅝ in.)
Oxford, Ashmolean Museum

Fig. 35. Henry Fuseli
*The Aetolians Imploring Meleager to Defend the City of
Calydon*, ca. 1771, pen and wash on paper, 36.2 × 53.5 cm
(14¼ × 21 in.)
London, British Museum

Fig. 36. Anne-Louis Girodet-Trioson
Hippocrates Refusing the Presents of Artaxerxes, 1792,
oil on canvas, 99.5 × 135 cm (39⅛ × 53⅛ in.)
Paris, Faculté de Médecine

Fig. 37. François Jean-Baptiste Topino-Lebrun
Death of Caius Gracchus, 1795–97, oil on canvas,
3.87 × 6.15 m (12⅝ × 20⅛ ft.)
Marseille, Musée des Beaux-Arts

Salon of 1798 a large painting representing the death of Caius Gracchus (fig. 37), the Roman tribune killed by aristocrats for his radical ideas on the ownership of land.[64] A year earlier, François-Noël Babeuf, the theorist of agrarian communism who went by the name Gracchus in honor of the tribune, had been convicted of planning to overthrow the Directory and had died under the guillotine. Although Topino-Lebrun's *Death of Caius Gracchus* was rejected by most critics on stylistic grounds—they called it an example of "peinture barbare," or even "peinture tartare" (as a monarchist apparently said)—its political implications could not be missed.[65] It was clearly an homage to the memory of Babeuf, to whom Topino-Lebrun had been politically close.[66] In 1800, Topino-Lebrun himself was guillotined for his involvement in a Jacobin conspiracy against Napoléon Bonaparte.[67]

My digression on a tradition focused on friezelike compositions, expressed in an agitated pictorial language, ends with Topino-Lebrun's large political painting. *Guernica*'s dimensions are quite similar—although a bit more oblong—to those of the *Death of Caius Gracchus*. The two paintings share other specific features as well. First, a friezelike arrangement, which has suggested to some interpreters of *Guernica* the name Jacques-Louis David. David's carefully balanced paintings, such as *Oath of the Horatii* (1784; Paris, Musée du Louvre) or *Intervention of the Sabines* (fig. 38), look very different from *Guernica*, in which nearly all the elements—from the woman with the lamp to the running woman, from the horse's head, which is the center of the painting, to the bull's head—point from right to left, creating a violently unbalanced composition (the exception is provided by the fallen warrior with a broken sword).[68] Partially inspired by Michelangelo's famous *Archers Shooting at a Herm* (fig. 39),[69] as well as by the *Borghese Gladiator* (fig. 40), Topino-Lebrun's composition is likewise dramatically unbalanced toward the group at the extreme left, formed by Caius Gracchus and his slave, who is shown in the act of killing himself with a sword, after having killed his master.

Here I will cite another remark about *Guernica* by Brendel, the classical archaeologist: "The formal composition of the painting itself is very interesting. It is oblong yet centered, as are many monumental compositions of ancient art. Thus even the formal order carries classical overtones. The effect is a certain static monumentality seemingly in contradiction to the vehement movements in which it becomes established, thereby creating a strong feeling of formal tension."[70] These comments suggest why—Picasso's persistent fascination with the neoclassical tradition notwithstanding—the reference to David is, in the case of *Guernica*, unsatisfactory.[71] Topino-Lebrun's attempt to combine David and Fuseli seems much more pertinent. But did Picasso ever see the *Death of Caius Gracchus*?

Appreciation of this remarkable painting presumably has been affected by its political and stylistic features. In 1798 it was acquired by the state, exhibited for some years in the Mairie du Midi in Marseille, apparently mutilated, then resold in 1809; it reappeared in 1876, when it was acquired and restored

Fig. 38. Jacques-Louis David
Intervention of the Sabines, 1799–1804, oil on canvas,
3.85 × 5.22 m (12⅝ × 17 ft.)
Paris, Musée du Louvre

Fig. 39. Michelangelo
Archers Shooting at a Herm, ca. 1531, red chalk on paper,
21.9 × 32.3 cm (8⅝ × 12¾ in.)
Windsor, Windsor Castle, Royal Library

Fig. 40. Agasias of Ephesus
Borghese Gladiator, ca. 100 B.C., marble, 157 cm (61¾ in.)
Paris, Musée du Louvre

by the painter Charles Glize, who then sold it to the Musée des Beaux-Arts in Marseille; it was put in storage in 1942 and forgotten until 1974, when it was rediscovered, restored once again, and exhibited. In 1908 it was listed and reproduced in the catalog of the Musée des Beaux-Arts.[72] Picasso spent two days in Marseille with Georges Braque in August 1912. "In a postcard to Kahnweiler," William Rubin wrote in the catalog for the exhibition *"Primitivism" in Twentieth-Century Art,* "Braque speaks of having shown Picasso around the city and having 'bought up all the African objects' ('... avoir acheté tous les nègres')."[73] We do not know whether on that occasion the two also visited the Musée des Beaux-Arts.

Picasso had an incredible visual memory. A recollection of the *Death of Caius Gracchus* could have remained in storage for twenty-five years before being activated during his work on *Guernica*.[74] I cannot prove this; but the point I would like to make above all is a different one. I think that the pictorial tradition I have pointed to, which Picasso may have known through a variety of sources, provides a framework for understanding *Guernica*'s contradictory attempt to "approximate [cubism] to the museum and Michelangeloesque idea of a grand style" impaired by Picasso's "innate lack of capacity for *terribilità*."[75] These remarks made by Clement Greenberg in 1957, although directed at Picasso's large paintings of the 1940s and 1950s, also apply to *Guernica*—a much more powerful painting, of course. But if Greenberg's allusion to Picasso's alleged innate lack of *terribilità* sounds absurd in front of a painting such as *Les demoiselles d'Avignon* (1907; New York, Museum of Modern Art), it is difficult to deny that *Guernica* was ultimately unable to achieve its monumental ambitions. Of this, Picasso himself was probably aware.[76]

10.

Timothy Hilton, who has made some valuable comments (which I have tried to qualify) on the neoclassical element in *Guernica*, has stated that

> an immediately recognizable link between *Guernica* and a neo-classical painting would be in the combination of stasis and turmoil; controlled with such a clench in neo-classical paintings of the best sort, though falling apart in Picasso. The reason why the protagonists of neo-classical battle paintings can be so frozen in their attitudes and yet appear so powerful is that they are charged with precision. *Guernica* is a *vague* painting. Nobody knows what is going on in it, and it is the merest literary double-talk to maintain that this is what gives it universal application. The vagueness is iconographic: there is no possible reading for the bull, the dominant figure, because it is always possible that the bull might stand for something else. But it is also pictorial: why should we have to decide whether the light in this barn is electric or supernatural?[77]

I will try to address this vagueness. My starting point will be a large still life known as *Studio with Plaster Head* (fig. 41) that Picasso painted in 1925.[78]

Fig. 41. Pablo Picasso
Studio with Plaster Head (*Tête et bras de plâtre*), 1925,
oil on canvas, 97.9 × 131.1 cm (38⅝ × 51⅝ in.)
New York, Museum of Modern Art

Picasso, as Hilton noted, never forgot any painting he made.[79] *Studio with Plaster Head* was in many ways an anticipation of *Guernica*. The plaster bust became a toppled warrior; the plaster hand holding a baton or scepter became a hand holding a broken sword; the book or newspaper was projected into the horse's body. On a more general level, *Studio with Plaster Head* attempted to combine a style broadly based on cubism with references to classical antiquity. But the mood of the two paintings is different: *Guernica* is tragic, *Studio with Plaster Head* has an ironic quality that, as Hilton has commented, recalls Giorgio De Chirico's contemporary, and no less ironic, evocations of antiquity.[80] The square over the table is not, as has been absurdly suggested, an allusion to Freemasonry but a quotation from De Chirico, the son of an engineer, who obsessively included in his paintings the tools of his father's profession. Strangely enough, Picasso also included in his *Studio with Plaster Head* references to his own father. In October 1943, after pointing out to Picasso that in a recent series of drawings all the men wore beards, like Zeus the Father, Brassaï received this disconcerting answer: "Yes. They all have beards... And do you know why? Every time I draw a man, involuntarily it's my father I'm thinking of... For me, a man is 'Don José,' and will be all my life... He wore a beard...."[81] The Freudian implications of these words are obvious, and Picasso was certainly aware of them. They suggest a personal overtone that is reinforced by the presence of the plaster casts. José Ruiz Blasco was an academic painter as well as a professor of drawing at fine arts academies in Malaga, Corunna, and Barcelona, and the first teacher of his son, Pablo. In an essay full of tact and insight Ernst Gombrich has commented on the psychological ambivalence that Pablo Ruiz Picasso—who from an early date signed his works with his mother's family name rather than his father's—developed from childhood toward the academy, and toward the pictorial tradition in general.[82] "I never made the drawings of a child," Picasso once said to the painter Balthus in a melancholy tone.[83]

Brendel has called attention to the psychological implications of *Guernica*'s fallen warrior: "the arm with the sword, by way of a grim paradox, reminds us of the academic plaster casts."[84] These personal overtones do not diminish—in fact, they reinforce—the political message of the mural. Father and fatherland are not mutually exclusive. But the broken sword, whose anachronism is emphasized by the presence of the lightbulb, suggests that the weapons of tradition are pathetically ineffective against Fascist aggression.[85] "Don't start from the good old things but the bad new ones," as Bertolt Brecht said to his friend Walter Benjamin at about this time.[86]

11.

The references to Spain, Picasso's homeland, in *Guernica* are obvious—the bull, the horse. Their meaning has often been discussed in the abundant literature on *Guernica*'s iconography. In 1945 Picasso said to Jerome Seckler: "Yes... the bull there [in *Guernica*] represents brutality, the horse the people. Yes, there I used symbolism, but not in the others." "My work is not sym-

bolic," Picasso went on. "Only the *Guernica* mural is symbolic. But in the case of the mural, that is allegoric. That's the reason I've used the horse, the bull and so on. The mural is for the definite expression and solution of a problem and that is why I used symbolism." Later he explains, "There is no deliberate sense of propaganda in my painting." "Except in the *Guernica*," Seckler suggested. "Yes," Picasso replied, "except in the *Guernica*. In that there is a deliberate appeal to people, a deliberate sense of propaganda."[87] But two years later, in a letter written to Barr by Daniel-Henri Kahnweiler, Picasso offered another interpretation, or more precisely no interpretation at all. "But this bull is a bull and this horse is a horse," he said, echoing his old friend Gertrude Stein.[88] As a piece of propaganda *Guernica* is very strange indeed. Picasso, as we will see, deliberately erased all political allusion from it. In this icon of anti-Fascist art, Fascism is absent. Is *Guernica*, then, a timeless image of violence, of war? Is it a slaughter of the innocents, as Anthony Blunt suggested?[89] Why are the slaughterers not represented?

To solve this crucial difficulty let us focus on a detail: the head of the fallen warrior, done at one of the last stages of the mural (figs. 42, 43). As pointed out long ago, this detail was inspired by a miniature depicting the Deluge (fig. 44) in an eleventh-century Spanish manuscript at the Bibliothèque Nationale: an illustrated commentary by Beatus of Liébana, known as the *Apocalypse of Saint Sever*. There has been some disagreement as to how Picasso became aware of this image. That he found it in some obscure or scholarly work seems very unlikely. But even the scholars who solved the puzzle have failed to recognize the significance of the source for Picasso.[90]

Picasso came across the miniature as an illustration to an essay on the *Apocalypse of Saint Sever* published in 1929 in the journal *Documents*.[91] The author of the essay, Georges Bataille, was a director of the journal (along with Carl Einstein and several others). Bataille commented at length on the genre of miniatures illustrating the Deluge, stressing their "gross realism and emotional grandeur," which he took to be a "symptom of the extreme disorder of unbound human reactions."[92] We do not know whether Picasso read the article — an idiosyncratic mixture of erudite remarks and the fascination with cruelty that was to become a recurring element in Bataille's work.

Documents, an illustrated journal bearing the subtitle *Doctrines* [later *Variétés*], *archéologie, beaux-arts, ethnographie,* was an extraordinary intellectual enterprise that lasted from 1929 to 1934. Its impact has belied its short existence. In 1991, the entire run of the journal was republished with an introduction by Denis Hollier in which Hollier focuses nearly exclusively on the role of Bataille; he barely mentions Einstein, who either wrote or planned most of the articles devoted to art historical issues.[93] It was Einstein who planned the issue of *Documents* devoted to Picasso. Bataille contributed to this issue, published in 1930, a short, dense piece called "Soleil pourri" [Rotten Sun].[94] Bataille wrote in this piece that the sun at noon is the loftiest human conception, the most abstract entity, since it cannot be looked at. It is the poetical symbol of mathematical detachment, of spiritual elevation. But if

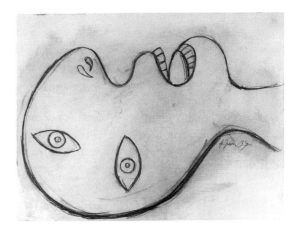

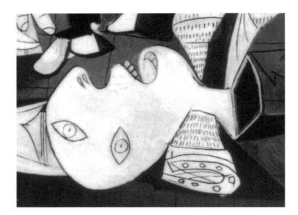

Fig. 42. Pablo Picasso
Study for Guernica, 4 June 1937, pencil and gray gouache on white paper, 23.2 × 29.2 cm (9¼ × 11½ in.)
Madrid, Museo Nacional Centro de Arte Reina Sofía

Fig. 43. Pablo Picasso
Guernica (detail)
Madrid, Museo del Prado

Fig. 44. *The Deluge*, 1028–72, illuminated manuscript, 36.5 × 28 cm (14⅞ × 11 in.)
From Beatus of Liébana, *Apocalypse de Saint-Sever,* MS lat. 8878, 85r
Paris, Bibliothèque Nationale de France

we succeed in stubbornly staring at the sun—an act that in itself implies a sort of madness—what appears is not production but evacuation (*déchet*) and combustion, expressed, on a psychological level, "by the horror given off by an incandescent arc-lamp."[95] After a digression on Mithraic cults, Bataille closed by identifying the productive sun with academic painting, as a form of balanced spiritual elevation, and the rotten sun with modern painting, especially the work of Picasso, since it aimed at excess, at the rejection of elevation, at formal elaboration or decomposition.[96]

12.

"Soleil pourri" is one of the earliest documents in Bataille's private mythology. I will attempt to decipher some of its implications. But first I would like to show that Picasso, its nominal addressee, was impressed by it at the very moment at which he was working on *Guernica*.

The various stages of the mural can be reconstructed through photographs made by Dora Maar, who was then Picasso's lover. Between 1934 and 1935 she had had an affair with Bataille. At that time Bataille was the leader of Masses, a minuscule Leftist group in which Maar was involved as well. In Maar's photograph of the first stage (fig. 45), dated 11 May 1937, the mural looked very different from its final version—the most prominent difference being the fallen warrior, who was depicted in the act of raising his clenched fist in the communist salute (a theme that had emerged in the last ensemble sketch, dated 9 May).[97] By the second stage (fig. 46), which dates to about 13 May, the gesture's political connotations were disappearing: the fist is raised against a huge sun and grasps a bunch of flowers.[98] At the third stage (fig. 47), which dates to between 16 and 19 May, both the fist and the sun were erased.

It has been suggested that this excision of the only explicit political symbol in the mural was Picasso's response to the events that took place in Barcelona between 3 and 8 May: a bloody street battle between communists and anarchists (five hundred people were killed) that led to the resignation of the prime minister, Largo Caballero, in favor of Juan Negrín Lopez, who was much closer to the Communist Party.[99] This hypothesis, which probably needs more supporting evidence, is not incompatible with the one I am going to propose.

At the third stage, the sun and the fist grasping the flowers were replaced by an oval shape, which in the fourth stage (fig. 48) became an oval and, finally, an eye-shaped sun with a lightbulb for an iris (see fig. 1).[100] Through a sequence of destructions, Picasso transformed the sun of production into the sun of decay, the rotten sun described by Bataille, the sun figured in "the horror given off by an incandescent arc-lamp."[101]

13.

At the entrance to the Spanish pavilion at the International Exhibition, one could read a poem by Paul Eluard, "La victoire de Guernica."[102] But neither Guernica nor Picasso's *Guernica* was a victory. Eluard, at that time probably Picasso's closest friend, must have liked the sun and the clenched fist. But the

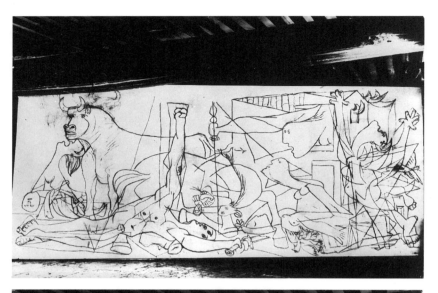

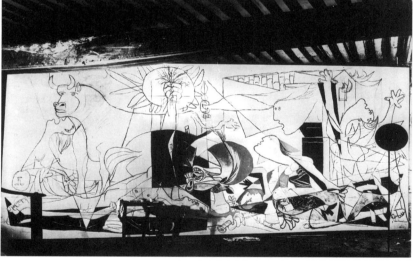

Fig. 45. Dora Maar
Guernica, Stage 1, 11 May 1937
From *Cahiers d'art* 12 (1937): 146

Fig. 46. Dora Maar
Guernica, Stage 2, ca. 13 May 1937
From *Cahiers d'art* 12 (1937): 147

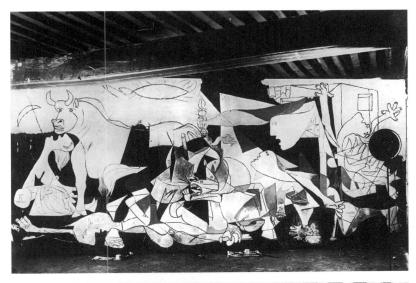

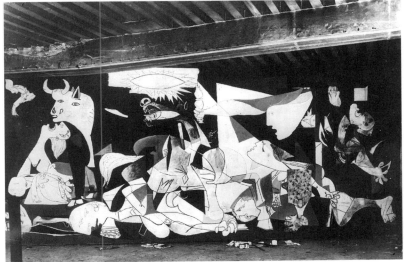

Fig. 47. Dora Maar
Guernica, Stage 3, ca. 16–19 May 1937
From *Cahiers d'art* 12 (1937): 148

Fig. 48. Dora Maar
Guernica, Stage 4, ca. 20–24 May 1937
From *Cahiers d'art* 12 (1937): 149

mural took a different direction, away from Eluard's surrealist-communist rhetoric.[103] Instead, as we have seen, the later stages of *Guernica*—a work that also had its own private dimension—incorporated elements from Georges Bataille's private mythology.

To make the unconscious public, to communicate at an unconscious level— this was, of course, the dream of the surrealists. Picasso had been close to them; Bataille had been first a member of their sect, then a heretic. The rejection of idealism, which is a prominent theme of Bataille's early work (including his text on Picasso, "Soleil pourri"), had an aggressive antisurrealist element. But it had a personal element as well. Readers of *Histoire de l'oeil*, Bataille's first pornographic novel—published under a pseudonym in 1928, apparently under the influence of his psychoanalyst—will recall its final section, which reveals a story with chilling autobiographical coincidences behind the fiction.[104] *L'anus solaire*, written in 1927 and published in 1931 with illustrations by André Masson, projected the sexual and scatological obsessions of *Histoire de l'oeil* into a cosmology full of political implications. The father, the blinding sun (Bataille's father was blind), and the proletarian, were exalted as expressions of "the low," of unproductive sexuality, of putrefaction and decay, and therefore opposed to what is high and noble, to nature as a generating force, to the "asexuated and noble heads of the bourgeoisie, which we will cut."[105]

In the 1930s Bataille became a leading presence on the Parisian intellectual and political scene. In addition to *Documents*, he contributed to Boris Souvarine's journal *La critique sociale;* started two Leftist groups, Masses and Contre-Attaque; and was among the organizers of the short-lived Collège de Sociologie.[106] His hostility toward France's Popular Front government led him, in March 1936, to sign a Contre-Attaque flyer ending, "We prefer to it, in any event, Hitler's antidiplomatic brutality, more peaceful, in fact, than the slimy excitement of the diplomats and politicians." A later version of this flyer reworked this sentence and added the qualifier "without being easily deceived."[107] This episode was not unique, an *accident de parcours*. Bataille's attitude toward Fascism was deeply ambiguous. He was fascinated by its aesthetic of violence, by its excesses. But he also insisted on several occasions that Fascism had to be fought on its own battleground, in the sphere of mass emotions.[108] This leads us back to *Guernica*.

14.

Guernica was finished in June 1937, and exhibited in July—the month in which Bataille published a double issue of his new journal, *Acéphale*.[109] The multiple meanings of *acéphale* (headless) captured some of Bataille's deepest themes—his fascination with violence, and specifically with beheading, as well as with irrationality, unreason, headlessness.[110] The double issue of July 1937 included Bataille's "Chronique nietzschéenne," in which he attacked the Nazi interpretation of Friedrich Nietzsche. But one section of this piece is a digression on a theatrical event that had taken place in April and May 1937: the production *Numance*, a French version of Miguel de Cervantes's late-

sixteenth-century play about the historic siege of the Spanish city of Numancia by the Roman army.[111] Jean-Louis Barrault, the director of the production, and André Masson, the painter (and Bataille's close friend) who had been the responsible for the sets and costumes, had underscored, as it had been done already in Spain, the parallel between ancient Numancia and contemporary Madrid, which was at that time under siege by Franco's army. Bataille subscribed to the political interpretation of the play but pushed it to a metaphysical extreme, as an opposition between the Romans, "a Caesarian entity, based on a leader," and the inhabitants of Numancia, an acephalous community, "a community without a leader connected by the obsessive image of tragedy." Human beings, Bataille went on, can be assembled either by a leader or by tragedy: "the emotional element which gives an obsessive value to a communal existence is death." On these grounds, Bataille rejected the opposition between Fascism and anti-Fascism, presenting it as "a comedy which, under the appearance of democracy, opposes the Soviet and the German Caesarian systems." He therefore rejected the anti-Fascist movement as "an empty assembling, a vast decomposition of human beings connected only by negation." To fight "Fascist misery," he went on, we need "the community of hearts symbolized by Numancia"—a community connected by tragedy and death.[112]

15.

Bataille and Picasso moved in the same circles, shared a lover and various friends. Whether they saw each other in the months in which Picasso was painting *Guernica* and Bataille was writing his pages on *Numance,* I do not know. But Bataille's ambiguous critique of the limits of anti-Fascism may throw light on the paradox of *Guernica*—a quintessential anti-Fascist painting from which the Fascist enemy is absent, replaced by a community of humans and animals connected by tragedy and death.

Notes

A version of this essay has been published in German as *Das Schwert und die Glühbirne: Eine neue Lektüre von Picassos* Guernica (Frankfurt am Main: Suhrkamp, 1999).

1. Brassaï, *Picasso and Co.,* trans. Francis Price (London: Thames & Hudson, 1967), 100 (ellipses in original); originally published as *Conversations avec Picasso* (Paris: Gallimard, 1964), 123:

> Pourquoi croyez-vous que je date tout ce que je fais? C'est qu'il ne suffit pas de connaître les oeuvres d'un artiste. Il faut aussi savoir quand il les faisait, pourquoi, comment, dans quelle circonstance. Sans doute existera-t-il un jour une science, que l'on appellera peut-être « la science de l'homme », qui cherchera à pénétrer plus avant l'homme à travers l'homme-créateur...Je pense souvent à cette science et je tiens à laisser à la postérité une documentation aussi complète que possible...Voici pourquoi je date tout ce que je fais (ellipses in original).

2. This point has been made by Anthony Blunt, who cites Picasso's forty-five preliminary studies and a set of photographs by Dora Maar of the mural at seven different stages; see Anthony Blunt, *Picasso's Guernica* (London: Oxford Univ. Press, 1969), 26, 28. These studies and photographs all appear in Ellen C. Oppler, ed., *Picasso's Guernica: Illustrations, Introductory Essay, Documents, Poetry, Criticism, Analysis* (New York: W. W. Norton, 1988), figs. 1–52.

3. I would like to acknowledge here my debt to what other scholars have written either on Picasso or on *Guernica* specifically. See, in particular, Otto J. Brendel, "Classic and Non-Classic Elements in Picasso's *Guernica*," in Whitney J. Oates, ed., *From Sophocles to Picasso: The Present-Day Vitality of the Classical Tradition* (Bloomington: Indiana Univ. Press, 1962), 121–59; Rudolph Arnheim, *Picasso's Guernica: The Genesis of a Painting* (London: Faber & Faber, 1964); Blunt, *Picasso's Guernica* (note 2); Timothy Hilton, *Picasso* (London: Thames & Hudson, 1981); and Werner Spies, "*Guernica* und die Weltausstellung Paris 1937," in idem, *Kontinent Picasso: Ausgewählte Aufsätze aus zwei Jahrzehnten* (Munich: Prestel, 1988), 62–99.

4. An earlier representation of the mass bombing of civilians occurs in Lev Kuleshov's film *Luch smerti* (1925; The Death Ray).

5. The essential reference is Catherine Blanton Freedberg, *The Spanish Pavilion at the Paris World's Fair of 1937*, 2 vols. (New York: Garland, 1986).

6. See Kenneth Frampton, "A Synoptic View of the Architecture of the Third Reich," *Oppositions*, no. 12 (1978): 68, 69.

7. Heinrich Hoffmann, *Deutschland in Paris, ein Bild-Buch* (Munich: Heinrich Hoffmann, 1937), 105.

8. Otto Karl Werckmeister, "The Political Confrontation of the Arts at the Paris World Exposition of 1937," *Arts and Sciences* [Northwestern University] 7, no. 2 (1984): 11–16, esp. 14.

9. Anthony Blunt, "Art in Paris," *Spectator* [London], 6 August 1937, 241. The artist's isolation in the capitalist world is the major theme in Blunt's "Art under Capitalism and Socialism," in C. Day Lewis, ed., *The Mind in Chains: Socialism and the Cultural Revolution* (London: F. Muller, 1937), 103–22 (see also, on p. 113, a rather disparaging allusion to Picasso).

10. Blunt, *Picasso's Guernica* (note 2), 26: "the symbols which Picasso used in Guernica were not invented suddenly for that painting but had been evolving…in the artist's mind during the previous years; but, whereas in the earlier phase they had been a means of expressing a private and personal tragedy, under the impulse of the Spanish Civil War Picasso was able to raise them to an altogether higher plane and use them to express his reactions to a cosmic tragedy."

11. Cf. Freedberg, *The Spanish Pavilion* (note 5), 1:83 n. 60, 222 n. 3, who says that four of the forty national pavilions—those of Germany, Russia, Belgium, and Italy—were ready on the opening day of the fair, 25 May 1937, but a further seventeen were functioning by week's end and most opened their doors during the following week. See also Georges Lefranc, *Histoire du Front populaire (1934–1938)* (Paris: Payot, 1965), 241.

12. This point has been made repeatedly, especially with regard to the German and the Soviet pavilions. See, for example, Hoffmann, *Deutschland in Paris* (note 7), 24,

117, 5. Spies, "*Guernica* und die Weltausstellung" (note 3), 80–81, quotes a passage from the first version of Theodor W. Adorno and Max Horkheimer's *Dialektik der Aufklärung* (1944) on the convergence between the German and the Soviet pavilions; the authors subsequently deleted this comparison.

13. Wolfgang Büchel, *Karl Friedrich Schinkel* (Reinbeck bei Hamburg: Rowohlt, 1994), 138, quoting Albert Speer, *Spandauer Tagebücher* (Berlin: Propyläen, 1975), 17: "ein zweiter Schinkel werden." Commenting on Hitler's well-known hostility toward Alfred Rosenberg, Speer has stated, "Hitler did not like him very much, he [Hitler] was really too much inclined to the Doric style, not the northern"; see "Interview with Albert Speer by Francesco Dal Co and Sergio Polano, October 1977," *Oppositions*, no. 12 (1978): 45.

The Ewige Wache temples were built on the Königslichen Platz in Munich in 1934 following plans by Adolf Hitler's personal architect, Paul Ludwig Troost; they housed the remains of the so-called Nazi martyrs killed in the Munich "beer hall" putsch of 1923. They were demolished in January 1947; see Gavriel D. Rosenfeld, *Munich and Memory: Architecture, Monuments, and the Legacy of the Third Reich* (Berkeley: Univ. of California Press, 2000), 89.

14. Gottfried Benn, "Dorische Welt: Eine Untersuchung über die Beziehung von Kunst und Macht," in idem, *Sämtliche Werke*, vol. 4, *Prosa 2, 1933–1945*, ed. Gerhard Schuster (Stuttgart: Klett-Cotta, 1989), 124–53; first published in Benn's *Kunst und Macht* (Stuttgart: Deutsche Verlags-Anstalt, 1934). See also Elizabeth Rawson, *The Spartan Tradition in European Thought* (Oxford: Clarendon, 1969).

15. On Mukhina's sculpture, see Burkhard Fehr, *Die Tyrannentöter, oder, Kann man der Demokratie ein Denkmal setzen?* (Frankfurt am Main: Fischer, 1984), 54–63. On the role of *The Tyrant-Killers* within the classical tradition, see Ernst Bloch, "Racial Theory in the Vormärz (1934)," in idem, *Heritage of Our Times*, trans. Neville Plaice and Stephen Plaice (Berkeley: Univ. of California Press, 1991), 86–87; originally published in *Erbschaft dieser Zeit*, enl. ed. (Frankfurt am Main: Suhrkamp, 1962), 90–93.

16. See *Exposition internationale des arts et des techniques dans la vie moderne, Paris 1937: Catalogue officiel*, vol. 2, *Catalogue par pavillons*, 2d ed. (Paris: R. Stenger, 1937), 378–80.

17. Freedberg, *The Spanish Pavilion* (note 5), 1:172.

18. See *Exposition internationale* (note 16), 131–32. In addition to *Guernica* and the five sculptures inspired by Marie-Thérèse Walter, Picasso exhibited his series of etchings *The Dream and Lie of Franco* and *Guernica*; see Freedberg, *The Spanish Pavilion* (note 5), 1:316–36; and Marko Daniel, "Spain: Culture at War," in Dawn Ades, Tim Benton, David Elliott, and Iain Boyd Whyte, *Art and Power: Europe under the Dictators, 1930–45*, exh. cat. (London: Thames & Hudson, 1995), 65, 66. Freedberg was the first to identify the three sculptures exhibited inside as *Head of a Woman with Globular Eyes* (1932; cement cast, Antibes, Musée Picasso), *Bust of a Woman* (1932; cement cast, Antibes, Musée Picasso), and *Figure of a Woman* (1932).

19. Eberhard Fisch, Guernica *by Picasso: A Study of the Picture and Its Context*, trans. James Hotchkiss, 2d ed. (Lewisburg, Penn.: Bucknell Univ. Press, 1988), 18–19; originally published as *Picasso,* Guernica: *Eine Interpretation* (Freiburg: Herder, 1983).

20. See "Symposium on *Guernica,* Museum of Modern Art, 25 November 1947," typescript, Museum of Modern Art Archives, New York; I have edited Sert's remarks slightly for the sake of clarity. See also Freedberg, *The Spanish Pavilion* (note 5), 1:611, 650–51.

21. Fisch, Guernica *by Picasso* (note 19), 19.

22. Spies, "*Guernica* und die Weltausstellung" (note 3), 83.

23. See, for example, Werner Spies, "Picasso und seine Zeit, II: Die Weltgeschichte im Atelier," in Werner Spies, ed., *Pablo Picasso: Eine Ausstellung zum hundertsten Geburtstag: Werke aus der Sammlung Marina Picasso,* exh. cat. (Munich: Prestel, 1981), 19–33. In another essay, Spies argues that the "initial shock" for *Guernica* was provided by Hans Baldung Grien's woodcut, *The Bewitched Groom* (1544), which was included in Alfred H. Barr Jr., ed., *Fantastic Art, Dada, Surrealism,* exh. cat. (New York: Museum of Modern Art, 1936), fig. 7. Spies himself undermines this argument by pointing out that Picasso had used the iconographic device of the woman with a torch in two works dating to 1934, *Bullfight* and *Composition;* see Spies, "*Guernica* und die Weltausstellung" (note 3), 72, 74 n. 12

24. Frank D. Russell, *Picasso's* Guernica: *The Labyrinth of Narrative and Vision* (London: Thames & Hudson, 1980), 116, identified the woman holding a lamp with Picasso on the basis of a (in my view nonexistent) physical resemblance.

25. Brendel, "Classic and Non-Classic Elements" (note 3), 133. Carl Einstein, *Die Kunst des 20. Jahrhunderts,* 3d ed. (Berlin: Propyläen, 1931), 76: "dann bricht man in private Mythologie auf"; the passage does not appear in the first edition (1926) or the second (1928).

26. Brendel, "Classic and Non-Classic Elements" (note 3), 137. See also the unconvincing suggestion made by Meyer Schapiro, "Picasso's *Woman with a Fan:* On Transformation and Self-Transformation," in Larissa Bonfante and Helga von Heintze, eds., *In Memoriam Otto J. Brendel: Essays in Archaeology and the Humanities* (Mainz: Phillip von Zabern, 1976), 249–54, esp. 253 n. 13, comparing the woman with the lamp in *Guernica* to François Rude's *La Marseillaise* (1833–36; Paris, Arc de Triomphe), Eugène Delacroix's *Liberty on the Barricades* (1830; Paris, Musée du Louvre), and Pierre Paul Prud'hon's *Justice and Divine Vengeance Pursuing Crime* (1808; Paris, Musée du Louvre). Fisch, Guernica *by Picasso* (note 19), 42–46, interprets her as representing both an Erinys and Lucifer.

27. Michel Leiris, *Journal 1922–1989,* ed. Jean Jamin (Paris: Gallimard, 1992), 595 (29 September 1963): "Il semblerait que, décidément, la peinture — l'acte de peindre — soit pour P[icasso] le thème majeur." Whenever a published source is not cited, the translation is mine.

28. Christian Zervos, "Statement by Picasso: 1935," trans. Myfanwy Evans, in Alfred H. Barr Jr., *Picasso: Fifty Years of His Art* (New York: Museum of Modern Art, 1946), 272; originally published as "Conversation avec Picasso," *Cahiers d'art* 10 (1935): 173:

> Auparavant les tableaux s'acheminaient vers leur fin par progression. Chaque jour apportait quelque chose de nouveau. Un tableau était une somme d'additions. Chez moi, un tableau est une somme de destructions. Je fais un tableau, ensuite je le

détruis. Mais à la fin du compte rien n'est perdu; le rouge que j'ai enlevé d'une part se trouve quelque part ailleurs.

Il serait très curieux de fixer photographiquement, non pas les étapes d'un tableau, mais ses métamorphoses. On s'apercevrait peut-être par quel chemin un cerveau s'achemine vers la concrétisation de son rêve. Mais ce qui est vraiment très curieux, c'est d'observer que le tableau ne change pas au fond, que la vision initiale reste presque intacte malgré les apparences.

Juan Larrea has interpreted this passage as referring to *Guernica;* see Roland Penrose, *Picasso: His Life and Work,* 3d ed. (Berkeley: Univ. of California Press, 1981), 302; see also Blunt, *Picasso's* Guernica (note 2), 28.

29. Perhaps because a bird surfaced in the final version of the painting.

30. Blunt, *Picasso's* Guernica (note 2), 12. Picasso also designed the scenery and "cubist" costumes for *Parade,* and the choreography was by Léonide Massine. *Guernica's* connection with *Parade* had been pointed out, in a broader terms, by Francesco Arcangeli in his unsympathetic but very perceptive article, "Picasso, 'voce recitante,'" *Paragone,* no. 47 (1953): 73.

31. *Parade's* influence has been noted by, for example, Hilton, *Picasso* (note 3), 138–39. See, in general, Deborah Menaker Rothschild, *Picasso's Parade: From Street to Stage* (London: Sotheby's Publications / Drawing Center, New York, 1991).

32. Giovanni Carandente, "Il viaggio in Italia: 17 febbraio 1917," in *Picasso: Opere dal 1895 al 1971 dalla Collezione Marina Picasso,* exh. cat. (Florence: Sansoni, 1981), 45–57.

33. Jean Cocteau, *Le rappel à l'ordre,* 13th ed. (Paris: Stock, 1926), 294–95 (see n. 6 on *Parade* and Cocteau's journey to Rome).

34. The drawing was reproduced in Cocteau's *Le coq et l'arlequin* (Paris: Editions de la Sirène, 1918); see Jean Cocteau, *Entre Picasso et Radiguet,* ed. André Fermigier (Paris: Hermann, 1967), 20.

35. Marcel Proust, "Introduction," in Jacques-Emile Blanche, *Propos de peintre,* vol. 1, *De David à Degas* (Paris: Emile-Paul Frères, 1919), xxii: "Certainement, comme Jean Cocteau, Jacques Blanche rendrait justice au grand, à l'admirable Picasso, lequel a précisément concentré tous les traits de Cocteau en une image d'une rigidité si noble qu'à côté d'elle se dégradent un peu dans mon souvenir les plus charmants Carpaccio de Venise."

Eugène Fromentin's *Les maîtres d'autrefois: Belgique-Hollande* (Paris: E. Plon, 1876) has been published in English as *The Masters of Past Time: Dutch and Flemish Painting from Van Eyck to Rembrandt,* trans. Andrew Boyle, ed. H. Gerson (London: Phaidon, 1948).

36. Cocteau, *Le rappel* (note 33), 51.

37. Ernst Bloch, "Time-Echo Stravinsky [1928]," in idem, *Heritage of Our Times,* trans. Neville Plaice and Stephen Plaice (Berkeley: Univ. of California Press, 1991), 216–17; originally published in *Erbschaft dieser Zeit* (Zürich: Oprecht & Helbling, 1935), 176–77:

Diese Starre ist der Tribut des späteren Stravinskij an die Pariser Reaktion, ja, an die kapitalistische Stabilisierung der Welt; dem entstammt auch, was man den

„Objektivismus" dieser Musik nennt. Er ist betonte Entfremdung von aller Psychologie, doch auch von allem Menschlichen.... Cocteaus lateinischer Text noch ganz andere, ja, fast rätselhafte Elemente von Faschismus hinzuließ.... Picasso, Stravinskij, Cocteau — sie sind, antiker Form sich nähernd, ein Dreiklang geworden und die letzte Verführung zu „Maß", die die Oberschicht der Bourgeoisie, in letzter Stunde, hervorgebracht hat.

38. Carl Einstein, "Obituary: 1832–1932," trans. Eugène Jolas, in idem, *Werke,* vol. 3, *1929–1940,* ed. Marion Schmid and Liliane Meffre (Vienna: Medusa, 1985), 535–41; originally published (in Jolas's English translation) in *Transition,* no. 21 (1932): 207–14. See also Sibylle Penkert, *Carl Einstein: Beiträge zu einer Monographie* (Göttingen: Vandenhoele & Ruprecht, 1969); Heidemarie Oehm, *Die Kunsttheorie Carl Einsteins* (Munich: W. Fink, 1976); *Kritische Berichte* 13, no. 4 (issue on Carl Einstein) (1985); and the new edition of Carl Einstein's *Die Kunst des 20. Jahrhunderts,* ed. Uwe Fleckner and Thomas W. Gaehtgens (Berlin: Fannei & Walz, 1996), which includes an important introductory essay.

39. Einstein, "Obituary" (note 39), 537.

40. Einstein, "Obituary" (note 39), 540.

41. Carl Einstein, "The Dinard Period," trans. A. D. Simons, in Gert Schiff, ed., *Picasso in Perspective* (Englewood Cliffs, N.J.: Prentice-Hall, 1976), 72–73; excerpted from the third edition of Einstein's *Die Kunst des 20. Jahrhunderts* (note 25), 96:

Picasso schuf damals eine Reihe Figurenbilder, Geschöpfe einer formalen Mythologie.... Die unmittelbaren Gesichte erscheinen dem Nachahmerischen, Gewöhnlichen als das Fernste. Diese Bilder entstammen den noch nicht angepaßten seelischen Bezirken und überholen die rechnende Vernunft. Die alten Zeichen von Pfahl, Schädel, Haus und Mutterleib sind wieder gefunden....

...Picasso hatte begriffen, daß das autonome Bild das Sterben des Wirklichen bedingt. Andererseits wird dieses dadurch verstärkt, daß neue Blöcke von Einbildung hineingesprengt werden.

In the 1996 edition of Einstein's *Die Kunst des 20. Jahrhunderts* (note 38), this passage is on page 134.

42. Thomas Mann, "Joseph und seine Brüder," in idem, *Essays,* vol. 5, *Deutschland und die Deutschen, 1938–1945,* ed. Hermann Kurzke and Stephan Stachorski (Frankfurt am Main: S. Fischer, 1996), 189: "Der Mythos wurde in diesem Buch dem Faschismus aus den Händen genommen."

43. In a classless society, Blunt wrote in 1937, the painter "will...develop the kind of realism which is at present being developed, without the use of any mythology, which...will no longer be necessary as a weapon for keeping some other class down in its place"; see Blunt, "Art under Capitalism" (note 9), 120.

44. Alfred H. Barr Jr., "Picasso: Fifty Years of His Art," in idem, *Picasso: Fifty Years of His Art* (New York: Metropolitan Museum of Art, 1946), 201. Clement Greenberg, "Picasso at Seventy-Five" (1957), in idem, *Art and Culture: Critical Essays* (Boston: Beacon, 1961), 59–69, esp. 65. Barr's definition has been echoed by, among others, Max Raphael, *The Demands of Art, with an Appendix: Toward an Empirical*

Theory of Art, trans. Norbert Guterman (Princeton: Princeton Univ. Press, 1968), 135–79; Eugene B. Cantelupe, "Picasso's *Guernica,*" *Art Journal* 31 (1971): 18–21; and Russell, *Picasso's* Guernica (note 24), 81–85.

45. Blunt, *Picasso's* Guernica (note 2), 32, made a similar remark, but without noticing that this new format started with the first drawing related to the advancing woman (see fig. 23).

46. Robert Rosenblum, *Transformations in Late Eighteenth Century Art,* 3d printing (Princeton: Princeton Univ. Press, 1970), 28–49, 154 ff.

47. Francis Haskell, "Poussin's Season," *New York Review of Books,* 23 March 1995, 50.

48. Although Greuze executed the painting in 1778, a drawing for *The Father's Curse: The Punished Son* was exhibited at the Salon of 1765; see Edgar Munhall, *Jean-Baptiste Greuze, 1725–1805,* ed. Joseph Focarino, exh. cat. ([Hartford, Conn.]: Wadsworth Atheneum, 1976), 114–15 (entry no. 49), 178–80 (entry no. 88). Gabriel de Saint-Aubin, in the margins of his booklet for the Salon of 1769, compared Greuze's *Death of a Cruel Father Abandoned by His Children* with Poussin's *Death of Germanicus;* see Munhall (cited above), 118–19 (entry no. 51). See also Rosenblum, *Transformations* (note 46), 37–38, who refers to Frederick Antal, *Hogarth and His Place in European Art* (London: Routledge & Kegan Paul, 1962), 198 ff., on Greuze's debt to Hogarth.

49. Munhall, *Jean-Baptiste Greuze* (note 48), 120–21 (entry no. 52).

50. Raphael [Daudet de Jaussac] and Jérôme, *Lettre sur les peintures, gravures et sculptures qui ont été exposées cette année au Louvre* (Paris: Delalain, 1769), 28: "Pendant que je suis occupé à reprocher le mauvais choix de sujets, il faut que tout d'une haleine j'exprime mon mécontentement d'un dessin du même Auteur qu'il se propose sans doute de traiter en grand. *La Mort du Père dénaturé abandonné de ses enfants.*... Quel sujet!... Ce sujet me scandalise: je suis fâché qu'un François l'ait imaginé."

51. Willibald Sauerländer, "Pathosfiguren im Oeuvre des Jean Baptiste Greuze," in Georg Kauffmann and Willibald Sauerländer, eds., *Walter Friedlaender zum 90. Geburtstag: Eine Festgabe seiner europäischen Schüler, Freude und Verehrer* (Berlin: Walter de Gruyter, 1965), 146–50.

52. See Nicolas Powell, *Fuseli: The Nightmare* (London: Allen Lane, 1973), 28 ff.

53. Gert Schiff, *Johann Heinrich Füssli, 1741–1825* (Munich: Berichthaus, 1973), 1:211, compares Fuseli's drawing *Vision of the Madhouse* (1791–93; Zürich, Kunsthaus) to Greuze's drawing *The Father's Curse: The Ungrateful Son* (1765; Lille, Musée des Beaux-Arts); he credits the observation to George Levitine, review of *Johann Heinrich Füsslis Milton-Galerie,* by Gert Schiff, *Art Bulletin* 47 (1965): 300–1.

54. Schiff, *Johann Heinrich Füssli* (note 53), 1:70, 2:65 (no. 333).

55. Allan Cunningham, *The Lives of the Most Eminent British Painters, Sculptors, and Architects,* 2d ed. (London: John Murray, 1830), 2:280, as quoted in Giorgio Melchiori, *Michelangelo nel Settecento inglese: Un capitolo di storia del gusto in Inghilterra* (Rome: Edizioni di Storia & Letteratura, 1950), 81.

56. See Schiff, *Johann Heinrich Füssli* (note 53), 1:112, 462 (entry no. 515), 2:121 (no. 515); and *The Age of Neo-classicism: The Fourteenth Exhibition of the Council of*

Europe, exh. cat. ([London]: Arts Council of Great Britain, 1972), 343–44 (entry no. 589 by Rhodri Liscombe). See also Frederick Antal, *Fuseli Studies* (London: Routledge & Kegan Paul, 1956), 29.

57. See Schiff, *Johann Heinrich Füssli* (note 53), 1:440 (entry no. 378), 2:86 (no. 378). Schiff suggests that this version of *Meleager* was executed in 1771 (there are at least five versions extant); it is dated 1776–78 in *The Age of Neo-classicism* (note 56), 344 (entry no. 591 by Rhodri Liscombe).

58. Antal, *Fuseli Studies* (note 56), 34, pl. 18a.

59. Gert Schiff, "Füssli, puritain et satanique," *L'oeil,* no. 63 (1960): 23–29, argues that David may have temporarily affected Fuseli's work, making it more realistic—a suggestion that I find untenable. Comparison of Fuseli's *Oath on the Rütli* (1778–81; Zürich, Rathaus) with David's *Oath of the Horatii* (1783–84; Paris, Musée du Louvre) suggests, on the contrary, that Fuseli may have influenced David; see Antal, *Fuseli Studies* (note 56), 71–72, pls. 28, 29a.

60. Frederick Antal, "Fuseli Studies," *Burlington Magazine* 96 (1954): 260–61: "his drawing of the *Madhouse*...corresponds to the jerky, agitated classicist style of the version of the *Death of Beaufort* from 1772."

61. See George Levitine, "The Influence of Lavater and Girodet's *Expression des sentiments de l'âme,*" *Art Bulletin* 36 (1954): 40–44. According to Thomas Crow, "Girodet et David pendant la Révolution: Un dialogue artistique et politique," in *David contre David* (Paris: La Documentation Française, 1993), 2:845–66, esp. 854, Girodet's *Hippocrates* was "la composition la plus purement davidienne de sa carrière" [the most purely Davidian composition of his career].

62. *Marseille en Révolution,* exh. cat. (Marseille: Editions Rivages, 1989), 150 (entry no. 171 by Philippe Bordes). Later Girodet himself started to "michelangelise"; see, for instance, his *Déluge* (1806; Paris, Musée du Louvre).

63. Alain Jouffroy and Philippe Bordes, *Guillotine et peinture: Topino-Lebrun et ses amis* (Paris: Chêne, 1977), 124 (letter of 20 November 1795): "Bien cher Lavater accepte de recevoir le porteur de la présente, c'est un peintre à la manière de Füssli de Londres, outre des connaissances physiognomiques, il est écrivain—et c'est un noble citoyen du monde." On Magdalena Schweizer-Hess, see Schiff, *Johann Heinrich Füssli* (note 53), 1:85 and passim.

64. James Henry Rubin, "Painting and Politics, II: J.-L. David's Patriotism, or the Conspiracy of Gracchus Babeuf and the Legacy of Topino-Lebrun," *Art Bulletin* 58 (1976): 547–68. But see Philippe Bordes, "Documents inédits sur Topino-Lebrun," *Bulletin de la Société de l'histoire de l'art français* (1976): 289–300; the exchange between Bordes and Rubin in "Letters to the Editor," *Art Bulletin* 59 (1977): 461–62; Jouffroy and Bordes, *Guillotine et peinture* (note 63); Philippe Bordes, "Les arts après la Terreur: Topino-Lebrun, Hennequin et la peinture politique sous le Directoire," *La revue du Louvre et des musées de France* 29 (1979): 199–212; and *Marseille en Révolution* (note 62), 149–52 (entry no. 171 by Pierre Bordes). On Giuseppe Ceracchi, who was guillotined with Topino-Lebrun, see *Dizionario biografico degli italiani,* s.v. "Ceracchi, Giuseppe."

65. Jouffroy and Bordes, *Guillotine et peinture* (note 63), 126 (*Journal d'indications*).

66. Rubin, "Painting and Politics, II" (note 64), esp. 555, which discusses a letter of 10 October 1795 in which Topino-Lebrun was asked to bring to the printer a piece written by Babeuf, who was then in jail, that was published as issue 34 of *Le tribun du peuple,* a journal that Babeuf had founded.

67. See Rubin, "Painting and Politics, II" (note 64), 560–63; and Etienne Jean Delécluze, *Louis David: Son école et son temps: Souvenirs* (Paris: Didier, 1855; reprint, Paris: Macula, 1983), 146–47, 238–40.

68. This point is missed by William Darr, "Images of Eros and Thanatos in Picasso's *Guernica,*" *Art Journal* 25 (1966): 338–46.

69. Arthur E. Popham and Johannes Wilde, *The Italian Drawings of the XV and XVI Centuries in the Collection of His Majesty the King at Windsor Castle* (London: Phaidon, 1949), 248–49 (entry no. 424).

70. Brendel, "Classic and Non-Classic Elements" (note 3), 154.

71. Hilton, *Picasso* (note 3), 246.

72. Phillippe Auquier, *Ville de Marseille, Musée des beaux-arts, Palais de Longchamp: Catalogue des peintures, sculptures, pastels et dessins* (Marseille: Barlatier, 1908), 305 (entry no. 575). I would like to thank Nadine Zannini, Assistante à la Conservation, Musée des Beaux-Arts, Marseille, for the information she kindly sent me in her letter dated 9 November 1993.

73. William Rubin, "Picasso," in idem, ed., *"Primitivism" in Twentieth-Century Art: Affinity of the Tribal and the Modern,* exh. cat. (New York: Museum of Modern Art, 1984), 1:305; see also a letter written by Picasso to Kahnweiler and dated 11 August 1912, in Isabelle Monod-Fontaine and Claude Laugier, *Daniel-Henry Kahnweiler, marchand, éditeur, écrivain,* exh. cat. (Paris: Centre Georges Pompidou, 1984), 111–12.

74. Carla Gottlieb, "Picasso's *Girl before a Mirror,*" *Journal of Aesthetics and Art Criticism* 24 (1966): 510; see also Hilton, *Picasso* (note 3), 222.

75. Greenberg, "Picasso at Seventy-Five" (note 44), 59–69, esp. 63. In the same direction, see Arcangeli, "Picasso, 'voce recitante'" (note 30), 73–74. Commenting on the purely coincidental acquisition of Picasso's *The Three Dancers* and Fuseli's *Lady Macbeth Seizing the Daggers,* the director of the Tate Gallery, Norman Reid, wrote, "A great deal of the past is wrapped up in Picasso; there may be a trace of Fuseli somewhere in the parcel"; see *The Tate Gallery Report 1964–65* (London: Her Majesty's Stationery Office, 1966), 14.

76. See notes taken by Roland Penrose about his conversations with Picasso (29–31 January 1965), published in *The Tate Gallery Report 1964–65* (note 75), 50: "I said: 'One of the things that makes *The Three Dancers* so important to me is that one sees in it the first traces of *Guernica.*' Picasso, looking at me in surprise: 'Perhaps, but of the two I much prefer *The Three Dancers.* It's more a real painting—a painting in itself without any outside consideration.'" At that time Picasso was selling *The Three Dancers* to the Tate Gallery, but his remark is significant anyway.

77. Hilton, *Picasso* (note 3), 246.

78. William Rubin, *Picasso in the Collection of the Museum of Modern Art, Including Remainder-Interest and Promised Gifts* (New York: Museum of Modern Art, 1972), 120.

79. Hilton, *Picasso* (note 3), 215.

80. Hilton, *Picasso* (note 3), 148. The same point was made by Roberto Longhi in his notes on Picasso dated 1953, which were published in *Paragone,* no. 371 (1981): 15: "In Picasso sembra quasi un'ironia del classicismo, parallela a quella di De Chirico negli stessi anni [1920–21]" [In Picasso there seems to be a sort of irony about classicism, parallel to that of De Chirico in the same years]; 52: "Come le sue pitture sono disegni al tratto, così i suoi colossi hanno la levità del calco di gesso, vuoto; del cassone di cemento. Forse Picasso ha guardato i calchi, non gli originali" [Just as his [Picasso's] paintings are line drawings, so his colossal figures have the lightness of the empty plaster cast, of the cement cast. Perhaps Picasso looked at the casts, not at the originals]. A similar point has been made in Otto J. Brendel, "The Classical Style in Modern Art," in Whitney J. Oates, ed., *From Sophocles to Picasso: The Present-Day Vitality of the Classical Tradition* (Bloomington: Indiana Univ. Press, 1962), 96.

81. Brassaï, *Picasso and Co.* (note 1), 55–56 (slightly modified from original); Brassaï, *Conversations avec Picasso* (note 1), 71: "Oui. Ils sont tous barbus… Et savez-vous pourquoi? Chaque fois que je dessine un homme, involontairement, c'est à mon père que je pense… Pour moi, l'homme, c'est « don José », et ça le restera toute ma vie …Il portait une barbe…" (ellipses in original).

82. E. H. Gombrich, "Psycho-analysis and the History of Art," in idem, *Meditations on a Hobby Horse, and Other Essays on the Theory of Art* (London: Phaidon, 1963), 30–44.

83. Semir Zeki, *Balthus, ou, La quête de l'essentiel* (Paris: Archimbaud, 1995), 38: "Picasso m'a dit un jour: 'Je n'ai jamais fait des dessins d'enfant'. Il a dit cela avec une grande tristesse."

84. Brendel, "Classic and Non-Classic Elements" (note 3), 140.

85. Sidra Stich, "Picasso's Art and Politics in 1936," *Arts Magazine* 58, no. 2 (1983): 113–18, esp. 117 n. 15: "Typically, Picasso did not give his warrior [on a sketch dated 28 May 1936 for the curtain for *Le quatorze juillet*] a modern weapon but the most primordial object of defense—a stone. As in earlier battle scenes (and in *Guernica* as well), his weapons (swords, daggers, knives, spears, javelins) serve to mythicize or affect a time displacement."

86. Walter Benjamin, *Understanding Brecht,* trans. Anna Bostock (London: Verso, 1983), 121; originally published in *Versuche über Brecht,* ed. Rolf Tiedemann (Frankfurt am Main: Suhrkamp, 1971), 171: "Nicht an das Gute Alte anknüpfen, sondern an das schlechte Neue."

87. Jerome Seckler, "Picasso Explains—[1945]," in Ellen C. Oppler, ed., *Picasso's Guernica: Illustrations, Introductory Essay, Documents, Poetry, Criticism, Analysis* (New York: W. W. Norton, 1988), 148–49, 151; originally published in *New Masses,* 13 March 1945. I checked the typewritten transcript of the interview preserved in the Museum of Modern Art's archives. The words "the bull is not Fascism, but it is brutality and darkness" do not refer to *Guernica,* as it has been mistakenly stated elsewhere, but to *Still Life with Black Bull's Head* (1938); see Seckler (cited above), fig. 148.

88. Dore Ashton, ed., *Picasso on Art: A Selection of Views* (New York: Viking, 1972), 155, quoting from "Symposium on *Guernica,* Museum of Modern Art, 25 November 1947," typescript, Museum of Modern Art Archives, New York.

89. Blunt, *Picasso's Guernica* (note 2), 44–47.

90. Juan Larrea, Guernica, *Pablo Picasso,* trans. Alexander H. Krappe, ed. Walter Pach (New York: Curt Valentin, 1947), 56–57, fig. 12. Larrea neither mentions *Documents* nor believes that the miniature was a source for Picasso, even though he interprets *Guernica* in a strictly apocalyptic perspective. Ruth Kaufmann, "Picasso's *Crucifixion* of 1930," *Burlington Magazine* 111 (1969): 553–61, has noted the connection with *Documents* (which she describes as a surrealist journal [p. 553], although Bataille conceived of it as an antisurrealist journal).

91. Georges Bataille, "L'apocalypse de Saint-Sever," in idem, *Oeuvres complètes,* vol. 1, *Premiers écrits, 1922–1940* (Paris: Gallimard, 1970), 164–70; originally published in *Documents* 1, no. 2 (1929): 74–84.

92. Bataille, "L'apocalypse" (note 91), 168–69, pl. VIII: "le réalisme grossier et la grandeur pathétique," "le signe de l'extrême désordre des réactions humaines libres."

93. Denis Hollier, "La valeur d'usage de l'impossible," in *Documents,* vol. 1, *Doctrines, archéologie, beaux-arts, ethnographie* (1929; reprint, Paris: Jean Michel Place, 1992), vii–xxxiv; reprinted in Hollier's *Les dépossédés: Bataille, Caillois, Leiris, Malraux, Sartre* (Paris: Editions de Minuit, 1993), 153–78. Einstein's contributions to *Documents* are collected in Carl Einstein, *Ethnologie de l'art moderne,* ed. Liliane Meffre (Marseille: André Dimanche, 1993). Michel Leiris, "De Bataille l'impossible à l'impossible *Documents*" (1963), in idem, *A propos de Georges Bataille* (Paris: Fourbis, 1988), 17–40, is disappointing. See Roberto Longhi, "Picasso e l'Italia [1953]," *Paragone,* no. 371 (1981): 7: "I tempi dei 'documents' del povero Carl Einstein, che aveva grande cultura ecclettica. E Picasso è un *ecclessi* di cultura" [Those were the times of the *Documents* of the late Carl Einstein, who was a great cultural eclectic. And Picasso is an embodiment of cultural eclecticism].

94. Georges Bataille, "Soleil pourri," in idem, *Oeuvres complètes,* vol. 1, *Premiers écrits, 1922–1940* (Paris: Gallimard, 1970), 231–32; originally published in *Documents* 2, no. 3 (issue titled "Hommage à Picasso") (1930): 173–74.

95. Bataille, "Soleil pourri" (note 94), 231: "par l'horreur qui se dégage d'une lampe à arc en incandescence."

96. Bataille, "Soleil pourri" (note 94), 232:

> Toutefois, il est possible de dire que la peinture académique correspondait à peu près à une élévation d'esprit sans excès. Dans la peinture actuelle au contraire la recherche d'une rupture de l'élévation portée à son comble, et d'un éclat à prétention aveuglante a une part dans l'élaboration, ou dans la décomposition des formes, mais cela n'est sensible, à la rigueur, que dans la peinture de Picasso.
>
> [It is nevertheless possible to say that academic painting more or less corresponded to an elevation—without excess—of the spirit. In contemporary painting, however, the search for that which most ruptures the highest elevation, and for a blinding brilliance, has a share in the elaboration or decomposition of forms, though strictly speaking this is only noticeable in the paintings of Picasso.]

The translation of this passage is from Georges Bataille, "Rotten Sun," in idem, *Visions of Excess: Selected Writings, 1927–1939,* ed. and trans. Allan Stoekl with Carl R. Lovitt and Donald M. Leslie Jr. (Minneapolis: Univ. of Minnesota Press, 1985), 58. The two scholars who perceived the relevance of this text were sidetracked by Bataille's

reference to Mithraic cults, which were utterly irrelevant to Picasso; see Penrose, *Picasso* (note 28), 304 n. 12; and Kaufmann, "Picasso's *Crucifixion*" (note 90), 553–61.

97. Blunt, *Picasso's* Guernica (note 2), 34.

98. Arnheim, *Picasso's* Guernica (note 3), 120: "The fist goes beyond a mere threat by clasping a bunch of flowers and surrounding itself with a flaming halo."

99. Blunt, *Picasso's* Guernica (note 2), 41–42; Werckmeister, "The Political Confrontation" (note 8), 16; Ruth Maria Capelle, "Die Bedeutung der Maitage in Barcelona in der ikonographischen Entwicklung von Picassos *Guernica*," in Jutta Held, ed., *Der Spanische Bürgerkrieg und die bildenden Künste* (Hamburg: Argument, 1989), 88–93; and Ludwig Ullmann, *Picasso und der Krieg* (Bielefeld: Karl Kerber, 1993), 136–38 (on events in Barcelona in May 1937), 524 n. 325 (mentions Werckmeister's essay).

100. Antonina Vallentin, *Pablo Picasso* (Paris: A. Michel, 1957), 326–27.

101. Bataille, "Soleil pourri" (note 94), 231. See also Russell, *Picasso's* Guernica (note 24), 324 n. 179, who has a vague remark on Picasso's surrealist friends. Different (and in my view unacceptable) interpretations have been suggested by Russell, *Picasso's* Guernica (note 24), 102–3, 268; and Ludwig Ullmann, "Zur Vorgeschichte von Picassos *Guernica*: Unbekannte und unbeachtete Arbeiten (Januar–April 1937)," *Kritische Berichte* 13, no. 4 (1985): 45–56, esp. 47.

102. Luc Decaunes, *Paul Eluard, Biographie pour une approche* (Rodez: Editions Subervie, 1964), 55.

103. Eluard's poem is given in full in French and in English (trans. Roland Penrose) in Larrea, Guernica (note 90), 6, 7. During the symposium held at the Museum of Modern Art in 1947, Larrea said, "I think there is a lot of the poem in the picture and a lot of the picture in the poem," but Rudolph Arnheim disagreed: "Guernica is not victory but defeat—a sprawling chaos, shown as temporary by its dynamic appeal to the towering, timeless figure of the kingly beast"; see "Symposium on *Guernica*, Museum of Modern Art, 25 November 1947," typescript, Museum of Modern Art Archives, New York. On Picasso, Eluard, and *Guernica*, see Penrose, *Picasso* (note 28), 315–16.

104. Martial Bataille, in reading an interview given by Georges in which his brother stressed the veracity of the *Histoire de l'oeil*'s final section, was horrified.

105. Georges Bataille, *L'anus solaire*, in idem, *Oeuvres complètes*, vol. 1, *Premiers écrits, 1922–1940* (Paris: Gallimard, 1970), 81–86, 644–45: "les têtes asexuées et nobles des bourgeois seront tranchées" (p. 86). On this text by Bataille, see Denis Hollier, "De l'équivoque entre littérature et politique," in idem, *Les dépossédés: Bataille, Caillois, Leiris, Malraux, Sartre* (Paris: Editions de Minuit, 1993), 109–30, esp. 119, where Hollier speaks of "héroïsation scatologique du prolétariat" [scatological heroizing of the proletariat].

To trace the echoes of the Marquis de Sade and Baudelaire in these texts would necessitate a long digression. But see Georges Bataille, "[Rêve]," in idem, *Oeuvres complètes*, vol. 2, *Ecrits posthumes, 1922–1940* (Paris: Gallimard, 1970), 9–10, 413 ("rédigé en 1927, vers juin," therefore connected to Bataille's analysis with Adrien Borel); and, on this dream, Denis Hollier, "La tombe de Bataille," in idem, *Les dépossédés: Bataille, Caillois, Leiris, Malraux, Sartre* (Paris: Editions de Minuit, 1993), 95–99. Bataille's hatred of nature led him to conceive death as a defeat: "Je retrouverai l'abjecte nature et la purulence de la vie anonyme, infinie, qui s'étend comme la nuit,

qu'est la mort. Un jour ce monde vivant pullulera dans ma bouche morte" [I will find abject nature again and the rottenness of the anonymous life, endless, as immense as night, which is death. One day that living world will swarm in my dead mouth]; as quoted in Michel Surya, *Georges Bataille, la mort à l'oeuvre* (Paris: Libraire Séguier: Frédéric Birr, 1987), 453.

106. *La critique sociale, no. 1 (mars 1931)–no. 11 (mars 1934)* (Paris: Marcel Rivière, 1931–34; reprint, Paris: Editions de la Différence, 1983); the reprint edition includes a prologue by the then eighty-seven-year-old Boris Souvarine. The proceedings of the Collège de Sociologie have been published in Denis Hollier, ed., *Le Collège de sociologie: 1937–1939* (Paris: Gallimard, 1979); see also the enlarged American edition: Denis Hollier, ed., *The College of Sociology (1937–39)* (Minneapolis: Univ. of Minnesota Press, 1988).

107. Jean Dautry, "Sous le feu des canons français...," flyer signed by George Bataille and other members of Contre-Attaque, in Georges Bataille, *Oeuvres complètes*, vol. 1, *Premiers écrits, 1922–1940* (Paris: Gallimard, 1970), 398: "Nous leur préférons, en tout état de cause, la brutalité antidiplomatique de Hitler, plus pacifique, en fait, que l'excitation baveuse des diplomates et des politiciens"; cf. "Sous le feu des canons français... et alliés," the revised flyer, which carries five additional signatures, 671: "Nous leur préférons, en tout état de cause, et sans être dupes, la brutalité antidiplomatique de Hitler, moins sûrement mortelle pour la paix que l'excitation baveuse des diplomates et des politiciens."

108. Carlo Ginzburg, "Germanic Mythology and Nazism," in idem, *Clues, Myths, and the Historical Method,* trans. John Tedeschi and Anne C. Tedeschi (London: Hutchinson Radius, 1990), 142–43; originally published in *Quaderni storici,* n.s., no. 57 (1984): 857–82.

109. The entire run of the journal has been reprinted as *Acéphale: Religion, sociologie, philosophie, 1936–1939* (Paris: Jean Michel Place, 1980).

110. Leiris, *Journal* (note 27), 721–22 (5 and 6 October 1979), remarks on "le thème de l'acéphale" in the 1930s, inspired by Hollier's publication of the proceedings of the Collège de Sociologie (see note 106).

111. Georges Bataille, "Chronique nietzschéenne," in idem, *Oeuvres complètes*, vol. 1, *Premiers écrits, 1922–1940* (Paris: Gallimard, 1970), 477–90, esp. 485–89 ("La représentation de 'Numance,'" "'Numance! Liberté!'"); originally published in *Acéphale*, no. 3–4 (1937): 15–23. The importance of this text has been stressed by Denis Hollier, "Desperanto," trans. Betsy Wing, *New German Critique,* no. 67 (1996): 19–31.

112. Bataille, "Chronique nietzschéenne" (note 111), 489: "à l'unité césarienne que fonde un chef, s'oppose la communauté sans chef lié par l'image obsédante d'une tragédie.... l'élément émotionnel qui donne une valeur obsédante à l'existence commune est la mort"; 488: "La comédie qui—sous couleur de démocratie—oppose le césarisme soviétique au césarisme allemand," "le mouvement antifasciste, s'il est comparé à Numance, apparaît comme une cohue vide, comme une vaste décomposition d'hommes qui ne sont liés que par des refus," "que le combat engagé ne prendra un sens et ne deviendra efficace que dans la mesure où la misère fasciste rencontrera en face d'elle autre chose qu'une négation agitée: la communauté de coeur dont Numance est l'image."

Cosmology, Crisis, and Paradox: On the White Spirit in the Kuna Shamanistic Tradition

Carlo Severi

An image is where past and present meet instantly to form a constellation.
— Walter Benjamin[1]

The link between various kinds of narratives and the construction of social memory has become, after the work of Paul Ricoeur and others, obvious to historians, anthropologists, and social scientists in general. If, as Ricoeur has argued, to narrate a story is a way not only to recall it but also "to refigurate one's own experience of time,"[2] narrative has to be seen not only as a particular literary style but also as a form of existence of memory itself. This perspective has tempted many historians as well as some psychologists to argue that no memory is imaginable without a narrative frame.[3]

The relation of social memory to images is less clear. All his life, Aby Warburg tried to outline a general theory of social memory based on images as well as on texts. His emphasis on the complex relations between visual symbols and meaning, on the need to consider a picture or a sculpted object as only one element in a series of representations that might involve ritual actions, texts, oral traditions, or even entirely mental images, and his insight that the analysis of social memory was a way to study the social life of symbols certainly were decisive steps toward a new approach to this question.[4] Unfortunately, Warburg's ideas on social memory have been poorly developed since his death, and, at least in the field of social anthropology, much has still to be done if we are to understand the ways in which a cultural tradition can rely upon images.[5]

The representation of traumatic experience in a cultural tradition is a particularly difficult aspect of this problem. The analysis of trauma as a phenomenon affecting perception and memory and as a psychological process generating painful symptoms was obviously one of the first steps in Sigmund Freud's discovery of the unconscious. However, as Freud pointed out very early on, not only can trauma cause painful reminiscences but it can also put in danger memory itself, as a process closely associated with the construction (and the survival) of an ego. In the latter case, no story can be told about the traumatic experience. Instead, a sort of blank or an enigmatic image appears to consciousness as a complex, often persistently misleading substitute for the reminiscence.[6] It is with these enigmatic images that any attempt to recon-

struct a *narrative* representation of the traumatic past (be it faithful or not) has to deal.

The crucial point here is precisely the relation between the enigmatic image and narration. From a metapsychological point of view, the emergence of these images as mnemic traces seems to replace, or even prevent, the narration of the reminiscence. Moreover, such images seem to be more effective than language, since in situations where no word can be spoken, they register some aspects of the recollection as a psychological process. However, if they bear witness to some psychological elaboration of the reminiscence, they not only often falsify the facts recollected but also prevent precisely that transformation of the subject's experience of time in a *récit* (narration), which is, according to Ricoeur, one of the decisive steps in the formation of memory.[7] That these images are to be treated as mnemic traces, not as accurate representations, was one of the discoveries that led to the psychoanalytic theory of symptoms. Since then (namely, since Freud's famous repudiation of the seduction theory), it has been acknowledged that, as Freud has soberly written, an internal, psychological reality must be distinguished from external, historical facts.

Nonetheless, the same "psychological reality" that in his first years of research Freud opposed to external facts was recognized by Freud in his later work as one of the more powerful forces acting in the lives of societies.[8] The relation between Freud's work and anthropological research in the twentieth century has not been, with a few exceptions,[9] an easy one. No direct transplantation of psychoanalytic theories into the field of cultural facts has proved really fruitful, and it would be unreasonable to deny that in this area many questions are unanswered and many problems have been left unsolved. However, it would be equally hard to deny that something that might be called "social mnemic traces" — linked with the task of representing trauma and having a complexity similar to the trauma — are found in practices that we usually associate with social memory. Ritual practices, in particular, are situations in which an extremely traumatic experience — something that can be so difficult to represent in everyday life — can be effectively expressed, and thereby inscribed, in ways that remain to be explored, in the memory of a society.

So how is the recollection of a collective crisis, a social trauma, inscribed in the memory of a society? How can a ritual tradition represent social trauma *as an experience?* To address these questions, I will focus on a relatively recent transformation in the shamanistic tradition of the Kuna of Panama: the invention of a spirit representing, in supernatural terms, the intervention of the most powerful of the traditional enemies of Kuna society, the white man.[10]

The history of the encounter between the white man and the Kuna has been clearly summarized by James Howe: "Inhabiting a region of great strategic significance, . . . [the Kuna] have found themselves caught up in other people's schemes and other people's wars, attempting on their part to trade and ally themselves with one side or another without giving up their independence. Repeatedly missionized and subdued, they have each time rebelled and broken free, even in the twentieth century."[11] Since the beginning of the

sixteenth century, the Kuna have resisted numerous attempts to colonize them. Many stories in the Kuna tradition tell the salient episodes of this history of external aggression, attempts by outsiders to take control of Kuna territories, and Kuna insurrections against Spaniards, Scots, Panamanians, and other Westerners (including gold miners, merchants, missionaries, and the authorities of the Republic of Panama, founded in 1903). To give an idea of the intensity of the Kuna tragedy, I will turn to Howe again. He writes that in 1792 "after nearly three hundred years, peace finally came to the Darién.... During just the last half of the eighteenth century, war and epidemic disease had cut the indigenous population in half, to an estimated five thousand."[12] Then, after a century of relative calm, Westerners resumed their attempts to take control of the Kuna's lands. The Kuna again fought back, until the treaty that followed their armed conflict with Panamanian forces in 1925. Even today that treaty warrants to the Kuna their precarious and hard-won political autonomy, and it represents for the Kuna, given the historical context, a remarkable success.

However, it should never be forgotten that American Indians, particularly those of Central America, have now been cohabiting with whites for several centuries. Even when, as in the case of the Kuna, they have been able to effectively combat a generally destructive physical contact, American Indians still maintain that this now inevitable presence has irreparably lacerated their world, upsetting once and for all the balance of forces regulating it. Even transformations not directly produced by repeated military expeditions, Spanish and other, are linked now to this deeply rooted and obsessive certainty that something has been torn apart.

The memory of this traumatic past, during which Kuna society nearly disappeared, is still very much present. In 1992, for instance, in a discourse on Columbus's discovery of America, the Kuna chief Leonidas Valdéz stated, "Now then, we are sitting together here.... We sit here feeling our pain.... When the Europeans came here, they abused us, you see. They beat our grandfathers, they killed our grandfathers, they cut open our grandmothers, you hear. They came here and killed our wise men, you see. So now they say, 'Celebrate the day,' you see,.... [T]hey're coming to celebrate the day of our grandmothers' and grandfathers' death."[13] In the shamanistic tradition, the recollection of this past, and the feeling of this pain, can also be expressed in more indirect, though equally poignant terms, through the invention of ritual images.

The great Swedish anthropologist Erland Nordenskiöld, during his month-long mission among the Kuna in 1927, collected many interesting objects that are now in the very rich collections of the Etnografiska Museet i Göteborg. Among the pieces he donated is a series of the statuettes carved out of balsa (*nuchugana*; singular *nuchu*) that are used by specialists during the recitation of chants devoted to the therapy of various illnesses and representing "auxiliary spirits." These spirits—called *nelegan* (seers; singular *nele*)—are evoked

and appealed to for help during healing rituals. Their function is to help the shaman in his search for the spiritual principle or "soul" whose absence has caused a particular illness, misfortune, or other kind of suffering to a person. As is the case in other American Indian traditions, the Kuna regard vegetal spirits and spirits of the forest (*nelegan*) as allies of the human beings in the supernatural conflict that opposes them to animal spirits (*niagana;* singular *nia*), who are thought of as dangerous and pathogenic.

The statuettes often represent birds, sea turtles, and other animals (fig. 1), or they may take vaguely anthropomorphic shapes and represent various supernatural beings from Kuna mythology (fig. 2). Some, however, are more surprising to Western eyes (figs. 3–6). As Nordenskiöld noted—without trying to explain the phenomenon—it is clear that they represent white persons wearing shirts, trousers, hats, and even ties.[14] There is little doubt that, while being used as auxiliary spirits by the shamans in their supernatural travels (and therefore standing for vegetal spirits), they *also* represent white persons.[15]

This representation of a white person as an auxiliary spirit of the Kuna shaman (confirmed by several recent sources,[16] including my own fieldwork) has been variously explained. Michael Taussig, for instance, has seen in these statuettes a sort of symbolic revenge by the Kuna against the white invaders. This interpretation is common and has been applied to other situations of cultural contact. By manipulating the image of the white man, argued Taussig, the Kuna shaman is able to "catch the power" of his antagonists symbolically, just like a Voodoo priest or just as in West Africa a possessed Songhai "catches the power" of a Catholic priest or a French administrator by taking up his image and thus becoming "similar to him."[17] Using the image of a paradigmatic enemy in a context of "sympathetic magic," Taussig argues, the Kuna have found a way to assimilate and ritually "tame" their enemy.[18] This is certainly true, and my own work on the chant devoted to the therapy of what the Kuna call "madness" confirms this point.[19]

Problems arise, however, when Taussig attributes to the Kuna shamanistic tradition intentions going well beyond this symbolic appropriation of the enemy realized through sympathetic magic. According to him, for instance, the Kuna representation of white persons expresses "the fact that the self is no longer clearly separable from its Alter. For now the self is inscribed in the Alter that the self needs to define itself against." Taussig also finds in these Kuna statuettes (and in particular in the images I have studied in a paper about the Kuna ritual representation of pain)[20] the illustration of "what has been termed the postmodern condition, the virtually undisputed reign of the image-chain in late capitalism where the commodification of nature no less than mechanical and uterine reproduction link in a variety of power-assuming, power-consuming, ways."[21]

Taussig presents his interpretation as part of a meditation on Walter Benjamin's ideas on mimesis and on what Taussig calls a "fabulous" history of the senses.[22] His analysis is not intended to be part of an "older anthropology," about which he claims to "know next to nothing" and, at any rate,

Fig. 1. *Nuchugana* from Ustupu, before 1927, wood,
top: 7.8 cm (3⅛ in.), bottom: 10.7 cm (4¼ in.)
Göteborg, Etnografiska Museet i Göteborg, Collection
Nordenskiöld

Fig. 2. *Nuchugana* from Kaynora, before 1927, wood,
left: 28.3 cm (11⅛ in.), right: 29.9 cm (11¾ in.)
Göteborg, Etnografiska Museet i Göteborg, Collection
Nordenskiöld

Fig. 3. *Nuchugana* from Kaynora, before 1927, wood,
left: 21.4 cm (8⅜ in.), right: 23.4 cm (9¼ in.)
Göteborg, Etnografiska Museet i Göteborg, Collection
Nordenskiöld

Fig. 4. *Nuchu,* before 1918, wood with pigment,
35 cm (13¾ in.)
Chicago, Field Museum

Fig. 5. *Nuchugana,* 1900s, wood, some with pigment,
18.3 to 28.3 cm (7¼ to 11⅛ in.)
Los Angeles, UCLA Fowler Museum of Cultural History

Fig. 6. *Ukkurwalagana*, 1900s, wood, left: 116.2 cm
(45¾ in.), right: 144.2 cm (56¾ in.)
Los Angeles, UCLA Fowler Museum of Cultural History

thinks would inevitably "miss the whole point."[23] However, Taussig's interpretation of the Kuna figurines in the form of white persons as a simple act of sympathetic magic oversimplifies the Kuna facts. In the Kuna context, the white man is not only a symbol of an alien power that can be caught and used by the shamans. Equally and simultaneously, the white man symbolizes anxiety, uncertainty, mental suffering, even madness.[24] Kuna tradition represents whites not only as powerful seers coming from the point of view of another culture who act as magic helpers of the shaman in his attempt to cure illnesses but also as frightful demons who appear only in dreams.[25] As we will see, the ambivalence of these images of white persons, their paradoxical representation of positive and negative values attributed to the same supernatural beings, is constitutive of their nature. Contradiction is the way in which these ritual images exist.

Taussig is right in remarking on the ironic, even comic character of these figurines.[26] At the same time, he completely mistakes the particular context in which these representations are inserted. Let me clarify this point by referring to an example. Keith Basso has studied a representation of whites used among the Western Apache in the United States that seems, at first sight, similar to the Kuna case. Since the 1940s, the Apache of an isolated village of the White Mountain Reservation in Arizona have reacted to the increasing intervention of white people in their daily lives with the invention of a particular joke: the game of "portraying the Whiteman." The rules of this game are, in Basso's analysis, essentially two: contrast and distortion. Having selected a typical Anglo-American behavior that strongly contrasts with a Western Apache custom (a way of greeting, for instance), the person willing to play this particular game will perform the behavior in public, distorting it so as to "portray" a hilarious caricature of it.

Basso has effectively shown that this humorous, everyday verbal genre by which Western Apaches satirize the white man, is very revealing, in social and in cultural terms. He has argued that from a cultural (or categorical) point of view, the Western Apache's verbal (and behavioral) imitation of whites mobilizes "a set of general ideas—their ideas of who Whitemen are, what they represent, and how they typically behave toward Indians."[27] From a social point of view, these jokes appear to increase solidarity among the Western Apache. As Basso writes: "The products of solidarity and commitment, joking imitations are inverted celebrations of them as well.... These performances are little morality plays in which Western Apaches affirm their conceptions of what is 'right' and proper by dramatizing their conceptions of what is 'wrong' and inappropriate. Concomitantly, they affirm their sentiments for one another, and nothing, they would claim, is more important."[28] Basso also shows that an important aspect of these "joking imitations" is the use of the English language, which in the Western Apache community of Cibecue was still relatively rare in everyday life in the 1980s. Speaking English in order to caricature and mock Anglo-Americans, Western Apaches symbolically appropriate an "image" of their ancient enemies in order to defend themselves and

to preserve their own culture. From this point of view, then, these everyday jokes are not far from what Taussig has called sympathetic magic; they seem to assume the same social and cultural functions.

Gordon Craig, a talented Apache cartoonist, has often illustrated in his images the verbal genre studied by Basso. As Basso has noted, "Mr. Craig... says with his cartoons many of the things I have tried to say with words. Indeed, he probably says them better."[29] Let us consider an example of Craig's work and then compare it with the Kuna statuettes collected by Nordenskiöld. We will see that, despite appearances, they differ radically in form, content, and context. Thus, in one of Craig's well-known cartoons, there are two young men standing outside at a small airport. The Anglo-American — who is wearing a baseball cap, glasses, a long-sleeved shirt, shorts, knee socks, hiking boots, two Band-Aids on a very hairy leg, and a camera — points to the sky and says to the Apache: "Look chief... heap big iron bird." Apparently unmoved, the Apache, who wears high-top sneakers, jeans, a short-sleeved football jersey, and a large black hat with a broken feather stuck in the band, thinks in reply, in fluent English: "That's an airplane... you turkey."[30]

The rules of the linguistic game described by Basso, contrast and distortion, are clearly present. Craig has not just translated the game of portraying the white man into visual terms, however; he has developed it further. To achieve a strong comic effect, Craig has realized a double inversion: instead of representing an American Indian imitating a white person, Craig (the Apache artist) has drawn a typical Anglo-American speaking like (the Anglo-American would presume) an American Indian would speak. The American Indian replies by showing the knowledge and common sense that white men would like (wrongly) to attribute only to themselves: the "big iron bird" is obviously an airplane. It is clear that in this case, the humor comes not only from the fact that the Apache portrayed in the cartoon sharply contradicts the conventional representation of the American Indian as seen though Western eyes but also from the fact that the white man impersonates an Anglo-American conception of the American Indian (still supposed to be unable to speak English correctly as well as totally immersed in a premodern or even mythological conception of the world). Let us remark as well that this double inversion is realized in a *Western* framework. The effectiveness of the image comes in part from a satirical, typically Apache use of a *Western* graphic style and genre, the cartoon.

In the Kuna case, the contrary happens. The white man, although vividly and realistically represented, becomes a different being, one fully belonging to the *Kuna* supernatural dimension. Carved in balsa and situated among the auxiliary spirits of the shaman, the white man assumes the figure, the function (and even the supernatural "flesh," constituted by the balsa) of a vegetal spirit.

A number of additional differences emerge when the context in which these representations are used in social life is considered. The Western Apache representation regularly appears in the informal context of everyday interaction.[31] Western Apache joking imitations, Basso has noted, "adapt themselves to their own expressive purposes and the *fluctuating requirements* of partic-

ular social occasions."[32] This means that, as Basso said, "no two imitations are ever the same"; and that the game itself changes rapidly through time: "Apache portraits of 'the Whiteman' are unfailingly contemporary and consistently experimental."[33] This instability of form and context has an important consequence: that the Western Apache "verbal portrait" of the white man is too fragile a symbolic instrument to preserve the tribe's social memory of the traumatic past. As Basso states, "Whitemen have stolen land, violated treaties, and on numerous other fronts treated Indians with a brutal lack of awareness and concern. But these are not the messages communicated by Western Apache jokers. Their sights are trained on something more basic, and that is making sense of how Anglo-Americans conduct themselves in the presence of Indian people."[34]

Many of Taussig's remarks about the symbolic appropriation of the Alter being realized through humor may apply to Western Apache portraits of the white man. Nonetheless, as should be clear from this comparison, Kuna shamanistic figurines are in many ways different from Western Apache verbal portraits. While the Western Apache representation relies on the game of "reversing roles," the Kuna representation expresses the accumulation of contradictory connotations on a single image. From this point of view, Western Apache portraits are hilarious inversions, while Kuna ritual statuettes are visual paradoxes. Furthermore, the context in which the Kuna statuettes are used is a *ritual* one. They are thus inserted in a relatively stable and far more complex context than the everyday context of the Western Apache verbal portrait. The Kuna statuettes do not represent primarily, as in the Western Apache case, a distorted image of "white people" focused on "foregrounding"[35] a cultural contrast in an ingenious way. This dimension is not absent from the Kuna figurines, but they also and simultaneously represent Kuna supernatural beings. In assigning to whites the function of the auxiliary spirits of the shaman, who are supposed to intervene and help in social and individual crises, in social misfortune as well as in individual suffering, they portray whites as *transformed* into *Kuna* supernatural beings. In this way, whites become part and parcel of a symbolic system organized around, like any shamanistic tradition, the understanding and treatment of suffering.

It is obvious that these representations are in some way connected with the social memory of the historical conflicts between the Kuna and whites. However, historians and anthropologists have found it difficult to understand them as such, mainly for two reasons. For one, while the *nelegan* function as the "helpers" of the shaman everywhere in Kuna shamanistic ritual and tradition, the figurines do not seem to be clearly connected with narratives dealing with encounters between Kuna and whites. The other, and more crucial, difficulty is that these images seem to be defined in *contradictory terms*. Whites are represented in the Kuna ritual figurines as seers (*nelegan*), who are supposed to further a shamanistic cure, and, simultaneously, in ritual narratives as pathogenic animal spirits (*niagana*), who attack Kuna men and women and make them ill. As a consequence, the temptation to consider these (apparently

inconsistent or contradictory) cultural ways of conceptualizing the presence of whites as "spurious," "marginal," or "anecdotal" has been very strong. In fact, such imaging has been hastily considered as symptoms of decadence in the indigenous tradition or even as a sign of symbolic submission to the "cultural change" brought about by the whites (that is, domination). In other words, representations of this kind have been considered as marking a step toward "modernization," a process regarded as implying social oblivion and the loss of Kuna ethnic identity.

I would like to show that this interpretation of the Kuna statuettes is deeply misleading, just as it is perfectly illusory to see them as representative of a conscious postmodern spirit, as Taussig does. Once we reconstruct their context, these paradoxical images can be seen instead as an example of what Warburg called "engrams of social memory,"[36] as the result of a process of ritual remembrance in which we can follow almost step-by-step the way a shamanistic tradition has managed to symbolize a situation of crisis.

The Kuna White Spirit[37]

Today in Kuna shamanistic tradition the White Spirit appears as a dangerous being who attacks people in the night, when they dream, and makes them *locos* (crazy). This is how the Kuna narrate the story of this particular *locura* (madness). When human beings, male or female, are struck by madness, they sound the hunting call of the jaguar, sing the song of a bird, or roll on the ground like snakes; they exhibit their sexual organs as monkeys do. Those who are struck by madness are, when the first fit is upon them, suddenly divested of their status as human beings. In fact, this fit of madness and the attendant delirium are always for the Kuna the signs of the presence of an animal spirit (*nia*) in an individual Kuna's body.

Behind this image for the fit of delirium are two dream stories, untiringly repeated, like a stereotype. One relates a hunting dream; the other, a dream of copulation. The hunting dream is a daytime dream and is dreamed with open eyes. When a hunter goes far off into the forest, so the story goes, and hears birdsong without being able to catch sight of the bird and immediately afterward becomes aware of the furious grunting of a boar without either seeing a boar or having tracked it, or the howling of an invisible monkey makes itself heard, he realizes that no matter how cunningly he lies in wait or lays an ambush, he will never come face-to-face with these animals. He knows that this characteristic succession of animal cries, which is suddenly accompanied by a harrowing sense of absence, announces the coming of the Jaguar of the Sky. Suspended from the farthest reaches of the sky, the celestial jaguar cannot be seen when he comes down to hunt in the forest. An animal of metamorphoses and an essentially invisible spirit, he will assume in passing the appearances of other animals. But this does not mean that he will hide himself behind their visual aspect—in the boar's skin, the antlers of a deer in flight, the red feathers of a parrot. He can only match his voice to theirs, make their hunting call, shake the leaves of the trees as monkeys do when they flee before

the hunter. Never will he come in sight. Consequently the chant to cure madness sung by the shamans places the Jaguar of the Sky in the supernatural Village of Darkness. Amid the storms that constantly wrack this place of night, the Jaguar of the Sky is seen setting off in pursuit of his prey, and here again, he is never wholly himself: now a bird sounding like a jaguar, now a jaguar sounding like a bird.

But this mythical being is not just a hunter of animals. He is also and above all a hunter of human beings. This is where the second dream story comes in, the dream of copulation. Invisible in the light of day, the Jaguar of the Sky appears in image form in certain dreams. In such dreams he discards the image of the threatening hunter to assume the equally dangerous guise of an intensely desired sexual partner. The sleeping human being who dreams of the disguised Jaguar of the Sky will fall in love with this vision forever and will be driven mad by it.

In *La memoria rituale,* I have discussed the Kuna "Chant of the Demon" and the complex conception of madness that it unfolds.[38] Let me focus here on a single point: the White Spirit is, in the "Chant of the Demon," identified as one of the manifestations of the Jaguar of the Sky. The White Spirit is, then, *not a human being* but a dangerous animal, even if his appearance might be human. However, instead of characterizing this manifestation in purely negative terms (as a sort of fairytale monster and a constant threat to human beings), the text qualifies this spirit in a more complex and ambivalent way. The White Spirit is called, in the ceremonial language of chants, a *pilator* (denizen of the spirits' village). In the vocabulary of the shaman, this word designates a category that associates persons who have been murdered (or committed suicide) with persons who have committed murder.[39] The White Spirit thus appears to be *represented simultaneously as an aggressor and as a victim.*

Such ambiguity is neither anecdotal nor peculiar to the Kuna. On the contrary, it seems to be in line with other representations of the white man in the supernatural world found in many American Indian cosmologies: the white man becomes ambiguous when, in social memory, the white man has ceased to be perceived and treated as a real person (a warrior, a trader, and so forth) and is instead represented as a spirit.[40] Let us therefore consider seriously the Kuna representation of the white man through pairs of contradictory terms and try to understand its cultural background. As I have said, the Kuna White Spirit is ritually defined in the shamanistic chants as a denizen of an invisible village situated in the realm of the dead. This transfer of the representation of the white enemy from the "real" world to the place inhabited by the dead is, in Kuna cosmology, crucial. Let us start from the two minimal features that seem to define the White Spirit — it is an inhabitant of a supernatural village, and it is related to the dead — and examine in some detail how the Kuna shamanistic tradition represents this supernatural world and in what terms it defines the nature of a spirit.

Kuna Landscapes: The Living and the Dead[41]

Today, most Kuna live on small islands of coral origin located in the Kuna Yala archipelago along the Atlantic coast of Panama. These inhabited islands, sometimes linked to the coast by a long log bridge, are usually flat, barren, and without natural sources of fresh water. The horizon is marked off on one side by the ocean and on the other by the Darién forest. This spatial arrangement, typical of the entire archipelago, is rigidly divided, according to Kuna mythology, among the living, the dead, the animals, and the trees. The world appears to be apportioned horizontally (north to south and east to west) among these four groups. The mainland is the site of agriculture, hunting, and fresh water; the islands are the place where social life and most rituals occur. On the mainland across from the island where the village of the living is located, at the mouth of the river that supplies fresh water, is an unusual clearing in the forest. Here lies the village of the dead in the "real" world, the cemetery, where funerary rituals are celebrated.

In Kuna society, when an adult dies, the corpse is dressed in the deceased person's best clothes and put in a hammock with her or his head turned "toward dawn," the east. A cotton rope is placed in the corpse's hands in order to help him or her in crossing underworld rivers during the perilous journey to the sky, where the supernatural realm of the dead is located; the rope, it is said, "will serve as a bridge." The corpse is then covered with a white cloth, and the long funerary chant known as "Way of the Dead"[42] is chanted. The next day, the family of the deceased sets off for the village of the dead at dawn's first light. After the procession of canoes has landed near the clearing at the mouth of the river, the corpse is laid out in a hut with no walls. Offerings of cooked food and leaves from a banana tree are placed on the body. Then the corpse is covered with dirt, which is then beaten with shovels and baked with the flame of a brazier until the dirt forms a smooth, compact shell. The brazier will remain at the burial place, and relatives will keep it burning throughout the ritual. Bunches of multicolored feathers are hung from the balsa poles holding up the roof of the hut. To help the dead person in making the voyage to the sky, the living build small ladders out of bamboo and a small boat that will carry the hunting weapons the dead man or woman will need for defense. The realm of the dead is a replica of the world of the living, with one exception. There, beyond the blinding light of the sun, everything is golden. Many Kuna sources state that gold is the *color* of the realm of the dead. What is invisible here, "shines like gold" there.

At sunset, the participants in the ritual go back to the island, where everyone shares a meal and then takes a communal bath of purification. Two ritual gestures are made before they leave the village of the dead. Red pepper seeds, mixed with water, are placed on the tomb. When the water reaches the buried body, the dead person, it is said, will suddenly open his or her eyes and start traveling, first downward through the eight chthonic layers of the earth, then toward the sky. In addition, a rope (obviously recalling the one put into the hands of the corpse) is stretched across the nearby river and then cut. The

final separation of the living from the deceased person and from the danger-ous places that he or she will being traveling through is achieved and explic-itly symbolized by this cutting of the rope. The deceased begins the journey to the realm of the dead, and the ritual is over.[43]

When a child dies, the ritual is much simpler. The body is buried among the living, inside the family hut beneath the hammock where the child slept. The Kuna say that this type of burial will help the family have another child. The dead child's body still bears the male seed, which will make it germinate like a plant. Whereas the proximity of the corpse of an adult to the living is strongly proscribed, the proximity of the corpse of a child is regarded as posi-tive, since it inseminates the barren (usually sterile) land inhabited by the liv-ing. Moreover, quite unexpectedly, the "golden world" is not situated in the sky when the burial of a child is involved, but underground. It is instead a place described, for instance in the "Way of Mu" (the chant devoted to the therapy of difficult childbirth),[44] as a "pure golden layer of the earth."

The rituals associated with the burial of the dead, whether an adult or a child, involve the second, vertical division of Kuna space into layers from the top of the sky to the depths of the underworld. The Kuna underground world comprises eight layers. The four upper layers are the birthplace and lair of the evil illness-bearing animal spirits, the *niagana*. At the very bottom of the fourth layer is the source of the "golden river" that leads to the four lower layers of the underworld. The "soul"[45] of a dead adult Kuna must travel through all these regions to reach the eighth and lowest layer, home of Balsa the Seer, and then ascend to the sky. By burying the dead child beneath the hammock in which she or he slept, not in the village of the dead on the main-land, the Kuna hope to keep the child's "soul" from having to travel through the perilous world of the spirits. Even though the first underground layer is the home of potentially hostile spirits, it is thought of as being as fertile and populated as the mainland across from the island. Burial in this place trans-forms the child's body into a plant that can reproduce and return to a woman's womb as a "bleeding fruit," a new child.[46]

I will make no attempt to study here the symbolism of these two rituals and the underlying conception of death. Let me simply point out that, despite their differences, the rite for the dead child and the rite for the deceased adult are built on the same analogy between the human body and the supernatural world. Buried below her or his hammock, the body of the child transforms into a fruit, and, consequently, the dead child's mother into a cosmic tree bearing a "bleeding fruit." Similarly, the crucial sequence of actions in the burial of an adult (covering of the body with a white cloth, which designates the vagina; the rope first given and then cut, like the umbilical cord; the food and banana leaves left on the corpse before burial), we find that the earth that will cover the corpse is gradually transformed into the body of an origi-nal Mother.

This double reference to a cosmological body and to a corporeal universe—that is, to the representation of a universe shaped in the form of a human

body—is constitutive of the Kuna shamanistic tradition: if the earth can pos-sess a female sex, the body of a woman can be said to contain "eight layers" like the earth,[47] or even "whirlpools"[48] like the ocean. As Mac Chapin has noted, a Kuna shaman may identify a "sun" inside the throat of a sick man or "a pain coming from the sixth (subterranean) level of the earth."[49] Elsewhere, I have tried to show that the representation of the supernatural world in Kuna shamanistic chants is associated in particular with the representation of pain in the human body.[50] The chants devoted to the therapy of illnesses always describe the soul's journey through the invisible world of the spirits as a metaphor for the experience felt by the sick person. The shamanistic chant, then, primarily describes the state of *perceiving without seeing* that is the feel-ing of pain.[51] In the Kuna shamanistic tradition, suffering is simultaneously described in cosmological and physiological terms: to suffer is to experience a *transformation of the universe* involving a dramatic impairment of the natural balance between what is seen and what is perceived by other senses. The physiological aspect is troped as an "inner body" that no visual per-ception can reach, and the cosmological aspect as an invisible world inacces-sible to normal vision. In this tradition, properties of the invisible world (such as "bleeding rivers") refer to the visible human body, and properties of the invisible inner body (for instance, the pain generated in childbirth) refer to the visible world.

According to this principle, and by virtue of his second sight or knowledge of the chants, the Kuna shaman "sees" the presence of the spirits in the body of an ill person in what is visible in the "real" world. He is able to recognize the signs of pain because he is familiar with a particular kind of landscape— namely, the inner theater of the human body as constituted by the "invisible villages" where the spirits live.[52] We can then draw the following conclu-sion. From the standpoint of Kuna tradition, "invisible" things can be said to be simultaneously "there" (beyond the horizon, in the invisible world) and "here" (among us, in the inhabited village, in the visible world) because they are *within* us: these invisible landscapes are in the human body. This is illus-trated in the chant accompanying the dead person on her or his journey. In the "Way of the Dead," death itself is strikingly described in these cosmological and physiological terms. Recounting the process through which the body becomes progressively cold, the text says, "The spirits of illness let a wind enter his body.... Into his body they let a wind enter." Later, this wind becomes a river that literally runs through the body: "And now the river is penetrating your body."[53]

In shamanistic texts, spirits are often said to be simultaneously "here" and "there." According to Kuna tradition, only a mythical imperative uttered at the beginning of time compels human society to be separated—and even then not in essence but only in the contingency of time—from animals, trees, and the mineral world. The underlying principles of life may continuously pass from one body to another, whether human, animal, or vegetal. Hence, the Kuna universe is constantly threatened by the excessive promiscuity of beings

and by the disorder that would result from their intermingling. To understand this, one has to understand the process of metamorphoses that dominates Kuna tradition. Every being that inhabits the Kuna universe is of a double nature and always on the verge of a transformation. We will see that, when the representation of the white man is included in this universe, it too is destined for "double metamorphosis." Let me begin tracing this process with two examples of the use of simultaneous and contradictory spatial indications in a single landscape and then see how the description of a landscape relates to the definition of the nature of a spirit.

Spirits, Images, and Voices

Speaking of an *ukkurwala* (lit. "light trunk"; plural *ukkurwalagana*), a tall statuette representing Balsa the Seer, who is both a *nele* and the chief of all the auxiliary spirits of the shaman, a Kuna specialist told Ronny Velásquez, "You see there the image of the Seer. It is here. But its spirit is not here. It lies far away, deep down under the earth."[54] To a Westerner, the meaning of this statement could seem obvious: the image of a spirit simply is not the spirit itself; the statuette is only the visible form of a "being" who is located elsewhere. But the Kuna specialist's comment is founded on an entirely different perspective. What really counts in a representation such as the statuette is not its form. Its most important aspect is the *matter from which* it is made: the balsa itself. From a shamanistic perspective, balsa is associated with two elements of the visible world: a powerful tree and the extraordinary lightness of the wings of a bird. We will see that this conjunction of contradictory elements is what constitutes the nature of Balsa the Seer in a far clearer way than its outward form.

This is how the "Chant of the Demon" describes the birth of Balsa the Seer:

In this way the Balsa Tree was born. At the source of the river called Maekanti at the beginning of time, only animals existed. They were like human beings, and they lived in the river. The pigs, the peccaries, and the other animals were like human beings. The Father looked all around. Evil beings were everywhere.

The *niagana*, the evil animal spirits, were already there, well before the Father. The Father came after them. He saw that the world could not stay that way and sent a son of his, who came in order to help the people. At that time, the evil spirits, the *niagana*, were everywhere; they were blind or legless. The Father then touched his penis, and the sperm came out. In eight days, the sperm, gathered in a cup, became solid and took the form of a nighthawk egg. Eight days later, the egg broke, making a sound similar to the chant of the nighthawk: "Tuu." A man came out, and the Father said, "My son has come. I see now that my great son has come." And the Father thought, and after this he said, "Still I do not have a wife." And the Father then worked the mountains[55] and saw in the distance the great invisible villages. And this is how the Father advised his young son: "You were born from me, the great Father. You will work for me." These were the words the Father addressed to Balsa, the Light Trunk. Then the Father caught in his garment all the invisible

villages, and [the son?] learned to know all the things situated in the earth, just as if he were the one who had worked in order to build them. The Father told Light Trunk: "You will be the chief of all the *nuchumar*.[56] Later you will obey the orders given by the shaman: you will do what he tells you, and you will avoid what he forbids you."[57]

This text describes the birth of Balsa the Seer as a sequence of extraordinary metamorphoses. His being seems to result from a series of transgressions of the "normal" way of generation. Balsa is born from a cup of sperm without a mother's participation. Then the cup of sperm becomes a nighthawk egg. This bird is interesting here for two reasons: it becomes visible only at sunset, between the realms of day and night; and its chant is explicitly related by the Kuna to the cries of a madman. From the egg of this quasi-human bird, Balsa is born as a *man*. Immediately after, though, the text calls him a *tree*. From the cosmological point of view, then, the birth of Balsa is described as the simultaneous presence of a being in three different and separate territories: the realms of the trees, the birds, and the humans. He is neither bird nor tree nor man. He is simultaneously all of them. His nature is to be multiple.

We find the same configuration developed in another part of this chant, where the Village of Transformations is described. "Here the spirits are transformed into beings of every kind, here they are born," says the chant to announce the appearance of this village, meaning that transformation and birth, for a spirit, are the same. The text describes the process of an animal spirit's transformation using a verbal formula — for instance, in these lines: "Here the *niagana* are transformed into peccaries, the peccaries are there with their black clothes, they cry 'ya-ya-ya-ya.' The peccaries are now changed into *niagana*, they are transformed into *niagana*, the *niagana* are transformed."[58]

The text describes the birth of the *nia* (the evil, animal spirit) through two distinct logical movements: first the invisible spirit is transformed into an animal, which is to say that it takes the visible form of the animal; in the following verse, the visible animals are in turn transformed into invisible spirits. This movement from spirit to animal and from animal to spirit is made possible by two operations. When the spirit's invisible presence is replaced by an animal's appearance, the peccaries (like all the other animals mentioned in the Village of Transformations, including fireflies, butterflies, snakes, deer, and monkeys) dress in "black clothes" and let out their hunting cry. We thus have a sequence of the following kind, which is repeated over and over:

the *nia* is an animal

the animal —— is dressed in black clothes

the animal —— lets out its hunting cry

the animal is a *nia*

By showing an animal in a form different from its usual visible form (always described in the text according to this formula), the text *gives the proof*—from a Kuna point of view—of the spirit's transformation into an animal. In this context, the *black clothes* that conceal from sight the peccary's fur can only refer to the nocturnal, invisible presence of the Jaguar of the Sky—the greatest of all the evil spirits, and the one who can transform itself into every kind of creature. The introduction of the idea of black clothes enveloping the animal's body is a way of expressing at one and the same time the invisible, nocturnal character of the spirit and its visible incarnation as a creature of the forest.

When the animal spirit ceases to be recognizable by its visible aspect, its presence will be unequivocally revealed by the reference to its hunting cry in the shaman's chant. And this reference to a concealed presence revealed by its acoustic image faithfully reproduces the dual mode of appearance of the Jaguar of the Sky: either a nocturnal image plunged into darkness, or an invisible presence that only the auditory hallucination of the animal's cry makes perceptible to the hunter in the forest.

The simultaneous presence of an invisible spirit and of an animal appearance that hides from the light of day defines, here again, the ontological nature of the spirit. Like Balsa the Seer, the *nia* reveals its nature in the act of transforming itself. The image of the spirit is situated *there* (far away in the cosmological space), but another sign of its presence (its voice) is always to be perceived *here,* close to the human village. In American Indian cosmologies, distinctions drawn between different territories of the universe (earth, sea, sky, underworld) often are a way of establishing different ontological categories. A being is defined by the territory to which it belongs. The shamanistic chants of the Kuna show, however, that a spirit can be defined as a being who possesses several natures and *therefore* belongs to several cosmological territories. *The ambiguous structure of the supernatural space* (where certain things can be simultaneously "here" and "there") *becomes then a way to characterize the multiple nature of the supernatural beings inhabiting that space.*

In the Kuna shamanistic tradition, the definition of the supernatural is connected with the idea of the conjunction of contradictory features: an animal, a tree, even a human being can become supernatural only if it also acquires the nature of other beings. Its inner contradiction (and the flow of metamorphoses connected to it) is expressed in spatial terms as the simultaneous presence of the same being in different locations of the landscape. In this worldview, not only can a river flow through the body of a suffering women but also a balsa tree and a peccary can be said to be—in supernatural landscapes, in dreams and after death—invisible "here" and shining like gold "there." In the same way, the White Spirit can be said to be simultaneously plant and animal, good and bad, magical healer and pathogenic spirit.

Like many other American Indian societies, Kuna shamanistic tradition *has chosen the supernatural dimension* (with its relationship to the representation of suffering) in which to represent social crises and collective trauma. It is *there* (in that world which is simultaneously represented as an invisible landscape and as a suffering body) that the real enemies of the Kuna have become also *new invisible beings*. Ritual recollection of the traumatic past paradoxically implies the renewal of the supernatural. However, the representation of the White Spirit (or, rather, the ritual metamorphosis of the whites into spirits), with its series of opposing connotations (murderer/murdered; human/animal; friend/enemy; and so on) follows exactly the pattern established for the representation of *any* spirit. The ritual transformation of an enemy into a spirit, far from being reducible to simple "sympathetic magic," marks just a further step in the same logic of condensation. Thus, these representations, seen from the indigenous point of view, are not ambiguous or "confused" (as they inevitably appear from a Western point of view), they are *negative in a complex way*.

While having the same complexity (the conjunction of contradictory features) that defines any Kuna supernatural being, these representations do convey "realistic" indications concerning the nature of the white enemy. In other words, far from being symptoms of a loss of identity (or of an imminent submission to "foreign" or "modern" values), these representations indicate that the social memory of the Kuna is very much alive. Ambiguity or, more precisely, the capacity to represent individual and social crises through paradox — a term by which we define the coexistence of contrary, conflicting aspects of the same situation — is a strength, not a weakness, of Kuna ritual images.

From a more general point of view, I wish to suggest that there are at least two ways of constructing social memory. One works through the narration (and continuous renewal) of a set of stories. The other, often linked to the elaboration of ritual practices, tends to make a number of relatively stable images more and more complex, increasingly loaded with meaning, and more persistent in time. Two aspects of this last way to produce social memory have emerged here. First, these images are constructed within a ritual context. They are to be regarded, in a Warburgian perspective, as steps in a sequence of ritual representations: Kuna "white" statuettes are unthinkable without the chants and without the elaborate cosmology that the chants evoke. Second, the representation of the white man is always realized only as a single, I would even say *contingent*, aspect of the Kuna supernatural world. Spirits are "white" *among other things*. To become "white" is *only one* of a spirit's possible manifestations, and spirits take on this form in keeping with their fundamental essence, which is to be continually engaged in ritually oriented metamorphoses.

There is little doubt that the emergence in Kuna shamanistic practices of the White Spirit as a possible manifestation refers to the long series of violent conflicts that have opposed the Kuna to the aggressors from the West. However, once inserted in the Kuna ritual tradition, stories of the traumatic past collapse and condense in complex images. Two processes seem to be at work in the elaboration of these images: one tends to obliterate the external facts to

allow the white man to be inserted into an indigenous conceptual frame, namely, the cosmology of the Kuna supernatural world; the other uses the ambiguities of Kuna cosmology to represent a salient aspect of the newcomers, namely, their association with suffering in the visible world. The result is an elaborate (and ritually powerful) "engram" of ritual tradition, and a significant part of social memory.

The study of the several ways in which the past can cause pain in the present was fundamental to Freud's early work. In a sense, Freud conceived of the symptom itself as a symbol of the past.[59] The way the ambiguous memory of the white man establishes itself in Kuna tradition shows a dynamic similar to the one described by Freud for the psychological elaboration of the trauma. These images work as mnemic traces: they evoke the traumatic past through the shamanistic exploration of suffering, but they make it present without representing it in narrative.

The study of crucial images selected from the Kuna shamanistic tradition suggests how a complex symbol, rooted in the representation of a traumatic experience, can work as the mnemic trace of an ever-returning past. A ritually recollected image of the past can strictly follow the definition of trauma: a reminiscence that, while refusing to fully emerge to consciousness, equally refuses to either find its way out or fall into oblivion. The images of whites, with their big hats, necklaces, painted shirts and trousers, roughly sculpted in balsa by Kuna shamans, once replaced in the supernatural landscape that situates them simultaneously "here in the body" and "there beyond the horizon," reveal that tension better than any story.

Notes

1. My translation; Walter Benjamin, *Das Passagen-Werk,* ed. Rolf Tiedemann (Frankfurt am Main: Suhrkamp, 1982), 578 (N 3,1): "Bild ist dasjenige, worin das Gewesene mit dem Jetzt blitzhaft zu einer Konstellation zusammentritt."

2. My translation; Paul Ricoeur, *Temps et récit,* vol. 1, *L'intrigue et le récit historique,* Collection POINTS (Paris: Editions du Seuil, 1991), 9: "réfigurer l'expérience du temps." Ricoeur writes, for instance, "le temps ne devient humain que dans la mesure où il est articulé sur un mode narratif, et le récit n'atteint sa signification première, que quand il devient une condition de l'existence temporelle" [time becomes part of human experience only when it is formulated in a narrative way; the narration, similarly, only reveals its deep meaning when it is seen as a condition for human existence in time] (p. 105) (my translation).

3. See Hayden White, *Metahistory: The Historical Imagination in Nineteenth-Century Europe* (Baltimore: Johns Hopkins Univ. Press, 1973); and Jerome S. Bruner, *Acts of Meaning* (Cambridge, Mass.: Harvard Univ. Press, 1990).

4. See Aby Warburg, *The Renewal of Pagan Antiquity: Contributions to the Cultural History of the European Renaissance,* trans. David Britt (Los Angeles: Getty Research Institute for the History of Art and the Humanities, 1999); originally published as *Die Erneuerung der heidnischen Antike: Kulturwissenschaftliche Beiträge*

zur Geschichte der europäischen Renaissance, ed. Gertrud Bing with Fritz Rougemont, 2 vols. (Leipzig: B. G. Teubner, 1932; reprint, Nendeln, Liechtenstein: Kraus Reprint, 1969).

5. One of the most common objections to the study of images in this context concerns what could be called the peculiar semiotic poverty of the iconic language. "Never mistake a drawing for a text," warned E. H. Gombrich, rightly, in his famous book *The Sense of Order: A Study in the Psychology of Decorative Art* (Oxford: Phaidon, 1979), 362. The way to produce the meaning of a design—argued the great historian of art—is totally different from that of a sign: a design should be freely appreciated aesthetically, a sign should be deciphered following implicit rules. As a consequence, as I have argued elsewhere, communication through signs tends to be easy and accurate, while communication through images is difficult, always arbitrary, inevitably vague; see Carlo Severi, "Kuna Picture Writing: A Study in Iconography and Memory," in Mari Lyn Salvador, ed., *The Art of Being Kuna: Layers of Meaning among the Kuna of Panama,* exh. cat. (Los Angeles: UCLA Fowler Museum of Cultural History, 1997). One of the reasons invoked for this vagueness is the impossibility, for images, to express a crucial aspect of language: negation. If nothing negative can be expressed in iconic terms, then images are to be considered logically too weak to become the support of any social memory.

6. See Sigmund Freud, *The Standard Edition of the Complete Psychological Works of Sigmund Freud,* vol. 16 (1916–1917), *Introductory Lectures on Psycho-Analysis (Part III),* trans. James Strachey, with Anna Freud, Alix Strachey, and Alan Tyson (London: Hogarth, 1963), 275.

7. See Paul Ricoeur, *Temps et récit,* vol. 3, *Le temps raconté,* Collection POINTS (Paris: Editions du Seuil, 1993), 9.

8. See, for instance, Freud, *The Standard Edition,* vol. 16, *Introductory Lectures on Psycho-Analysis* (note 6), 368; as well as Freud's "The Unconscious" and "Mourning and Melancholia," both in *The Standard Edition of the Complete Psychological Works of Sigmund Freud,* vol. 14 (1914–1916), *On the History of the Psycho-Analytic Movement; Papers on Metapsychology; and Other Works,* trans. James Strachey, with Anna Freud, Alix Strachey, and Alan Tyson (London: Hogarth, 1957), esp. 187, 246.

9. The works of George Devereux and Gregory Bateson are, for different reasons, the most accomplished and competent attempts to develop an approach to the study of social facts that could enrich Freud's ideas. See, in particular, Gregory Bateson, *Steps to an Ecology of Mind: Collected Essays in Anthropology, Psychiatry, Evolution, and Epistemology* (Saint Albans, Australia: Paladin, 1972); George Devereux, *Ethnopsychoanalysis: Psychoanalysis and Anthropology as Complementary Frames of Reference* (Berkeley: Univ. of California Press, 1978); and George Devereux, *Basic Problems of Ethnopsychiatry,* trans. Basia Miller Gulati and George Devereux (Chicago: Univ. of Chicago Press, 1980).

10. Kuna statuettes representing white persons were collected in Panama before 1918 by G. L. Fitz-William, an American chemical and mining engineer, and in Kuna Yala in June 1927 by the Swedish anthropologist Erland Nordenskiöld. Fitz-William's collection is at the Field Museum in Chicago; see, for example, Mari Lyn Salvador, ed., *The Art of Being Kuna: Layers of Meaning among the Kuna of Panama,* exh. cat. (Los

Angeles: UCLA Fowler Museum of Cultural History, 1997), 323, 333 (cat. nos. 23, 24). Nordenskiöld's collection is at the Etnografiska Museet i Göteborg, Sweden; see Erland Nordenskiöld, with Ruben Pérez Kantule, *An Historical and Ethnological Survey of the Cuna Indians,* ed. Henry Wassén (Göteborg, Sweden: Göteborgs Etnografiska Museet Avdelningen, 1938; reprint, New York: AMS Press, 1979). We can thus safely assert that a ritual representation of the relationship with white persons has been present in Kuna shamanism since at least 1918.

11. James Howe, "The Kuna and the World: Five Centuries of Struggle," in Mari Lyn Salvador, ed., *The Art of Being Kuna: Layers of Meaning among the Kuna of Panama,* exh. cat. (Los Angeles: UCLA Fowler Museum of Cultural History, 1997), 85.

12. Howe, "The Kuna and the World" (note 11), 89.

13. See Howe, "The Kuna and the World" (note 11), 101.

14. See, for examples, Nordenskiöld, *An Historical and Ethnological Survey* (note 10), 345, 426.

15. I will not address in this paper the question of sexual differentiation of the White Spirit. Let me remark, however, that spirits, in Kuna mythology, are usually supposed to come "in pairs," in both male and female incarnations. For a good illustration of this aspect of Kuna mythology, see Nordenskiöld, *An Historical and Ethnological Survey* (note 10), 389–93.

16. See, for instance, Norman Macpherson Chapin, "Curing among the San Blas Kuna" (Ph.D. diss., University of Arizona, 1983), 93: "the *nuchugana* (ritual figurines or statuettes carved in balsawood) are usually about a foot tall, and almost invariably are carved to look like non-Indians." Chapin worked with Kuna specialists between 1971 and 1976.

17. Michael Taussig, *Mimesis and Alterity: A Particular History of the Senses* (New York: Routledge, 1993). On the Voodoo priest, see Alfred Métraux, *Voodoo in Haiti,* trans. Hugo Charteris (New York: Schocken, 1972); originally published as *Le vaudou haïtien* (Paris: Gallimard, 1958). On the Songhai, see Paul Stoller, "Horrific Comedy: Cultural Resistance and the Hauka Movement in Niger," *Ethos* 12 (1984): 165–88; and Paul Stoller, *Fusion of the Worlds: An Ethnography of Possession among the Songhay of Niger* (Chicago: Chicago Univ. Press, 1989). The facts described by Stoller about the Hauka movement in Nigeria are memorable and thought-provoking. The members of this movement, begun among the Songhai in French Niger and British Accra around 1925, danced and became possessed by the spirits of colonial administrators. The reaction of the colonial authorities was to repress the movement and to imprison as many members of the Hauka they could get hold of. Since the publication of Taussig's book, Stoller has written a study of the Hauka movement that is directly inspired by Taussig's ideas about the Kuna; see Paul Stoller, *Embodying Colonial Memories: Spirit Possession, Power, and the Hauka in West Africa* (New York: Routledge, 1995).

18. See Taussig, *Mimesis* (note 17), esp. 250–55.

19. See Carlo Severi, "Talking about Souls: The Pragmatic Construction of Meaning in the Kuna Shamanistic Chants," in Pascal Boyer, ed., *Cognitive Aspects of Religious Symbolism* (Cambridge: Cambridge Univ. Press, 1993).

20. See Carlo Severi, "The Invisible Path: Ritual Representation of Suffering in Cuna Traditional Thought," *Res,* no. 14 (1987): 66–85.

21. Taussig, *Mimesis* (note 17), 252, 251.

22. Taussig, *Mimesis* (note 17), 252.

23. Taussig, *Mimesis* (note 17), 238, 253.

24. See Carlo Severi, "Image d'étranger," *Res,* no. 1 (1981): 88–94; and Severi, "Talking about Souls" (note 19).

25. See Severi, "Talking about Souls" (note 19).

26. Since this kind of representation has passed generally unnoticed in the ethnography of the American Indian societies, the Kuna case is probably not an isolated one. Franz Boas witnessed among the Kwakiutl of the Pacific Northwest coast, during the winter of 1895–96, two "play performances" of potlatches in which Europeans were impersonated and derided; see Franz Boas, "The Social Organization and Secret Societies of the Kwakiutl Indians," in *Report of the U.S. National Museum for 1895* (Washington, D.C.: U.S. Government Printing Office, 1897). Almost sixty years before Boas, writing while among the Osage on a tour of the prairies in 1832, Washington Irving noted that "the Indians that I have had an opportunity of seeing in real life … are by no means the stoics that they are represented; taciturn, unbending, without a tear or a smile.… They are great mimics and buffoons, also, and entertain themselves excessively at the expense of the whites with whom they have associated"; see Washington Irving, "A Tour on the Prairies," in idem, *The Works of Washington Irving,* vol. 6, *The Adventures of Captain Bonneville, Crayon Miscellany,* author's rev. ed. (New York: G. P. Putnam, 1865), 51–52.

27. Keith Basso, *Portraits of "the Whiteman": Linguistic Play and Cultural Symbols among the Western Apache* (Cambridge: Cambridge Univ. Press, 1979), 12–13, 14.

28. Basso, *Portraits* (note 27), 76.

29. Basso, *Portraits* (note 27), xx–xxi.

30. This cartoon is reprinted in Basso, *Portraits* (note 27), 62.

31. Of the "joking performances" studied by Basso, 72 percent were performed "by men who were drinking with friends and relatives"; see Basso, *Portraits* (note 27), 32.

32. Basso, *Portraits* (note 27), 14 (emphasis mine).

33. Basso, *Portraits* (note 27), 14, 80.

34. Basso, *Portraits* (note 27), 81–82.

35. The notion of "foregrounding" as an aspect of communication has been defined as a way to signal "as 'relevant now' a particular conceptual framework for understanding what is said and done"; see Basso, *Portraits* (note 27), 12.

36. On Warburg's theory of memory and its "engrams," see E. H. Gombrich, *Aby Warburg: An Intellectual Biography* (London: Warburg Institute, 1970), 242–47.

37. Kuna Indians live today in the San Blas Archipelago of Panama. The population of Kuna land (Tule Nega or Kuna Yala) is about twenty-seven to thirty thousand persons who speak a language traditionally associated with the Chibcha family; see Nils M. Holmer, *Critical and Comparative Grammar of the Cuna Language* (Göteborg: Göteborgs Etnografiska Museet, 1947); and Nils M. Holmer, *Cuna Chrestomathy* (Göteborg: Göteborgs Etnografiska Museet, 1951). A small Kuna group, which still rejects all contact with the white man, lives in the Chucunaque region of the Darién forest, near the Colombian border. Essentially, the Kuna are tropical farmers. In his

brief historical survey, David Bond Stout speculated that Kuna society, one of the first to come in contact with white men after the discovery of the American continent, was "heavily stratified, and divided into four classes: leaders, nobles, citizens and slaves"; see David Bond Stout, *San Blas Cuna Acculturation: An Introduction* (New York: Viking Fund, 1947; reprint, New York: Johnson Reprint, 1964). Political power today is held by the *onmakket,* an assembly of all the adult males in the village, supported by a varying number of elected leaders (*sailagan*). The Kuna kinship system is bilineal, uxorilocal, and founded on strict group endogamy; see James Howe, "Communal Land Tenure and the Origin of Descent Groups among the San Blas Cuna," in Mary W. Helms and Franklin O. Loveland, eds., *Frontier Adaptations in Lower Central America* (Philadelphia: Institute for the Study of Human Issues, 1976); and James Howe, *The Kuna Gathering: Contemporary Village Politics in Panama* (Austin: Univ. of Texas Press, 1986).

A general survey of Kuna literature is to be found in Fritz W. Kramer, *Literature among the Cuna Indians* (Göteborg: Göteborgs Etnografiska Museet, 1970); James Howe, Joel Sherzer, and Mac Chapin, *Cantos y oraciones del congreso cuna* (Panama: Editorial Universitaria, 1980); Joel Sherzer, *Kuna Ways of Speaking: An Ethnographic Perspective* (Austin: Univ. of Texas Press, 1983); Joel Sherzer, *Verbal Art in San Blas: Kuna Culture through Its Discourse* (Cambridge: Cambridge Univ. Press, 1990); and Carlo Severi, *La memoria rituale: Follia e immagine del Bianco in una tradizione sciamanica amerindiana* (Florence: Nuova Italia, 1993), which has been published in Spanish as *La memoria ritual: Locura e imagen del blanco en una tradición chamánica amerindia,* trans. Ricardo Pochtar (Quito, Ecuador: Ediciones Abya-Yala, 1996).

38. See Severi, *La memoria rituale* (note 37), 49–174.

39. In the shamanistic tradition, the murderer and the murdered person are both potentially dangerous. On this point, see Severi, "Image d'étranger" (note 24).

40. A comparative study of this representation of the white man among American Indians is still to be done. Some interesting indications concerning the Amazonian groups can be found in Philippe Erikson, *La griffe des aïeux: Marquage du corps et démarquages ethniques chez les Matis d'Amazonie* (Paris: Peteers, 1996).

41. An earlier draft of this section was presented at "Totenriten und Jenseitslandschaften" (Death Rituals and Supernatural Landscapes), a conference organized by the Arbeitskreis Religionwissenschaft of the Ruprecht-Karls-Universität Heidelberg, May 1996.

42. A version of the "Serkan Ikala," in Kuna with a Spanish translation, is in Nils M. Holmer and Henry Wassén, *Dos cantos shamanísticos de los indios cunas* (Göteborg: Göteborgs Etnografiska Museet, 1963).

43. "After the mourners have gone, the last act of the gravediggers is to fasten a string to one of the protruding hammock stakes and lead it down to and across the river and tie it on the other side; the first person coming up or down the river must cut it"; see Stout, *San Blas Cuna Acculturation* (note 37), 40. This rite of stringing and cutting the rope is repeated for three consecutive days after the death, as well as on the ninth day of the first month following the death and on the thirtieth day of the month for six months following the death. Arnulfo Prestán Simón adds that "a number of shots" are fired with a gun "to let people know that the ritual is finished," and he also

mentions two aspects of this ritual that I will not study here: sharing a meal with the deceased person, and offering cacao beans to the spirits; see Arnulfo Prestán Simón, *El uso de la chicha y la sociedad kuna* (Mexico: Instituto Indigenista Interamericano, 1975), 105, 106. For more details on this ritual, see also Severi, "The Invisible Path" (note 20).

44. This chant was published first in English and Kuna, in an incomplete version, in Nils M. Holmer and Henry Wassén, *Mu-igala; or, The Way of Muu* (Göteborg: Elanders Boktryckeri Aktiebolag, 1947), and then in a new, complete version in Nils M. Holmer and Henry Wassén, *The Complete Mu-Ikala in Picture Writing* (Göteborg: Elanders Boktryckeri Aktiebolag, 1953).

45. On the Kuna concepts relating to the principle of life (*burba*, "double"; *niga*, "physical strength"; *gurgin*, "spiritual force, or influence"), see Carlo Severi, "Le chemin des métamorphoses: Un modèle de connaissance de la folie dans un chant chamanique cuna," *Res*, no. 3 (1982): 32–67; and Severi, "The Invisible Path" (note 20).

46. See Holmer and Wassén, *The Complete Mu-Ikala* (note 44), vv. 164–65.

47. See Ruben Pérez Kantule and Erland Nordenskiöld, "The Creation of the Turtles (La creación de las tortugas)," in Erland Nordenskiöld, with Ruben Pérez Kantule, *An Historical and Ethnological Survey of the Cuna Indians*, ed. Henry Wassén (Göteborg: Göteborgs Etnografiska Museet Avdelningen, 1938; reprint, New York: AMS Press, 1979), 389 n. 1.

48. See Ronny Velásquez, "El canto chamanico de los indigenas kuna de Panama" (Ph.D. diss., Universidad Central de Venezuela, Caracas, 1992), 702 ff.

49. See Chapin, "Curing" (note 16), 216, 217.

50. See Severi, "Le chemin" (note 45); and Severi, "The Invisible Path" (note 20).

51. See Severi, "The Invisible Path" (note 20), 81–84.

52. See "Serkan Ikala" (note 42), vv. 54–56.

53. "Serkan Ikala" (note 42), vv. 54–55, 130–32.

54. Velásquez, "El canto chamanico" (note 48), 735.

55. "To work" in this case means "to have sexual intercourse with."

56. The *nuchumar* are the auxiliary spirits of the Kuna shaman, generally (though not always) representing trees or vegetal spirits; *nuchumar* is another word for *nuchugana*.

57. I collected this text, here translated from the Kuna, during my 1982 mission in the Kuna village of Mulatupu.

58. Enrique Gomez and Carlo Severi, "Nia Ikar Kalu," in Carlo Severi, "Los pueblos del camino de la locura: Canto chamanístico de la tradición cuna," *Amerindia: Revue d'ethnolinguistique amérindienne*, no. 8 (1983): 134–79, esp. vv. 248, 249–50.

59. See Michael Roth, "Freud's Use and Abuse of the Past," in idem, ed., *Rediscovering History: Culture, Politics, and the Psyche* (Stanford: Stanford Univ. Press, 1994).

Male Ancestors and Female Deities: Finding Memories of Trauma in a Chinese Village

Jun Jing

People in every locality in China can relate stories of how their lives were shattered as Mao Zedong's radical socialist programs convulsed Chinese society in the name of continuous revolution and rapid modernization. The cost in human suffering was immense, and more than two decades after Mao's death, the landscape of everyday life in the People's Republic remains "littered with dangerous memories of arbitrary injuries."[1]

This is certainly the case in Dachuan, a village on the Yellow River some fifty miles southwest of Lanzhou, the capital of Gansu province in northwest China. More than 85 percent of the residents of this village are surnamed Kong and trace their ancestry to Confucius (Kong Fuzi, in Chinese), the ancient sage whose teachings provided the moral framework for traditional Chinese society.[2] Before the Chinese Communist Party came to power in 1949, the Kong lineage of Dachuan dominated not only the village itself and Yongjing county, where Dachuan is located, but other parts of Gansu province as well. By status and name, the Kongs of Dachuan personified the old order that the Communist government vowed to supplant, and throughout the Maoist era, they were hit hard by state-organized assaults on the vestiges of old China.

It was also their misfortune to be living in the path of one of the grander projects of the late 1950s, namely, the series of hydroelectric dams that was to tame the mighty Yellow River and provide the electricity needed for the industrialization of northern China. Dachuan is the oldest and largest of the sixteen villages whose original sites were permanently flooded as a consequence of the Yanguo Gorge dam project, and it was one of the first villages in Yongjing county to face relocation. By the time Dachuan was flooded on 31 March 1961, nearly half of its twenty-six hundred residents had been transferred to communities downriver from the Yanguo Gorge. Those who had managed to stay behind had moved to higher ground, into an elevated section of the old settlement and a row of cemeteries at the foot of a barren hill. For the Kongs of Dachuan, the damming of the river meant eviction from their ancient homes, the scattering of a close-knit community, the loss of hundreds of family graves, and a deepening of the famine's effects.

The dam project at the Yellow River's Yanguo Gorge that proved so disastrous to Dachuan was a centerpiece of the Great Leap Forward of 1958 to

1961, Mao's "attempt to leapfrog history and bring China to world-beating modernity through one vast effort of modernization."[3] In the industrial sector, it involved the building of millions of backyard furnaces to make steel from the metal cooking pots, nails, tools, and other hardware collected from countless individuals. In agriculture, it entailed the organization of peasants into vast communes, the construction of huge irrigation and hydroelectric projects, and the introduction of dubious farming methods such as the tripling of the number of rice seedlings on a plot. The results were catastrophic. The smelted metal was useless for industrial purposes, and the new farming methods led to widespread crop failure.

The Yanguo Gorge dam was characteristic of the spectacular failures of the Great Leap Forward. The dam's construction was launched in haste, without so much as a blueprint. Because the problem of silting in the dam's reservoir was grossly underestimated, the accumulation of mud and pebbles quickly reduced the dam's electrical generating capacity by as much as half. The dam's construction caused the destruction of fifteen hundred houses, two thousand acres of farmland, one hundred eleven thousand fruit trees, and two thousand graves. Nine thousand peasants were relocated against their will, many evicted by the militia at the peak of a famine that was to take as many as thirty million lives nationwide. From 1959 to 1961, the population of Yongjing county dropped by fifty thousand, to one hundred twenty thousand. Many starved, others fled, and the birth rate collapsed. And the people most vulnerable during these years were those relocated to make way for the dam and its reservoir. For them, the deadly impact of food shortages was exacerbated by the scarcity of shelter and medicine.

Most people with a sense of twentieth-century history know of its great horrors, in which millions of people perished — the Holocaust in Europe, the Soviet Union's gulag, the killing fields of Cambodia. The Chinese famine of 1959 to 1961 ranks with such disasters, although as yet it lacks a commonly recognized name that captures its severity and effect.[4] Depending on how the demographic statistics are interpreted, the famine is estimated to have claimed twenty to thirty million lives.[5] It was, researchers agree, a man-made disaster. Even as harvests were failing as a result of flawed agricultural policies, local officials eager to meet quotas exaggerated crop yields, and state agencies ardently pursuing grain-procurement programs swept the countryside clean of food. In China's official discourse, however, the famine and its attendant horrors are designated, to this day, as "the three years of natural disasters."

But how are the hardships of this time remembered by the people of Dachuan? How do they recall the years of famine and the flooding of their village? How do individual villagers articulate their memories in ways that may be identified as expressions of collective memory? I will address these questions here by exploring the revival of worship of male ancestors and female deities in Dachuan since the 1980s.

In Chinese peasant belief, the family is viewed as a closely interconnected group of living and dead relatives.[6] It is characterized by symbiotic relation-

ships among the dead, the living, and those yet to be born. The rites associated with ancestor worship—whether performed at temples honoring ancestral spirits or at household shrines dedicated to recent forebears—express concern for the welfare of the dead. The ancestors, in turn, cooperate with the living to help fulfill the family's common goals, which include continuity of familial lines and the unity of the lineage. These beliefs, I would argue, are the ground of collective memory in Dachuan, against which individual villagers recall the suffering of their families during the Maoist era. In other words, because the Chinese family system is a religious microcosm, the violations to the family system that the villagers of Dachuan experienced have cosmic repercussions and their attempts to recover from their systemic injuries find expression in religious ritual.

The Great Famine in Local Memory

Because I wished to track how the great famine of 1959 to 1961 had affected Dachuan, and because the villagers had not formally documented any famine-related deaths, in 1992 I planned to carry out a household survey among Dachuan's thirty-three hundred residents. The village's three leading cadres immediately advised against this. They said that my survey would cause the community as much pain as tearing open an old wound. They also feared punishment from higher level authorities if they were to allow me to conduct such a survey, for in the early 1990s, as it is now, the famine was a forbidden subject of research inside China.

The three village cadres decided that the best approach would be to invite three elderly villagers, all literate men, to join them in discussing the famine with me in private and in a systematic manner. The initial evening session, which lasted for five hours, was followed by a four-hour afternoon session. During these sessions, the six participants named fifty people who had died in Dachuan during the famine. Most of those they named were close relatives, the very old and young, but they named as well men in other families who had died at what should have been the prime of their lives. They also insisted that many more villagers had perished, although they were unsure of exactly how many. To the information provided by these six men, I was later able to add the results of six hours of semistructured interviews with three county officials as well as the results of the interviews I conducted over the course of one month with a group of fifteen villagers in Dachuan. The initial group of three village cadres and three elderly men provided the most valuable information about the famine, however, and the interviews with these six are the source for the stories and information that I use in this section.

All of these discussions were marked by emotions that helped me to understand why the village cadres regarded the famine as too painful a subject to be discussed openly. The stories were fraught with guilt, humiliation, and lingering disbelief. Typical of the statements I heard is this: "My brother dived into the water to dig potatoes from a submerged field. The water was icy and he was shivering all over. He gave all the potatoes to us and went out searching

for food again. He died at the top of a tree. He had been trying to gather leaves to eat."[7] Surviving while other family members died was not the sole source of guilt. His failure at the time to appreciate the severity of the famine clearly bothered one village cadre: "My sister and I were quite young and did not know better. We ate whatever my mother had saved. We nagged her for food every day. We all survived. But my mother became sick and old. She worked too hard feeding us. Now life is better but there is no way to make up for the bitterness my mother endured."

Famine was not unfamiliar to the people of Dachuan. Most of the local non-Kong households had arrived in the village as refugees from war and famine in the late nineteenth and early twentieth centuries. Unlike previous famines, however, that triggered by the Great Leap Forward reduced the traditionally least vulnerable segment of the population — healthy male adults. As one villager put it, "Physically strong men naturally have a bigger appetite. In the three years of natural disasters" — note that he used the official name for the famine — "they died quickly. Terribly starved, their bodies began to shrink. To satisfy their craving for food, they ate roots, barks, and boiled leather belts. They became sick with big bellies. No one in the village, not even doctors at the county seat, had a cure for the big-belly epidemic."[8]

If the deaths of these men confounded villagers, so did the lengths to which some went to survive. All those I talked to reported having heard of instances of what can be termed *survival cannibalism*.[9] Only two said they had personal knowledge of cannibalism, however, and each described the incident as an act of insanity that took place in other villages. One of these incidents involved the killing of a child by a stranger. When government officials were informed, the man was arrested and shot. The villager recalled, "The madman showed little fear when he was executed. Maybe he just had enough to eat and was therefore not afraid of dying anymore. The crowd watching the execution was equally unfeeling, and nobody even cursed the murderer. Whatever his reasons, he had swallowed human flesh." Although the man who related this incident to me did not know whether the killer had lost his mind before or because of the famine, he insisted that the only explanation was mental breakdown, arguing that most people who were starving did not kill other humans for their flesh so as to survive.

The other villager who said that he had encountered cannibalism was a government official during the famine. He and several militiamen had apprehended the killer and recovered the bodies of a boy and a middle-aged woman. He too described the killer as suffering from insanity: "The killer was expressionless. No matter what we asked him, he just nodded his head. If he was not crazy, he would have covered up the crime scene. As soon as I pushed open the door to the central room of his house, I saw a trail of blood on a table." The killer's wife had starved to death a few months earlier. The child and the woman he killed were beggars who were traveling through the village.

This official was to suffer disgrace after the famine. He was dismissed from office in 1961 when higher level authorities discovered that some three

hundred people had died of starvation in his district. A team of officials from Beijing and Lanzhou forced him to make a self-criticism in front of three thousand people, many of whom had lost relatives in the famine. One of the officials from Beijing told him beforehand that the peasants at the rally would decide whether he should be allowed to live. This is how he recounted what happened: "The people gathered around the stage were furious. They thought I had plenty to eat while they didn't. They were grinding their teeth with hate. They demanded that I be beheaded. But in the end, the masses showed mercy. Many people in the crowd started sobbing when I told them that I could not save even my own family. My wife, one of our sons, my brother, his wife, and their son all died of starvation in Dachuan."

Public humiliation was not always staged by officials; sometimes it was inflicted by fellow villagers. The same villager who had been spared by the peasants at the rally described its lethal consequences for his sister-in-law: "She was hungry and stole a handful of vegetables from the public dining hall. The cook caught her eating these rotten vegetables and kicked and cursed her in front of men and women, old and young. She came back home weeping and went to bed. She never woke up again." I also heard about public beatings, often by village cadres, to force peasants to accomplish various tasks for the Great Leap Forward.

Such stories suggest that among the people who could be considered victims of the famine were the local agents of victimization. When the Great Leap Forward dictated that public dining halls replace family kitchens, eight canteens were set up in Dachuan to prepare and supply food and hot water. When the food ran out, the canteens were shut down. Decades later, at least one former village cadre and two former cooks were still resented for having beaten people and having favored their immediate relatives in the distribution of food. My request for their names was denied, however, on the grounds that two of them were still alive, politically influential, and very much involved in the Kong lineage's revival of the worship of Confucius and local ancestors. To investigate now how villagers had suffered or died because of their neighbors and even close kinsmen would, I was warned again, reopen old wounds and undermine efforts to reorganize and reassert the Kong lineage.

Remembering the Destruction of Graves

The famine affected the dead as well as the living, because most of the villagers were too weak or too involved in the struggle to survive to forestall the mass destruction of graves that was one consequence of the Yanguo Gorge dam project. To understand what this meant to the people of Dachuan, let me briefly explain the significance of Chinese family graves. In China, as in many societies, body and soul are thought to be intimately linked, even in death. As J.J.M. De Groot noted, in China "both the body and the soul require a grave for their preservation. Hence the grave, being the chief shelter of the soul, virtually becomes the principal altar dedicated to it and to its worship."[10] The soul, he argued, can suffer from an improper burial, and if the

soul is not settled, the living may also suffer. The soul is dangerous unless tamed or properly settled in the grave.

As Chinese ghost stories attest, the dead interact with the living, for good or ill, and are indeed capable of harming the living, especially to avenge injuries. But the relationship between deceased ancestors and their living descendants is special, for together they are especially and directly responsible for the welfare of one another and the familial lineage. The notions of *feng shui*, literally "wind and water," but best translated in English as "geomancy," provide a way of understanding this relationship. *Feng shui*, in Stephan Feuchtwang's words, "stands for the power of the natural environment, the wind and water of the mountains and hills; the streams and the rain; and much more than that: the composite influence of the natural processes.... By placing oneself well in the environment feng shui will bring good fortune."[11] In Chinese peasant belief, familial responsibility intertwines with *feng shui* such that the grave and the bones it contains are regarded as transmitters of propitious wind and water. This is why Rubie Watson has described the remains of Chinese ancestors as "conductors of a power that originates in nature."[12] She explains that the proper placement of the remains has a direct effect on the worldly success or failure of the living. A carefully chosen burial site, a properly constructed tomb, and correctly performed rituals are all necessary to channel the wind and water of prosperity to the living.[13] The ancestral remains are not the source of power or renewal. But their capacity to transmit good fortune from the natural environment is regarded as crucial to the living descendants. To build a good tomb for the dead is to build a good life for the living. By the same reasoning, an improper burial for the dead does just the opposite. It brings misfortune and even catastrophe to the living.

It is in this context that the mass destruction of graves in Dachuan in 1961 must be placed. For the most part, the residents managed to retrieve the remains of immediate ancestors before the village was flooded, but the majority of the graves from earlier generations had to be abandoned. At a small drinking party in 1992, I showed three elderly men a document from a government file that said that 209 graves in Dachuan were destroyed by the reservoir. These graves were apparently opened before the actual flooding, because, according to a footnote, the bottom of the reservoir was "thoroughly cleansed for sanitation purposes." Construction workers, it stated, removed from Dachuan "twenty tons of garbage, human waste, and material detrimental to people's health" — the last a euphemism for human remains — and buried it above the reservoir's designated flood line.

After the three men read the document, they said that the official figure represented only the graves destroyed within the boundary of the reservoir. It did not include graves demolished on higher ground. This occurred, they reluctantly explained, when the villagers were forced uphill. Local topography dictated that the displaced residents construct houses and create farmland on what had been cemetery grounds. In other words, many ancestral graves were destroyed by the villagers themselves. Later, one of the elderly men confided

that the street corner where I often played chess with my host family's neighbors had been a graveyard. He then identified other sites in the new village that had been cemeteries. The resettlement site, I came to realize, had been one of the old village's major burial grounds.

Although the older graves were abandoned, the remains of immediate ancestors were usually collected and reburied by family members. But during the forced evacuation of Dachuan, one tradition after another was violated by villagers who were hurried, shocked by their eviction, and weakened by famine. Bones were not carefully transported and reinterred intact in miniature coffins; new graves were located randomly, without considering traditional geomancy; reburials were conducted without appropriate rituals.

For example, when I asked how he gathered his ancestors' bones at the time of relocation, one older man looked disconcerted. Then, grumbling as if accused of a grievous mistake, he said, "We just picked up the bones with chopsticks and put them into cement bags we collected from the reservoir construction sites. We carried them on our backs and buried them in Quannian Mountain. I tell you it was no time to be polished about such things." Another older man made an obvious effort to remember whether any reburial ceremonies were conducted. After a few moments he shook his head: "How could anyone hold ceremonies? We knew the dead were being tormented by the living but nobody could get any food to make sacrifices to comfort the deceased. At that time, food was rationed and kept in the collective dining halls. You cannot imagine how we were starving. Even the living had to eat roots." Indeed, not all villagers could muster enough strength to save the graves of even their immediate relatives. By the time the village was about to be relocated, the people of Dachuan had been eating for more than a year what the government inventively called "substitute foodstuffs" (*dai shipin*). These included chaff, grass, wild herbs, elm bark, potato stems, fennel seeds, and even wall plaster.

But perhaps most disturbing to the villagers was their perception that they themselves were responsible for the destruction of some of the older graves. Dachuan's original site was destroyed at the end of March 1961, when the Yanguo Gorge dam's floodgate was closed, forcing the river to surge sideways to form a reservoir. After two days and nights, much of what had been Dachuan was submerged in the man-made lake. When I mentioned the village's destruction in Dachuan, few could remember its exact date or even the year. They invariably described it, however, as a sudden, unanticipated assault. They spoke of the terror they felt when the river spilled over its banks; they reported how older people had to be carried to safety through streets knee-deep in water; and they recounted how they wept as they watched from higher ground while familiar landmarks disappeared from sight.

Listening to such accounts, I initially assumed that the government had flooded the village without warning. Actually, thirty months had elapsed between the first official decree of resettlement and the activation of the dam. When work on the Yanguo Gorge dam began in 1958, the engineers boasted

that the Yellow River would be dammed within a year. But villagers in Dachuan did not believe that the mighty Yellow River, as an elderly man put it, could be "cut at its waist." Youngsters heard from older people that in 1945 the Nationalist government had tried but failed to build a dam in the area. Memories of this earlier attempt to harness the Yellow River, actually abandoned because of civil war rather than for technical reasons, gave rise to predictions that the new project would falter as well.

So in spite of the relocation order issued immediately after the project was launched, few villagers left Dachuan. Toward the end of 1960, resettlement officials took drastic measures. Militia were sent into Dachuan, and they singled out for eviction households without young men. After residents were dragged out, their houses were pulled down. This action shocked other villagers into the realization that they had to not only move but also tear down their houses and salvage whatever materials they could. Only a few people, mostly elderly men trying to guard material from dismantled buildings, stayed in the village during the next few months, until the flooding that followed the dam's activation. Thus, the loss of so many of the ancestral remains in older graves was, in part, caused by the villagers' miscalculation of the Maoist government's ability to complete the Yanguo Gorge dam.

From any angle, the destruction of graves and loss of ancestral remains in Dachuan was profoundly disturbing to villagers. They had been robbed of a source of expectations for a good life and of important transmitters of nature's blessings. In addition, the rushed reburial of some of the salvaged ancestral bones violated ritual propriety and raised questions about the villagers' complicity in damaging the relationship between the living and the dead. As the Chinese ritual of offering food and wine to the ancestors suggests, death does not terminate obligation across generations. Although the soul of the dead moves into another world, it can be summoned back to join the living. The continued relationship of the living and the dead is dramatically revealed in ancestor worship and death rituals. Money, food, and other goods from the living are transferred to the dead through these ritualized actions.[14] In return, the ancestors are expected to transfer the wind and water of nature's blessings to the living, helping them succeed in pursuits such as farming, business, and school examinations. This exchange operates on the assumption that the dead are given a proper burial site and ritual. But in Dachuan, rescued remains were interred improperly, abandoned remains were buried as garbage by the dam project's workers, and part of the new village was built on top of burial grounds. The relationship between the living and the dead was in disarray, to say the least, in Dachuan after the activation of the Yanguo Gorge dam.

Religion and Remembrance

The recorded history of the Kong lineage in Dachuan dates to 1501. The earliest documented reference to the worship of Confucius by the Kongs of Dachuan is a register of sheep sacrificed and offered at the village's Confucius temple between 1643 and 1664. In 1950, such sacrifices were banned by

Communist officials, in an attempt to deprive the Kongs of their ritual unity and undermine the lineage, so that the Kongs would not foment collective resistance to land reforms and other programs of social and economic change.

After the death of Mao in 1976 and the subsequent introduction of economic and political reforms that dismantled the collective farming system and relaxed restrictions on many traditional practices, the relocated village of Dachuan, like many other localities in China, saw a revival of religious activity. In Dachuan, residents concentrated their energies on the reconstruction of temples, the revival of worship of ancestors and fertility goddesses, and the reproduction of written genealogies. That these centuries-old elements of family relationship and intergenerational obligation — central to Chinese folk belief and violated, often by decree, during the Maoist period — found religious expression once the political sanctions were lifted is not very remarkable. What is remarkable, however, is that in Dachuan these activities, which at first glance appear to be a simple resurgence of prerevolutionary ways, were saturated with memories of loss during the 1950s and 1960s — of starvation and death, breakages in the family system, and diminished hopes for continuing the family line.

Memories of the famine had a direct bearing on the reconstruction of temples in Dachuan starting in the early 1980s. Dachuan's new Confucius temple is a towering wooden structure built in 1991 at the rear of the new settlement (fig. 1).[15] This temple replaces a structure that was sealed off by government decree in 1958, subsequently damaged by the changes to the water table effected by the reservoir, and finally dismantled by the villagers during the campaign against Confucius of 1974. Because many of the old temple's beams, tiles, bricks, and window frames were salvaged and stored, over half of the building material used to construct the new Confucius temple was from the old temple. The present Confucius temple serves primarily but not exclusively as the Kong lineage's ancestor hall and is managed by five men, four quite elderly (fig. 2). For the most part, women do not participate in the maintenance and administration of the Confucius temple, although they do participate in rituals at this sacred site (fig. 3).

Because the Kong lineage's cemetery grounds and the remains of many of their ancestors were destroyed as a consequence of the Yanguo Gorge dam project, the temple rebuilt in Dachuan in memory of Confucius plays a special role in the revitalized practice of ancestor worship during the post-Mao era for the Kongs as a group. The new temple has five altars: three are devoted to Confucius and his exemplary followers, one honors the four Kong brothers who settled in Dachuan at the beginning of the sixteenth century, and one is dedicated to the father of these four Kong brothers. While the latter is recognized by the Kongs of Dachuan as their local common ancestor, his four sons are remembered as the primogenitors of four divisions of patrilineal descent within the local Kong lineage. For each of the four divisions of the Kong lineage in Dachuan, one of the four key local ancestors' graves served as the site of sacrificial rites before all these graves were destroyed as a result of the dam

Fig. 1. Confucius temple, Dachuan, 1992

Fig. 2. Managers of the Confucius temple and the preschool on the temple's grounds, Dachuan, 1992

Fig. 3. A young girl and elderly women of the Kong
lineage during an ancestor worship ceremony, Dachuan,
1992

project. Put differently, the Confucius temple in Dachuan was rebuilt, in part, as a response to the destruction of the four Kong brothers' graves. Today the collectively reconstructed Confucius temple serves the Kongs as their central site of ancestor worship. It provides a new sacred site where the local Kongs can jointly pay respect to their common ancestors, thus facilitating the reassertion of the Kong lineage in Dachuan by affirming their common descent and the importance of the continued worship of male ancestors. The temple also provides a sacred site where the living and the dead of the Kong lineage can communicate, where the living can appease and gain benefits from their ancestors by making ritual sacrifices and offerings for the dead.

In addition to the Confucius temple, four temples have been rebuilt on the barren hill behind Dachuan. The construction of these four temples relied heavily on female villagers, who were mobilized by six older women to collect the requisite money and materials. The original temples had not been flooded or damaged by the reservoir but rather leveled by government decree during the Cultural Revolution, a political campaign that lasted from 1966 to 1976 and was meant to destroy all vestiges of the old order.[16]

Whereas the Confucius temple may be regarded as a monument to the village's distant past and the Kong patrilineal heritage, the four temples on the mountain betray a concern for the present and future as negotiated primarily through the village's women. The four temples enshrine six goddesses and one male deity (a drought and flood-control god) in the form of elaborately painted clay statues. All these goddesses are thought to help women conceive and give birth, protect children, and cure illness, but the most popular are the Three Heavenly Mothers (sanxiao niangniang), a triplet of fertility deities. Their statues, dressed in silk robes, are displayed in a temple known locally as the Palace of One Hundred Sons (bai zi gong) (fig. 4). Hanging from the temple's internal beams are embroidered symbols of fertility that are regarded by Dachuan villagers as talismans ensuring the speedy and safe delivery of sons. These symbols are constantly replaced by newly embroidered symbols donated by desperate couples or their anxious parents. An offering of money and incense permits a couple to take home a piece of the temple's embroidery blessed by the Three Heavenly Mothers. It is kept in the couple's bed to attract the birth of a son. Most of embroidered symbols in the Palace of One Hundred Sons depict stylized fish, lotus flowers, or pomegranates. Some of the embroideries include as well images of tiny little boys riding fish, playing with lotus flowers, or climbing out of half-open pomegranates. Because fish produce a multitude of eggs and both pomegranates and lotus flowers contain many seeds, they are regarded as perfect symbols of fertility in Chinese culture. All these works of religious art are made by village women.

The veneration of fertility goddesses and ritual exchange of embroidered works of religious art are not recent inventions,[17] but their revival in post-Mao China followed two difficult experiences: the famine of the Great Leap Forward, which sent death rates soaring and birth rates plunging between 1958 and 1961; and the Chinese government's introduction in 1979 of a stringent

Fig. 4. Statues of the Three Heavenly Mothers, Palace of
One Hundred Sons, Dachuan, 1992

family-planning policy. The generation most directly affected by the government's attempt to depress fertility was made up of those who had, as children, survived the famine in which so many babies and children had died. This generation, particularly its young women, which embodied its parents' anxious hopes for reviving a family line threatened with destruction in the early 1960s, now found their chances of reproduction limited, again by government decree.

Child mortality statistics for Yongjing county during the famine are incomplete, but official figures for China as a whole indicate that half of those who died in 1960 were children under ten years old. The statistics also show that the birthrate in Yongjing county in 1956–57 was 2 percent of the population. It dropped to 1.1 percent in 1958–59 and then rose slightly to 1.3 percent in 1960 and 1.6 percent in 1961.[18] Periods of famine-induced demographic decline are often followed by a noticeable baby boom, and this was the case in Yongjing county. Beginning in 1962, the county's annual birthrate increased rapidly, reaching 3 percent of the population in 1964.[19] From 1968 to 1978, the birthrate fluctuated between 4 and 1.7 percent. In 1982, however, three years after the government's birth-limitation policy was implemented, Yongjing county's annual number of births was down to 1.3 percent of the population, coincidentally matching the low birthrate in the famine year of 1960. This new decline in fertility was achieved in large measure thanks to the government's policy of using severe methods such as forced abortion and sterilization to restrict each rural couple to two children.[20]

The government's aggressiveness in checking population growth obviously alarmed the peasantry. In private interviews, the six women who had led the movement to rebuild the four goddess temples in Dachuan discussed the government's population policy with reference to the famine. They deplored that the government was now thwarting fertility as much as the famine had. They explained that during the famine many women had stopped menstruating and some suffered from prolapse of the uterus. Four of the women said that they lost children because of the shortages of food and medicine during the famine and the lack of adequate shelter after forced resettlement. When one woman mentioned that some girls survived the famine but remained in poor health, the others noted that the girls who had been born around the time of the famine had just reached their childbearing years when the government launched its birth-control policy. These younger women, they said, desperately needed the assistance of the fertility goddesses to conceive and give birth to healthy babies, and to have a least one boy to carry on the family line.

If the worship of female deities is a forward-looking response to the traumas of the Maoist era, and the revival of the veneration of male ancestors focuses on repairing relations between the traumatized dead and their living descendents, the resurgence of genealogy writing in Dachuan inscribes the breakages in the family system in a ritual narrative of continuity. Usually covering ten generations of ancestors, a genealogy contains a list of the names of the dead, and it is used ritually to register the name of a newly deceased family member during a funerary ceremony before the body is transferred

from home to a burial ground. The three older genealogies of the local Kong lineage that survived the Maoist era were missing recent information, so in the early 1980s each of the eight smaller segments of the Kong lineage in Dachuan compiled a new genealogy. Each of these includes special entries that identify the locations of destroyed graves and reburial sites with specific place names. In addition to genealogies, which measure about eight-by-ten inches, I saw eight large painted ancestral charts in Dachuan (fig. 5). Like the genealogies, these charts cover ten generations of ancestors, and the names of the newly dead are added during funerary rites.

In the ritualized registration of names during the funerary rite, the genealogy itself is an object of veneration. Before the genealogy is opened, the registrar and his assistants wash their hands, set out oil burners, and light sticks of incense. They place the genealogy on the altar of the dead person's home and kowtow to it before locating a page to write the name. A symbol of family continuity is entered into the genealogy by drawing a vertical line across the dead person's name with blood drawn from the back of the eldest son's neck. Whenever a Kong genealogy is open in Dachuan to write down the name of a recently deceased person as part of the ritual procedure, a neatly written inventory of the dead whose bones or graves were destroyed by the Yanguo Gorge dam project is displayed before the living. On that list as well appear the names of all those who died during the years of political persecution and famine under Mao.

Conclusion

An important aspect of social change in post-Mao China has been the increasingly visible influence of religion on village life. Everywhere in China's vast countryside, ordinary peasants are joining in various kinds of revival movements. This phenomenon can be variously explained. We could explore whether it is a particular response to what Richard Madsen describes as "the general failure of the bureaucratic party-state to provide any satisfying experience of moral community or any plausible sense of transcendent meaning."[21] Or we could examine, as Donald MacInnis has done, the sociopolitical factors that have contributed to the government's relaxed policy toward religion.[22] We might also want to consider the impact of economic reforms — investigating, as Mayfair Yang has proposed, whether "economic privatism has paradoxically produced not so much individualism as a great deal of community participation in the rebuilding of local infrastructure and traditional culture."[23]

All these inquiries are on the right track, but I would like to suggest that there is also something else, something perhaps deeper, behind the intensity of religious revivalism in rural China since Mao's death and especially since agriculture was decollectivized in the early 1980s. What I have in mind is the deeply imprinted memory of the suffering and times of crisis that peasants endured under Mao. The brunt of the great famine of 1959 to 1961, in particular, was borne not by urbanites or intellectuals but by the many millions of peasants in the countryside. Given the severity of the famine, which caused the elimination of entire families in some places, it seems unlikely that memories

Fig. 5. Unfolding an ancestor chart, Dachuan, 1992

of the famine would simply fade away now that its survivors are better fed and clothed. The famine produced a sea change in peasant attitudes toward the Communist regime. The Great Leap Forward led not to the heaven promised by Mao but to years of hell.

In the case of Dachuan, it was not the famine alone that made the aftermath of the Great Leap Forward so traumatic. The forced resettlement for the sake of the government's Yanguo Gorge dam project created additional aberrant conditions that violated the symbiotic relationships among past, present, and future generations. Repairing the damage to the family system has required more than money, food, or material goods. It has taken the efforts of the survivors to restore ancestor worship, reproduce and update genealogies, and perform traditional funerary rites to affirm that the dead still have a role to play for the living and that the living still need and honor their dead. But since life passes, and the living are bound to join the dead, the survivors have also made efforts to address the decimation of family lines during the Maoist era. It is precisely because anxiety over the next generation's ability to sustain the family line has been exacerbated by government-dictated population controls that the worship of fertility goddesses in Dachuan and many parts of rural China has enjoyed such a vigorous revival. The veneration of ancestors and the worship of fertility goddesses both point to the revered place of the family in Chinese society and to the violence the family system suffered under Mao. In at least one Chinese village, the memory of the traumas of the Maoist era has found expression in the revitalized worship of male ancestors, on the one hand, and female deities, on the other hand. These two religious activities complement each other in healing a wounded community.

Notes

The National Science Foundation and the Wenner-Gren Foundation for Anthropological Research financed my fieldwork in 1992. An award from the Rifkind Center at the City College of the City University of New York allowed time to write this essay in 1997. I am grateful to Michael Roth of the Getty Research Institute's Research and Education Program for his encouragement and suggestions, to Fileve Palmer for bibliographic research, and to Michelle Bonnice for her skillful editing. My thanks to these institutions and individuals. Some of the information in this essay has been published in Jun Jing, *The Temple of Memories: History, Power, and Morality in a Chinese Village* (Stanford: Stanford Univ. Press, 1996). In this essay, I have expanded the brief treatment of the famine of 1959 to 1961 to be found in that book, and I provide new information about the revived worship of female deities in Dachuan.

1. Richard Madsen, "The Politics of Revenge during the Cultural Revolution," in Jonathan N. Lipman and Stevan Harrell, eds., *Violence in China* (Albany: State Univ. of New York Press, 1990), 187.

2. Their claim of descent from this illustrious ancestor is recorded in the last edition of a genealogy compiled in 1937 by the council of elders of the Kong clan of Qufu, Confucius's hometown, in the northern coastal province of Shandong. The history of

the Kong clan in Qufu and Dachuan's genealogical linkage to one of the major branches of the Kong clan are too complex to be fully discussed here. In brief, the Kongs in Qufu, Dachuan, and elsewhere in China claim to be connected to an unbroken descent line from Confucius. The Kongs in Qufu have a systematically compiled collection of genealogical records to prove that they are the living embodiments of Confucius. But the allegedly intact line of their holy descent over so many centuries and down to the present invites skepticism. The Kong genealogies reveal many unanswerable questions as well as the simple fact that the Kong clan was a political invention. It became the largest Chinese clan and had smaller branches all over the country primarily because of the imperial state cult of Confucius.

3. Arthur Waldron, "'Eat People'—A Chinese Reckoning," *Commentary* [New York] 104, no. 1 (1997): 29.

4. Sophia Woodman, "Reclaiming Lost History," review of *Hungry Ghosts: China's Secret Famine,* by Jasper Becker, *China Rights Forum,* fall 1996, 36.

5. See, for example, Penny Kane, *Famine in China, 1959–61: Demographic and Social Implications* (New York: St. Martin's, 1988); John Jowett, "Mao's Man-Made Famine," *Geographical Magazine* 61, no. 4 (1989): 16–19; Jasper Becker, *Hungry Ghosts: China's Secret Famine* (London: John Murray, 1996); and Dali Yang, *Calamity and Reform in China: State, Rural Society, and Institutional Change since the Great Leap Famine* (Stanford: Stanford Univ. Press, 1996).

6. The word *peasant* in this essay follows the meaning of the Chinese word *nongmin.* Taken narrowly, *nongmin* can be a synonym for *farmer.* But its general meaning is much broader, covering nearly all ordinary people living in rural areas, whether they are farmhands, fishermen, seasonal construction workers, employees in village-based factories, or migrant workers holding temporary jobs in cities. I intend both this broader meaning and the contrast of lifestyles between rural and urban areas that the word in Chinese implies. It can also carry a derogatory meaning, like its English counterpart, when it is used by some people in Chinese cities; I do not intend this meaning. For a fuller discussion on the cultural implications of the word *peasant* as used by Chinese urbanites and twentieth-century revolutionaries, see Myron L. Cohen, "Cultural and Political Inventions in Modern China: The Case of the Chinese 'Peasant,'" *Daedalus* 112, no. 2 (1993): 151–70.

7. All the interviews mentioned in this essay were conducted in Chinese; the English translations included here are mine and are based on my interview notes.

8. The symptom of a swollen belly described in this account is a typical effect of the second stage of acute starvation. At this point, the body stops shrinking and begins to swell due to the lack of protein that could have prevented liquid from leaving the blood and getting into the tissues.

9. I borrow the term *survival cannibalism* from Jasper Becker, who distinguishes it from the practice of cannibalism as a symbolic gesture of taking revenge against one's enemies; see Becker, *Hungry Ghosts* (note 5), 211–19.

10. J. J. M. De Groot, *The Religious System of China: Its Ancient Forms, Evolution, History and Present Aspect, Manners, Customs and Social Institutions Connected Therewith* (Leiden: E. J. Brill, 1892–1910; reprint, Taipei: Southern Materials Center, 1989), 3:855.

11. Stephan D. R. Feuchtwang, *An Anthropological Analysis of Chinese Geomancy* (Vientiane, Laos: Editions Vithagna, 1974), 2. See also Laurence G. Thompson, *Chinese Religion: An Introduction,* 4th ed. (Belmont, Calif.: Wadsworth, 1989), 23–25.

12. Rubie S. Watson, "Remembering the Dead: Graves and Politics in Southeastern China," in James L. Watson and Evelyn S. Rawski, eds., *Death Ritual in Late Imperial and Modern China* (Berkeley: Univ. of California Press, 1988), 206.

13. Watson, "Remembering the Dead" (note 12), 205–10.

14. For a fuller discussion, see James L. Watson, "The Structure of Chinese Funerary Rites: Elementary Forms, Ritual Sequence, and the Primacy of Performance," in James L. Watson and Evelyn S. Rawski, eds., *Death Ritual in Late Imperial and Modern China* (Berkeley: Univ. of California Press, 1988).

15. I have discussed the mnemonic values of Dachuan's new Confucius temple in Jun Jing, *The Temple of Memories: History, Power, and Morality in a Chinese Village* (Stanford: Stanford Univ. Press, 1996).

16. Dachuan was by no means the only village whose temples were destroyed during the Cultural Revolution. Throughout China under Mao, temples were damaged, destroyed, or turned into schools, warehouses, or factories. Only after Mao's death were many of these temples restored. In Yongjing county only one temple remained intact in 1976. By 1992, however, every Han Chinese village had rebuilt at least one temple, according to county officials.

17. The cult of Three Heavenly Mothers is the product of a sixteenth-century novel of myth and adventure in which three sisters are killed while attempting to avenge their brother's death. The popularization of this novel by storytellers and in theatrical performances eventually led to the deification and worship of a number of the novel's characters.

18. See *Yongjing xianzhi* (Yongjing County Gazetteer) 9 (1992): 133.

19. Nationwide, the number of births dropped from 27 million in 1957 to 15 million in 1961. During the aftermath of the famine, some 35 million babies were born in 1963, and over three years China registered 90 million births. The famine and the baby boom had a long-term impact on Chinese society. The official birth control policy was adopted in 1979, when the many babies born in the post-famine period were reaching the threshold of parenthood; see Jowett, "Mao's Man-Made Famine" (note 5), 17.

20. For example, as of 1979, just over one thousand women in Yongjing county had been sterilized by tubal ligation; this figure jumped to fifty-eight hundred by 1983 and by 1985 had increased to seven thousand.

21. Richard Madsen, "Foreword," in Donald E. MacInnis, *Religion in China Today: Policy and Practice* (Maryknoll, N.Y.: Orbis, 1989), xvi.

22. Donald E. MacInnis, *Religion in China Today: Policy and Practice* (Maryknoll, N.Y.: Orbis, 1989).

23. Mayfair Yang, "Tradition, Travelling Anthropology, and the Discourse of Modernity in China" (paper presented at the Fourth Decennial Association of Social Anthropology Conference, Oxford, England, 1993), 2.

Designed by Bruce Mau Design Inc.,
Bruce Mau with Chris Rowat and Catherine Rix
Coordinated by Stacy Miyagawa and Suzanne Petralli Meilleur
Type composed by Archetype in Sabon and News Gothic
Printed and bound by Thomson-Shore, Inc., on Cougar Opaque
Cover printed by Phoenix Color Corp.

Issues & Debates
Series designed by Bruce Mau Design Inc., Toronto, Canada

Issues & Debates
A Series of the Getty Research Institute Publications Program
Julia Bloomfield, Thomas F. Reese, Michael S. Roth, and Salvatore Settis,
Editors

In Print
*Art in History / History in Art: Studies in Seventeenth-Century Dutch
Culture*
Edited by David Freedberg and Jan de Vries
ISBN 0-89236-201-4 (hardcover), ISBN 0-89236-200-6 (paper)

*American Icons: Transatlantic Perspectives on Eighteenth- and Nineteenth-
Century American Art*
Edited by Thomas W. Gaehtgens and Heinz Ickstadt
ISBN 0-89236-246-4 (hardcover), ISBN 0-89236-247-2 (paper)

Otto Wagner: Reflections on the Raiment of Modernity
Edited by Harry Francis Mallgrave
ISBN 0-89236-258-8 (hardcover), ISBN 0-89236-257-X (paper)

Censorship and Silencing: Practices of Cultural Regulation
Edited by Robert C. Post
ISBN 0-89236-484-X (paper)

Dosso's Fate: Painting and Court Culture in Renaissance Italy
Edited by Luisa Ciammitti, Steven F. Ostrow, and Salvatore Settis
ISBN 0-89236-505-6 (paper)

Nietzsche and an "Architecture of Our Minds"
Edited by Alexandre Kostka and Irving Wohlfarth
ISBN 0-89236-485-8 (paper)

In Preparation
*Looking for Los Angeles: Architecture, Film, Photography, and the Urban
Landscape*
Edited by Charles G. Salas and Michael S. Roth
ISBN 0-89236-616-8 (paper)

Index

	York. Photo: Archivo fotográfico, Museo Nacional Centro de Arte Reina Sofía, Madrid
160, fig. 43	© 2001 Estate of Pablo Picasso/Artists Rights Society (ARS), New York. Photo: Giraudon/Art Resource, New York
160, fig. 44	Photo: Bibliothèque Nationale de France, Paris
162, 163	Courtesy Cahiers d'Art, Paris. Photo: Dora Maar
182	© Etnografiska Museet, Göteborg, Sweden. Top: GM.27.27. 1302, bottom: GM.27.27.1301
183	© Etnografiska Museet, Göteborg, Sweden. Left: GM.27.27. 1283, right: GM.27.27.1282
184	© Etnografiska Museet, Göteborg, Sweden. Left: GM.27.27. 1278, right: GM.27.27.1279
185	© The Field Museum, Chicago. Cat. no. 5840, neg. no. A113303. Photo: John Weinstein
187	© UCLA Fowler Museum of Cultural History, Los Angeles. Left to right: X96.25.17 (purchased 1996, height 18.3 cm); X97.3.3 (purchased 1997, height 22.4 cm); X84.645 (collected 1969, height 21 cm), X84.639 (collected 1969, height 28.3 cm), X83.484 (donated 1983, height 26.7 cm): Gifts of Dorothy M. Cordry in memory of Donald B. Cordry; X97.3.4 (purchased 1997, height 22.5 cm). Photo: Don Cole
188	© UCLA Fowler Museum of Cultural History, Los Angeles. Left: X84.159 (date unknown), right: X84.158 (date unknown). Gifts of Dorothy M. Cordry in memory of Donald B. Cordry. Photo: Don Cole
216, 217	Photo: Jun Jing
218	Photo: Jeanne Moore
220, 223	Photo: Jun Jing

York. Photo: Archivo fotográfico, Museo Nacional Centro de Arte Reina Sofía, Madrid

126, fig. 10 © 2001 Estate of Pablo Picasso/Artists Rights Society (ARS), New York. Photo: Giraudon/Art Resource, New York

126, fig. 11 Courtesy Cahiers d'Art, Paris. Photo: Dora Maar

127 © 2001 Estate of Pablo Picasso/Artists Rights Society (ARS), New York. Photo: © 2001 The Museum of Modern Art, New York

129–32 © 2001 Estate of Pablo Picasso/Artists Rights Society (ARS), New York. Photo: Archivo fotográfico, Museo Nacional Centro de Arte Reina Sofía, Madrid

134 © 2001 Estate of Pablo Picasso/Artists Rights Society (ARS), New York. Photo: Photothèque des Collections de Musée National d'Art Moderne, Centre National d'Art et de Culture Georges Pompidou, Paris

135 © 2001 Estate of Pablo Picasso/Artists Rights Society (ARS), New York

136 Photo: Giraudon/Art Resource, New York

137, fig. 20 © 2001 Estate of Pablo Picasso/Artists Rights Society (ARS), New York. Photo: courtesy Paul Herring, New York

137, fig. 21 © 2001 Estate of Pablo Picasso/Artists Rights Society (ARS), New York. Photo: Bayerische Staatsgemäldesammlungen, Munich

138 © 2001 Estate of Pablo Picasso/Artists Rights Society (ARS), New York. Photo: © Photo RMN–Picasso

141, 142 © 2001 Estate of Pablo Picasso/Artists Rights Society (ARS), New York. Photo: Archivo fotográfico, Museo Nacional Centro de Arte Reina Sofía, Madrid

144 Courtesy The Minneapolis Institute of Arts

145 Photo: Giraudon/Art Resource, New York

146, fig. 29 Photo: Giraudon/Art Resource, New York

146, fig. 30 Photo: Alinari/Art Resource, New York

147, fig. 31 Courtesy The Detroit Institute of Arts. Founders Society Purchase with funds from Mr. and Mrs. Bert L. Smokler and Mr. and Mrs. Lawrence A. Fleischman. Photo: © 2001 The Detroit Institute of Arts

147, fig. 32 Photo: © The Whitworth Art Gallery, The University of Manchester

148 Photo: © The British Museum, London

150, fig. 34 Photo: © Ashmolean Museum, Oxford

150, fig. 35 Photo: © The British Museum, London

151, 152 Photo: Giraudon/Art Resource, New York

154, fig. 38 Photo: Giraudon/Art Resource, New York

154, fig. 39 Photo: The Royal Collection © 2001 Her Majesty Queen Elizabeth II; courtesy Royal Collection Enterprises Ltd.

155 Photo: Alinari/Art Resource, New York

157 © 2001 Estate of Pablo Picasso/Artists Rights Society (ARS), New York. Photo: © 2001 The Museum of Modern Art, New York

160, fig. 42 © 2001 Estate of Pablo Picasso/Artists Rights Society (ARS), New

Illustration Credits

The following sources have granted permission to reproduce illustrations in this book:

85 From "Lenin v skul'pture," *Sovetskoe iskusstvo,* no. 3 (1925): 62. Photo: Robert Barden

86, 87 Courtesy Embassy of the Russian Federation, Washington, D.C. Photo: Robert Barden

88 From *Lenin: Sobranie fotografii i kinokadrov,* vol. 1, *Fotografii, 1874–1923* (Moscow: Iskusstvo, 1970), 79 (no. 55/54). Photo: Robert Barden

89 From *Lenin: Sobranie fotografii i kinokadrov,* vol. 1, *Fotografii, 1874–1923* (Moscow: Iskusstvo, 1970), 180 (no. 144/145). Photo: Robert Barden

90, fig. 6 From I. I. Brodskii, *Moi tvorcheskii put'* (Moscow: Khudozhnik, 1965), 114. Photo: Robert Barden

90, fig. 7 Courtesy Embassy of the Russian Federation, Washington, D.C. Photo: Robert Barden

96, 98, 99, 102 Courtesy Rodchenko/Stepanova Archive, Moscow. Photo: Robert Barden

112 © 2001 Estate of Pablo Picasso/Artists Rights Society (ARS), New York. Photo: Giraudon/Art Resource, New York

114 Photo: Heinrich Hoffmann; courtesy Bildarchiv, Bayerische Staatsbibliothek, Munich, no. L.38: 14390-13

117 Photo: Heinrich Hoffmann; courtesy Bildarchiv, Bayerische Staatsbibliothek, Munich, no. L.38: 0328

118 Photo: Heinrich Hoffmann; courtesy Bildarchiv, Bayerische Staatsbibliothek, Munich, J.134: 13714

119 Photo: Heinrich Hoffmann; courtesy Bildarchiv, Bayerische Staatsbibliothek, Munich, L.82: 14390-11

120 Photo: © 2001 Michael David Coffey, Riverside, California

121 Courtesy Soprintendenza Archeologica della Provincia di Napoli e Caserta, Naples

122 © 2001 Estate of Pablo Picasso/Artists Rights Society (ARS), New York. Photo: © Photo RMN–Picasso

124 © 2001 Estate of Pablo Picasso/Artists Rights Society (ARS), New

on the theory and methodology of historical studies; history of historiography; intercultural comparison of historiography; structure and development of historical consciousness; theory of historical learning; theory, empirical manifestations, and historical development of historical culture; history of human rights; and intercultural communication. His many publications include, in English, *Studies in Metahistory* (1993). He is the editor of the series "Making Sense of History: Studies in Metahistory, Historiography, Historical Culture, and Intercultural Communication," published by Berghahn Books.

Charles G. Salas is head of Research and Education at the Getty Research Institute. A cultural historian, Dr. Salas has a long-standing interest in how the classical past has been represented and appropriated in Europe in the early modern and modern periods. He has published in diverse fields, including mathematics, the philosophy of history, and historiography.

Carlo Severi is Chargé de Recherche at the Centre National de la Recherche Scientifique. His book on Kuna shamanistic tradition, *La memoria rituale: Follia e immagine del Bianco in una tradizione sciamanica amerindiana* (1993), has also been published in Spanish. In addition to several articles on various aspects of Kuna life and culture, he has written *Naven, or the Other Self: A Relational Approach to Ritual Action* (with Michael Houseman, 1998), a volume on ritual transvestism among the Iatmul of Papua New Guinea.

Carlo Ginzburg is Franklin D. Murphy professor of Italian Renaissance studies at the University of California, Los Angeles. His book *Il formaggio e i vermi: Il cosmo di un mugnaio del '500* (1976; *The Cheese and the Worms: The Cosmos of a Sixteenth-Century Miller,* 1980) has been published in sixteen languages. Dr. Ginzburg is an honorary foreign member of the American Academy of Arts and Sciences; a member of the Accademia delle Arti del Disegno, Florence; and the recipient of the 1992 Aby Warburg Prize. *History, Rhetoric, and Proof* (1999) is his most recent book.

Philip Gourevitch is a staff writer at the *New Yorker.* His first book, *We Wish to Inform You that Tomorrow We Will Be Killed with Our Families: Stories from Rwanda* (1998), has received numerous prizes. Among these are the National Book Critics Circle Award for nonfiction; the George K. Polk Award for Foreign Reporting; and, in the United Kingdom, the Guardian First Book Award. His second book, *A Cold Case* (2001), tells of the thirty-year investigation of a double homicide in New York City.

Jun Jing is assistant professor of anthropology at the City College of the City University of New York. He is the author of *The Temple of Memories: History, Power, and Morality in a Chinese Village* (1996), which was nominated for the 1999 American Ethnological Society First Book Prize, and the editor of *Feeding China's Little Emperors: Food, Children, and Social Change* (2000). He has published many articles on Chinese popular religion and on environmental issues in China. In 2000, Dr. Jing received two research grants funding his work on the social effects of the world's largest hydroelectric dam, which is under construction in the middle reaches of the Yangtze River. A native of Beijing and a Chinese citizen, Dr. Jing graduated from Harvard University with a Ph.D. in social anthropology in 1994.

István Rév is professor of history and political science at Central European University in Budapest and director of the Open Society Archives. His writings include *Representing the Counterrevolution* (1996) and *Retroactive Justice* (2000).

Michael S. Roth is president of the California College of Arts and Crafts. He is an intellectual historian and curator. Dr. Roth's publications include *Psycho-Analysis as History: Negation and Freedom in Freud* (1987), *Knowing and History: Appropriations of Hegel in Twentieth-Century France* (1988), *The Ironist's Cage: Memory, Trauma, and the Construction of History* (1995), and *Irresistible Decay: Ruins Reclaimed* (with Claire Lyons and Charles Merewether, 1997).

Jörn Rüsen is president of the Kulturwissenschaftliches Institut of the Wissenschaftszentrum Nordrhein-Westfalen in Essen and professor of general history and historical culture at the Universität Witten/Herdecke. His research centers

Biographical Notes on the Contributors

David William Cohen is professor of history and anthropology at the University of Michigan, Ann Arbor. His research and teaching interests have focused on precolonial eastern and central Africa, twentieth-century Africa, African political culture, the methodology of oral history, the production of history, and the politics and sociology of scholarship. Among Dr. Cohen's publications are *Burying SM: The Politics of Knowledge and the Sociology of Power in Africa* (with E. S. Atieno Odhiambo, 1992) and *The Combing of History* (1994).

Veena Das is Kreiger-Eisenhower professor of anthropology at Johns Hopkins University. She has published numerous articles as well as the monographs *Structure and Cognition: Aspects of Hindu Caste and Ritual* (1977; rev. 2d ed. 1995), which received the Ghurye Award for the best book in sociology in 1977; and *Critical Events: An Anthropological Approach to Contemporary India* (1995). She is coeditor of *Social Suffering* (1997) and *Violence and Subjectivity* (2000). Dr. Das is a foreign honorary member of the American Academy of Arts and Sciences.

Leah Dickerman is assistant professor of art history at Stanford University, where she teaches twentieth-century art, the history of photography, and critical theory. With Magdalena Dabrowski and Peter Galassi, Dr. Dickerman curated the major exhibition of Aleksandr Rodchenko's work mounted in 1998 at the Museum of Modern Art, New York, and authored the exhibition's catalog. Her other curatorial projects include *ROSTA: Bolshevik Placards, 1919–1921* (1994), *Building the Collective: Soviet Graphic Design, 1917–1937: Selections from the Merrill C. Berman Collection* (1996), and *Duchamp/Man Ray: The Photograph and the Readymade* (2000).

Saul Friedländer is professor of history at the University of California, Los Angeles, and a member of the American Academy of Arts and Sciences. Dr. Friedländer has devoted his life to researching and understanding the complexities of the Holocaust. The recipient of a five-year fellowship from the John D. and Catherine T. MacArthur Foundation in 1999, he is now completing a two-volume history of Jewish life under Adolf Hitler. The first volume, *Nazi Germany and the Jews: The Years of Persecution, 1933–1939* (1997), has been translated into Dutch, French, German, Hebrew, Italian, and Swedish.

the Geneva Office of the Zionist Organization and of the Jewish Agency for Palestine, Central Zionist Archives, Jerusalem.

2. Dominick LaCapra, *Representing the Holocaust: History, Theory, Trauma* (Ithaca: Cornell Univ. Press, 1994), 189.

3. Lotte Köhler and Hans Saner, eds., *Hannah Arendt/Karl Jaspers: Correspondence, 1926–1969,* trans. Robert Kimber and Rita Kimber (New York: Harcourt Brace Jovanovich, 1992), 54; originally published as *Hannah Arendt/Karl Jaspers: Briefwechsel, 1926–1969* (Munich: Piper, 1985): 90–91:

> Diese Verbrechen lassen sich, scheint mir, juristisch nicht mehr fassen, und das macht gerade ihre Ungeheuerlichkeit aus. Für diese Verbrechen gibt es keine angemessene Strafe mehr; Göring zu hängen, ist zwar notwendig, aber völlig inadäquat. Das heißt, diese Schuld, im Gegensatz zu aller kriminellen Schuld, übersteigt und zerbricht alle Rechtsordnungen. Dies ist auch der Grund, warum die Nazies in Nürnberg so vergnügt sind; sie wissen das natürlich. Ebenso unmenschlich wie diese Schuld ist die Unschuld der Opfer. So unschuldig wie alle miteinander vor dem Gasofen waren, . . . so unschuldig sind Menschen überhaupt nicht. Mit einer Schuld, die jenseits des Verbrechens steht, und einer Unschuld, die jenseits der Güte order der Tugend liegt, kann man menschlich-politisch überhaupt nichts anfangen.

4. See, in particular, Norbert Frei, "Farewell to the Era of Contemporaries: National Socialism and Its Historical Examination en route into History," *History and Memory* 9, nos. 1/2 (1997): 59–79.

5. See, in particular, Martin Broszat and Saul Friedländer, "Um die 'Historisierung des Nationalsozialismus': Ein Briefwechsel," *Vierteljahrshefte für Zeitgeschichte* 36 (1988): 339–72; translated as "A Controversy about the Historicization of National Socialism," in Peter Baldwin, ed., *Reworking the Past: Hitler, the Holocaust, and the Historians' Debate* (Boston: Beacon, 1990).

6. The most profound comment on this debate and its implications is to be found in Jörn Rüsen, "The Logic of Historicization: Metahistorical Reflections on the Debate between Friedländer and Broszat," *History and Memory* 9, nos. 1/2 (1997): 113–44.

7. See Arno J. Mayer, *Why Did the Heavens Not Darken? The "Final Solution" in History* (New York: Pantheon, 1988), esp. 376–408.

8. Hannah Arendt, "Some Questions of Moral Philosophy," *Social Research* 61 (1994): 739–64.

9. As translated in Tony Judt, *The Burden of Responsibility: Blum, Camus, Aron, and the French Twentieth Century* (Chicago: Univ. of Chicago Press, 1998), 154.

10. Thomas Laqueur, "The Sound of Voices Intoning Names," *London Review of Books,* 5 June 1997, 3.

11. Serge Klarsfeld, *French Children of the Holocaust: A Memorial,* ed. Susan Cohen, Howard M. Epstein, and Serge Klarsfeld; trans. Glorianne Depondt and Howard M. Epstein (New York: New York Univ. Press, 1996).

12. See Alfons Heck, *The Burden of Hitler's Legacy* (Frederick, Colo.: Renaissance House, 1988), 62.

is not sufficient. There is, as I have mentioned, a run-of-the-mill history of the Holocaust that demands to be thoroughly questioned. In 1997 the historian Thomas Laqueur wrote a critique of what he called the "business as usual" historiography of the Holocaust, namely, the historiography that fails to confront both the particular moral breakdown these events imply and the subjective terror that they inspired.[10] For Laqueur, as for myself, only the integration of the fate of the individual victim into the historical narration could eventually enable the historian to overcome the dichotomy between the unfathomable abstraction of the millions of dead and the tragedy of individual life and death in the time of extermination. Laqueur evoked the sketchy biographical data and pictures of thousands of children deported from France, collected by Serge Klarsfeld.[11] These children could not speak in their own voices, but the little that could be recovered about the life and deportation of a boy of eight or a girl of three sufficed, precisely because it was so little.

The victims' testimony cannot enlighten us about the internal dynamics of Nazi persecutions and exterminations, but they put the behavior of the Nazis in fuller perspective. The victims remind us of the face-to-face encounters of the perpetrators with the victims being persecuted, deported, and killed. But, mainly, the victims' testimony is our only source for the history of their own path to destruction. Their words evoke, in their own chaotic way, the depth of their terror, despair, apathetic resignation — and total incomprehension.

The integration of the victims' voices radically widens the narrative span of history. It has to be complemented by the historian's effort to find correspondingly new concepts that would express, however inadequately, the breakdown of all norms and the dimensions of suffering that traditional historiography cannot easily deal with.

Wittlich (in the Mosel region), 10 November 1938: The synagogue has been set on fire, the windows of Jewish-owned shops have been smashed. Herr Marks, the butcher, and most of the Jewish men have been shoved into a truck about to leave for a concentration camp. On the street, in front of the ruined butcher shop, among jeering SA men, Frau Marks stands wailing, "Why are you people doing this to us? What have we ever done to you?" And, on both sides of the street, the Marks' lifelong German neighbors stand at their windows, watching her — in silence.[12] Was it fear? Hatred? Just plain human indifference to the despair of today's outcasts who had been yesterday's friends? The most elementary human ties had disappeared, and the tornado evoked by Richard Lichtheim in his anguished letter to Henry Montor had not even started its sweep across Europe.

Notes

1. Richard Lichthein, "What Is Happening to the Jews of Europe," attachment to a letter from Richard Lichtheim to Henry Montor, 13 August 1942, L22/79, Archives of

tions. But the historian should not avoid the precise definition of interpretive concepts and categories, especially in a domain so wide open to extraordinary flights of imagination or malicious denials. And, on a very different level, the historian should dare to challenge the complacency and routine existing in the domain of history.

To illustrate the first issue, I will turn to the continuing debate about the comparability of Nazi and Stalinist crimes within the framework of similar totalitarian regimes. Totalitarianism as a key interpretive category is back in fashion. Decades ago, during the cold war, it was enlisted in the fight against Communism. Today it is used to bury Communism historically by trying to show that Stalin's crimes may have been "worse than" those of Hitler. In Eastern Europe, first and foremost, but also in France and to a lesser degree in Germany, this "greater evil" theory has sometimes taken strange accents. We are confronted not with Arendt's inquiry into the origins of totalitarian systems but with a crusade of sorts, meant to demonstrate not only that totalitarianism is the explanation but also that on the scale of mass criminality Stalin scores first and highest, whereas Hitler merely comes in second.

This line of inquiry is certainly legitimate, but it demands that the following, for example, be considered. In fall 1942, the Wehrmacht was on the banks of the Volga at Stalingrad. Had they crossed the river, it would probably have brought about the military collapse of the Soviet Union, a significant prolongation of the war, the nonliberation of Auschwitz in January 1945, and the complete extermination of the remnants of European Jewry. How many people today would declare, in retrospect and notwithstanding their knowledge of Stalinist crimes, that they wish the Wehrmacht had crossed the Volga?

The majority that would answer negatively is, I believe, influenced by an intuition related to a historical-philosophical distinction admirably expressed by the French-Jewish intellectual Raymond Aron. Aron's anti-Stalinism was straightforward and uncompromising from the immediate postwar years onward, but, nonetheless, he clearly perceived the difference between Nazism and Communism, just as Arendt did in her "Some Questions of Moral Philosophy"[8] and as many historians do to this day. Aron identified the quintessential difference between the two regimes at the conceptual level—where indeed it subsists: "For those who wish to 'save the concepts,'" Aron wrote, "there remains a difference between a philosophy whose logic *is* monstrous, and one that lends itself to a monstrous interpretation."[9]

It is the historian's prime responsibility to probe the concrete aspects of such distinctions and to work through the details of related arguments. Therein lies the major challenge as well. In the face of simplified representations of the past, the historian's duty is to reintroduce the complexity of discrete historical events, the ambiguity of human behavior, and the indeterminacy of wider social processes. The task is daunting, especially given the difficulty of conciliating the nuanced results of scholarship and the necessary reference to historical, moral, and philosophical categories.

In the face of a phenomenon such as Nazism, however, such an approach

similar media representations in order to criticize the so-called moralistic representation of Nazism. In the unfolding Historians' Debate and in the controversy about the historicization of National Socialism, it was this "moralistic," "black-and-white" dimension of the representation of the events—and, thus, the limits of their historicization—that was at stake, among other things.[6] To this day, the link between the writing of the history of the Holocaust and the unavoidable use of implicit or explicit moral categories in the interpretation and narration of the Nazi era remains a major challenge. It is around moral categories that, of necessity, we encounter one of the central differences between history and memory. The apparent dichotomy between a necessarily detached history of National Socialism and the no less unavoidable presence of a moral dimension in dealing with this epoch may well find its resolution only in the sensitivity and creative intuition of the individual historian.

In the memory of the contemporaries, and increasingly in present-day perception, the Nazi extermination of the Jews may have become one of the defining events of our time. Yet it seems impossible to situate its historical place. What, for instance, is the significance for the writer of history of Chełmno, Bełżec, Sobibór, and Treblinka, sites whose sole function was the immediate extermination of the Jews sent there? Approximately two million people were murdered at these places in less than a year, between spring 1942 and spring 1943.[7] How can such events be integrated into the interpretation of our epoch when they influenced neither the course of the war nor any major trend in postwar history? When, for many historians, so brief a span is but the foaming crest on the waves of the *longue durée?* Is the impact of such events solely in the memory they have left?

Historical writing about the Holocaust has attempted to circumvent such problems by focusing on the mechanisms within Nazism itself that led to the "Final Solution" or on the logistics, technology, and bureaucratic processes of its implementation, or on the agencies of extermination and the behavior of the perpetrators. For example, Raul Hilberg has stated repeatedly that in writing *The Destruction of the European Jews,* he concentrated on the "how" rather than on the "why" of that history. Historical inquiry into the mechanisms of the "Final Solution" is the very basis of our knowledge and undoubtedly remains a primary task. But, ultimately, the "why" overshadows all other concerns.

It goes without saying that major issues of interpretation, of historical roots, and of historical categories have been addressed from the very beginnings of this historiography. We all know at least some of these interpretations: the special course of German history (*Sonderweg*), anti-Semitism (eliminationist or not), Fascism, totalitarianism, modernity. It is at this level that a peculiar responsibility of the historian comes to the fore.

On the Historian's Responsibility

The historian cannot and should not be the guardian of memory. The historian's gaze is analytic, critical, attuned to complexity, wary about generaliza-

greatest challenge the papacy was resolutely on the side of the victims, and that the Vicar of Christ stood undaunted *against* evil in our time.

The most basic function of this representation of evil is essential to the self-image of liberal society as such. Nowadays, liberal society is not faced with any concrete enemy; its existence was not threatened, even before the complete demise of Communism. But, to identify its ideals and the nature of its institutions, a society needs to define the quintessential opposite of its own self-image. Due to its unquestionable horror, to its immense number of victims, to the heroic sacrifices demanded to achieve victory over it, Nazism has fulfilled and continues to fulfill the function of the Enemy per se. This is true not only for the United States but also, for different and no less obvious reasons, for present-day liberal, democratic Germany and for the West more generally. Few are the regimes that, since 1945, would have chosen to identify with the Nazi model.

The memory of the extermination, of the suffering and the agony imposed by Nazism, and of the fateful commitments demanded of those willing to resist remains a landscape of death in which choices were made that still appear to many to be the most important decisions of modern times. In a world in which such choices seem to have all but disappeared, the memory of the Shoah is paradoxically linked to a simplified yet real and probably deep-seated longing for the tragic dimension of life.

On Memory and History

As may have become evident from what I have said up to now, the various facets of the expanding memory of the Holocaust may create an array of dilemmas in the writing of its history. The impact of generational change on the transformation of the historiography of Nazism and the Shoah has been mentioned by scholars,[4] for example, and the ways in which the personal memories of those historians who were the contemporaries of Nazism find their expression in distinct forms of emphasis or avoidance have been explored.[5] More generally, it has been argued that emotional involvement in these events precludes a "rational" approach to the writing of their history. The "mythic memory" of the victims has been set against the "rational understanding" of others. I do not wish to reopen old debates but merely to suggest that regardless of his or her background, the historian cannot avoid a measure of transference in relation to this past and of necessity this will impinge on the writing of its history. But the historian's necessary measure of detachment is not hindered by such involvement, given that there is sufficient self-awareness. It may indeed be harder to keep one's balance in the other direction; a constantly self-critical gaze might diminish the effects of subjectivity, but it could also entail other, no lesser risks, those of undue restraint and paralyzing caution.

The main aspect of the interaction between the memory of the Holocaust and its historiography belongs to the moral dimension of the events, that is, to the demand for justice and to Nazism as a metaphor for evil. In the early 1980s, German historians seized upon the television show *Holocaust* and

guilt. On all sides, the quest for justice focuses on the shaping of memory — and contributes to the growth of the memory of the Shoah.

The demand for justice also fuels fierce debates on comparative victimization within the Nazi system of terror and extermination or among terror and extermination systems such as the Stalinist and the Nazi. Over the last three decades or so, some of these debates have spread. The growing demand of diverse ethnic minorities for recognition of their own historical heritage, one that would offer a tale of suffering and triumph, is leading to overt confrontations about degrees of historical martyrdom. In this context, the Holocaust has become a focus of resentment and the demand for justice fuses with increasingly acrimonious arguments about the historical comparability or exceptionality of the extermination of the European Jews. Mainly, the adoption of the Holocaust by popular culture has increasingly added a peculiar dimension to its image in the consciousness of vast sectors of American and Western society.

Nazism has become the central metaphor for evil in our time. It may well be that in our age of genocide and mass criminality, the extermination of the Jews of Europe, apart from its specific historical context, is now widely perceived as the standard of evil by which all degrees of evil may be judged. Before and especially during the war, such a perception of Nazism was already present among the Allies, in occupied Europe, and even among resistance groups in Germany. After the war, Hannah Arendt was among those who identified Nazism with radical evil, and her later notion of "the banality of evil" was no contradiction: in our epoch, radical evil is linked to the utter banality of its perpetrators, the Adolf Eichmanns of this world.

The most extreme insult that one can hurl at any behavior is "Nazi," the worst tag that one can fasten on a leader is "Hitler." And, incidentally, the only given name that may have disappeared from the repertory after 1945 is "Adolf." In other words, Nazism and evil have become so intertwined that such identification triggers an ongoing and expanding process not only of representation but also of recall by association: Steven Spielberg's *Schindler's List*, Roberto Benigni's *La vita è bella* [*Life Is Beautiful*], Bernhard Schlink's *Der Vorleser* [*The Reader*]; Kosovo, France's Jean-Marie Le Pen, Austria's Jörg Haider; gay bashing, mercy killing, abortion; and so on. But doesn't that ever-spreading reference entail ever-greater dilution, simplification, and vulgarization? Is the process self-triggered and does it fulfill a function of sorts in our society?

I wish to suggest here that there is a link between the simplification in the representation of Nazism and the Holocaust in popular culture and the function of this simplified representation in our society. By *function* I do not mean to dwell on the politics of group identity or on the diverse forms of instrumentalization of the Holocaust. More relevant would be the urge of the Catholic Church to convince believers today and in the future that at the time of its

macht were far apart in terms of experience from adolescents merely two or three years younger who at the end of the war had only manned antiaircraft batteries. Because a single year could make a major difference, in Germany there often is an age group (or generational) element in what I called the return of the repressed.

The Historians' Debate, for instance, took place among scholars who, with few exceptions, were members of the Hitler-Jugend generation, who had been adolescents in the Third Reich. The positions of these scholars were sharply divided, as we know, but the intensity of the debate manifestly stemmed, at least in part, from the impact of long-buried experiences under National Socialism and their refraction through the prism of later political choices. Similarly, the novelist Martin Walser's outburst at the Friedenspreis ceremony at the International Book Fair in Frankfurt in 1998 against what he called the media's preoccupation with Germany's Nazi past, the standing ovation he received, and the accolades his sentiments accrued later from people such as the Social Democrat Klaus von Dohnanyi and *Der Spiegel* editor Rudolf Augstein all carried once more the signs of an age group. In responding to Walser's statements, the Holocaust survivor and leader of modern Germany's Jewish community, Ignatz Bubis, however clumsily or angrily, expressed the outrage of a memory much less deflected or reinvested by time.

In a letter to Karl Jaspers dated 17 August 1946, Hannah Arendt wrote,

> The Nazi crimes, it seems to me, explode the limits of the law; and that is precisely what constitutes their monstrousness. For these crimes, no punishment is severe enough. It may well be essential to hang Göring, but it is totally inadequate. That is, this guilt, in contrast to all criminal guilt, oversteps and shatters any and all legal systems. That is the reason why the Nazis in Nuremberg are so smug. They know that, of course. And just as inhuman as their guilt is the innocence of the victims. Human beings simply can't be as innocent as they all were in the face of the gas chambers.... We are simply not equipped to deal, on a human, political level, with a guilt that is beyond crime and an innocence that is beyond goodness and virtue.[3]

Arendt's cri du coeur made much sense in 1946, and I would argue that even today many people would opt for such an absolute stand in regard to Nazi crimes. The judicial process is basically not at issue anymore, for the generation that lived through World War II is passing away. Indeed, the trial of the former Vichy official Maurice Papon was possibly the last major court case regarding Nazism and related crimes. But the demand for an absolute, uncompromising, and almost metaphysical justice remains, mainly in the community of the victims. It also appears in those segments of European society somehow involved in the collaboration with Nazism. There it becomes a demand for distinctions between degrees of involvement, responsibility, and

exposed French complicity in the persecution and deportation of Jews, then at the political and institutional levels, as well as in the intellectual and artistic domains. The unexpected uproar over the role of Switzerland during the war has led to fierce public controversy about the material and financial exploitation and defrauding of Jewish victims not only in that country but also throughout Europe. This debate, it has to be added, has contributed to the reappearance in Switzerland and possibly elsewhere in Europe of a kind of anti-Semitism that had seemed to be a thing of the past: an anti-Semitism of the middle classes that is *salonfähig*—in other words, openly acceptable.

The religious domain may turn out to have an even more lasting impact on the presence of the past than the national. Establishing a Carmelite convent at Auschwitz in the 1980s was a minor matter compared to the storm that may erupt if the Vatican proceeds with the beatification of the wartime pope, Pius XII. The entire set of controversies regarding the role of Christianity, its anti-Jewish teachings, and its traditional hostility toward the Jews—all of which provided the obviously involuntary but historically unavoidable background to the extermination of the Jews—would reappear.

As these instances suggest, the Holocaust in Western consciousness resembles that of some sort of lava rising ever closer to the surface and announced by ever stronger rumblings. Yet recognizing this growing presence of the past does not explain it. Let me turn to three possible interpretations: the generational factor, the ongoing demand for justice, and the transformation of Nazism into *the* metaphor of evil for our time.

The generational factor is the first explanation that comes to mind. The "generation of the grandchildren," mainly among Europeans (Germans in particular) but among Jews as well, has sufficient distance from the events in terms of both the sheer passage of time and the lack of personal involvement to be able to confront the full impact of the past. Thus, the expansion of the memory of the Shoah could be interpreted as the gradual lifting, induced by the passage of time, of collective repression.

This interpretation could be understood, metaphorically, as a collective "working through" but also, possibly, as a collective "return of the repressed." Are we now ready to face the worst aspects of this past, or is the repressed returning, as the historian Dominick LaCapra has written, in the form of "renewed disavowal in certain quarters ... and commodified, commercialized, politically tendentious, and self-interested (if not pornographic) representations in other quarters"?[2] In other words, are we mainly witnessing a gradual lifting of defenses, or could one argue that, simultaneously, the growing awareness of the past is also due to very different impulses, such as the fascination with the aesthetics of Nazism that flourished in the 1970s or, more recently, the diatribes of negationists and the activism of radical right-wing groups?

Generations, it should be added, are not merely categories of time but also clusters of shared experience. Young German men who served in the Wehr-

On the Expanding Memory of the Shoah

The two decades following the war can be characterized as a period of virtual silence about the Shoah. The consensus of the adult contemporaries of Nazism who still dominated the public scene was one of repression and oblivion. Even the survivors chose to remain silent, since very few people were interested in listening to them (even in Israel) and since, in any case, the survivors' own main goal was social integration and a return to normalcy.

In the mid-1960s, as the generation born during or toward the end of the war was moving into the limelight, a wave of controversies shook the previous generation's defenses. Mainly in Europe, the student unrest in the later part of the decade and its sequels called into question various aspects of contemporary culture as well as the lies and obfuscation regarding the Nazi period. The greatest turmoil occurred in West Germany, but the famous slogan "Nous sommes tous des Juifs allemands" [We are all German Jews] of the French students protesting the expulsion of the Jewish student leader of the 1968 riots, Daniel Cohn-Bendit, had more than one meaning; at the same time, in Marcel Ophuls's film *The Sorrow and the Pity,* France witnessed a first rift in the construction of the mythical self-representation of its history during the war years. However, this return of the past was quickly neutralized by exculpatory theoretical abstractions about all pervasive Fascism, produced mainly on the extreme left, and by the extreme politicization of the debates.

In the late 1970s and early 1980s, a second wave of controversies opened the way for a growing subjectivity and weakened the hold of some of the theoretical constructs of the previous decade. An explosion of autobiographical literature written and read by Germans and Jews and of probing and innovative films, along with the quest for the history of everyday life under National Socialism, created a new, more direct confrontation with the Nazi past—even though some of these endeavors carried an unmistakable apologetic urge, in West Germany in particular, and some early postmodern representations were not devoid of perverse fascination with the Nazi era. Yet, strangely enough, it was a mass-media event—the broadcast of the NBC miniseries *Holocaust* in 1978 and 1979—that became a turning point of sorts all over the West, by drawing increased attention to the extermination of the Jews as the defining event of the Nazi period. Over the last decade, this past has become even more present—particularly, it seems, for the third postwar generation, the grandchildren of the contemporaries of National Socialism—following the fierce *Historikerstreit* (Historians' Debate) of 1986 and 1987 in Germany and as an indirect sequel to the fall of Soviet Communism and the reunification of Germany.

The duration of these phases has varied in different national and religious contexts. For example, the period of amnesia may have been particularly lengthy and the passage to broader awareness quite abrupt in France and, even more so, in Switzerland. In France, the surge of a national memory of the Vichy regime's anti-Jewish policies found its first major expression in the 1980s, first in the judicial branch with a series of trials that repeatedly

missed the defining aspect of these events—total physical extermination—it conveys, in words not to be forgotten, something that defies direct expression: the sense of despair and doom of tens and tens of thousands of Jews fleeing "hither and thither" like "trapped mice running in circles," as well as—unreported by Lichtheim but pervading his essay—the suffocating terror of the remaining millions.

"I am bursting with facts," Lichtheim went on, "but I cannot tell them in an article of a few thousand words. I would have to write for years and years.... That means I really cannot tell you what has happened and is happening to five million persecuted Jews in Hitler's Europe. Nobody will ever tell the story—a story of five million personal tragedies, every one of which would fill a volume."[1]

As strange as Montor's demand for fifteen hundred words on the situation of the Jews in Europe may appear to us today, it can, in a way, be considered paradigmatic for most representations and commemorations of the Shoah; Lichtheim's answer expresses an opposite mode of evocation. On the one hand, we find the desire for precise factual information offered within strict limits and probably organized around a central idea that would give it coherence; on the other hand, we meet an outburst of pain and despair that, in principle, rejects the possibility of order and coherence.

Over the last decades the memory of the Shoah has crystallized at these extremes. Whereas the first one connotes closure, the second indicates the existence of an open-ended process of remembrance. In other terms, the first is embodied in set rituals, in organized presentations ranging from textbooks to museums, monuments to civic commemorations. This public memory of the Shoah demands simplicity as well as clear interpretation; its aim, unstated and maybe unperceived, is the domestication of incoherence, the elimination of pain, the introduction of a message of redemption. The second knows no rules. It manifests in the sudden disruption of any set rendition of the Shoah among those who imagine this past—the overwhelming majority now—and those who lived through it. In the testimonies of those who remember, both expressions of the past surface: the organized, oft-rehearsed narration, as well as the uncontrolled and chaotic emotion.

In the long run, the memory of the Shoah will probably not escape complete ritualization. Yet, to this day at least, an open-ended representation of these events seems present in the West and possibly beyond. More so, it appears to be growing as time goes by. After suggesting some interpretations of the paradoxical expansion of this memory and pointing to the complex interaction between the memory of the Shoah and the writing of its history, it is on the challenges and responsibilities incumbent on the historian that I would like to dwell in the conclusion. In this domain there can be no credo, merely reflections about compelling assignments and unresolved questions.

History, Memory, and the
Historian: Facing the Shoah
Saul Friedländer

O n 9 July 1942, Henry Montor, the president of the United Palestine Appeal, asked Richard Lichtheim, the representative of the Jewish Agency in Geneva, to send him an article of fifteen hundred words reviewing the position of the Jews in Europe. "I feel at present quite unable to write a 'report,' a survey," Lichtheim answered on 13 August, "something cool and clear and reasonable. . . . So I wrote not a survey but something more personal, an article if you like, or an essay, not of fifteen hundred words but of four thousand, giving more of my own feelings than of the 'facts.'" Lichtheim ended his accompanying letter with "all good wishes for the New Year to you and the happier Jews of 'God's own country.'" His essay, entitled "What Is Happening to the Jews of Europe," opened,

> A letter has reached me from the United States, asking me "to review the position of the Jews in Europe." This I cannot do because the Jews of Europe are today no more in a "position" than the waters of a rapid rushing down into some canyon, or the dust of the desert lifted by a tornado and blown in all directions.
>
> I cannot even tell you how many Jews there are at present in this or that town, in this or that country, because at the very moment of writing thousands of them are fleeing hither and thither, from Belgium and Holland to France (hoping to escape to Switzerland), from Germany—because deportation to Poland was imminent—to France and Belgium, where the same orders for deportation have just been issued. Trapped mice running in circles. They are fleeing from Slovakia to Hungary, from Croatia to Italy. . . . At the same time, thousands are being shifted under Nazi supervision from the ghetto of Warsaw to forced-labor camps in the country further east, while other thousands just arrived from Germany or Austria are thrown into the ghettos of Riga or Lublin.

Whether, when he sent his essay on 13 August 1942, Lichtheim was privy to the information that five days earlier his colleague in Geneva, Gerhard Riegner, had conveyed to the U.S. State Department and the British foreign office, we do not know. In fact, the plan for a general extermination of European Jewry that Riegner transmitted to London and Washington had been implemented months earlier, and by August 1942 close to a million and a half European Jews had been murdered. Yet, even if Lichtheim's description of "what was happening to the Jews of Europe" was factually false because it

der Geschichtswissenschaft und der Geschichtsdidaktik im Blick auf nicht-narrative Faktoren," *Internationale Schulbuchforschung* 18 (1996): 501–43; and "Was heißt: Sinn der Geschichte? (mit einem Ausblick auf Vernunft und Widersinn)," in Klaus E. Müller and Jörn Rüsen, eds., *Historische Sinnbildung: Problemstellungen, Zeitkonzepte, Wahrnehmungshorizonte, Darstellungsstrategien* (Reinbek: Rowohlt, 1997). Revised versions of these article appear in Jörn Rüsen, *Zerbrechende Zeit: Studien über den Sinn der Geschichte* (in press).

25. See Theodor W. Adorno, "Erziehung nach Auschwitz," in idem, *Stichworte: Kritische Modelle 2* (Frankfurt am Main: Suhrkamp, 1969), 85–101, esp. 85.

"Zwischen Geschichtslegende und Revisionismus? Das Dritte Reich im Blickwinkel des Jahres 1980," in Rudolf Augstein et al., *Historikerstreit: Die Dokumentation der Kontroverse um die Einzigartigkeit der nationalsozialistischen Judenvernichtung* (Munich: R. Piper, 1987), 13–35.

19. This again can be exemplified by Ernst Nolte's thesis that Nazi dictatorship was only a reaction to bolshevism and the Holocaust only an answer to a "more original" event, namely the October Revolution and the crimes of the Bolsheviks and Stalin.

20. Alexander Mitscherlich and Margarete Mitscherlich, *The Inability to Mourn: Principles of Collective Behavior,* trans. Beverly R. Placzek (New York: Grove, 1975); originally published as *Die Unfähigkeit zu trauern: Grundlagen kollektiven Verhaltens* (Munich: R. Piper, 1967).

21. Hans-Ulrich Wehler notes that Martin Broszat has emphasized the political consequences of this approach: by "selbstkritischen Umgang mit ihrer älteren und jüngeren Geschichte" [self-critical handling of their older and more recent history], the citizens of West Germany have brought about "eines der besten Elemente politischer Gesittung, das seit den späten 50er Jahren allmählich in diesem Staatswesen entwickelt worden ist" [one of the best elements of political ethics, which has been slowly developing in this nation since the late 1950s] (my translation); see Hans-Ulrich Wehler, *Entsorgung der deutschen Vergangenheit? Ein polemischer Essay zum "Historikerstreit"* (Munich: C. H. Beck, 1988), 103.

22. The most important and influential representative of this concept is Jürgen Habermas. In historical studies it is manifest in the so-called Bielefeld school of social history.

23. Christian Meier, for example, has argued in favor of the integration of the Holocaust into the identity-building perspective of German history; see his foreword to the new edition of his *Vierzig Jahre nach Auschwitz: Deutsche Geschichtserinnerung heute,* 2d ed. (Munich: C. H. Beck, 1990), 10, where he speaks of a "hypothetischen Versuch, die Deutschen von 1933 bis 1945 in ein historischen 'Wir' einzuschließen" [hypothetical attempt to incorporate the Germans from 1933 to 1945 into a historical "we"] (my translation). Meier himself moved from hypothesis to positive assertion in an article on the debate about building a Holocaust memorial in Berlin, in which he used the words "unsere Verbrechen" [our crimes]; see Meier's "Zweierlei Opfer," *Die Zeit,* 11 April 1997, Feuilleton section, 48. See also Reinhart Koselleck, "Vier Minuten für die Ewigkeit," *Frankfurter Allgemeine Zeitung,* 9 January 1997, Feuilleton section, 27; and Thomas Auchter, "Jenseits des Versöhnungsprinzips: Die Grenzen des Erinnerns," *Universitas* 52 (1997): 230–40, esp. 231: "Als Deutscher stehe ich unvermeidlich auf der Seite der Täter.... Wenn ich mich in meinem Land verwurzelt fühlen möchte, muß ich mich auch in die Geschichte seiner Menschen hineinversetzen. So werde und bleibe ich verantwortlich verbunden mit dem, was Deutsche getan haben, durch aktives Handeln und aktives Unterlassen" [As a German, I stand inevitably on the side of the perpetrators.... If I wish to feel comfortable in my own country, I must place myself in the history of its people. So I am and will remain responsible, connected with what the Germans did, through active commission and active omission] (my translation).

24. I have discussed this principle in more detail in two articles: "Historische Sinnbildung durch Erzählen: Eine Argumentationsskizze zum narrativistischen Paradigma

8. This does not mean (as it is commonly thought today) that historical consciousness assigns value to the events after they have happened, thus giving them historical importance retrospectively (from the present to the past, so to speak). The matter is much more complicated: on the one hand, the events in question are kept alive in memory by their normative force and relevance in the present; on the other hand, the force and relevance of the events in question have to be renewed by activities of historical commemoration.

9. See Bernd Faulenbach, *Ideologie des deutschen Weges: Die deutsche Geschichte in der Historiographie zwischen Kaiserreich und Nationalsozialismus* (Munich: C. H. Beck, 1980).

10. See Jörn Rüsen, "Historische Erinnerung — zweideutig — eindeutig: Zum 5. Jahrestag der Deutschen Wiedervereinigung," *Schulverwaltung: Zeitschrift für Schulleitung und Schulaufsicht: Ausgabe Nordrhein-Westfalen* 6, no. 9 (1995): 239–40.

11. See Martin Heidegger, *Sein und Zeit*, 8th ed. (Tübingen: Max Niemayer, 1957), 175 ff.

12. See Martin Broszat, *Nach Hitler: Der schwierige Umgang mit unserer Geschichte*, ed. Hermann Graml and Klaus-Dietmar Henke (Munich: R. Oldenbourg, 1986).

13. This nationalism and its origins in the late nineteenth century is described in Frank Trommler, "Arbeitsnation statt Kulturnation? Ein vernachlässigter Faktor deutscher Identität," in Albrecht Schöne, ed., *Kontroversen, alte und neue: Akten des VII. Internationalen Germanisten-Kongresses, Göttingen 1985*, vol. 9, *Deutsche Literatur in der Weltliteratur: Kulturnation statt politischer Nation?* (Tübingen: M. Niemeyer, 1986).

14. See Friedrich Meinecke, *Die deutsche Katastrophe: Betrachtungen und Erinnerungen*, in idem, *Werke*, vol. 8, *Autobiographische Schriften*, ed. Eberhard Kessel (Stuttgart: K. F. Koehler, 1969).

15. This is the famous thesis of Hermann Lübbe, which originally caused much emotionally charged contradiction but has now gained widespread acceptance; see Hermann Lübbe, "Der Nationalsozialismus im deutschen Nachkriegsbewußtsein," *Historische Zeitschrift* 236 (1983): 579–99.

16. An example for this extraterritorialization is the inaugural speech of Leopold von Wiese at the first postwar meeting of German sociologists: "Und doch kam die Pest über die Menschen von außen, unvorbereitet, als ein heimtückischer Überfall. Das ist ein metaphysisches Geheimnis, an das der Soziologe nicht zu rühren vermag" [The plague came unexpectedly upon the people from outside. This is a metaphysical secret, which cannot be treated by a sociologist] (my translation); see Leopold von Wiese, "Die gegenwärtige Situation, soziologisch betrachtet," in *Verhandlungen des Achten Deutschen Soziologentages: Vom 19. bis 21. September 1946 in Frankfurt am Main* (Tübingen: Verlag J. C. B. Mohr, 1948), 29.

17. A rather late example for this presentation of the Nazi era is the film *Hitler — eine Karriere* (1976), dir. Christian B. Herrendörfer and Joachim C. Fest.

18. *Reversing* is found even in the refinements of academic discourse. See, for example, Ernst Nolte's argument that the Zionist world congress had declared war on Nazi Germany, so Hitler was warranted at least in interning the Jews; see Ernst Nolte,

Notes

I would like to thank Inge Rüsen and Christian Geulen for their critical reading of the manuscript for this essay.

1. My translation; from the German translation (of the original Egyptian hieroglyphic text) that appears in Wolfgang Helck, "Ägypten im frühen Neuen Reich: Grundzüge einer Entwicklung," in Arne Eggebrecht, ed., *Ägyptens Aufstieg zur Weltmacht,* exh. cat. (Mainz am Rhein: Philipp von Zabern, 1987), 11: "Hätte ich doch unbekannte Worte, fremde Sprüche, in neuer Sprache, die noch nicht entstanden ist, ohne Wiederholung — keine Sprüche der Vergangenheit, die schon die Vorfahren gesagt haben." Dating to the second century B.C.E., the "Teachings of Khakheperreseneb" are the author's complaints about the state of the nation.

2. My translation; from a German translation of Aeschylus, *Agamemnon,* ll. 179–81, whose source I have been unable to locate:

Statt des Schlafes tropft vor das Herz

schwer die Erinnerung und ihre Qual, und

ob der Sinn sich auch sträubt, es kommt

die Erkenntnis.

I ask the translator or publisher to contact me, so the correct information can be published in subsequent editions.

3. My translation; Friedrich Nietzsche, *Unzeitgemässe Betrachtungen, II: Vom Nutzen und Nachteil der Historie für das Leben,* in idem, *Sämtliche Werke: Kritische Studienausgabe in fünfzehn Einzelbänden,* ed. Giorgio Colli and Mazzino Montinari, 2d rev. ed. (New York: De Gruyter, 1988), 1:270: "Denn da wir nun einmal die Resultate früherer Geschlechter sind, sind wir auch die Resultate ihrer Verirrungen, Leidenschaften und Irrthümer, ja Verbrechen; es ist nicht möglich sich ganz von dieser Kette zu lösen."

4. See Jörn Rüsen, "The Logic of Historicization: Metahistorical Reflections on the Debate between Friedländer and Broszat," trans. William Templer, in Gulie Ne'eman Arad, ed., *Passing into History: Nazism and the Holocaust beyond Memory: In Honor of Saul Friedländer on His Sixty-Fifth Birthday* (Bloomington: Indiana Univ. Press, 1997), 113–46.

5. See Jörn Rüsen, "Was ist Geschichtsbewußtsein? Theoretische Überlegungen und heuristische Hinweise," in idem, *Historische Orientierung: Über die Arbeit des Geschichtsbewußtseins, sich in der Zeit zurechtzufinden* (Cologne: Böhlau, 1994), 3–24.

6. A good example of this challenge is to be found in Saul Friedländer's "Writing the History of the Shoah: Some Major Dilemmas," in Horst Walter Blanke, Friedrich Jaeger, and Thomas Sandkühler, eds., *Dimensionen der Historik: Geschichtstheorie, Wissenschaftsgeschichte und Geschichtskultur heute: Jörn Rüsen zum 60. Geburtstag* (Cologne: Böhlau, 1998). He closed with the observation that the historical experience of the twentieth century prompts one to raise again the question: What is the nature of human nature?

7. This does not mean that there have not been attempts to give the crisis meaning and to break its ban on memory. The critical character of what had happened becomes obvious by the failure of these attempts.

of events that constitutes collective identity historically includes the Holocaust, with all its negative meaning and significance, it prevents any form of coherence in the historical dimension of the self. Instead of coherence, which is usually brought about by an entirely positive identification with the past, the historical dimension of the self has become fragmented and loaded with tensions and even contradictions. As long as this fragmentation and tension is conceptualized by applying a principle of historical sense, it can serve as a reliable frame for cultural orientation and identity building. In this case, "historical sense"[24] means an essential openness to the temporal dimension of historical identity, a contrafactual validation of those principles of human self-understanding that place collective self just on the borderline between past and present where the transformation of existing circumstances takes place. For German collective identity, an essential queasiness in respect to origins and descent ends in the projective force of the human mind, which discloses creative possibilities for change. Identity—whether individual or collective—is always a synthesis of what one was and of what one would like to become. Thus, the constitutive force of the Holocaust in the historical dimension of German identity evokes its complement in the form of a projection of a future that is committed to the categorical consequence of the Holocaust, which Theodor W. Adorno has stated as a general principle of human thought: It should never happen again.[25]

From this line of rupture, even the catastrophic element of the Holocaust as crisis can be recognized: it disturbs the previous standards of coherence based on self-understanding in the concept of historical identity. With this new feature of collective identity, the relationship of crisis and identity has essentially changed. In traditional cultural procedures of commemoration, the crisis is overcome: the discontinuity and rupture in collective identity caused by contingency is transformed by historical consciousness into a new and meaningful coherence through the temporal connection of past, present, and future. Now, however, crisis becomes an element of collective identity itself. This means that the people cannot rely on a deep conviction that their way of life is fundamentally legitimate but they can rely on the permanence of their way of life, at least in its essential elements. An inbuilt "critical" element in this feature furnishes this permanence and legitimacy with projective elements with regulative ideas of practical reason. They are permanently generated and pushed forward by the sting of memory, which keeps the Holocaust present. At the third stage, the memory of the Holocaust has been transformed into a historical consciousness that infuses the collective self with a character of imperfectability, an imperfectability that requires practical activities.

It is an open question whether and how this new logic of identity building through the memory of the Holocaust will bring about a new relationship between German national identity and the Holocaust, as well as a new structure to the concept of collective identity, one in which other and self achieve a mediation beyond the cultural logic and practice of identity building by exclusion of otherness.

to the perpetrators and bystanders of the Holocaust. At the second stage, moralistic criticism of the Nazi era, accompanied by identification with the regime's victims, kept this relationship outside of the constitutive historical elements of the Germans' self-identity. The increasing distance from the Nazi era associated with generational change has enabled many Germans to bridge the mental gap that separated them from their parents and grandparents in the previous, value-based perspective of their collective identity. It has been accepted that even when those who committed the Holocaust are viewed as the other, they are at the same time Germans like those who were trying to radically dissociate themselves from them. At the third stage, this mediation takes place: historians start to say "we" to the perpetrators.[23]

This enormous shift requires the reconceptualization of German collective identity. The genealogical chain of generations is now a structural element in the historical perspective within which German identity is shaped, and Germans have started to define themselves as a result of a historical process in which the perpetrators and the bystanders are integral parts of the historical experience. This remakes the feature of German self-awareness. The atemporal moral distance of the second stage is transformed into a specifically *historical* distance, and the Holocaust is placed in the chain of historical events by which German collective identity is constituted. In this historical place, the Holocaust has not, of course, lost its character as the contrary to any valid system of values to which Germans feel collectively committed. The point is that this "otherness" is now a part of the self.

What this means for the symbolic order of historical experience as a feature of German collective identity is not yet apparent. Such a feature needs a certain coherence, one that can arrange the events of the past into a concept of temporal order that may function as a pattern of collective self-understanding and cultural orientation. Coherence allows constitutive values to play a legitimating role. For Germans, however, the Holocaust cannot serve to legitimize their singularity as a nation. On the one hand, the genealogical connection between the Germans of today and Germans of the past is too various: it includes victims and opponents of the regime as well as perpetrators and bystanders. On the other hand, the genealogical connection is so strong that any legitimating approach to the Holocaust would require that the Germans of today play the role of the successors of the perpetrators. This strictly contradicts the respect for universalistic values that is now deeply rooted in German political culture and a constitutive element of German collective identity. As long as the perpetrators are integrated into a common "Germanhood," and as long as the perpetrators are recognized as Germans, German collective identity will feature a negative constituting event as an essential part of Germans' own history.

This inclusion of the "otherness" of the Holocaust and its perpetrators requires a new logic of historically shaped collective identity, for the strict exclusion of negative elements from the horizon of the historical experience related to one's own people has become impossible. Once the temporal chain

counterevent that constituted German collective identity in a negative way. In this negative way, the Nazi era became an integral part of German history.

The new generation grounded its self-esteem in a strictly moralistic criticism of the Nazi period that used the universalistic standards of political culture (as they were embodied in human and civil rights) that had become valid in their political socialization.[21] In its most elaborated form, the negative constitutive role given to the Nazi period was confirmed and realized by taking an identificatory step into that era: the "self" achieved its moralistic power by identification with the victims, making the "other" the perpetrators and bystanders. "Otherness" lost its transhistorical status and became a part of German history itself, the part against which the new Germany was defined.

What were the consequences for the concept of collective identity of this integration of the Holocaust into German history? For one, the idea of a distinct and obligatory German historical tradition was replaced by universalistic values and norms. This universalism became a constitutive factor of reshaping German collective identity.[22] The new generation gained its psychological power and the strength of its conviction against the negative historical experience of Nazism. When brought into the horizon of German self-awareness, the Nazi era pushed the new generation to stand for whatever they perceived as being contrary to Nazism. They also rejected the Nazi era as a constitutive part of themselves, and made "critique" the essential attitude in interpreting German history. The result was that "otherness" was manifested in the past of the German people, but in a way that excluded it (by critique) from the realm of the self.

This distinction between self and other within the same German history was a constructive step beyond the extraterritorialization of Nazis and the Holocaust from identity-building history. It allowed a German collective identity that could come to terms with the Holocaust by interpreting it historically in a framework based on universalistic values. However, this move leaves unanswered a question decisive for topical interpretation of the Holocaust: is the catastrophic character of the Holocaust left out, or at least normalized, when the Holocaust functions as a historical example that validates the value system of Western civilization by clarifying the disastrous consequences of its negation?

In any case, this relation between German collective identity and the Nazi period is a fragile mixture of a metahistorical universalistic values and historical experience mediated by contradiction. It still prevails for many Germans, but the next stage has begun to emerge. The third stage is dedicated to the task of overcoming the fragility of this relation through an entire historicization of the Nazi past, including the Holocaust.

Stage 3: Further Historicization of the Holocaust

The third stage has just started to coalesce, and whether it will lead to a peculiar new form of collective identity for Germans is an open question. But there are clear indications that it may. The decisive new element reshaping German identity is an opening of the German mind to their genealogical relationship

In addition, the threatening features of the Nazi era were projected beyond the limits of the self onto the "otherness" of the perpetrators. The Nazis were demonized and extraterritorialized into a realm beyond the mainstream of German history. Nazism was shrunk into an invasion of a relatively small group of political gangsters who came out of nowhere and occupied Germany.[16] "Ordinary" Germans—including those who had to come to terms with their own Nazi past—were characterized as victims of a devilish Nazi seduction.[17] The psychological strategy employed in this molding of collective memory to shed the burden of the self's own entanglement is described in psychoanalysis as "reversing."[18] The concept of totalitarianism was used later on to confirm this extraterritorialization. During the cold war period, the perpetrating "others" could be placed behind the Iron Curtain, and the burden of Nazism could be ascribed to the common totalitarian enemy, the Communists. So a collective conviction could be brought into being: not we but those "others" were guilty.[19]

This strategy of public silence about Nazism and extraterritorialization of the Nazis and their crimes was criticized later on as a mental failure, a structural deformation of the "German mind." This criticism was the consequence of the new moralistic approach to the Nazi period that would constitute the second stage. This criticism, whose most prominent document is Alexander and Margarete Mitscherlich's *Die Unfähigkeit zu trauern* [*The Inability to Mourn*],[20] overlooked the limited possibilities for mental survival and the function of forgetfulness in overcoming a deep identity crisis caused by a rupture of historical continuity.

There were lines of continuity, of course, that went across the Nazi period and bound it to the "real" German history and therefore could be publicly commemorated. German opposition to Hitler (except for its Communist branch), for example, could function as an exemption from the rupture of continuity in German identity. Another example is the practice of *innerer Widerstand* (internal opposition), which many intellectuals who were not expelled and who did not leave Germany used to explain their behavior in the Nazi era. By this sort of "opposition," they intended to stand for the ongoing validity of traditional German values in the time of their negation and destruction.

Stage 2: The Holocaust Became a Constitutive Event by Moralistic Condemnation of the Nazi Era

The second stage came along with the next generation of Germans, which sought to gain its own concept of collective identity by struggling with their parents. This new concept was characterized by its relation to the Holocaust as expressed in two conflicting intentions: to keep the memory of the Holocaust alive, and to make it relevant to German collective identity. For the first time, the Holocaust was to be given its place in a historical narrative that ended in the mental field of German historical self-understanding. As it turned out, it was not so much the Holocaust as the Nazi period in general that played a role in building a new collective identity. It was used as the

gained its historical significance in the transforming process by which the memory of the Nazi era developed the features of historical consciousness.

Postwar German Identity Building

I would now like to propose an outline of the development of German historical consciousness and the related concept of collective identity shaped according to the catastrophic traits of the Nazi era and the Holocaust. I will characterize the complex development of postwar German identity in an ideal-typological way, distinguishing three main stages. It would be a mistake to believe that these stages replaced each other in sequence, however. In fact, they have coexisted and mixed over time — even though logically and even chronologically, they can clearly be distinguished.

Stage 1: Concealment of the Holocaust and Extraterritorialization of Nazism

During the first stage, the crimes of the Nazi era were remembered by the perpetrators and the victims and by those who knew about what had happened. As such, the Holocaust had the importance of an event against which German collective identity was shaped, or at least the importance of an event that changed their collective identity substantially. Germans entered the postwar era with a feeling of a collective catastrophe and complete defeat. The breakdown of the German empire was seen as a rupture of identity that radically weakened the hitherto strong nationalism that had supported German collective identity. Self-esteem, which belongs to the traditional nationalism, was impossible given its important role in the Nazi period. Only one manifestation of it could survive: the self-esteem of being industrious and effective workers.[13]

For the purposes of mental survival, Germans had to bridge the rupture within their historical identity to overcome this fundamental crisis. One answer to the challenge of this rupture entailed — at least on the level of intellectual debate and the educational system — the evocation of national traditions that could be interpreted as opposed to Nazi ideology. The historian Friedrich Meinecke, for instance, recommended Goethe as a renovating historical element for German identity.[14] Other events or elements from German history by which collective identity could be positively rooted had survived the Nazi era and the Holocaust.

The Holocaust was not a historical element that fitted into the realm of "real" German history. If it had an identity-building role at all on the level of deliberate (rather than unconscious) mental activity, it indicated and manifested "otherness." Thus, the crisis of German collective identity was overcome, for the most part, by leaving aside, if not suppressing, the memory of the Holocaust and other crimes of the Nazi era in the realm of public discussion and political activity. The new West German democracy became very successful, and this success was due in part to the integration of the majority of the Nazi elite into the new republic. There was an unspoken agreement that Germany's ongoing entanglement with the Nazi system was not to be discussed.[15]

ent, and future is a synthesis of continuity and change, caused by changes in the life circumstances of the people.

Different kinds of traumatic transference. The mental heritage of the victims as well as that of the perpetrators of National Socialism has been handed down to at least some of their children and grandchildren—a fact that accounts in part for the silent continuity of attitudes.

The memories of those who participated in the Holocaust. A determining factor of historical consciousness, the participants' recollections have changed over the course of time due to experiences such as the cold war and to new interpretations that have changed the content and the patterns of significance of the Nazi era. But their memories (including a suppressive forgetfulness) have remained the most important representation of the Holocaust as an event of central importance for German identity.

Together these existing circumstances produced the turning point in postwar historical consciousness in Germany. It was initiated by these circumstances insofar as a bridge had to be built between future-directed intentions and given reality of the past, which differ structurally. Historical consciousness has to work through these circumstances in presenting them as the end of a historical development that started in or at least passed through the Nazi era but will lead into a different future. Bridging the gap between the conditioning past and the intended future, historical consciousness has attempted to change fateful dependence on the Nazi past into value-guided acceptance or legitimization of German identity. In this transformation, the experience of catastrophe has remained decisive. On the intentional level, it works as a normative factor that determines the interpretation by which the past becomes history for the present generation. Catastrophe here works as a negative evaluation that structures the decisive events in the narrative flow of the historical arguments that shape Germans' self-awareness, their idea of collective identity, and their sense of "otherness."

contemporaries, bystanders, perpetrators, victims, opponents	past
↑	↑
modes of subjective relation (value-guided commitment)	history
↑	↑
collective identity of the (West) Germans as a result of cultural activities dedicated to the memory and the consequences of the past	present

The Holocaust has not always been the decisive event of the Nazi period in respect to which Germans related themselves to that past. On the contrary, the postwar development of German historical consciousness has been characterized by the increasing importance of the Holocaust as the temporal distance to it increases.[12] Since this distance occasions the already mentioned difference between memory and historical consciousness, one can say that the Holocaust

Germany, the loss of territory and the expulsion of the people who lived there, and a burden of guilt, shame, horror, suppression, trauma, and responsibility. The chain of generations is the mechanism by which the Nazi past is related to the external and internal circumstances under which Germans live today. It would be misleading to look at this mechanism as simple and direct. In fact, it is very complex, for it involves in various ways many different aspects of the German people. The historical perspective associated with this mechanism is a heterogeneous mixture of subperspectives in which different groups of Germans in the present are related to different groups of Germans and non-Germans in the past. In looking at the people whose activities and sufferings constituted decisive elements in the fateful dependence of modern Germans on the Nazi past, one can distinguish different groups — contemporaries, bystanders, perpetrators, victims, and opponents of National Socialism. There is no clear and self-evident historical relationship between these groups of Germans from the Nazi era and specific groups of Germans today. The majority of modern Germans may be related biologically, culturally, and historically to the bystanders and perpetrators, but one should not overlook that a remarkable proportion of the victims and opponents were German. This is even true for a number of the Jewish victims, some of whom felt themselves to be German. The relation between the Nazi era and contemporary Germany is illustrated in the following schema:

contemporaries, bystanders, perpetrators, victims, opponents past
↓ ↓
modes of objective relation ("causality of fate") history
↓ ↓
the people of (West) Germany living under conditions present
that are the result of what happened in the past

From this network of generational relationships, the fateful ties of modern Germans to the Holocaust can be typologically differentiated into four classes:

Continuity of consequences. The consequences of the Nazi era are intrinsic in the lives of the Germans of today. To the already mentioned consequences (e.g., division of the nation), I want to add here (1) the rupture in the genealogical chain caused by the deaths of soldiers and civilians due to the war and — not to be forgotten — (2) the disappearance of influential Jewish parts of German culture.

Silent continuity of attitudes. A change in at least parts of these attitudes (e.g., the authoritarian personality, a certain kind of work ethic, a power-protected inwardness [*machtgeschützte Innerlichkeit*], anti-Western resentment) is observable. German identity and its change is characterized not so much by a single attitude that connects the generations but by certain modes of realization and by the relationship of Germans to others. The historical character of German identity's relationship between past, pres-

people in the present and have come to be regarded as fateful—foreordained, decisive, even prophetic. So the dependence of historical consciousness on the past is characterized by a "causality of fate" (*Kausalität des Schicksals*). "Causality" can be concretized as a property of the chain of generations that exists aside from and independent of the awareness of and the deliberate interpretative relationship to this chain that is maintained by those who are a part of it. They are bound to or even "thrown into" [11] (Martin Heidegger) this chain, and through the chain the past permeates the external and internal preconditions and circumstances of everyday life at every moment, without asking, and sometimes even against the will of, those who have to come to terms with the past. In this perspective, historical consciousness depends upon the past, which it has to transform into a sense-bearing and meaningful history.

This "causal" or "fateful" relationship between past and present is not limited to the external conditions of human life. It includes as well internal conditions, the mental presuppositions and possibilities important in dealing culturally with the past, when making history out of it. The fateful generational chain has a mental dimension effective through traditions, prejudices, resentments, threats, hopes, value systems, basic convictions, and—not to be forgotten—the forces of subconscious attitudes and instincts guided by suppressive forgetfulness.

From another perspective, the past in the form of sense-bearing and meaningful history depends upon the interpretative turn given to it by those for whom it is important. In this case, events are, so to speak, raw material that must be formed into a concept of temporal change by which human activity and suffering in the present can be oriented toward the future. In this scenario, the burden of the past pressing human identity into the responsibility for things and events that happened before their time or outside their experience is replaced by the creativity of the human mind. The creative mind shapes the past into a narrative of development that ends in a projection of future that propagates the group's identity along the lines of their self-esteem. Fateful causality is replaced by value-guided commitment deliberately related to the events of the past, and these events are treated as if they had to be redeemed in the future, during the course of temporal change in the human world.

Within the framework of the tension between fateful causality and value-guided commitment, historical consciousness pursues its operations of identity building.

The Holocaust Roots German Identity in a Catastrophe

In most perspectives of historical consciousness, the Holocaust constitutes German identity by catastrophe. As a given that must be dealt with, the Holocaust belongs to those events of the past that have determined life in Germany today. It is a part of a history that culminated in the complete defeat of the nation, the destruction of large parts of the country, the political division of

Events that renew valid patterns of collective identity. The American Civil War is one example, to the extent that its outcome enforced the previously valid pattern of "one nation."

This list is not complete and could be developed and differentiated. For the purpose of my argument it is sufficient, however, because it shows that historical events can focus collective identity in very different ways. There is not just one mode of presenting those historical events that have the normative power of forming collective identity by the causality of fate, but rather a multitude.

Finally, I would like to note that normal and catastrophic events relate to the cultural process of identity formation differently. A normal crisis brings about a concept of history within which an event representing this crisis (for example, the fall of the Bastille in the French Revolution) constitutes collective identity in the usual way. A catastrophic crisis, however, brings events into the cultural process of identity formation that prevent a positive constitution of the group's historical identity and destroy the possibility of founding collective identity on an event that happened in the context of the crisis. In this case, the events take on a traumatic character and have the power to disturb (individual and collective) self-esteem. Because of this power, the catastrophic crisis remains a permanent threat to collective identity.

Identity Building by History

Collective identity is rooted in the presentation of events as "historical events." *Historical* means that the events have a specific meaning and significance in the lives of the people who rely on them when they reflect upon who they are and when they characterize the "otherness" of others. So a historical event is a synthesis of *factuality* based on actual experience, on the one hand, and *intentionality* (traditionally called "spirituality" [*Geistigkeit*] and today mainly called "fictionality") based on the creative forces of the human mind, on the other hand. These two elements should be carefully distinguished when analyzing the process of identity building through historical consciousness — although we should bear in mind as well that the historical character of an event *is already* a synthesis of norms and facts; from its origins onward, it is experienced and afterward remembered as such. Distinguishing factuality and intentionality is an artificial but necessary act, since the dynamics of identity building are constituted in the mental processes by which an event becomes historical and which mold the experience of the past into a meaningful history by interpretation and representation.

Its dependence upon the past means that historical consciousness takes place in a context where the past has brought about presuppositions that condition the mental activities for remembering it. These presuppositions are not easily identified or discarded, but they have to be recognized if we are to understand the mental procedures for making sense of the past and to promote the culturally orienting function of historical consciousness. They are the result of developments in the past that have determined the lives of the

tem against the French "ideas of 1789." Germany claimed for itself a *Sonderweg* (special way) defined by its deviation from the Western way of modernization.[9] During the history of German nationalism, no unique event such as the American or French Revolution gained the normative character of constituting German national self-understanding. Instead, in most cases the historical events that served as a focus of national self-understanding (such as the Reformation in the 1500s, the war of liberation against the French of 1813–14, the Battle of Sedan in 1870 and the victory over France of 1871, the national enthusiasm for "die Ideen von 1914") were conceptualized against other "ideas" of national identity, and especially against the French "ideas of 1789," with their universalistic dimension, including human and civil rights.

Events or chains of events that change old concepts of collective identity into new ones. In this case the event constitutes an (individual and collective) identity that is considered to be more convincing than the old identity in light of the current situation of the group and its expectations for the future. An example of such a change is a process of secularization that changes a religious into a nonreligious (cultural) identity; another is the replacement of one constitution by another. For current German national identity, the following sequence is such a chain of constituting events: defeat of the Nazi regime in 1945, a new constitution in West Germany in 1949, unification of West and East Germany in 1989. It is remarkable but characteristic of the topical concept of national identity in Germany that unification has served no "founding" or "constituting" function—so objectively the new Germany is only an enlargement of the former West Germany, although subjectively unification has been quite another experience for many, a difference that causes problems in German identity today.[10]

The nature of events that are remembered as decisive in the historical process leading to the conception of collective identity can be typologically distinguished as follows:

Events as turning points. German unification can serve as an example of such an event. It has turned German national identity after 1945 into a new form. The unspecific feeling of togetherness after 1945 comprehended the Federal Republic and the Democratic Republic, although it was weakened by emerging West and East German identities. These merged after 1989 into a clear national dimension of political identity. Other turning points that have influenced German national identity are the events of European unification.

Events that revoke hitherto valid patterns of collective identity. Examples are the defeat of the Nazi regime in 1945 as an abrogation of traditional German nationalism, the breakdown of the Communist system in 1989 as a blow to Soviet identity.

share and have in common, what gives them a specific character and separates them from others. In the realm of religious identity, for example, Christians are fundamentally related by the events of Jesus' life, just as Muslims are related by the events of Muhammad's life, and so on.

In the realm of historical consciousness, collective identity is constituted by historical events with normative power and by their individual and social commemoration. In the narrow sense, the term *historical* indicates that the constitutive event is of the same nature as events within the horizon of experience of the people who rely on it. In some cases, however, if they are relevant for the social world in general, the constituting events may have taken place beyond the horizon of the group they constitute, outside of the experience of its people. In such cases, the constituting historical event has a "mythical" character. But this does not mean that the people think that the event did not really happen. On the contrary, they often estimate the reality of such an event as being greater, or more real, than the events of the so-called real world. *Historical* as I am using it here covers the range of the constitutive event, from the mundane to the mythical.

It is not always a single event, of course, that constitutes collective identity, but a constituting event usually gains its specific importance, its constitutive power, from a temporal connection to other events. There is always a chain of events that connects the present with the specific event that people rely on to explain to themselves and those they live with who they are, what the order of their lives is, and how they understand the "otherness" of others. As the expression of historical consciousness, "history" consists of this temporal chain of events. This chain of events has the cultural power to shape identity, a power that can be described using the Hegelian term *Kausalität des Schicksals* (causality of fate). This chain of events is a determination about the peculiarity of one's own self as a cultural element of life. It is not at all constructed by those who are defined by it, but rather it constructs them in their differences from others.

So historical identity is shaped by the representation of historical events passed down through the chain of generations. These events have different levels of importance as determined by their power to form collective identity. In an ideal-typological way, one can distinguish the following possible relations between historical events and collective identity:

Events with a positive founding or constituting function. Well-known examples are the Declaration of Independence for the political identity of citizens of the United States, the resurrection of Jesus for Christians, the exodus from Egypt for Jews.

Events that constitute identity in a negative way. In this case identity is constituted in opposition to events or ideas that a rival group uses to constitute its identity. For instance, for a long time German identity in its modern national form was shaped in opposition to the Western (mainly French) model. The Germans focused their obligatory political value sys-

the temporal unity of a collective self consists of a synthesis of experiences of the past and expectations for the future. In this synthesis, the past is present as a force by which the human mind is directed toward the future. The force of memory shapes the features of (collective and individual) identity and makes the past a projection of the future.

So memory and historical consciousness are closely interrelated, but they are not the same. Historical consciousness is grounded in memory, but it surpasses memory in one decisive way: it keeps or makes the past alive even when the past lies beyond the memory of the social group concerned. It even influences and shapes the memories of people by furnishing them with conceptualized experiences that they themselves did not have. Historical consciousness enlarges the temporal extension of memory into an intergenerational continuity and duration for the collective self. The idea of this continuity, which meets the (individual and collective) self's desire to transcend birth and death, drives forward the cultural procedures and practices by which a society reflects upon and confirms its togetherness and its difference from others.

The concept of continuity in the two modes of crisis differs substantially. A normal crisis binds past, present, and future together into an unbroken unity of self; the wounds contingency makes in historical identity heal in the course of time. In the case of a catastrophic crisis, however, unity becomes precarious at its core; the wounds to historical identity remain open.

Identity Emerges from Events

In the procedures and practices by which a society builds its identity, historical events play a decisive role. They are commemorated and represented such that their factual contingency stands for the peculiarity and uniqueness of the collective self—to describe in philosophical terms a very familiar phenomenon. Marriage, for instance, is an element of social identity, and it is grounded and constituted in a single event: the ceremony in which a man and a woman become husband and wife. Each person's life is full of such constitutive events; in early societies every stage in the human life cycle of social importance was accompanied by a ceremony that constituted an element of the individual's identity. By memory the constitutive events are kept alive, and with each life the constituted identity is maintained and then constantly confirmed in social interaction and communication, where identity is always of concern—directly or indirectly.

The same is true in the temporal realm of historical consciousness, beyond the limits of personal and generational memory. Here historical events play a constitutive role in shaping collective identity. Historical consciousness furnishes and molds events according to the norms and values that regulate human activities through cultural orientations and impulses as well as objectives of will.[8] The social group whose identity is of concern relates itself to events in the past beyond the life span of its members. They feel committed to these events in a certain way: they use them to formulate, express, activate, and confirm the cultural patterns of their common self, to define what they

consciousness as a procedure for overcoming the crisis. The challenging contingency is put into a narrative within which it makes sense so that humans can come to terms with it by exhausting the existing mechanisms for making sense of temporal change. A catastrophic crisis destroys historical consciousness's ability to digest contingency in a sense-bearing and meaningful narrative. In this case, the basic principles of sense generation that bring about the coherence of a historical narrative are themselves challenged[6] and have to be violated or even given up. Therefore it is impossible to give such a crisis a place in the memory of those who lived through it. When a catastrophic crisis occurs, the language of historical sense falls silent. It takes time (sometimes even generations) to find a language that can articulate the catastrophe.[7]

This distinction between normal and catastrophic crises is artificial, of course. Without some element of catastrophe, no normal crisis would be really challenging; and without some element of normality, no catastrophic crisis could even be identified as a specific challenge, much less become a source of radical change in the perception and interpretation of history.

In any case, the interpretative work of historical consciousness is a procedure for identity building. This is true for individuals as well as for groups. *Identity* is a term for the concept of the coherence of oneself in relation to others and to oneself as well. This coherence has both a synchronic and a diachronic dimension. Synchronically, identity integrates the different relationships between an (individual or collective) self and others into a unity in which the self is aware of itself at a moment in time. It reflects the self's present relationships to others back to the self and gives the self an internal unity in the variety of the self's manifold relationships to others. Diachronically, this reflection of the self to the self is related to the change in the self and in the self's relationships to others over the course of time. In this respect identity is a concept of the continuity of the sameness of oneself in the changes that each person and group undergoes in the course of a lifetime. In this essay I will neglect the relationship between the synchronic and diachronic dimensions of identity and deal only with two aspects of the diachronic dimension of identity: the extension of identity across generations, and the grounding of identity in events of the past kept present by the consequences and the memory of those events.

The temporal coherence of the self is not necessarily limited to the life span of any one individual. Social units that achieve a collective identity tend to extend their members' temporal awareness of and relationship to the (individual and collective) self to an intergenerational duration and continuity. Belonging to such a self furnishes the individual members with an awareness of an eternity-like duration; it transforms the biological chain of generations within which each member lives into an enduring cultural unity that comprehends past, present, and future beyond the individual's life span. It is this temporal unity that individual members feel and consider to be their collective self beyond the limits of their own births and deaths, defining the cultural nature of their social relationships. Brought about by historical consciousness,

beyond the level of the subject matter of historical thinking into the core of the mental procedures of historical thinking itself.[4]

In this essay, I reflect on the borderline character of the Holocaust in relation to the role historical thinking plays in the process of building collective identity. I will deal mainly with problems of (West) German national identity after World War II, although I think that these problems involve elements of identity formation that can be found in other societies as well. To clarify this specific case, I will discuss the issue against the background of a general theory of historical consciousness and its cultural functions.

Crisis Elicits History, and History Elicits Identity

A crisis is nothing special or peculiar in the realm of historical consciousness. On the contrary, I would argue, crisis constitutes historical consciousness, so one can say that there is no historical consciousness without crisis. By *crisis* I mean a certain experience of temporal change: that of contingency. This experience prompts the human mind to conceptualize the relation between human activity and change in the human world over time. Temporal change always has a "critical" character: it cannot be sufficiently understood as the result of change brought about by human activities along the lines of deliberate intention. On the contrary, it usually happens against intended objectives, or at least deviates from them. No human goes through life without this experience of disturbing change in the human world against expectation and intention. This specific temporal experience of rupture and discontinuity is what I mean by *contingency*.

Historical consciousness is one response to the challenge of contingency.[5] A contingent event does not fit into the existing, culture-orienting patterns of human life. Owing to its disturbing character, such an event has the ontological status of a crisis in relation to those patterns, which orient human activities in such a way that humans can pursue and realize their objectives. The security that humans find in the familiar relationships among objectives, means, and realizations of actions is permanently and fundamentally irritated when things that are relevant to those actions happen in a way that cannot be understood within the instrumental-rational model of human activity. I want to say that the temporal change of the world in general cannot be understood along the lines of causality by intention (something happened because somebody wanted it to happen and pursued his or her will). To obviate this irritation of security, the human mind establishes patterns of meaning and significance that follow a logic different from the logic of instrumental rationality, namely, the logic of storytelling, which makes sense of contingent events by changing the existing patterns of meaning. Historical narrative puts contingent events into an order such that the crisis of contingency dissolves into a sense-bearing and meaningful concept of temporal change in the human world.

This is what I meant in saying that crisis constitutes historical consciousness. In respect to the Holocaust, however, one should differentiate two kinds of crisis, the "normal" and the "catastrophic." A normal crisis evokes historical

Holocaust Memory and Identity Building: Metahistorical Considerations in the Case of (West) Germany

Jörn Rüsen

If only I had unfamiliar words, strange sayings, in a new language that has not yet been invented, without repetition—not sayings from the past, not precepts that our ancestors have already used.

—Khakheperreseneb[1]

In sleep drop by drop the memory of pain falls heavily upon the heart, and so wisdom comes to men, whether they want it or not.

—Aeschylus[2]

For as we are the product of previous generations, we are also the product of their aberrations, passions, and mistakes, even crimes; it is not possible to free oneself completely from this chain.

—Friedrich Nietzsche[3]

The Holocaust is the most radical experience of crisis in Western history. It is unique in its character as a genocide and in its radical negation of the basic values of modern civilization. As such, it destroys even the principles of its historical interpretation. Often characterized as a black hole of sense and meaning, it consumes every concept of historical interpretation and crushes all meaningful (narrative) relationship between the time before and the time after. Every attempt to apply comprehensive concepts of historical development and every attempt to integrate it into a coherent historical narrative has failed.

Nevertheless, the Holocaust must be recognized as a historical event and given a place in the historiographical pattern of modern history, within which we understand ourselves, express our hopes for and fears about the future, and develop our strategies of communicating with one another. If we were to place the Holocaust beyond history by giving it a "mythical" significance, it would lose its character as an actual event accompanied by empirical evidence. At the same time, doing so would limit the historian's approach to the experience of the past. The Holocaust as myth would contradict the logic of history, since a myth is not tied to experience as proof of reliability. In sum, the Holocaust is a borderline event whose importance consists in its reaching

49. Http://www.mkogy.hu/naplo/184/1840044.htm; http://www.mkogy.hu/naplo/194/1940214.htm.

50. Http://www.mkogy.hu/naplo/184/1840289.htm.

51. Http://www.mkogy.hu/naplo/188/1880331.htm.

52. Http://www.mkogy.hu/naplo/188/1880333.htm.

53. Mikhail Bulgakov, *The Master and Margarita,* trans. Michael Glenny (New York: Meridian, 1993), 311; originally published in Russian posthumously, in 1966–67.

54. See, for example, Luke 23:13–16 and Matt. 27:24–25 Revised Standard Version. Philo of Alexandria, who probably was a contemporary of Pontius Pilate although a far from impartial observer, described Pilate in a letter, which Agrippa I sent to Caligula, as "naturally inflexible, a blend of self-will and relentlessness" and attributed to him "graft, insults, robberies, assaults, wanton abuse, constant executions without trial, unending grievous cruelty" (Philo Judaeus, *Legatio ad Gaium* 38).

55. Http://www.mkogy.hu/naplo/188/1880335.htm. The liberal participant in this biblical debate had been one of the leading dissidents in the 1970s and 1980s. In July 1997 he published a paper on the relationship of the democratic opposition to the events and the memory of 1956 after the defeat of the revolution. He noted there that

It is mentioned customarily that one of the most important reasons for the unsympathetic attitude of former Marxists dissidents toward 1956 was the fact that the majority of them came from Jewish Communist families, from Jewish families by nomenclature. These families, even if they had stood against Stalinism before 1956, even if they looked favorably on the events of 23 October 1956, became distressed by the sights in the streets, by the unforeseeable nature of the behavior of the crowd.... This ambivalence characterized the majority of the Jewish families, even those who were definitively not Communist, and even those who supported the revolution. Despite the absence of open incidents of anti-Semitism, the days of Arrow Cross rule in 1944 could not be forgotten.

See Ferenc Kőszeg, "1956: A magunk képére formált forradalom" (1956: The Revolution That Was Formed in Our Image), *Beszélő,* ser. 3, 2, no. 7 (1997): 32.

56. The bill honoring Francis Joseph I was passed in February 1917, in the midst of World War I, upon the death of the emperor.

57. The description of the event is from "Megőrizni Joszif Viszarionovics Sztálin örök emlékét" (Preserving the Immortal Memory of Generalissimo Iosif Vissarionovich Stalin), *Szabad Ifjúság,* 10 March 1953, 5.

139: "il racconto di avvenimenti veri, organizzato in una continuità articolata i cui nessi hanno un senso (esplicativo), il senso della comprensione della storia."

32. *Magyar Szocialista Munkáspárt* (note 1), 2:1359.

33. *Magyar Szocialista Munkáspárt* (note 1), 2:1377.

34. In the case of 1944, what he meant was not the Nazi occupation in March 1944, not the takeover of the Arrow Cross Party (a Hungarian Fascist organization that controlled the government from October 1944 to April 1945), not the deportation of nearly 600,000 Hungarian Jews, but the formation of the provisional assembly and the provisional government on 21 December 1944. In the case of 1945 to 1948, the period before the Communist takeover, he was referring to the coalition government, the multi-party system, and everything that paved the way for the Soviets to liquidate all competing forces and alternative historical paths.

35. *Magyar Szocialista Munkáspárt* (note 1), 2:1362 (emphasis added).

36. Roland Barthes, "The Reality Effect," in idem, *The Rustle of Language,* trans. Richard Howard (Berkeley: Univ. of California Press, 1989), 146; originally published as "L'effet du réel" in 1968 and reprinted in Roland Barthes, *Le bruissement de la langue* (Paris: Seuil, 1984), 172: "réel concret."

37. Http://www.mkogy.hu/naplo34/001/0010029.htm.

38. The vote is posted under "Szavazások" (Polls) on the Website of the Parlamenti Információs Rendszer (Information System of the Hungarian National Assembly); see http://www.mkogy.hu/szavaz/szavlist/66pi2510.htm.

39. Http://www.mkogy.hu/naplo/183/1830042.htm. Here and below I am quoting from the accounts of parliamentary proceedings posted under "Napló" (Diary of the Hungarian Parliament) on the Website for the Parlamenti Információs Rendszer (Information System of the Hungarian National Assembly).

40. Http://www.mkogy.hu/naplo/184/1840307.htm.

41. Http://www.mkogy.hu/naplo/183/1830046.htm.

42. Http://www.mkogy.hu/naplo/188/1880313.htm.

43. After the defeat of the short-lived first Hungarian Soviet Republic in August 1919, right-wing army officers formed special commando units to hunt down, torture, and kill leaders of the Communist experiment. The hunt was broadened to include Jews and left-wing intellectuals in general—among them György Lukács, the composers Béla Bartók and Zoltán Kodály, the art historians Charles de Tolnay and Arnold Hauser, and the economist Karl Polanyi.

44. "Franczia Kiss Mihály ivadéka egyik vezetője volt az ellenforradalomnak" (Mihály Francia Kiss's Offspring Was One of the Leaders of the Counterrevolution), *Népszabadság,* 14 March 1957, 5.

45. Including a general of the interwar regime and the first, conservative speaker of the post–World War II Parliament.

46. Http://www.mkogy.hu/naplo/184/1840020.htm.

47. Http://www.mkogy.hu/naplo/184/1840028.htm; http://www.mkogy.hu/naplo/184/1840044.htm.

48. The Young Democrats were a party that started as a liberal, new age party of the young in 1989, but after sensing real political opportunity in the center right, reinvented itself as right-wing populist conservative.

21. Emil Kimmel, "Az utolsó beszéd" (The Last Speech), *Magyarország*, 18 May 1990, 25 (emphasis added).

22. "Köztársaság Square and *similar atrocities*" became an *epithet ornans* (embellished term of description) for the "the second edition of the white terror," which is how the 1956 Hungarian revolution appeared in Communist historiography. Note that "counterrevolution" was a term applied in Communist historiography to the insurgent movement of 1956, while the insurgents applied the same term to the Kádár regime that put an end to the insurgents' hopes.

23. For the entire discussion, see Magyar Országos Levéltár (Hungarian National Archives), BB. 1. fond 11957/8. ö.e. This document has been published in János Kenedi, *Kis Állambiztonsági Olvasókönyv* (Small National Security Textbook) (Budapest: Magvető, 1996), 1:9–12. There are slight differences between the original and the published version. I quote from the original typescript.

24. It was the Soviet leadership that after some hesitation chose Kádár as their trusted man; on 2 November 1956, Kádár found himself in Moscow and was taken to the GUM (the large state department store) to buy a pair of shoes in which he could appear before the Soviet leadership. See János M. Rainer, *Döntés a Kremlben, 1956* (Decision in the Kremlin, 1956) (Budapest: 1956-os Intézet, 1996).

25. See Michel de Certeau, *The Writing of History,* trans. Tom Conley (New York: Columbia Univ. Press, 1988), 89; originally published as *L'écriture de l'histoire* (Paris: Gallimard, 1975), 105: "à « réduire » l'élément aberrant."

26. *Magyar Szocialista Munkáspárt* (note 1), 2:1403–4.

27. *Magyar Szocialista Munkáspárt* (note 1), 2:1347–48. Both Nagy and Kádár were among the seven founding members of the Hungarian Socialist Workers' Party; according a statement in the proceedings, 31 October stands "for their joint efforts, their 'action in concert,' their close relationship."

28. *Magyar Szocialista Munkáspárt* (note 1), 2:1350.

29. Lévi-Strauss, *The Savage Mind* (note 5), 259–60; Lévi-Strauss, *La pensée sauvage* (note 5), 343–44:

> [U]ne date est un membre d'une classe. Ces classes de dates se définissent par le caractère signifiant que chaque date possède, au sein de la classe, par rapport aux autres dates qui en font également partie, et par l'absence de ce caractère signifiant au regard des dates qui relèvent d'une classe différente....
>
> ...[U]ne date historique n'aurait pas de sens puisqu'elle ne renverrait pas à autre chose que soi.... Le code ne peut donc consister qu'en classes de dates, où chaque date signifie pour autant qu'elle entretient avec les autres dates des rapports complexes de corrélation et d'opposition....
>
> ...[L]es dates propres à chaque classe sont irrationnelles par rapport à toutes celles des autres classes.

30. De Certeau, *The Writing of History* (note 25), 89; de Certeau, *L'écriture de l'histoire* (note 25), 105: "il suffit que l'un des termes en conflit soit classé comme passé."

31. See Patrick Nerhot, *Law, Writing, Meaning: An Essay in Legal Hermeneutics,* trans. Ian Fraser (Edinburgh: Edinburgh Univ. Press, 1992), 89; originally published as *Il diritto, lo scritto, il senso: Saggio di ermeneutica giuridica* (Ferrara: Corso, 1992),

13. "János Kádár's Last Speech" (note 1).

14. On 7 November 1956, Kádár was sworn in as prime minister, and a new government was formed. However, the Presidential Council of the Hungarian People's Republic (the Hungarian equivalent of the Supreme Soviet) did not announce the firing of Nagy as prime minister until 12 November. Even from this chronological point of view, the new government was illegal. See *A Magyar Szocialista Munkáspárt ideiglenes vezető testületeinek jegyzőkönyvei* (The Protocols of the Temporary Leading Bodies of the Hungarian Socialist Workers' Party), vol. 1, *1956 november 11–1957 január 14*, ed. Karola Neméthné Vágyi and Levente Sipos (Budapest: Intera Rt, 1993), 53 n. 11.

15. In 1956 the tapes disappeared and the transcripts were removed from the party archives, but an archivist made a photocopy of the transcripts and successfully hid it away. The first public mention of the existence of either the tapes or the transcripts is dated 12 February 1991. In 1955 at Rajk's retrial, a technical officer of the secret police was questioned about the authenticity of the tapes, which still existed at that time. He testified that "the transcripts were made on the basis of the tapes that I had personally recorded." The two secretaries who transcribed the tapes also testified as to the tapes' authenticity and stated that "when transcribing the tapes we were able to recognize the voices of some of the defendants, since we had previously taken part in taping the telephone conversations of some of the accused, Rajk among them." See Tibor Hajdú, "Kádár és Farkas Rajknál" (Kádár and Farkas at Rajk), *Társadalmi Szemle* 47, no. 10 (1992): 75.

16. Quoted by Tibor Hajdú in "Kádár és Farkas Rajknál" (note 15), 73.

17. Hajdú, "Kádár és Farkas Rajknál" (note 15), 74. On 7 January 1969, on the occasion of the sixtieth anniversary of Rajk's birth, the meeting of the Politburo of the Hungarian Socialist Workers' Party, under Kádár's chairmanship, decided to name "an important street in Budapest after comrade Rajk, and place a plaque there." The Politburo did not consider it right "to name the police academy after him," according to the minutes of the meeting. "Instead, it is appropriate to name either a civilian educational institution or a college after comrade Rajk." See Magyar Országos Levéltár (Hungarian National Archives), 288 fond 5/481. ö.e.

18. Kovács is a very common name in Hungary, like Smith in the United States. There are thousands of listings under "Kovács" in the Budapest telephone directory, and dozens of them in the telephone directories of every major American city. See David Crystal, *The Cambridge Encyclopedia of Language*, 2d ed. (Cambridge: Cambridge Univ. Press, 1997), 112: "There are some impressive similarities in naming practices across different languages, such as the use of names based on professions. *Smith,* and its foreign-language equivalents, is the best-known case, being the most common surname in many parts of Europe: Arabic *Haddad,* Hungarian *Kovács,* Russian *Kuznetsov,* Portuguese *Ferreiro,* German *Schmidt,* Spanish *Hernández/Fermández,* French *Le Fèvre/ La Forge,* and so on."

19. *Magyar Szocialista Munkáspárt* (note 1), 1:758.

20. Lévi-Strauss, *The Savage Mind* (note 5), 198 n; Lévi-Strauss, *La pensée sauvage* (note 5), 262 n: "Il en résulte qu'à la différence des systèmes de positions dont la nature discontinue est manifeste, les systèmes de relations se situent plutôt du côté du continu."

National Archives) in 1993; see *A Magyar Szocialista Munkáspárt Központi Bizottságának 1989: Évi Jegyzőkönyvei* (The Central Committee of the Hungarian Socialist Workers' Party 1989: Annual Proceedings) (Budapest: Magyar Országos Levéltár, 1993), 1:758–67. I quote from the recorded version.

2. *Magyar Szocialista Munkáspárt* (note 1), 1:756.

3. Nagy was rehabilitated by retrial before the Hungarian Supreme Court. In the film made of the retrial, one can see a small sheet of paper being passed among the occupants of the benches in the courtroom. Written on it was the news of Kádár's death.

4. Immediately after Kádár's speech before the Central Committee, rumors started circulating in Budapest about a "dramatic, monomaniac speech by Kádár."

5. On the term *necronym,* see Claude Lévi-Strauss, *The Savage Mind* (Chicago: Univ. of Chicago Press, 1966), esp. 191–216 (chap. 7); originally published as *La pensée sauvage* (Paris: Plon, 1962). According to Lévi-Strauss, a necronym refers to a kinship tie and is a "relational" term: "The necronym contains no proper name at all and consists in the statement of a kinship relation, which is that of an unnamed 'other' relation with a 'self,' equally unnamed. It can therefore be defined as an *'other' relation.* And finally, this relation is negative since the necronym mentions it only to declare it extinct" (p. 192); "Le nécronyme, d'où tout nom propre est absent, consiste dans l'énoncé d'une relation de parenté, qui est celle d'un autre, non nommé, avec un soi, également non nommé. On peut donc la définir comme une relation autre. Enfin, cette relation est négative, puisque le nécronyme ne la mentionne que pour la proclamer abolie" (pp. 254–55). Because Lévi-Strauss's reading of the necronym as a category of classification has not entered into wide circulation, I have been emboldened to resurrect it and attach a somewhat different meaning to it.

6. See, for example, Gáspár Miklós Tamás, "Veszélyben a demokrácia" (Democracy Is in Danger), *Világ,* 28 September 1989, 34: "Since his fall he [Kádár] is called a 'tyrant' or an 'executioner.'"

7. Lévi-Strauss, *The Savage Mind* (note 5), 198; Lévi-Strauss, *La pensée sauvage* (note 5), 263: "chez les Penan — le vivant perd le sien [nom] en pénétrant dans le système, et assume un nécronyme, c'est-à-dire devient terme d'une relation dont l'autre terme — puisqu'il est mort — n'existe plus que dans la relation qui définit un vivant par rapport à lui." I use *necronym* in the sense "Brutus" equals "the murderer of Caesar." It is interesting to note that Brutus's name is often remembered from Caesar's reproach to him in Shakespeare's *Julius Caesar* (3.1.77), "Et tu, Brute!" — a rendering into Latin of the Caesar's words to Brutus as recorded in Suetonius's *Lives of the Caesars,* "Kaì sú, téknon" [Thou too, my child] (*Divus Iulius* 82).

8. After 1956, 15 March — the day when the 1848 revolution broke out — became a day of anti-Communist demonstrations (or attempted demonstrations).

9. István Tanács, "Mit mond Kádár János?" (What Does János Kádár Say?), *Élet és Irodalom,* 3 February 1989, 3.

10. Rodney Needham, "The System of Teknonyms and Death-Names of the Penan," *Southwestern Journal of Anthropology* 10 (1954): 428.

11. Needham, "The System of Teknonyms" (note 10), 418 (emphasis added).

12. "Voices of the Revolution," sixteen excerpts from "Kossuth" and "Petőfi" Rádió, 23 October–4 November 1956, Open Society Archives 306/2000-18:1, audiotape.

with the Socialists—was the widow of one of the codefendants at Nagy's trial. She called Parliament's attention to previous occasions on which it had honored individuals in parliamentary bills. Among those previously enshrined were Stephen I, Hungary's founder, first king, and patron saint; Lajos Kossuth, the leader of the 1848 revolution; and Francis Joseph I, the emperor who defeated the 1848 revolution, ordered the execution of its leaders, and forced Kossuth to emigrate.[56] Mihály Károlyi, the first president of Hungary who as the leader of the short-lived 1918 democratic revolution had dethroned the Habsburgs, had been so named not once but twice.

Parliament had last passed such a bill in 1953, when the deputy prime minister introduced it as "the bill that will preserve forever the immortal memory of Stalin." The bill stated that

> The name, the work, and the teaching of Josif Vissarionovich Stalin have been united indissolubly with the history of our country. The sovereignty of the Hungarian nation, the liberty of the Hungarian people, the rise of the Hungarian workers are all forever connected with what comrade Stalin created and stood for both for the peoples of the Soviet Union and for progressive mankind.... In view of this, the Parliament inscribes in law the memory of Josif Vissarionovich Stalin for all that he achieved in the liberation of Hungary, in establishing and guaranteeing the freedom of the Hungarian nation, and in the political, economic, and cultural betterment and rise of the Hungarian working classes.

The deputy prime minister in 1953 struggled for words while commenting on the bill: "With my heart constricted I am looking in vain for the appropriate words to find a way to express who Stalin was for mankind." But he found the words and spoke for more than one-and-a-half hours. "Stalin is dead," said the deputy prime minister, "but he will live until the end of times in his work. The faithful and thankful Hungarian people decided to preserve his glorious memory in law. By passing the law that I have introduced in the name of the Council of Ministers of the Hungarian People's Republic, we are binding the imperishable wreath of the love and gratitude of our people around the deathless memory of our dear and great comrade Stalin."[57] So ended the memorial address given on 8 March 1953 by the deputy prime minister of the Hungarian People's Republic, Imre Nagy.

Notes

1. "János Kádár's Last Speech, Given at the 12 April 1989 Meeting of the Central Committee of the Hungarian Socialist Workers' Party," Open Society Archives 306/96-32:2, audiotape. All translations of quoted material originally in Hungarian are mine.

Kádár's speech was recorded secretly. On the tape, the official radio announcement of the exact time is superimposed (a voice announces the exact time every ten seconds) to guarantee the authenticity of the recording and to prevent later manipulation of the speech. The full text was published by the Magyar Országos Levéltár (Hungarian

rather be a day of mourning. One cannot celebrate Good Friday and Easter Sunday on the very same day," a biblically well-versed Christian Democrat reminded his colleagues in Parliament.[50] His remark was perhaps the impetus for an interesting conversation in the corridors of Parliament between a liberal member, who as a young student had spent some time in prison after the Hungarian revolution, and the Socialist Lutheran clergyman who was one of the signatories of the proposal. According to the first, "During the intermission, I had a conversation with my fellow parliamentarian, the learned clergyman who reminded me of the fact that the name of Pilate is in the credo.... The name of the evil is also part of the story of salvation."[51] The clergyman confirmed his colleague's words:

> There is a need to mention at every mass and at every worship service the name of Pilate. And there are several reasons for this:...Traditionally, two-thousand-year-old Christianity coexists with anti-Judaism; yet, in opposition to it [anti-Judaism], the credo of the first Christians clearly states who was responsible for the death of Jesus. Instead of accusing randomly, instead of seeing a criminal in every person, each Christian at all times, in all historical fairness, should know who had the political responsibility. I think of Pilate. Salvation is a historical difference that means that redemption on this earth has no meaning unless somebody is victorious over the evil. We, too, cannot deny that there was somebody who thought it his historical mission to become the executioner. One cannot pronounce the name of Imre Nagy without thinking of the name of the executioner.[52]

What these two could have had in mind was Mikhail Bulgakov's description in *The Master and Margarita* of the dream of Pontius Pilate after Christ's crucifixion: "'You and I will always be together,' said the ragged tramp-philosopher who had so mysteriously become the traveling companion of the Knight of the Golden Lance. 'Where one of us goes, the other shall go too. Whenever people think of me, they will think of you.'"[53]

It was clearly the two parliamentarians' intention to replace Pilate's name with the necronym "he who was responsible for the death of Jesus," despite the relative neutrality of the Gospels about Pilate.[54] As could be expected, however, the leader of the Christian Democrats was unable to let this interpretation pass without comment. "I think that in Jesus' case, it would not be right to present Pilate as the scapegoat, for he was not the main character there. Likewise, in this case too, it is not those who signed the sentence who are the chief actors. According to theology, we, all of us sinners, are responsible for Christ's death," he argued, in pursuit of the finer points of biblical interpretation. To save Pilate or to promote a certain interpretation of the synoptic gospels, he even would have pardoned Kádár for his sins against Nagy and left the name of the executioner out of the bill.[55]

The leading member from the liberal party—the Association of Free Democrats, the party of former anti-Communist dissidents that after 1994, in a strange and risky compromise, had entered into a coalition government

The inclusion of Mihály Francia Kiss (and a few others)[45] on the list of martyrs read to Parliament in 1996 served to challenge one more time the Reform Communists' reading of the Hungarian revolution. If we look at the list of martyrs, the picture being painted by conservatives in 1996 recycled many of the elements used by the Communists to construct their portrait of the "counterrevolution": déclassé individuals, former landowners, and right-wing victims of the Communists trying to go back in time, to before the Germans invaded Hungary. The conservatives were confirming the Communists' claims about the counterrevolutionary nature of 1956 — namely, that the real aim of the uprising had been to put back on track the "authentic" national history derailed first by the Nazis in 1944 and then by the Communists in 1948.

The conservative parties in Parliament opposed the bill to honor Nagy. "We should state objectively," said an old Christian Democrat, who had been a member of Parliament in 1945 and had known Nagy at that time, "that unlike most revolutionary leaders, including Kossuth, the leader of the 1848 revolution, Imre Nagy was not the leader of the revolution. From a political point of view, he may have been the leader, but not from the point of view of the revolution. This was the only revolution in world history that had no leaders, only ideas; workers, peasants and students were generals without names and titles. Nobody can be named, as there was no identifiable individual initiator."[46]

For the Socialists, Imre Nagy's name stood for the man "who approached the impossible," a Communist who was for "humanist, national, and democratic socialism"; for the conservatives, Nagy's fate taught instead that "democracy and Communism are incommensurable. . . . Only his death could solve this otherwise insoluble dilemma."[47] As a representative of the Young Democrats[48] stated, "In order to have democracy — this is what we had to learn — it is not enough to take back the power from those who usurp it, but we must also take back the past, our history." He argued,

> The real aim of the bill is to smuggle Communism into the mainstream of Hungarian progression one more time. . . . We have to ask the question: what is the real aim behind this bill? The bill is plainly an initiative to build a historical foundation for the Socialists. This is why it is unavoidable that they repaint 1956 as a democratic and Socialist revolution. . . . If what the Socialists claim were true — that Imre Nagy remained a Communist even under the gallows and identified himself with his ideas, with democracy and with his Hungarianness — then his name might be suitable for commemoration. But in this case, it would clearly be unsuitable for the Hungarian Socialist Party to take part in the formulation of a bill commemorating him. The forebears of the present-day Socialists first repudiated the nation, disavowed democracy, then — in order to be able to privatize what they had previously nationalized in the name of Communism — renounced their ideology.[49]

"June 16th, the day of Imre Nagy's execution, was baptized the 'day of Hungarian freedom.' But that day cannot become a day of rejoicing. It should

270 names as his fellow parliamentarians stood in silence.[41] When he finished, a historiographical and philological debate erupted. One of the original signatories of the bill, the liberal chair of the Defense Committee, reported that he had spent a few months on death row with one of those on the list and stated that this "martyr" had, in fact, taken advantage of the chaos created by the revolution to murder his wife and cut her into pieces. This murderer had been included in one of the postrevolution political trials by the Communists to show that the revolutionaries were in fact criminals and among the most dangerous elements of Hungarian society.[42]

There were other problematic names on the list. True, Mihály Francia Kiss was hanged in 1957 during the postrevolution terror, but he had spent the twelve days of the revolution hiding in a small cottage far from Budapest. Moreover, in 1945 he had been sentenced to death in absentia for his involvement in the so-called white terror of 1919.[43] In other words, the "martyr of the revolution" Mihály Francia Kiss had been involved in the torture and murder of Jews, left-wing intellectuals, and Communists after the defeat in August 1919 of the short-lived first Hungarian Soviet Republic.

The prosecution of Francia Kiss in 1945 for crimes committed in 1919 provided the court with a politically useful link between the genocide of the Hungarian Jews and other war crimes committed by the Fascists after the Nazis invaded in April 1944 and the anti-Communist white terror of 1919. By sentencing Francia Kiss (and a few others like him) in the context of the war crime trials of 1945, the court—influenced by the Communists and by the presence of the Soviet administration and the Red Army—could frame the anti-Communist interwar regime in Hungary as the direct precursor of Nazism and make the argument that anti-Communism and genocide were inherently connected. The seeds of the Hungarian state's criminal actions in World War II, it seemed, had been sown when the conservative regime of Admiral Miklós Horthy came to power in 1919. Those who oppose Communism are de facto Fascists, opined the court.

Likewise, Francia Kiss's inclusion among those prosecuted during the post-1956 trials was meant to show the intimate connection between the "counterrevolution" of 1956, the crimes of the Fascists in 1944, and the white terror of 1919. The difficulty with including the aging Francia Kiss was that no direct link existed between his deeds in 1919 and the revolution of 1956. Nonetheless, on the day after his capture was publicized, the newspaper of the party reported that "Mihály Francia Kiss's counterrevolutionary offspring has been caught."[44] The sensational article stated that a certain Béla Francia Kiss had robbed a grocery store during the uprising and that he was the "offspring" of the infamous war criminal. Béla Francia Kiss was tried and sentenced to four years in prison for "counterrevolutionary activities." In fact, the man (rehabilitated in 1963) had not robbed the store and had no family relation to Mihály Francia Kiss. But the article and his trial, sentence, and imprisonment had served their purpose. They sustained the links between 1919, 1944, and 1956.

From 1955 onward the name of Imre Nagy became the symbol of the possibility of *humanist, national, and democratic socialism.* In light of this, it was no accident that the Reform Communists gathered around him in order to prepare for the revolution.... His was a human life exactly because it was not a uniform life history. Had Saul remained a Christian-bashing agent of Rome, nobody would remember his name today; but he turned into Paul on his way to Damascus. Although this road has been truly crowded in the past six or seven years, nobody can deny the possibility of true awakening.... There are people who might question his idea of a socialism that could be achieved by rational and democratic means.... And he is the symbol of the political transition of 1989–90 as well. It was at his coffin that the Hungarian society made a decision, by judging the past and promising the future. We propose to commemorate the name of a person who approached the impossible.[39]

By reading the 1956 revolution as a fight for national sovereignty as well as an attempt to introduce "socialism with a human face," the Socialists were attempting to tie the name Nagy not only to an imagined democratic and humanistic version of socialism but also to the nation. The "person who approached the impossible" was now to be seen as the forerunner of the post-Communists who were at that very moment so energetically engaged in the heroic struggle to build a free-market economy in order to create at last, on the ruins of Communism, a just society and fill their own pockets at the same time.

"Imre Nagy's execution prevented him from becoming a true Social Democrat, so he had to die as a national democratic Communist," said the majority leader. "But he was nevertheless a forerunner of Alexander Dubček."[40] The Socialist argument extended Nagy's life beyond his untimely death. By linking Nagy to the leader of Czechoslovak Communist Party during the Prague Spring of 1968 and the speaker of the Czechoslovak Parliament after the Velvet Revolution of 1989, the Socialists were clearly trying to implicate not only Dubček but also Václav Havel, the quintessential dissident who became the president of Czechoslovakia (Dubček withdrew his name from consideration for the presidency and, on the basis of an agreement with Havel, became the speaker of Parliament instead). A direct connection was being made between Communists, Reform Communists, Social Democrats, and dissidents — a succession leading from Stalinism to an alliance between former Communists and former anti-Communists. In this Socialist reading, without the former Communists there would be no place for the former anti-Communists in history or on the present political stage. That is, the post-Communist transformation originated in 1956 and even before, in 1953, when Imre Nagy became prime minister of Hungary for the first time.

A representative of the conservative, right-wing Smallholders' Party proposed that the bill be modified to honor not only the martyred prime minister but everyone executed in the course of the postrevolution terror: "Imre Nagy, who fought against the Stalinist cult of personality would no doubt agree with the inclusion of all these names, he has never wanted to isolate himself from his fellow revolutionaries." After this rhetorical flourish, he read more than

3.

> The freely elected new Parliament considers it as its urgent task, one that cannot be postponed, to enshrine in a bill the historical significance of the revolution and fight for freedom of the autumn of 1956. This glorious event of modern Hungarian history can only be compared to the revolution and fight for freedom of 1848. The Hungarian revolution of the autumn of 1956 created the foundation for the hope that democratic social order can be created, that no sacrifice is in vain for the independence of the fatherland.

So begins the first bill passed by the first post-Communist Parliament minutes after the last Communist government officially stepped down.[37] On the previous day, 1 May 1990, the draft of the bill contained Imre Nagy's name. His name was still there during the night, when representatives of the new parties of the Parliament were adding the final touches to the text. But by the time the bill was formally presented in Parliament (in the name of the new, conservative, anti-Communist prime minister, who had played a minor role in the events of 1956), Nagy's name had been erased. The festive protocol in place for the opening day of Parliament left no room for debate. With 366 supporting votes and 2 abstentions, the bill passed.

On 30 April 1996 — about a week before the centenary of Imre Nagy's birthday — a bill honoring his name was introduced by six parliamentarians. They included the leader of the Socialist parliamentary majority; a Socialist Lutheran clergyman, the son of a deceased member of the Nagy government (his father was imprisoned between the world wars, again by the Stalinists at the beginning of the 1950s, and yet again after 1956 by Kádár); László Rajk Jr. (son of the show-trial victim, godson of Kádár, stage designer of Nagy's reburial in 1989, and a liberal member of Parliament since 1990); the liberal chair of the Defense Committee of the Parliament, who had been sentenced to death after the 1956 revolution and spent a year on death row before his sentence was commuted to life in prison; and another post-1956 prisoner, now a Socialist. The proposal was initiated by one of the successors of Kádár's Hungarian Socialist Workers' Party, the Hungarian Socialist Party, which succeeded in persuading a few symbolic figures to support the bill that would "legislate the memory of Imre Nagy, prime minister of Hungary who suffered martyrdom." After a long and charged debate, the Parliament passed the bill on 25 June 1996 (missing the anniversary — Nagy was born on 6 or 7 June 1896). There were 167 votes in favor, 77 against, and 64 abstentions; of the 167 supporting votes, 163 were cast by Socialists.[38]

The leader of the Socialist majority reminded Parliament that Imre Nagy first became known in the country as the Communist minister of agriculture who had signed the decree on the parceling of the landed estates and their partition among the millions of landless peasants in 1945.

These classes of dates are definable by the meaningful character each date has within the class in relation to other dates which also belong to it, and by the absence of this meaningful character with respect to dates appertaining to a different class....

...[A] historical date, taken in itself, would have no meaning, for it has no reference outside itself.... The code can therefore consist only of classes of dates, where each date has meaning in as much as it stands in complex relations of correlation and opposition with other dates....

...[T]he dates appropriate to each class are irrational in relation to all those of other classes.[29]

If there are antinomic positions, and thus an "irrationality" of dates, then—contrary to what de Certeau said—it does not suffice "that one of the terms of conflict be classified as past."[30] In this case, the past should be re-created with the help of new successivity of dates. A "proper" historical continuity "in which the links have an (explanatory) meaning" must be constituted.[31]

After a close reading of the "day of reconciliation" proposal, a Central Committee member with a hermeneutical bent pointed to contradictions in the sentence, "We bow our heads in front of those too, who, led by good intentions and by their own conviction, became the victims of assaults or atrocities while fighting on both sides, even on the other side." He noted that "in the context of the text, 'we' are in fact 'the other side' as well."[32] He continued (I paraphrase): If everybody fought for democratic socialism, for the sovereignty of the nation, for deep reforms, than we are the heirs of everybody; then we are on both this side and the other one (if "the other side" has any meaning at all). We shot at ourselves while defending ourselves from ourselves, and either we are the Soviets, too, or both of us (that is, we) were invaded and finally defeated.[33]

The director of the Institute of the Party and the Party Archive (and one of my history professors at Budapest University) drew the historical conclusion implicit in the proposal: "If 23 October is to be 'the day of renewal of the people's democracy,' then we could be the heirs both of 1944 and of the period between 1945 and 1948, of two very valuable traditions of our nation.[34] In this way we could create *continuity* for our own present history."[35]

The proposed series—23, 30, 31 October—promised temporal certainty and continuity—the certainty not only of dates but also of their proximity. With so little distance between its numbers, the series erases the appearance of interpretation and points to what Roland Barthes referred to in a different context as a "concrete reality."[36] In this proposed concretion of reality, Kádár continued the work of Nagy, there was no break on 4 November, and (after Nagy's reburial, after Kádár's death, in July 1989 when new parties are being formed) the Hungarian Socialist Workers' Party is continuing its march forward on the path to democratic socialism envisioned by Kádár and Nagy.

tion not only covered the events but also compressed them in time. The intent was clear: to fill any potential temporal vacuum, to bridge any chronological gap, however narrow, and establish a strong sense of successivity. As Michel de Certeau has pointed out, the desire for successivity in writing history aims "to 'reduce' the aberrant element."[25] The ambition here was not simply to attenuate "aberrant" chronological elements but rather to eliminate them firmly and persuasively from the story.

On 28 July 1989, weeks after the reburial of Nagy and not long after the death of Kádár, the Central Committee of the Hungarian Socialist Workers' Party discussed a proposal for a "day of national reconciliation." The suggestion was that the date set for the day of reconciliation should be 23 October. On that date, according to the proposal, a popular uprising broke out against a regime that had alienated the people. The revolt was a reaction to great offenses against national sovereignty by the Soviets and their Hungarian henchmen. "The now renewed Hungarian Socialist Workers' Party," stated the proposal, "sees 23 October as the symbol of the movement for democratic socialism, for national sovereignty, for comprehensive and deep reforms.... We bow our heads in front of those too, who, led by good intentions and by their own conviction, became the victims of assaults or atrocities while fighting on both sides, even on the other side."[26]

In the end, the Central Committee decided on a series of commemoration dates: 23 October was to be "a national day of remembrance," 30 October "the day of martyrs and victims," and 31 October "the anniversary of the formation of the Hungarian Socialist Workers' Party."[27] There was no mention of 4 November. This omission was explained by one committee member, the secretary in charge of agitation and propaganda, as follows: "We wanted to point at two alternatives, two possible directions the events could have taken—one that could have led to a compromise, the other that happened—paths that had still been open on 31 October 1956. We wanted to emphasize the openness of the events instead of their closure."[28]

In this new series of commemorative dates, 4 November did not belong. Obviously, the time was not right to remind the country of the role of the Soviets in repressing the revolution. Even the traditional cover of 4 November, 30 October, ceased to have an intelligible place in the new series. Explicitly recognizing 31 October as the day of the formation of the Hungarian Socialist Workers' Party meant that the defenders of the Budapest Party Committee headquarters on 30 October could not be claimed as the *party's* martyrs. Moreover, the party could not have its *own* martyrs when it aspired to become the initiator of collective, national dates of remembering for *all* Hungarians. The context for 30 October and 4 November had changed, such that there was utility neither in associating 30 October with 4 November nor in folding 4 November into 30 October. In the new, post-Communist era, 4 November had to disappear and the importance of 30 October had to be redefined.

"[A] date is a *member* of a class," Lévi-Strauss reminds us.

Then a well-known hard-liner came up with a new idea: "Serious thought is being given to the idea of organizing a sort of military parade on 4 November in the former Stalin Square, where comrade Kádár would address the masses. In this case we could hold a rally on the 30th and still mobilize at least fifty thousand people for the military parade [on 4 November]." But another participant, who had sat silent until this moment, now expressed serious concern about a massive military demonstration: "I do not agree with this plan of a military parade. In October, because of the anniversary, the mood is somewhat nervous anyway. The people are waiting for something to happen. The military parade is not without risks; it might be misunderstood." In the end, the comrades agreed that, since they did not have reliable information about the plans of the higher leadership of the party, they could and would not make a decision; instead they would ask the party leaders about their ideas and then act accordingly.[23]

On 30 October 1957—following the Executive Secretariat's tiresome and cautious discussion—a rally was held in Köztársaság Square, the first and last big rally to be held on that day. From 1958 to 1989, the celebration was held on 4 November and according to a strict ritual: wreaths were laid on a memorial tablet (and, eventually, at the huge monument that would be erected in the middle of the square) and short speeches were given, then the dignitaries proceeded to the national cemetery and laid wreaths at the Memorial of the Martyrs of the Labor Movement, and, finally, at Szabadság Square the dignitaries decorated the Memorial of the Soviet Heroes, which still stands in front of the American embassy. Until 1965 no member of the Central Committee officially took part in the ritual except the first secretary of the Budapest Party Committee, who was customarily a member of both the Central Committee and the Politburo. Kádár participated only once, in 1966, on the occasion of the tenth anniversary of the end of the revolution.

After 1956, and until 1989, not holding a public ceremony on 4 November, on the day when Soviet troops returned to Budapest, was unimaginable. The uprising would not have been defeated without the Soviets; only they could have repressed the revolution.[24] However, simply celebrating the defeat of Hungarian insurgents by Soviet troops would have called unwanted attention to the victors, the foreigners, the invaders, "the Soviet army stationed *temporarily* in Hungary," as these troops were officially referred to after 1956. Alone, 4 November could not have legitimized the new government. But by remembering on 4 November those who died on 30 October while defending the party headquarters, not only could the Soviet intervention be pushed into the background but also the repression of the uprising could be presented as an immediate reaction to the brutal killing of the bearers of the flag of truce.

In other words, the rigid ritual set down for the annual commemoration served two ends. It allowed the Hungarians who gave their lives in defense of the Communist regime in 1956 to be remembered every year—but not the many Soviet soldiers who died. And it made the defeat of the "counterrevolution" to both closely follow and follow from the massacre—the commemora-

On 7 October 1957, nearly a year after the outbreak of the revolution, the Executive Secretariat of the Budapest Party Committee held its regular meeting at its reconstructed headquarters in Köztársaság Square. One of the secretaries started with a

> theoretical question on which we have to take a stand. In view of the fact that we had to give up this building a year ago, we should commemorate the anniversary. The only question is whether we should commemorate it on 30 October or 4 November? I prefer 30 October, but other comrades prefer 4 November. I think that we should organize the commemoration on the 30th because it symbolizes not only that the Budapest Party Committee was defeated and lost a battle but also that it fought a glorious fight against the counterrevolution.... The only question is how to commemorate? Should there be a large rally or not? Should we award the medals on that day or on 7 November [the fortieth anniversary of the Bolshevik Revolution of 25 October 1917, a date that became 7 November 1917 once the Soviets reformed the Russian calendar in 1918]?

In the view of another secretary,

> The Central Committee has already worked out a plan for a big, centrally organized rally on 4 November. If we also decided to organize a rally in Köztársaság Square on 4 November, it would not be the right thing to do, as it is almost impossible to organize two big rallies on the same day. The other question is the following: If we go on with the rally on 4 November, could another rally still be organized on 30 October?

A third functionary had rather different concerns:

> It is true that 30 October is the first anniversary. However, 4 November is the day that stands for the beginning of the victory [when the Soviet troops came back to Hungary]. The new government led by János Kádár was formed on that day; surely November should become an important date in the history of all the Hungarian people.

According to a fourth, "We have martyrs, whom we should honor every year.... In my view there should be a smaller commemoration on 30 October and a rally on 4 November." Someone else recommended that instead of a rally on 30 October there should be "an unveiling of a memorial plaque on the wall of the Budapest party headquarters with the names of our martyrs." A former race-car driver (and future deputy minister of transportation) supported holding the large, centralized rally on the 30th, but asked, "Will there be a rally on 7 November, on the anniversary of the great October [Bolshevik] Revolution?" The answer to his question was "No! No rally on that day!" whereupon he opted for smaller, decentralized rallies. A female functionary cautioned, "We must turn 30 October into a day not of rejoicing but rather of honoring our martyrs."

because she had radical stomach surgery while I was in prison. And she was called to repudiate me, but she did not do that. And then she was forced to renounce my name; she was forbidden to use her husband's name."[19] What happened to Rajk's son in 1949 happened to the wife of the godfather of Rajk's son in 1951: just as the name of László Rajk Jr. was stolen, for it so clearly referred to the (nonexistence of) father, so Mrs. János Kádár was forced to change her name, for it pointed so unmistakably to the (absent) husband.

The post-1956 period is referred to in Hungary as "the Kádár era" or "the Kádár regime." Had Imre Nagy been alive as a dead person—that is, had his name been used in public—then Kádár's original sin would have threatened the hegemony of the name Kádár and undermined the claim of the regime connected to his name to legality and thus to legitimacy. "Systems of relations," said Lévi-Strauss, taking Needham's observations further, "unlike systems of positions whose discontinuous nature is evident, tend rather to be continuous."[20] It was not enough to execute Imre Nagy. Nagy's very name had to be removed; otherwise the continuity between Kádár's treason—which finished the 1956 Hungarian revolution and ended the life of his predecessor—and the Communist restoration under Kádár could not be erased. There would have remained an unforgettable and unerasable relationship between the hanged prime minister and his successor (and executioner).

Hungarian television covered the reburial of Imre Nagy live. The event lasted for more than six hours. On the day of the reburial, 16 June 1989, the deputy press secretary of the Hungarian Socialist Workers' Party was sent by the Central Committee to Kádár's home to console him. Kádár was physically sick and emotionally shaken. He did not watch television but instead sat in almost complete silence, asking from time to time, "Is *it* today? . . . Is *that* happening today? . . . Does *that* take place now? Is this *the* day?"[21]

2.

On 30 October 1956, armed groups belonging to the irregular, uncentralized revolutionary forces attacked the headquarters of the Budapest Party Committee. Rumors had spread that underneath the building was a labyrinth where hundreds or even thousands of political prisoners—including women and children—were being kept by the secret police. The revolutionaries planned to capture the building, dig up the labyrinth, and free the innocent thousands. A cruel and bloody fight ensued, in the course of which tanks sent by the ministry of defense to protect the building went over to the side of the revolutionaries. Dozens died, and the building was almost completely ruined. When those inside surrendered, the five men sent out under a white flag to negotiate a surrender were killed, their bodies hanged and mutilated, their hearts cut out. This was the most significant anti-Communist atrocity during the twelve days of the 1956 Hungarian revolution. Afterward, whenever the Communists wanted to prove the brutality of the "counterrevolution" (as the revolution was represented in Communist historiography), they referred to Köztársaság Square.[22]

for Kádár to be reborn as Hungary's new leader after 4 November 1956. In his speech of 12 April 1989, Kádár struggles (not) to refer to his guarantee to Nagy: "a simple sentence" and "all sorts of consequences rooted in that simple sentence." "I never read my old writings when I speak, for they might influence me, believe me or not—even that which was in that statement." He uses "they," "their," "him," "he," and other circumlocutions instead of the names of Nagy and the other refugees. So struggles the old man with broken promises and the shadow of a dead man.

Other dead men shadow Kádár's speech as well, if we look carefully. László Rajk was the minister of interior at the end of the 1940s and the most famous victim of the Stalinist show trials in Hungary after the defection of Titoist Yugoslavia from the Soviet bloc. According to secretly recorded audio-tapes made in Rajk's prison cell, it was Kádár—Rajk's successor as minister of interior—who convinced Rajk that he had no choice but to confess and cooperate in his own destruction.[15] After Rajk's execution on 15 October 1949, it was Kádár's turn. Imprisoned in April 1951, Kádár was released on 20 July 1954 and rehabilitated. (Stalin had died on 5 March 1953, and Nikita Khrushchev, then first secretary of the Communist Party, had denounced Stalin's excesses on 24 and 25 February 1956, before the Twentieth Party Congress in Moscow.) From a document that Kádár handwrote one or two days before he was released from prison, we know that as minister of interior he was present at Rajk's execution. Perhaps because he had found the execution so shocking, Kádár asked a few days later for permission to resign his post.[16] His important role in persuading (forcing) Rajk to confess was a well-kept secret after 1956.[17]

Rajk's son—Kádár's godson—was six months old when his father was hanged. The mother of the six-month-old infant was sent to prison, and the infant was sent to an orphanage, where his name was changed from László Rajk Jr. to István Kovács.[18] After Stalin's death, and after many unsuccessful attempts by relatives to find Rajk's son, the boy's paternal grandparents received a telephone call indicating that they could retrieve their grandson at the corner of Pannonia and Katona József Streets, where they lived. (In 1969 the Politburo renamed Pannonia Street after László Rajk. In 1990, after the fall of Communism, the street was re-renamed Pannonia.) When they arrived at the corner, a car stopped, discharged a boy, and quickly drove away. Although the grandparents immediately recognized him (as he resembled, and still resembles, his father), the five-year-old boy did not respond to his name. Hours later the boy, playing with a teddy bear at home, was overheard saying to himself, "Pisti has a bear." (Pisti is one the nicknames of István.) In 1970, László Rajk Jr., then an architecture student, founded an experimental theater workshop and named it the "István Kovács Studio."

"Let me make a remark," says Kádár on 12 April 1989. "I have an illness. And my illness is similar to my wife's. She is losing weight, and I am losing weight too. The medical opinion is the following: my wife has been walking with a stick for five years; she has to use a stick, and she is losing weight

On 31 October 1956, János Kádár and Imre Nagy had reformed the Hungarian Communist Party to create the Hungarian Socialist Workers' Party, which would exist until October 1989. Nagy, who pledged to the liberalization of the Communist regime and the evacuation of Soviet troops, had been brought to power on the strength of the uprising begun on 23 October 1956. Kádár was a member of the Nagy government when the decision was made to withdraw from the Warsaw Pact and the neutrality of Hungary was proclaimed on 1 November 1956. He gave a major speech on the revolutionary radio in which he said, "[T]he glorious uprising of our people achieved the freedom of the people and the independence of the country.... We are proud that you held strong in the armed struggle."[12] Then Kádár vanished, went over to the Soviets, and rematerialized publicly (on the radio) to announce that he had asked Soviets to "defend" Hungary and that he had formed a new government to defeat the revolutionary government of Imre Nagy. On the morning of 4 November 1956, the day of the Soviet invasion, Nagy fled to the Yugoslav embassy. There, Nagy and other members of his government—including György Lukács and close associates such as the widow of László Rajk—were granted refuge.

Nagy refused to sign the letter in which the Soviets were retroactively asked to invade the country. "The man who has died since refused to sign ... I had to sign it too, somewhere, God knows where," Kádár says about this letter on 12 April 1989.

> I did guarantee the safety of him. But such a naive man as I am, I gave a guarantee because I thought that on my request he would make a statement, in order not to create a base for later support. Well now, I too see everything historically differently. But if I gave a guarantee according to their wish ... but it was their wish to leave home freely. I could not carry this through to effect as I never read my old writings when I speak, for they might influence me, believe me or not—even that which was in that statement. Unfortunately, there was a simple sentence in that statement. And since then there have been all sorts of consequences rooted in that simple sentence.[13]

On 19 November 1956 the Yugoslav deputy minister of foreign affairs arrived in Budapest and delivered to Kádár the letter in which the Yugoslav leadership urged the Hungarian party to resolve the Nagy situation. Two days later the Yugoslavs and the Hungarians reached an agreement that allowed Nagy and his associates to leave the embassy building freely, with Kádár personally guaranteeing the refugees' safety. When they left on 22 November, the refugees were kidnapped by the Soviets (with the prior consent of Hungary's party leaders) and transported to Romania. Nagy stayed in Romania until he was returned to Hungary, tried, and hanged on 16 June 1958.

From a legal standpoint Kádár's government was and remained illegitimate, because Nagy never signed a letter of resignation.[14] That government, the new rule, was conceived in Kádár's broken promise. Nagy had to perish

as if there were a self-imposed prohibition on the name of the dead man, as if referring to Nagy by name would have produced a *relational* term. In fact, this is what happened in 1989. Once it was permitted to pronounce the name of the dead man publicly, Kádár increasingly lost his proper name and acquired in its stead the *necronym*[5] "Imre Nagy's executioner."[6]

According to Claude Lévi-Strauss's analysis of naming and the kinship systems of the Penan, a tribe of hunter-gatherers in northwestern Borneo, "when the living Penan enters the system he assumes a necronym, that is to say, he [the living Penan] becomes one of the terms in a relationship, of which the other — since he [the other Penan] is dead — no longer exists save in that relation which defines a living person with reference to him."[7] Had Imre Nagy, the executed prime minister, existed in public discourse between 1958 and 1989 as a dead person, had he been referred to by name, a relation could have been created between Nagy — the dead one — and Kádár — the one who was very much alive. Instead of having a fixed attribute attached to his name (such as "the old man," which is what his closest aides affectionately called him), instead of existing in a system of positions (as, for instance, "general secretary of the party"), Kádár could have been locked into a system of dangerous relations beyond his control — as he was later. On 15 March 1989 banners carried through the streets by demonstrators read: "Kádár–Haynau, Imre Nagy–Batthyány."[8] Julius Jacob von Haynau, known as the "hyena of Brescia," was the henchman whom emperor Francis Joseph I sent to put down the uprising in Brescia in 1848. After the defeat of the 1848 Hungarian revolution, Haynau as the military governor of Hungary ordered the execution of the thirteen leading generals of the Hungarian army (on 6 October 1849, in Arad, Transylvania) and the hanging of the moderate prime minister of the first Hungarian ministry, Count Lajos Batthyány (on the same day, in Pest).

"And please remember," said Kádár to the Central Committee on 12 April 1989, "that whenever I remember — because already this is what I have to do — I will always tell the truth...I cannot refuse that since everybody says that I am the living one." Kádár clearly said not "I am alive" but "I am the living one" (*én vagyok az élő*), thus referencing the one who is not living, who cannot testify. Nine weeks earlier, a two-page article published in the most important Hungarian literary weekly had declared, "Now it is high time for János Kádár to say something. Not about the future, for visions are seldom fulfilled, but about the past.... János Kádár is a chief witness in any account in the [László] Rajk case and in the Imre Nagy case.... He cannot disappear silently."[9]

Death-names — as Rodney Needham, the first anthropologist who tried to analyze this classificatory category, refers to necronyms — "are not vehicles or evokers of sorrow [among the Penan], but merely classes of persons with reference to the deaths of true kin."[10] According to Needham, "The principle of application of the death-names is that on the death of a true kinsman or kinswoman a Penan assumes a name *according to his relationship to the deceased.*"[11]

On the afternoon of 12 April 1989, the chair of the session at the meeting of the Central Committee of the Hungarian Socialist Workers' Party takes the floor. He has something unexpected to report:

> Dear comrades! I have a very difficult, even humanly very difficult task. I would like to inform you that comrade János Kádár is in very poor health. He has been preparing for this meeting for many days; he has very much wanted to take part, and he has formulated a lot of thoughts. Until yesterday, or at least yesterday it seemed that he understood my — our — request to stay away from our meeting today. But now he is here; he has arrived. Yesterday we parted under dramatic circumstances. But now he is here and wants to come into the session. We have neither the possibility nor the right to prevent him, but I would like to forewarn you that he is in bad condition both humanly and even biologically. I am not a medical doctor, but I have concrete information about his medical condition. If he takes the floor — I warmly ask you — please make an effort to understand.[2]

At 3:30 P.M. the members of the Central Committee break for lunch; an hour later they reconvene, and the chairman gives the floor over to János Kádár.

Kádár is seventy-seven years old. A year earlier, on 22 May 1988, he had been ousted from his position as general secretary of the party — a post he had held since 31 October 1956 — and given the titular post of party president. In May 1988, Kádár had also undergone hand surgery, and he seems to have considered this surgery as being more serious than it was. He thought it had incapacitated him and led to the loss of his faculties.

It is 12 April 1989. Kádár's best-known victim is about to be exhumed and reburied. Kádár knows that his weakening and confused party has no choice and has given its consent. He knows that there is no longer any way to stop it. The hanged prime minister of the 1956 Hungarian revolution, Imre Nagy, whose body had been thrown into a ditch in the most distant corner of a cemetery on the outskirts of Budapest, is coming back. (Kádár will be removed from both the party presidency and the Central Committee on 8 May 1989. He will survive Nagy's reburial by three weeks, dying on the morning of 6 July 1989, the very day on which Hungary's Supreme Court rehabilitates Nagy.)[3]

Kádár speaks for ninety minutes, his words and associations disjointed, his thoughts and sentences disconnected. The Central Committee sits in complete silence. When he finishes, the session is suspended. From his speech, it is more or less obvious that Kádár is preoccupied by the coming reburial and by his own role in ending the 1956 revolution, in bringing Soviet troops back into Hungary, and in executing the "dead man" or "the man who has died since," as he kept referring to Nagy. It is not until the very end of his monologue, on the last page of the published minutes, that Kádár pronounces the name: "before Imre Nagy and his people, those belonging to him were … killed."[4]

According to documents and available testimony, Kádár almost never referred to Imre Nagy by name after 16 June 1958, when Nagy was hanged —

Covering History

István Rév

1.

Perhaps you have not heard me for quite some time; bear with me ... You will hear something strange from me ... What is my responsibility? ... It is not I—I haven't used this myself—but a man from the West in the presence of the Soviet tanks who said, "The flow at the Danube is too quick" ...

My illness, the reason for my forgetfulness is that I often know what I want; this is why I am losing weight ... My problem is that my mind is constantly whirling around and around, and this requires energy ... I do not mind what you say afterward and what you say, as anybody can shoot me dead, as I was aware of the responsibility that I would not name anybody ... And now I want a lot of water because I am nervous ...

The doctor says that my real problem is that I keep thinking about my responsibility ... and they say: "You are the president of the party, and still you do not speak. If you are the president, why are you not able to speak?"

Now I am not the same, not who I was a long time ago ... but I will not name anybody ... I don't know why my presence is important for anybody, as I am a scapegoat in the biblical sense. Because I am older than anybody else ...

If I remember well, the man who has died since refused to sign ... Now, historically I see everything differently as well ... I had to sign it too, somewhere, God knows where ... For how long am I talking now? I will come to the end ... I just cannot stand, I cannot bear remaining passive and unable to respond. I cannot stand this. And this is what makes me ill. I have an illness different than what my wife has.

And what is memory? ... And what is leaking words? ... I am a very old man, and I have so many kinds of illnesses that I do not even mind if somebody shoots me to death. I apologize ...

And please remember that whenever I remember—because already this is what I have to do—I will always tell the truth ... I cannot refuse that since everybody says that I am the living one. I must speak ... Now I remember it started on the 28th when by pointing at the [manner of] dress or the color of the skin or by pointing at I don't know what, unarmed people were killed on the basis of a pogrom. And they were killed before Imre Nagy and his people, those belonging to him were ... killed. And if I looked at it unhistorically, then I too would quietly say ... And if I look at it from the distance of thirty years, then, then I feel sorry, yes, for everybody ...[1]

Part III

Memory
and History